SOLDIERS & SUFFRAGETTES

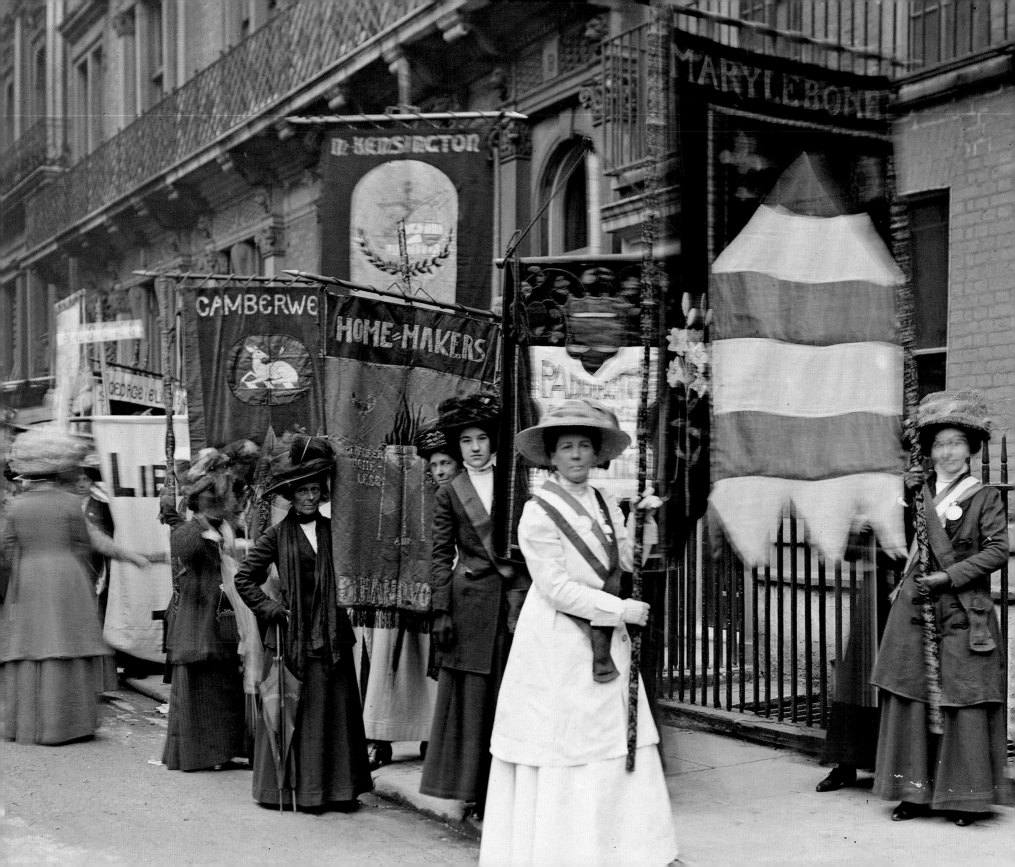

SOLDIERS & SUFFRAGETTES: THE PHOTOGRAPHY OF
CHRISTINABROOM

Anna Sparham

with contributions by
Margaret Denny, Diane Atkinson and Hilary Roberts

Published on occasion of the exhibition
Soldiers & Suffragettes: The Photography of Christina Broom, Museum of London
(19 June–1 November 2015)

Published in 2015 by Philip Wilson Publishers
an imprint of I.B.Tauris & Co Ltd
London • New York

www.philip-wilson.co.uk

ISBN 978 1 78130 038 1

Designed and typeset in Classic Roman and Gotham
by Caroline and Roger Hillier, The Old Chapel Graphic Design,
www.theoldchapellivinghoe.com

Frontispiece: Suffragists prepare to take part in the NUWSS Procession, 13 June 1908. The Home-makers' banner in the centre was one of a series designed by Mary Lowndes, founder of the Artists' Suffrage League

Image repro by Artilitho s.n.c., Lavis, Trento, Italy
Printed and bound by Printer Trento, Italy

MIX
Paper from
responsible sources
FSC® C015829

CONTENTS

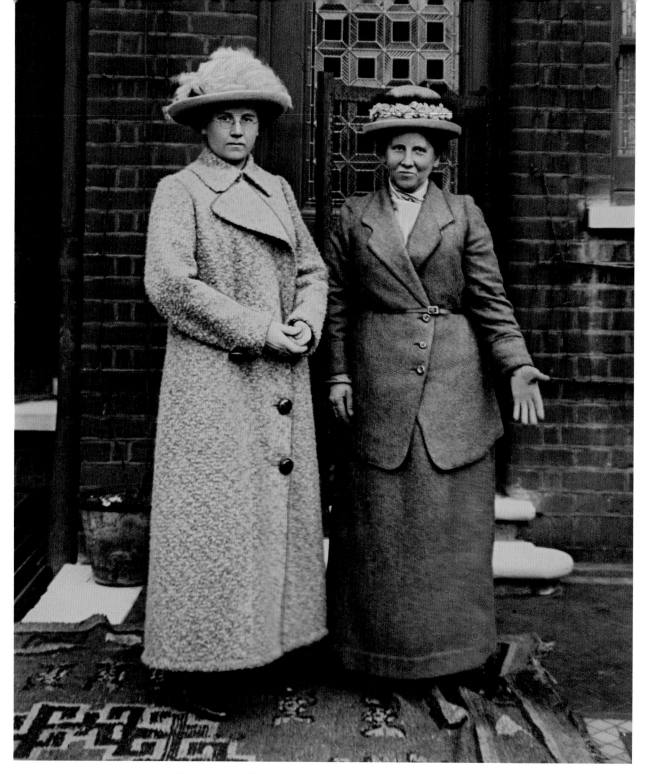

Christina and Winifred Broom, unknown photographer, c. 1915

INTRODUCTION

Anna Sparham

IN 1903, CHRISTINA BROOM – MRS ALBERT BROOM, to use her professional name – propelled herself into the field of photography as a business venture to support her family. Rising from self-taught novice to a semi-official photographer for the Household Brigade, she emerged as a pioneer for women press photographers in the UK. This is the first publication dedicated to the exploration of her life and spectrum of works.

Active in the Edwardian period through to the eve of the Second World War, Broom observed seismic changes in society. Among her photographs she recorded arresting images of suffrage activity, leading topical sports and royal occasions, and poignant, insightful pictures of soldiers over the course of the First World War. Broom's photography is immersed in an era of grandeur and tradition yet it also conveys and acknowledges change. Indeed, she finds herself perfectly placed to record extraordinary moments in London. Despite the high-profile, often formal environments and events she frequents, Broom's remarkable ability to remain people-focused and engaged with those she photographs makes her work both unpretentious and even more alluring. Collectively, the breadth of Broom's photography casts light on the important moments she documents, the people at the heart of them and the determined, intriguing woman behind the lens itself.

The photographs and ephemera selected for this book are predominantly sourced from the Museum of London's extensive Broom collection. It is not an exhaustive collation but strives to showcase her strongest work. It is supported by contextual essays examining the fascinating background to her life and photographs.

For many years the Museum of London has cared for 306 half-plate glass negatives made by Broom. These plates reveal topographical London views and events, the latter dominated by records of suffrage processions and exhibitions. The negatives were donated to the museum by Broom's daughter Winifred. Winnie had herself been her mother's sole assistant, producing many thousands of prints from the negatives, mainly as post cards, for the business. She was extremely devoted, both to the work and to her mother. As Broom found herself with crippling back pain at times, her daughter would push her to the barracks or the Royal Mews in her wheelchair, so that she was still able to use her camera. Winnie was also a VAD nurse during the First World War. Although unable to pursue the photography business alone into the Second World War, she remained committed to the work that had been achieved, making it her objective to ensure that the existing negatives were preserved and that her mother received due credit. In reality, it

initially proved a struggle for Winnie to have the work accepted into institutions, largely due to the scale and medium of, and limited appreciation for, the images. And over the years, Broom was not always acknowledged when her work was reproduced. Nevertheless, Winnie did succeed in rehousing many negatives among museums, libraries and other organizations, from which several are drawn for this publication.

In 2013, the Museum of London acquired the remaining prints that had belonged to Winnie and, while in private hands, had been supplemented by further original postcards from the open market. The acquisition, consisting largely of photographic postcard prints, enlargements, ephemera and correspondence, has enabled this story to be most effectively brought together and told. Exposure of Broom's work has increased gradually over the years, with inclusion in a number of exhibitions, most notably at the National Portrait Gallery in 1994. However, she remained a photographer relatively few people were aware of. A fuller assessment and understanding of the person, the photographs and the occasional assumptions made to date can now be more comprehensively addressed and discussed.

All the authors within this book know Broom's work intimately. Each shares a distinct passion for both her photographs and her story.

Dr Margaret Denny, as a photo-historian, has pursued a specialist interest in the work of commercial women photographers in both the USA and Europe. During research on the Gernsheim Collection at the Harry Ransom Centre, University of Texas, Denny focused on the Broom photographs held there. Denny provides a valuable insight into the domain of commercial photography, examines Broom's early focus on London street views specifically and draws comparison with some of her contemporaries.

Dr Diane Atkinson has previously authored a publication of Broom's Suffragette photography. Her considerable knowledge of the suffrage campaign and London in this era brings to the publication important contextual support for these remarkable images. As a biographical writer, Atkinson also considers Broom herself, as a woman approaching the photography of this enormous subject.

Hilary Roberts works with the Broom collection at the Imperial War Museum and has undertaken ongoing research into Broom's work with the army, particularly with a view to positioning its significance during the First World War and beyond. With such immense expertise in conflict photography, Roberts is the ideal author to communicate Broom's unique contribution to the war as a woman photographer on the home front.

Anna Sparham has worked with the photographs collection at the Museum of London since 2004. The rich visual history this offers has generated a broad knowledge of the multitudinous ways in which photographers record the city and its people. Pageantry, tradition and ceremony are strong unifiers across Broom's work. As these elements are so affiliated with London, it was appropriate for Sparham to focus on this aspect, unravelling Broom's relationship with subjects from royalty to the Boat Race. Sparham also curated *Soldiers and Suffragettes: The Photography of Christina Broom* in 2015.

It is intriguing to observe how absorbed those new to Broom's work become. People are attracted to her story, her amateur beginnings and the path she carves out for herself. They are struck by her audacity and inspired by her achievements. When responding to her photographs, there is a distinct pull towards the suffrage work and equally that on the soldiers leaving for war; the acute contrast and comparison between the two is exciting in itself. The draw to the photographs is enhanced by nostalgia; yet, despite their historic content, they can appear curiously contemporary at times. Perhaps a rise in attraction to the spectacle – the opening ceremony of the London Olympic Games, royal weddings and commemorations held around the centenary of the First World War – encourages twenty-first-century viewers of Broom's work to find much of relevance today.

Broom successfully wove together her delight for photography, her aptitude for opportunity, her location and her determined

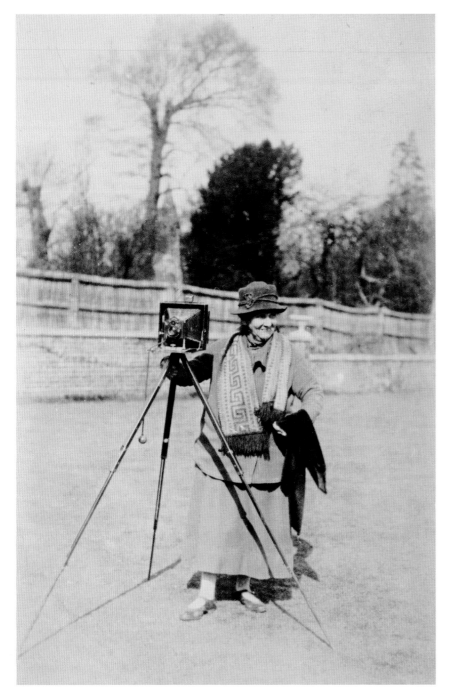

Mrs Albert Broom photographed by one of the Oxford Crew, c. 1935

character. In 1955, photography collectors Helmut and Alison Gernsheim proclaimed her to be 'probably the first [UK] woman press photographer'.[1] This accolade alone gives weight to her status. Yet due to Broom's commercial emphasis and focus on the middle to upper classes of London society, her work has been somewhat under-appreciated in favour of other genres and content.[2]

The chance to look more closely at Broom herself, the enormous contribution of Winifred and the breadth of the photographs as a whole has allowed them to be viewed afresh. These photographs serve to enhance London's visual photographic history in ways that go far beyond their original purpose.

In a published letter written by Winnie in 1966, she concludes with the remark 'naturally the Museums are not interested in our lives – but are glad of the negatives'.[3] The words and pictures that follow prove that, alongside the photographs, the focus on Christina and Winnie is clearly also of paramount importance.

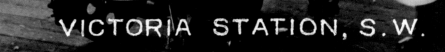

TEA 2 PER CUP

J.LYONS & COLTD

BROOM, 421.

VICTORIA STATION, S.W.

'MRS ALBERT BROOM'S

INTERESTING "SNAP SHOT" POST CARDS'

Margaret Denny

ON 23 JUNE 1911, A DIMINUTIVE WOMAN with a view camera, tripod and glass plate negatives eased her way through the throng of people that had gathered at Admiralty Arch Stand to witness the coronation procession of England's King George V. Undaunted by the teeming crowds, Mrs Albert Broom (Christina Livingston) had official permission to photograph at this historic event, as she had been documenting royal proceedings since the early 1900s.[1] Capturing all things from coronations to funerals, soldiers to Suffragettes, and everyday street scenes, Mrs Broom with her camera was a familiar sight in and around London for over three decades. Moreover, at the moment when the picture postcard emerged as a cultural phenomenon, preserved in albums or posted to friends, Broom transformed her documentary photographs into postcard views to be distributed through stationery shops.

Mrs Broom exploited and expanded the printed postcard category, building a repertoire of scenes that are at once historic, nationalistic and nostalgic. In addition to documenting military manoeuvres, royal pageantry and women's suffrage groups, her photographic postcards feature architectural monuments, parks and sporting events, and scenes of everyday Londoners at work and play. These London photographs depict the evolving social, cultural and political urban

landscape of the Edwardian era, which according to one source reflected an 'age made more attractive by its leisurely tempo and elegance'.[2] What was most unusual about her postcard business is that she produced thousands from her home in collaboration with her daughter Winifred, who developed the negatives and printed the postcards. Whether photographing architectural treasures, groups or individuals, Broom aimed to show her subjects in the best possible light, literally and metaphorically. As material objects, the images serve a mimetic function, preserving an historic record of what was and offering today's viewers a glimpse of a time past. The appeal of her photographic postcards is largely nostalgic. The manifestation of Broom's documentary postcard business raises a number of questions. How did her working practice and photo production compare with those of other women photographers in London at that moment? Did personal experiences influence her choice of photography as a profession and her selection and treatment of photographic subjects? In what ways did her postcards differ formally and contextually from those of her competition, mostly larger publishing firms with photo-mechanical reproduction capabilities?

Financial insecurities drove Christina to seek photography as a medium in which to earn an income. Married to Albert Edward Broom

Fig. 1 Lyons tea stall at Victoria Station, c. 1905

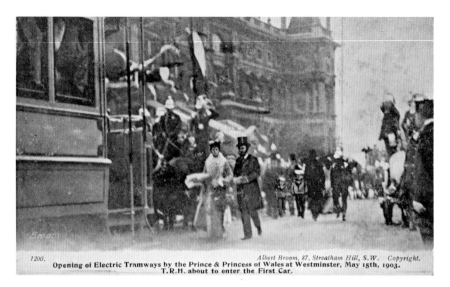

Fig. 2 The opening of the Electric Tramways by the Prince and Princess of Wales at Westminster, 15 May 1903. Broom's first photograph

Fig. 3 Rock Sand, winner of the 1903 Derby, ridden by his jockey Danny Maher

in 1889, she gave birth to their only child Winifred the following year. The 1891 census records them residing in Fulham, with Albert operating his family's ironmongery business.[3] During the first decade of their marriage, her husband had a crippling cricket accident that forced him to retire from active employment.[4] Never one to shy away from difficult circumstances, following her husband's debilitating injury Christina Broom set out to support her family.[5] Initially, on the suggestion of one of her brothers, the couple opened a stationery shop at 87 Streatham Hill.[6] Even though it was not a financial success, in the course of conducting business she recognized the emerging trend in postcards.[7]

While a novice business woman and basically self-taught in photography, at the age of 40 Broom launched a photographic venture producing picture postcards of local views.[8] Her first promotional brochure in 1903 titled *Mrs Albert Broom's Interesting 'Snap Shot' Post Cards*, announced her earliest pictures for sale: *Opening of Electric Trams by Prince and Princess of Wales at Westminster* (Fig. 2); *Rock Sand, winner of the Epsom Derby* (Fig. 3); *Finish of the Gold Cup race at Ascot*; and *King Edward and President Loubet driving in London, July 1903* (p. 19), among others. After the Great War, when the postcard's heyday was over, her credited pictures appeared in the national press in such publications as the *Illustrated London News,* the *Sphere,* the *Tatler* and *Country Life.*

WOMEN PHOTOGRAPHERS IN EDWARDIAN LONDON

In the 1900s, the fact that women had broken into genres of photography deemed most appropriate for their gender – portraiture of women and children – makes Broom's move beyond these sanctified subjects into the business of picture postcards and documentary photography even more fascinating. Mrs Broom's active engagement photographing primarily outdoors and at public events aligned her more closely with the period's growing genre of

photojournalism. The work was demanding of her time and energy. To obtain such diverse landscape views, Broom had to traverse the city of London with her camera, tripod and dozens of glass-plate negatives – a considerable weight and bulk for a petite woman. Similarly, obtaining the desired perspectival views of church interiors was difficult as she had to climb narrow winding stairs with her equipment weighing roughly 40 pounds.

The production of these postcards carried out at home by her daughter and assistant Winifred was an equally daunting feat. At their busiest, particularly during the First World War, the mother-and-daughter team produced 1,000 cards a day. Traces of the collaboration emerge in an order book of 1910. Maintained by Winifred, the order book lists the number of postcards printed from March through to December 1910, by date and category, including the 4,500 postcards of King Edward VII lying in state produced between 19 May and 30 May. The account likewise draws attention to one of Broom's recurring series, the Oxford and Cambridge Boat Race, which she photographed for 35 years. In the weeks leading up to the 67th annual race held on 23 March 1910, Winifred processed 4,238 postcards, six different scenes and a nearly equal number of each of the crew teams. The order book's final pages list chemical components and formulas for sensitizing plates, developing negatives and preparing postcard stock to receive the print, among other procedures necessary for their production.

When undertaking portraiture Broom used natural light, photographing groups and individuals in situ as seen in her portraits of soldiers and Suffragettes in context. Her gelatin silver prints on postcard stock granted her wide distribution of imagery, in stark contrast to the studio photographer who made photographs for a private clientele. The subjects, technique and method of production and distribution performed by Mrs Broom contrast significantly with the photography practice of elite society portraitists Alice Hughes, Kate Pragnell and Lallie Charles. In the early 1890s, Hughes (1857–1939) began making portraits of elegant women and children in her home studio at 52 Gower Street, the residence in Bloomsbury that she shared with her father, society painter Edward Hughes. Introduced to the world of British aristocracy and royalty through her father, she soon attracted many of his clients for portrait sittings. Her images include the royal subjects Princess Alexandra (later Queen Alexandra) with her children, taken in 1894, and Queen Mary, among other titled women.

Early on, Hughes instituted the practice of photographing only women alone or with their children. The portraits produced as platinum prints – the most expensive photographic process – are distinguished by their attractive subjects and creative settings, which often featured her signature use of fresh flowers, especially lilies.[9] Quite naturally, Hughes discovered a market for her society portraits as frontispieces for prestigious journals, outpacing some of the long-established male photographers and observing, 'I had almost a monopoly of the front page of *Country Life*.'[10] Hughes maintained her London studio until 1909, but continued practising photography well into the 1930s.[11]

If Alice Hughes preferred to photograph strictly female clients then her London counterpart Kate Pragnell (c. 1852–1905) distinguished herself by employing only women studio workers, noting in an interview: 'All our printing – and you know what a very important item that is – is done by ladies.'[12] While her studio appealed to titled British clientele, it likewise attracted a variety of female *and* male subjects: 'some of the most distinguished statesmen, soldiers, and artists of the day have been taken by her ...'[13] Pragnell photographed Elsie Blythe after she had won a gold medal in golf at the North Berwick Ladies Club,[14] the famed *Punch* cartoonist Linley Sambourne,[15] and General Sir Beauvoir de Lisle when he was still a Lieutenant Colonel.[16] Their portraits featured in such publications as *Bystander*, *Black and White*, *Cassell's*, *Country Life* and *Hearth and Home*. Careful posing of her subjects and manipulation of light and

shade that rendered a sophisticated and artistic image became her trademark. One elegant example is the wedding portrait of Mrs Lionel Portman that highlighted *Country Life*'s cover on 11 November 1905, possibly one of the photographer's last published photographs.[17]

Following in these footsteps, the photographic studio operated by Lallie Charles (Charlotte Elizabeth Martin, 1869–1919) likewise drew stylish and titled subjects whose portraits graced the covers of prestigious magazines. In 1897, Charles opened a portrait business with the help of her two younger sisters, Rita and Isabel Martin.[18] One of her early sitters was Lady Alice Montagu, the 'beautiful daughter of the Duchess of Manchester', whose photographs were featured in *Sketch* and *Country Life*.[19] Her studio portraits of actresses regularly illustrated *Country Life*'s 'At the Theatre' column. In contrast to the style of her antecedents, Charles's portraits, featuring head shots or three-quarter views without elaborate backgrounds or props, appear to anticipate modernity's more streamlined mode.

THE BUSINESS OF POSTCARDS

Against the example of these leading Edwardian women photographers, Broom's entrée to postcard production stood out as a unique business venture. She turned to producing picture postcards just as they were becoming a popular cultural phenomenon. Although pre-stamped official government postcards had been available for sending messages in Britain since 1870, the picture postcard offered a product that was original, functional and commercial. In 1902, under pressure from private enterprises and the general public, the British postal service authorized the divided-back card that left one side for short messages and a mailing address, and the reverse for an illustration. The standard size 5½ inch × 3½ inch card cost a halfpenny to mail compared to one penny for a letter, the mailing cost contributing to its popularity. Even if some people were reluctant to leave an open message that others could potentially read, the picture postcards still rapidly gained an accepting audience both for communication and for their prospective collectability. One could write a brief note to a friend in the morning and, with the frequency of mail delivery, they would receive their card later that same day.[20] These factors opened the market for private postcard publishers, such as Mrs Broom.

Countless postcard manufacturers of various magnitude and capacity emerged on the scene, and their businesses survived for equally varied lengths of time.[21] Likewise, these companies had a diverse range of specialties. The more well-known producers of British postcards included Bamforth & Co., the *Daily Mail*, Raphael Tuck & Sons and Valentine & Sons. Bamforth, of Holmfirth in Yorkshire, initially gained fame for their production of narrative lantern slides. Along these same lines, they developed postcards that utilized a narrative format incorporating models to enact the roles.[22] Specialists in sentiment, Bamforth produced series that illustrated songs and hymns, many humorous series, and patriotic and sentimental cards, especially during the First World War.[23] The 'song cards' were often sold in sets of three or four, bearing the words to a well-known song or hymn (one verse to each card).[24] Raphael Tuck & Sons of London were well-established art publishers to Queen Victoria when the picture postcard developed. In July 1900 they advertised their first numbered series, '12 London Views', a theme which was expanded to 48 views of London and the Thames.[25] Royal, political and military themes likewise featured among these early series, produced in chromolithography, an inexpensive colour-printing process.[26] Valentine & Sons of Dundee, Scotland, another large firm with an output similar to that of Tuck & Sons, began producing postcards in 1897. Valentine's specialty was photographic view cards covering the whole of the British Isles.[27] The firms Bamforth, Tuck and Valentine published in a number of postcard formats including coloured reproductions of artists' drawings and real photographic postcards toned in black and white or sepia, or hand-tinted. During the First

World War, in September 1916, the *Daily Mail* began selling its 'Battle Postcards' which reproduced photographs of fighting on the Western Front taken by official war photographers. Sold in sets of eight cards, the series, 20 sets in total, continued until the spring of 1917.[28] Views of weapons, military leaders and life on the battle front revealed the hardships of the Great War in graphic detail and were in popular demand at the time of production.[29]

Although early postcard historians have accounted for a number of these existing publishers, Mrs Broom's information doesn't appear in their scholarship, even though her photographs were reproduced as illustrations in their text.[30] Yet Broom became the most prolific female publisher of picture postcards in Great Britain, if not in the Western world.[31] Still, her two-person business and at-home production was minor in comparison to the giant postcard publishers of the day who had the printing capacity for large runs. According to postcard historian Richard Carline, 'One publisher alone claimed he had issued forty-three million cards in one year.'[32] Broom's small editions of real photographic postcards were printed chemically in the darkroom. She made direct contact prints from glass plate negatives on sensitized postcard stock. The locations of the scenes, handwritten on the negatives, appear as white text on the finished prints, which are black and white or sepia toned. Additionally, her early cards are numbered and include 'Broom' on the front; with later editions her name and address are stamped on the reverse. These postcards filled a niche market because they were real photographs of sights and scenes that resonated with Britons.

Broom's scenes reflected a commemorative attitude towards all things British – royal pageantry, events, monuments, and people engaged in everyday activities and at leisure. Unlike many postcards of the era, hers avoided gimmicky themes, fantasy or comics, and did not undertake to record individual disasters. The few postcards that she made of the donkeys at Margate emerge as one of her more light-hearted subjects, echoing her childhood memories of

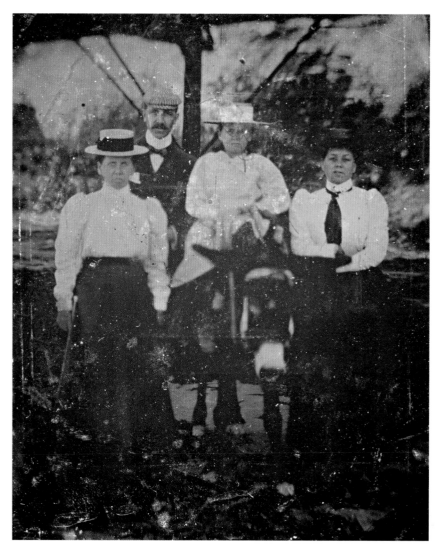

Fig. 4 Christina, Albert and Winifred Broom with Margaret Dunkley, Christina's sister, Margate, 1897

the long holidays the Livingstons (Fig. 4) spent at this popular Victorian seaside resort. At the 'Beach House', a hostelry on the jetty at Margate where her family stayed, the proprietor Maggie May kept several donkeys.[33]

As other authors have discussed, Mrs Broom assiduously recorded royal ceremony, the women's suffrage movement and military exercises of the British armed forces. By the time of the First World War, Broom's reputation as photographer to military units was well established. She sought to show the men at their most heroic, noting, 'I have photographed all the King's horses and all the King's men and I am never happier than when I am with my camera among the crack regiments of Britain.'[34] The images of soldiers, individually and in groups, posed with their weaponry and equipment ready for inspection, and the farewells with family and loved ones that took place at London railway stations as the men departed for the Western Front, are some of the most poignant

photographs taken by her during the Great War.

Equally significant were her photographs of the latest British battleships, HMS *Bellerophon* and HMS *Dreadnought*. Her documentation of HMS *Dreadnought* (Fig. 5), commissioned in 1906, included photographs of the sailors on board. Military images such as these situate Broom's photography in close relationship to those of American photojournalist Frances Benjamin Johnston, who in the summer of 1899 travelled to Naples, in Italy, to photograph Admiral George Dewey and his naval crew on the USS *Olympia* following his successful campaign in the Philippines.

If she had focused only on these three subjects – the military, royalty and woman's suffrage groups – her photographic output

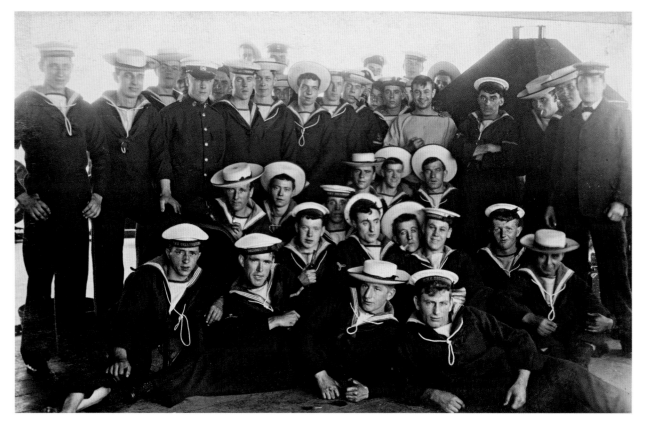

Fig. 5 Sailors on board HMS *Dreadnought*, Southend, 1909

would have been significant. But instead she expanded her oeuvre considerably. One of her early business cards announced: 'Mrs. Albert Broom, Postcard Specialist – To: The Brigade of Guards, Duke of York, RM School, Royal Hospital, Chelsea, etc., etc.' In addition, she demonstrated a willingness to photograph diverse subjects in varied circumstances: 'Private Residences Attended, Groups, Children, Pets, Statuary, Interiors, etc.'[35] Seemingly, she took her documentarian role to represent Edwardian London at its finest very seriously. Her postal card series of residential architecture, churches, streetscapes, parks and recreation facilities, among other topical subjects, remain some of her most endearing photographs.

POSTCARDING THE CITY

Around 1900, the 'postcarding' of cities became an international phenomenon with publishers rushing to capture the essence of urban expanse.[36] With the rapid growth of London during the Victorian era, real photo postcard views of the city were sought after by the local population whose intimate knowledge of its environs enabled them to interpret changes with accuracy. Broom's streetscapes demonstrate the daily actions of its citizenry – at work, going to and from their employment, shopping, and/or engaged in conversation. Scenes of *Brompton Road* (p. 24) in Knightsbridge, *Earls Court Road* (Fig. 6) and *Edgware Road* (p. 22) capture the sense of reality and animate the lives of people associated with these neighbourhoods. The

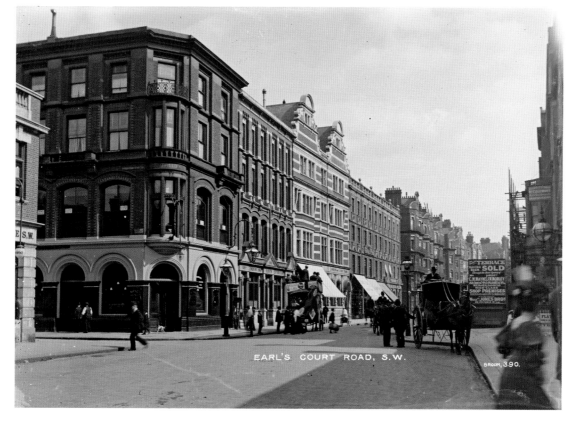

Fig. 6 Earls Court Road, Kensington, c. 1905

idiosyncratic incorporation of visual tropes – a post box, lamppost or horse-drawn vehicle – serves as a framing device inducing the viewer's attention to the heart of the scene.

Some of Broom's urban views taken in the early morning hours, such as *Addison Road* (p. 29) with its lone man and cart, exhibit little evidence of pedestrians, while others display the hustle and bustle of prosperous streets lined with businesses, shops and restaurants, and occupied by pedestrians and transport vehicles. Her discovery of London's industry and trade manifests in views of commercial and arterial streets – the everyday activities of *Oxford Street* (Fig. 7); commerce at *Cheapside* (p. 23), the city's main thoroughfare and market, with its classic view of Christopher Wren's St Mary-le-Bow; and *Victoria Street* (p. 24) from the station to Westminster.

Signage and advertisements add visual significance and provide information on the era's social and cultural events. The *Bank of England, Threadneedle Street* (Fig. 8) displays the imposing financial institution, but it is the horse-drawn omnibus in the centre

announcing 'The Mysterious Mr. Bugle' playing at the Strand Theatre that draws our attention, as it did in Broom's time. Other photographs set a mood – a street in quiet repose, such as *Chesham Place* (p. 26) in Belgravia. Here, the photographer has captured a serene and harmonious moment with the street's lush foliage on the left, Pont Street leading to the right, several gas lamps in the near foreground and a hansom cab receding into the distance, hinting at the richness and opulence of this neighbourhood.

One of Broom's historic postcards of Holland Park, the first artists' community of Victorian London, signals the city's expanding boundaries and evolving modernity. The area developed in the 1860s when Frederic Leighton, an associate of the Royal Academy, built his distinguished home and studio on Holland Park Road along the perimeter of Lord Holland's estate. Still a relative novelty at the time, an early automobile appears parked on tree-lined *Melbury Road* (p. 29) opposite Little Holland House at 6 Melbury Road, the studio-home of the painter George Frederic Watts.[37] Nearby, architect

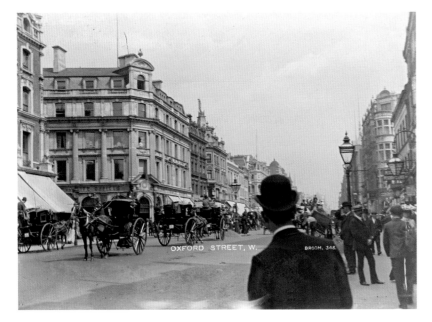

Fig. 7 Oxford Street, c. 1905

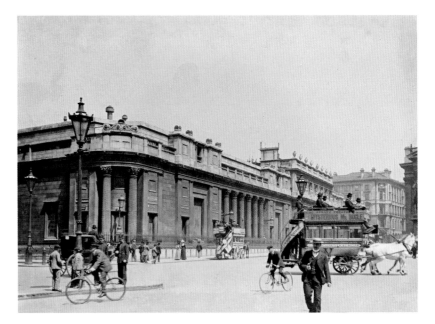

Fig. 8 The Bank of England, Threadneedle Street, c. 1905

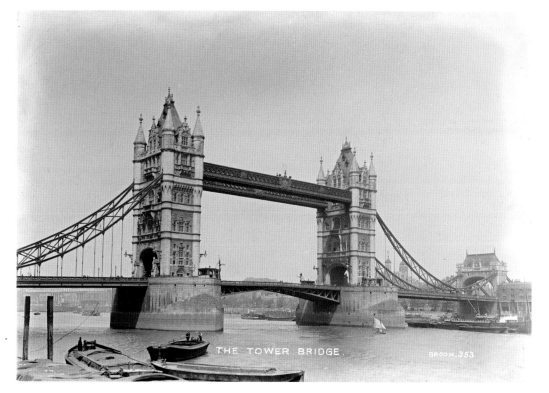

Fig. 9 Tower Bridge, c. 1905

Richard Norman Shaw built two Queen Anne-style artists' houses in 1875–6 for the painters Marcus Stone at No. 8 and Luke Fildes at No. 11 (now No. 31).

Some of her images attracted tourists as well as locals. With strategic framing and vantage point, she places viewers in the scene *Tower Bridge* (Fig. 9), where several smaller boats at the bottom edge of the photograph act as anchoring devices, drawing our attention first to the boats and then upward to the impressive edifice opened in 1894. The image *Victoria Embankment* (p. 25) likewise conveys her adroitness with compositional arrangement. Now, a boat on the river and one carriage on the road lead the spectator's eye along the sweeping curve of the river embankment and into the far distance, where we see the silhouettes of the Houses of Parliament and Big Ben. In the summer and autumn of 1913, Broom followed the three-month renovation to the principal façade of Buckingham Palace, showing the front elevation before restoration, under scaffolding, and after the application of its new Portland stone façade designed by the architect Aston Webb.[38] Documenting the changes to the Palace façade in postcard format provided her customers with an inexpensive souvenir of this glorious and proud moment – something locals and visitors alike would appreciate.

That many of the photographer's sites were of a personal nature seems especially true of King's Road in Chelsea, an active thoroughfare of which Broom made a number of views. As a child she grew up in Chelsea, where her father operated a boot and shoe manufacture at 8 King's Road. Therefore the inclusion of the shoe purveyor's sign within the landscape *King's Road in Chelsea* (p. 27) seems a relevant detail that she obviously relished. In other photographs, clues of a self-reflexive nature materialize pointing to the photographer, and the fact that she was the primary wage earner for *her* family.

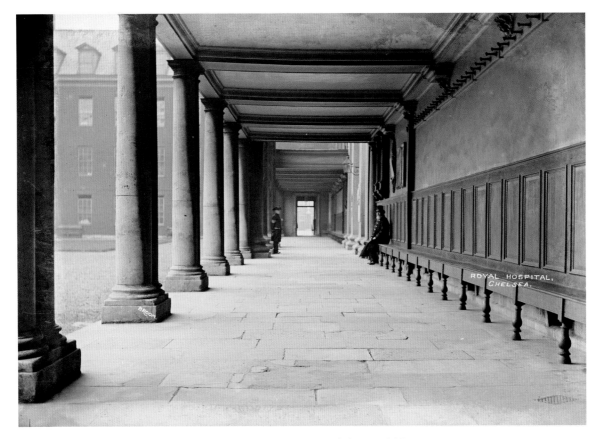

Fig. 10 The Royal Hospital, Chelsea, c. 1905

Early morning streetscapes that capture retail vans, omnibuses and vendor carts embody the vital city processes and the functions of workers which enable the city to grow and prosper. A workman waters the garden of *Campden House Court* (p. 24), and in South Kensington's *Collingham Place* (p. 26) a lone delivery van appears with the initials RBK, standing for Royal Borough of Kensington. At the *Lyons Tea Stall, Victoria Station* (Fig. 1, p. 4) a group of workers stop their activities to pose for her. That Broom includes evidence of work and workmen in her photographs seems purposeful for their symbolic impact. In addition to their reference to work, and the workings of the city, these iconic motifs pay homage to ways of life that were disappearing. When Broom photographed horse-drawn omnibuses in the early twentieth century, this mode of transportation was on the wane.

Even though evidence is lacking to suggest that Christina had training in art when she attended a private school in Margate, or even had exposure to great artists' work at a young age, what is discernible in her photography is a developed sense of design aesthetics. The formal qualities found in *Royal Hospital Chelsea* (Fig. 10) entice the viewer and provide context for the scene. With the building's classical columns leading the eye through the sombre arcade whose rhythm is broken by one seated veteran in top hat and another standing further in the background, we are reminded of the scene's deeper resonance. The columns perform like soldiers at attention, while the lone dark figures stand out against the pale stone building – as synecdoche, representing all who have served valiantly for their country and the countless numbers that may do so in the future.

CHURCHES, RESIDENCES AND PLACES OF LEISURE

Perhaps because her camera equipment was heavy and cumbersome, it appears that Broom sought to condense her travel time by photographing in close proximity to her residence. Many photographs were taken of places within a three-mile radius of her home in Fulham. Besides, these local monuments were ones that she had frequently observed during her lifetime – and that were of importance to her – and she may well have felt that they would appeal to her customers' feelings of nostalgia as well. Her recording of churches in the Royal Borough of Kensington and Chelsea is encyclopaedic, representing a London of many styles: *St Barnabas Pimlico* (Gothic Revival) (p. 32); *Brompton Oratory* (Renaissance Revival) (p. 31); and *Holy Trinity Sloane Street* (Arts and Crafts) (p. 31).

These picture postcards remind us of the Victorians' propensity for and the popularity of revival architecture in church and residential design. The earliest Gothic Revival church in London, *St Luke's Chelsea* (p. 31), designed in 1819 by architect James Savage, is a product of the Church Building Act of 1818, under which the majority of churches were completed in the Gothic Revival style.[39] Broom captured the splendid formal interior, with its Perpendicular-style arcade built of Bath stone. On Addison Road in Kensington, *St Barnabas* (p. 33), designed by Lewis Vulliamy, reflects the Tudor Gothic. Broom made several postcard views of its picturesque forms, including distant shots and close-ups. The Greek Revival style, still popular in the 1820s, is epitomized in the stately *St Peter's, Eaton Square* (p. 32), designed by Henry Hakewill; at this point Broom captures its classical portico of six Ionic columns crowned with a pediment and tower rising above.[40]

During the Victorian era, as the population of London grew beyond the city centre, its expansion followed major transportation routes. For example, the construction of the Metropolitan District Railway Station in 1865–9 was a catalyst for the development of Earls Court, formerly a rural area adjacent to the Gunter Estate. Other long-enduring country estates gave way to encroaching suburbs, as historian J. M. Richards has observed: 'From the end of the 1870s onwards large parts of the Cadogan Estate, Chelsea, were built over with tall houses for the rich and fashionable.'[41] Further developments emerged in the Royal Borough of Kensington and Chelsea, where tree-lined avenues and gardens were the attractive settings in which to insert terraced housing. Two such developments received Broom's fervent attention: *Bramham Gardens* (p. 28) near Earls Court Road, designed by architects Ernest George and Harold Peto and begun in 1883; and the Victorian mansion block *Campden House Court* (p. 24), with its observatory gardens located in Gloucester Walk near Kensington High Street.

Broom ardently photographed *Oakwood Court* (p. 29), near Holland Park, in vertical format and distant views, probably intending to capture its entire structure that reaches eight storeys in what would have been an unusually tall residence for its time. Designed by architects F. and E. C. Pilkington, the complex was completed in 1899. She was equally drawn to *Egerton Gardens* (p. 24), off Brompton Road in Knightsbridge, the street designed by T. H. Smith in 1886, where her images highlight the structure's decorative balconies of cast iron. Most of her documentation of housing, although factual, tends to romanticize the residential settings in lush gardens or with landscaped avenues. In addition to being historic records, these photographic view cards were mementoes depicting pride in the local community.

In keeping with the late nineteenth-century's interest in leisure, Broom captures middle- and upper-class Londoners at play, enjoying moments of recreation and relaxation at fairs, parks and sporting events. Leisureliness and ease are visualized in her documentation of people taking pleasure in London's public parks: at the Round Pond in Kensington Gardens, where a family expresses joy sailing miniature boats, while others are found in further modes of relaxation such as horse-back riding in Hyde Park. An equally popular recreation spot,

Battersea Park, became a frequent subject for her scrutinizing gaze, in which she captured its cricket club, bowling green, lake and sub-tropical gardens. At Dulwich Park, created in 1890 from farmland by the Metropolitan Board of Work, several of her views demonstrate children enjoying its amenities. These scenes were not necessarily the most prevalent views of the city but ones that would resonate with its citizens, bringing back memories of time spent in these places and the people whose company they kept.

KINDRED SPIRIT IN ATGET

Insofar as their photographic production included royal subjects and illustrated press photographs, Broom shared kinship with Alice Hughes, Kate Pragnell and Lallie Charles. However, as a documentary photographer her practice, style and production separated her from these studio portraitists. Broom held a unique position among Edwardian women photographers in that she recorded public events on site, printed her photographs as postcards, and distributed them through shops and sold them directly to her customers. If Mrs Broom's documentary work was atypical for women photographers of her moment, a closer comparison may be drawn with the work of Eugène Atget, the doyen of urban photography in Paris. The parallel between their photographic practices is intriguing. Working at roughly the same time, Broom documented the architecture and street scenes of London as they existed in Edwardian times, as Atget recorded the neighbourhoods and streets of Paris, many before they surrendered to urbanization. Both were self-taught photographers working independently with no publicly visible studios.[42] They photographed their respective cities with intensity and affection, using old-fashioned methods – view cameras, tripods and glass plate negatives – even when hand cameras and celluloid film were available. Atget's client list also included the addresses of nearby Metro stops and, although unconfirmed, it is quite likely Broom

used public transport to get to her desired locations in and around London. Consequently, throughout their careers that spanned 30 plus years, they would both have routinely hauled their bulky and heavy photographic equipment. Both photographers pursued a vast number of themes or series, without giving them equal attention.

Several authors, among them the critic Walter Benjamin, have noted that Eugène Atget 'photographed Paris like the scene of a crime'. Atget received notices from friends when a neighbourhood or building was to be razed. With similar deliberation, Mrs Broom judiciously recorded historic buildings, some that no longer exist, such as *Chelsea Congregational Church in Markham Square* (p. 30), St Mathias in Earls Court and *Holborn Viaduct Hotel* (Fig. 11), or whose original function and/or appearance have changed dramatically, for instance *Christ Church at Lancaster Gate* (the tower and spire survive). But however close their working practices, the final outcome is markedly different. Atget's city scenes are hauntingly void of people while Broom's show evidence of both the early waking hours when few citizens are visible and later when the streets vibrate with daily activity. Atget's landscapes were empty, like a stage after the final act, when in effect these photographs may have been the last views of these buildings and/or neighbourhoods before they underwent urban change. In the areas around where she grew up, Broom would have been keenly aware of changes to the landscape and advancing urbanization. For the most part, her frequent historicizing of these architectural developments suggests a positive attitude towards the city's growth.

CONCLUSION

Mrs Albert Broom's 1903 brochure *Interesting 'Snap Shot' Post Cards* (p. 21) made a number of promises: prompt delivery, reasonable prices and the execution of orders on the same day as received. She aimed to please her customers. Further, she listed that she was

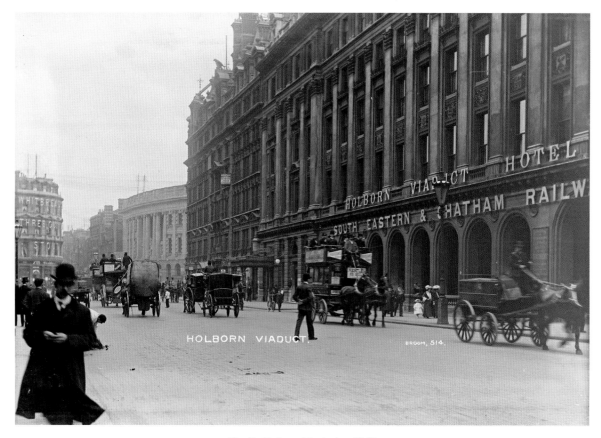

Fig. 11 Holborn Viaduct, c. 1905

'Under Royal Patronage'. Throughout the years, Mrs Broom was rather evasive as to how she gained this enviable position and/or the person whose influence enabled her to become photographer to the Guards.[43] Through developed relationships and trust with figures of authority, she was granted unhindered access with her camera to a variety of privileged settings including royal proceedings and military manoeuvres. In matters of protocol, her discretion with people of rank stood her in good stead and the relationship appears to have been one of mutual respect.

In actuality, Mrs Broom moved adroitly among people of various stations in life, seemingly because she had experienced a number of difficult circumstances herself and was sympathetic to the situations of others. Although as a young child she grew up in a comfortable position, after her parents died and later as a widow and single mother she would never again realize such pecuniary security.[44] Having weathered several financial downturns during her lifetime, in photography Mrs Broom discovered self-reliance, financial security, confidence and assuredness in her craft. While providing an income for her family, she developed a passion for photography and the power that it ultimately provided her. She ferreted out interesting postcard subjects in the city of London and its expanding neighbourhoods, presenting them in the best possible manner whether architectural treasures, military and royal figures, or women's activist groups. That these subjects reflected closely the interests of the photographer gives a study of photographs an additionally equal fascination.

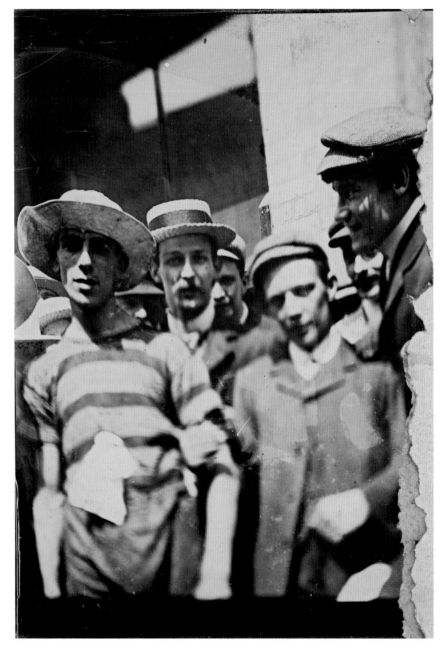

Men about to start the London to Brighton Music Hall Walk, 1903

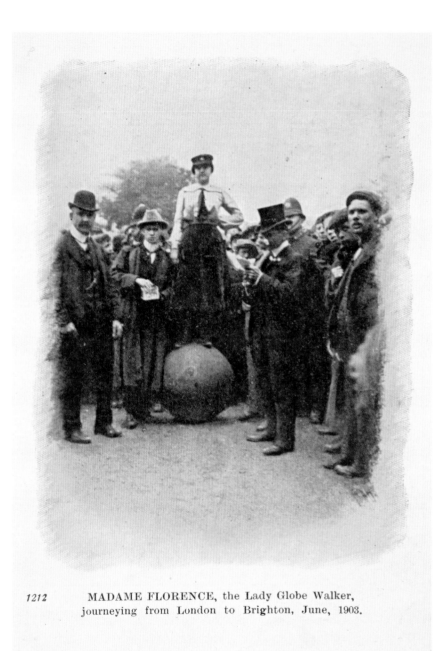

1212 MADAME FLORENCE, the Lady Globe Walker,
journeying from London to Brighton, June, 1903.

Mademoiselle Florence walked the globe from Westminster to Brighton over one week,
June 1903. Broom's pictures were sold by her father along the way

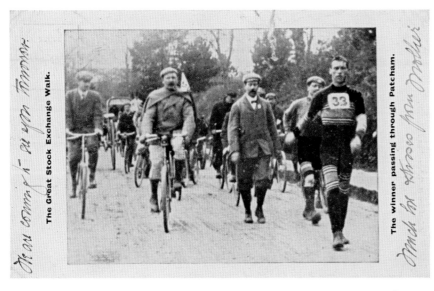

Postcard of the winner of the Great Stock Exchange Walk passing through Patchman, July 1903

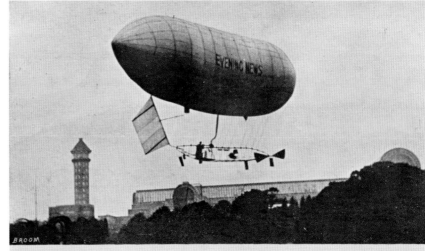

Mr Stanley Spencer's Air Ship beginning a voyage to St Paul's, September 1903

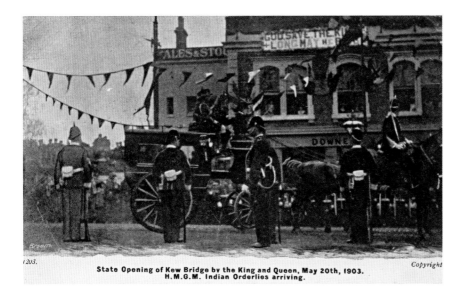

The state opening of Kew Bridge by King Edward VII and Queen Alexandra, 20 May 1903. HMGM Indian Orderlies arriving. Broom registered the copyright for this image two days later

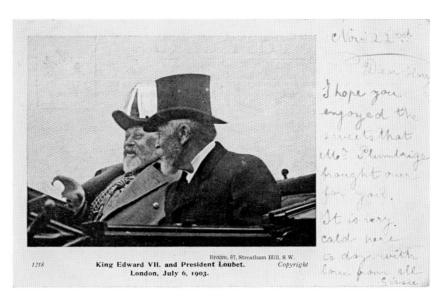

Postcard of King Edward VII and French President Emile Loubet in London, 6 July 1903

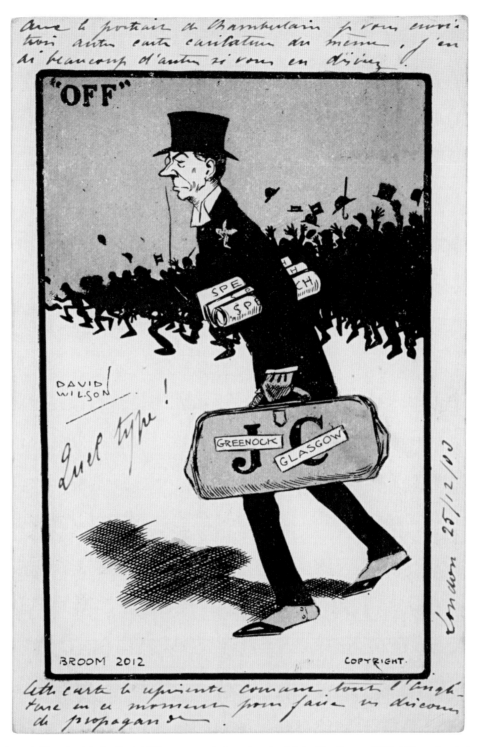

Used postcard, 'Off', illustrating Joseph Chamberlain by David Wilson, commissioned and published by Broom, 1905. Wilson lived close to their shop in Streatham Hill

Interesting " Snap Shot " Post Cards.

UNDER ROYAL PATRONAGE.

❧

87, Streatham Hill,

London, S.W.

1903 .

Dear Sir,

I beg to enclose samples of my latest " Snap Shot " Picture Post Cards, and shall be glad if you can favour me with an order for the same.

All my cards are published at the same price, viz. :— 7/- per gross ; smaller quantities 3/9 per half-gross : 8d. per dozen, carriage paid. Nett cash at 7 days.

You can always rely on prompt delivery, as I carry a very large stock and make a point of executing all orders the same day as received.

On the other side you will find a full list of the cards already published, but I am constantly adding to them and shall be pleased to send you samples at any time.

I am,

Yours faithfully,

MRS. ALBERT BROOM.

LIST OF
INTERESTING "SNAP SHOT" POST CARDS.

No.	SUBJECT.
1200.	Opening of Electric Trams by Prince and Princess of Wales at Westminster. T.R.H. about to enter the first car.
1201.	Opening of Kew Bridge by the King and Queen. Their Majesties returning after the Ceremony.
1202.	Opening of Kew Bridge by the King and Queen. H.R.H. The Duke of Cambridge returning.
1203.	Opening of Kew Bridge by the King and Queen. His Majesty's Indian Orderlies arriving.
1204.	Opening of Electric Trams by Prince and Princess of Wales at Westminster. T.R.H. approaching the first car.
1205.	Rock Sand, winner of the Derby, with Maher up, being led by Sir James Miller, his owner.
1206.	Head of Rock Sand, winner of the Derby, 1903.
1207.	Finish of the Gold Cup race at Ascot, 1903.
1209.	McIntyre, jockey, rode winner of the Gold Cup Race at Ascot, 1903.
1210.	Len Hurst, winner of the " Go as you please " race, London to Brighton, June 20th, 1903.
1212.	Mademoiselle Florence, the Lady Globe-walker, journeying from London to Brighton, June, 1903.
1214.	Gypsies on Epsom Downs.
1215.	T.M. The King and Queen driving in semi-State.
1216.	The Stock Exchange Walk, London to Brighton.
1217.	The " Go as you please " race, London to Brighton, June 20th, 1903. Coleman and Luxford run a dead heat for fourth place.
1218.	King Edward and President Loubet driving in London, July, 1903.
1219.	President Loubet.
1220.	" Earl Poulett " with his organ on Brighton Beach.
1221.	Professional Walking race, London to Brighton, July 4th, 1903. The Winner entering Brighton, and portrait of Winner.
1222.	The Music Hall Walk from Lambeth to Croydon. The start, and portraits of the three Winners.
1223.	F. S. Kelly, the great Leander Sculler.
1224.	The Band of the Scots Guards in Pall Mall.
1225.	Amateur Walking race, London to Brighton, July 18th, 1903. The Winner entering Brighton.

Broom's first sales list produced from their shop in Streatham Hill, 1903

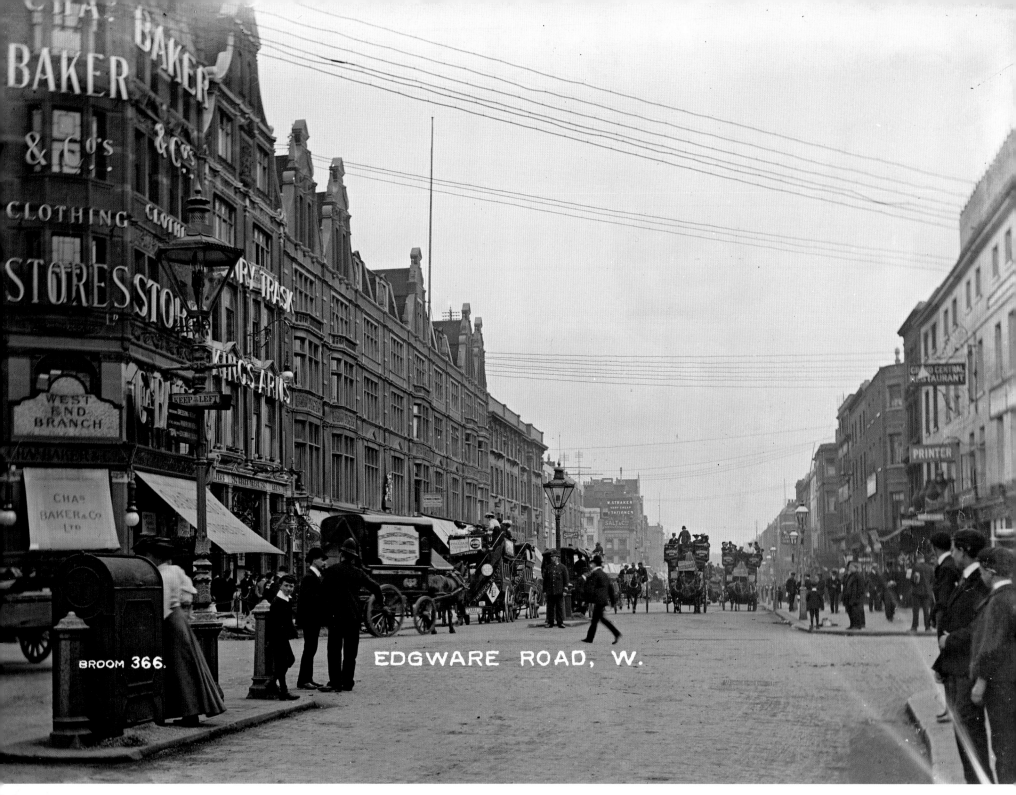

Edgware Road, c. 1905

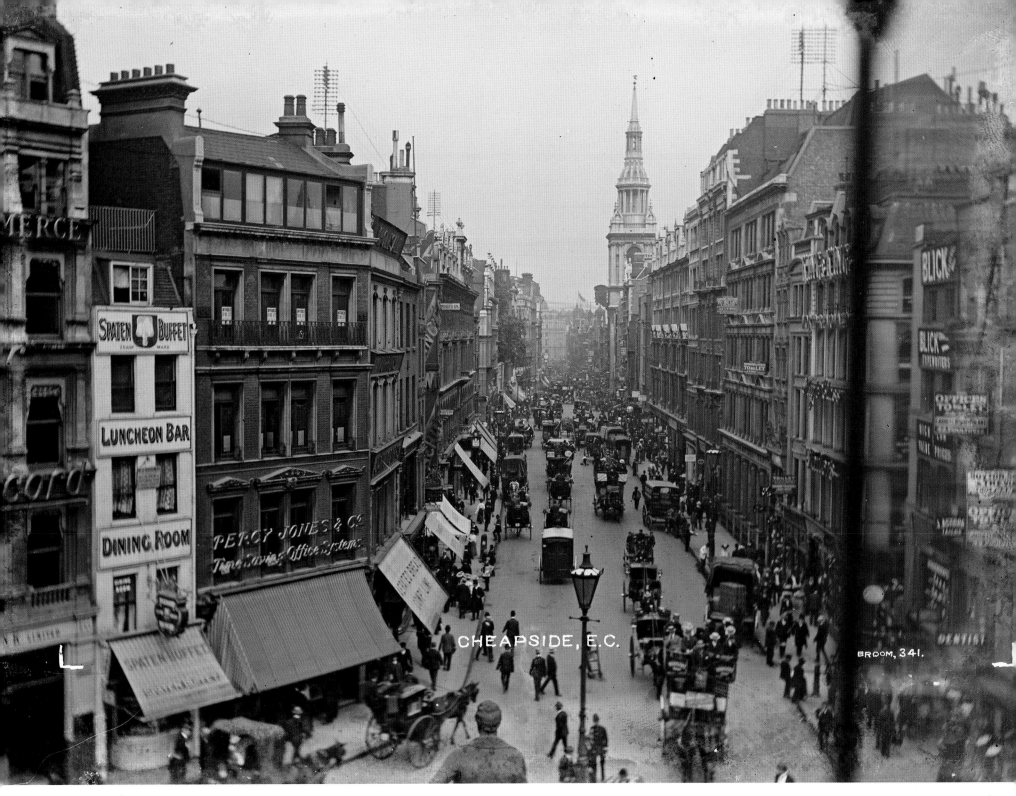

A view looking down Cheapside towards St Mary-le-Bow Church, City of London, c. 1905

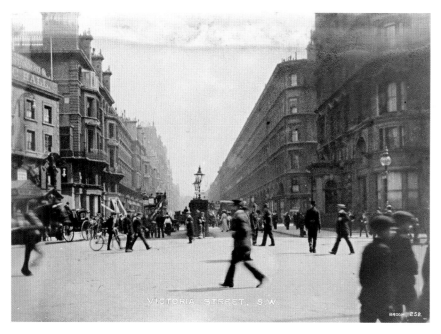

Victoria Street, towards Westminster, c. 1905

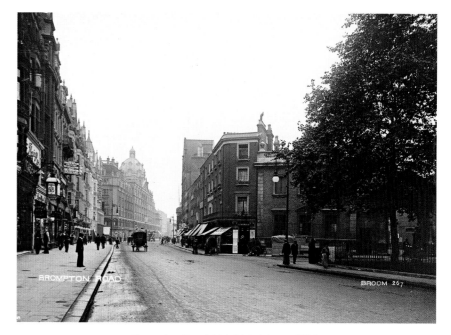

Brompton Road, Knightsbridge, c. 1905

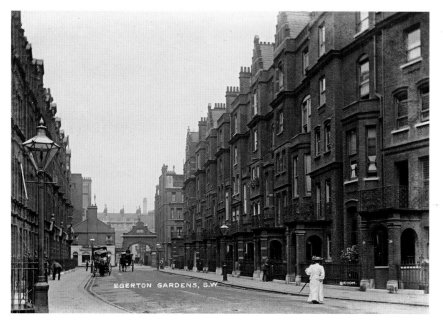

Egerton Gardens off Brompton Road, Knightsbridge, c. 1905

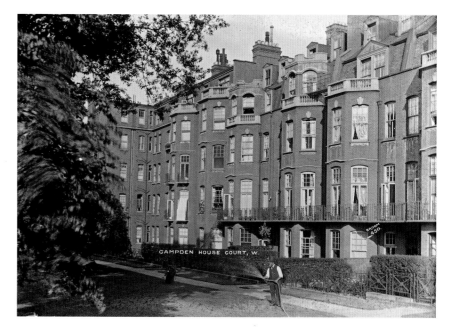

Campden House Court in Gloucester Walk, Kensington, c. 1905

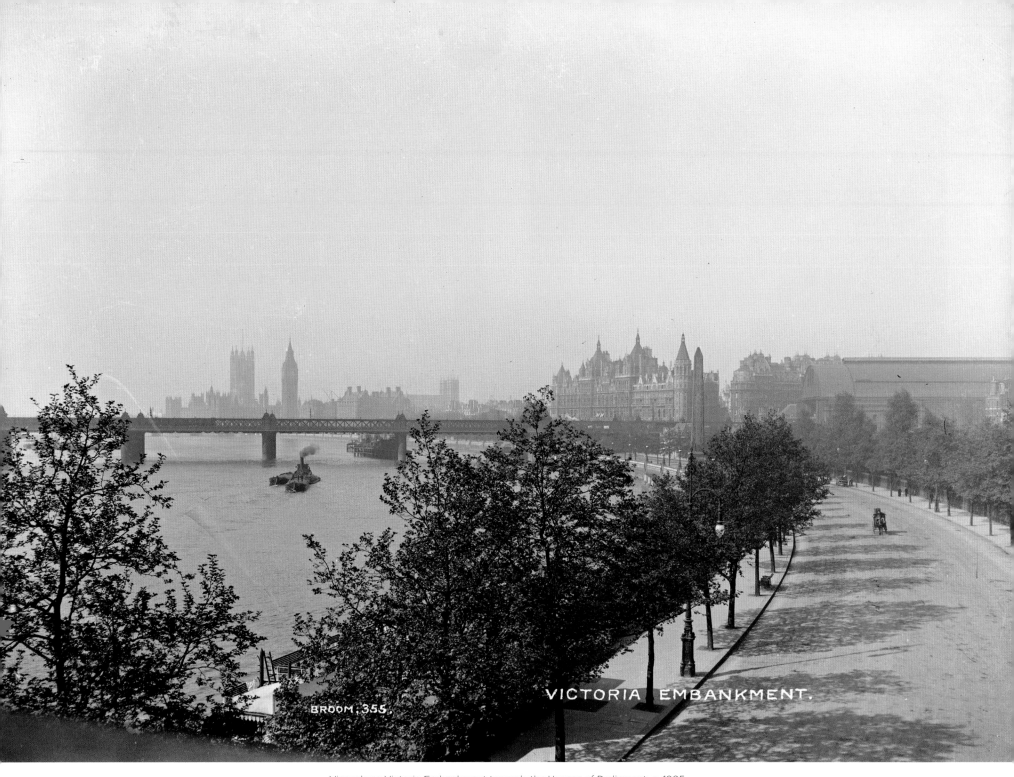

VICTORIA EMBANKMENT.

BROOM, 355.

View along Victoria Embankment towards the Houses of Parliament, c. 1905

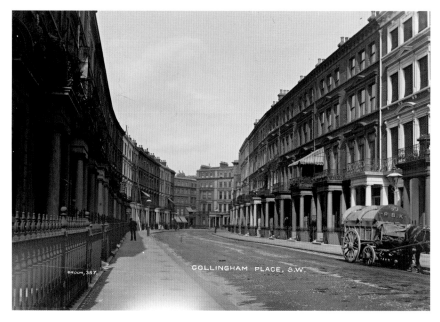

Collingham Place, South Kensington, c. 1905

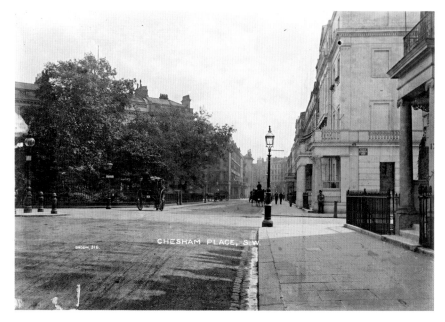

Chesham Place with Pont Street leading off to the right, Belgravia, c. 1905

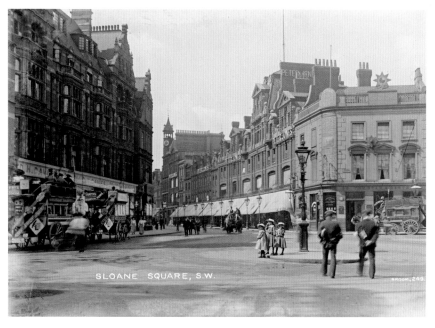

Sloane Square looking towards the King's Road where Christina Broom was born, c. 1905

Sloane Square looking towards Sloane Street, c. 1905

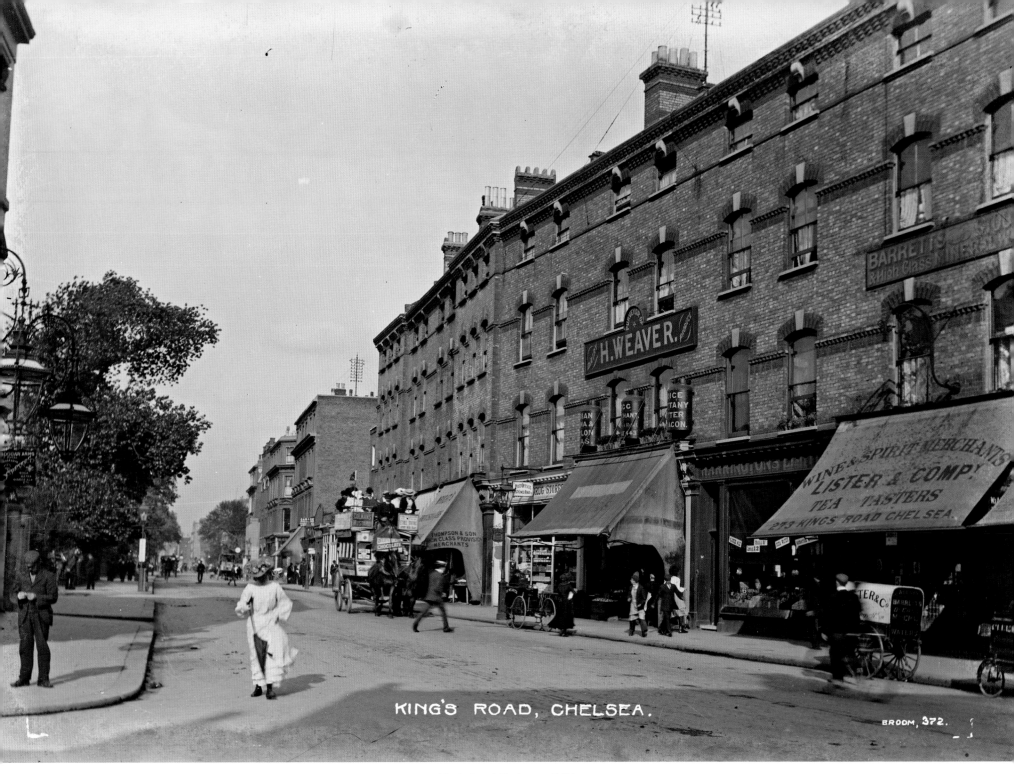

King's Road, Chelsea, c. 1905

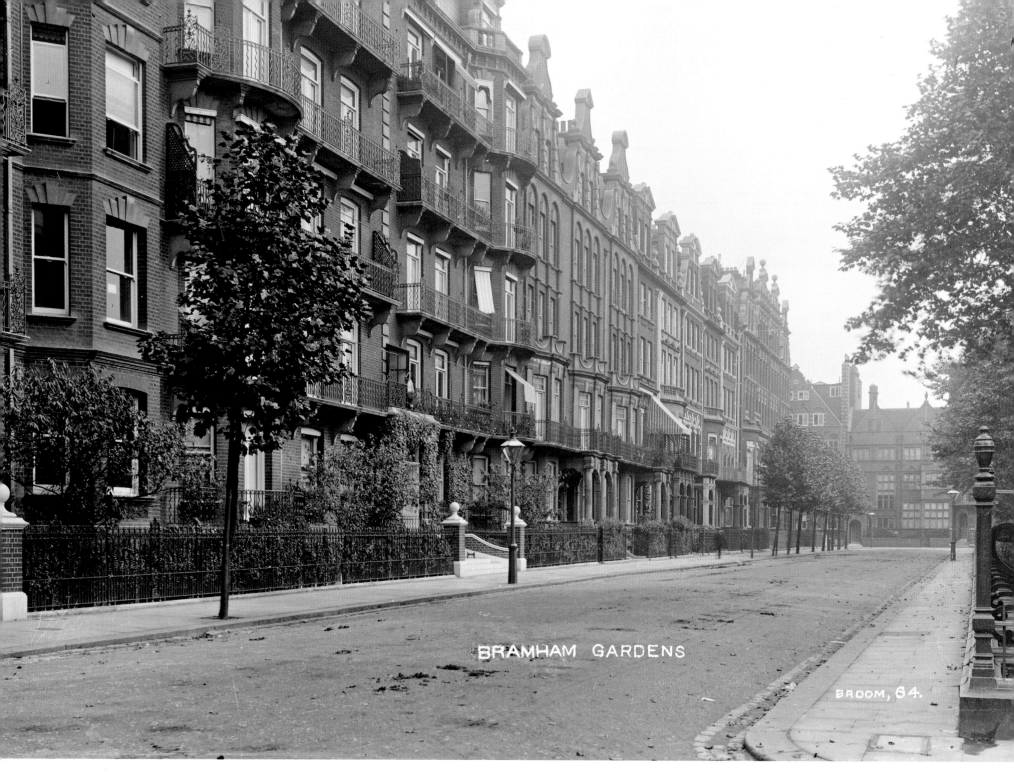

BRAMHAM GARDENS

BROOM, 64.

Bramham Gardens off Earls Court Road, c. 1905

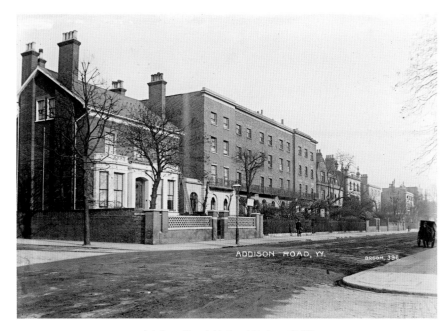

Addison Road, Holland Park, c. 1905

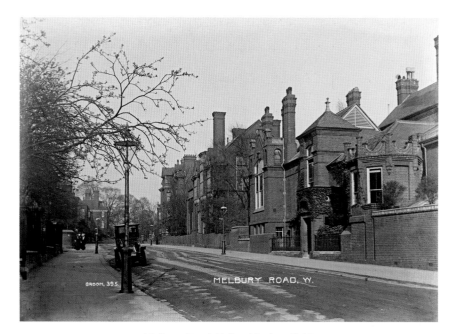

Melbury Road, Holland Park, c. 1905

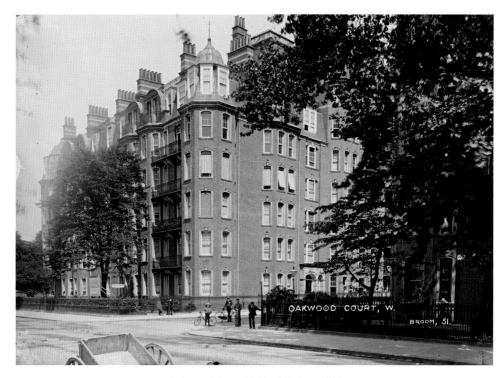

Oakwood Court, Holland Park, c. 1905

Chelsea Congregational Church, Markham Square, 1906

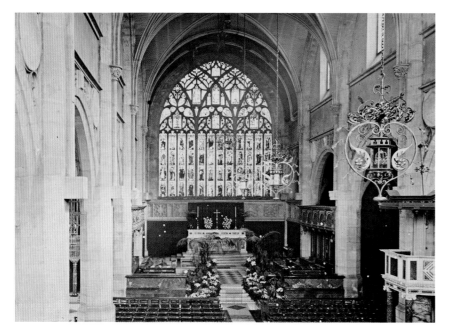

Holy Trinity Church, Sloane Street, 1905–6

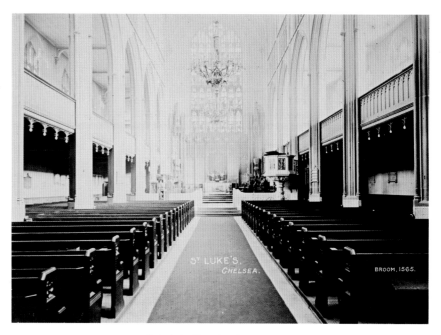

St Luke's Church, Chelsea, 1905

Altar of St Wilfred, Brompton Oratory, 1906

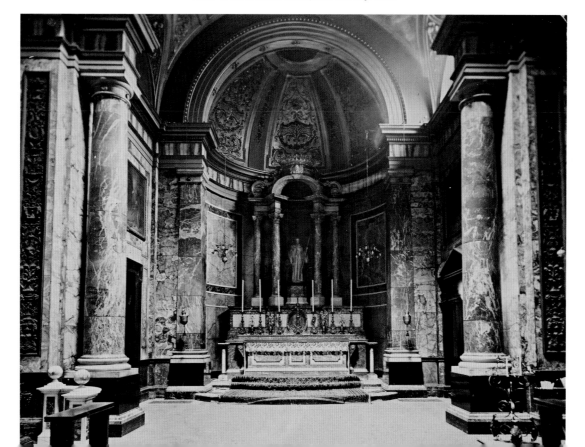

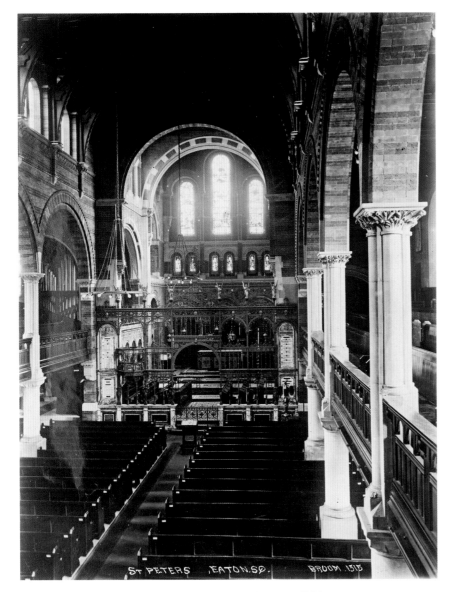

St Peter's Church, Eaton Square, c. 1906

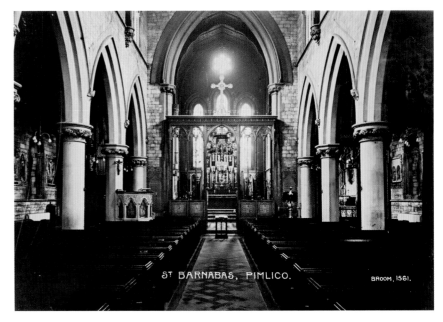

St Barnabas Church, Pimlico, 1906

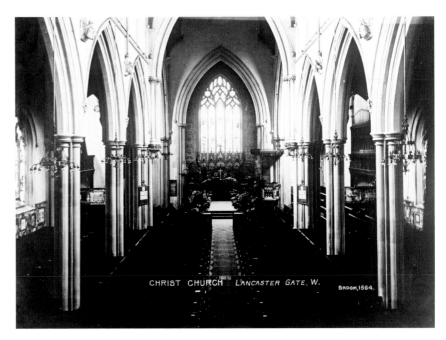

Christchurch, Lancaster Gate, c. 1906

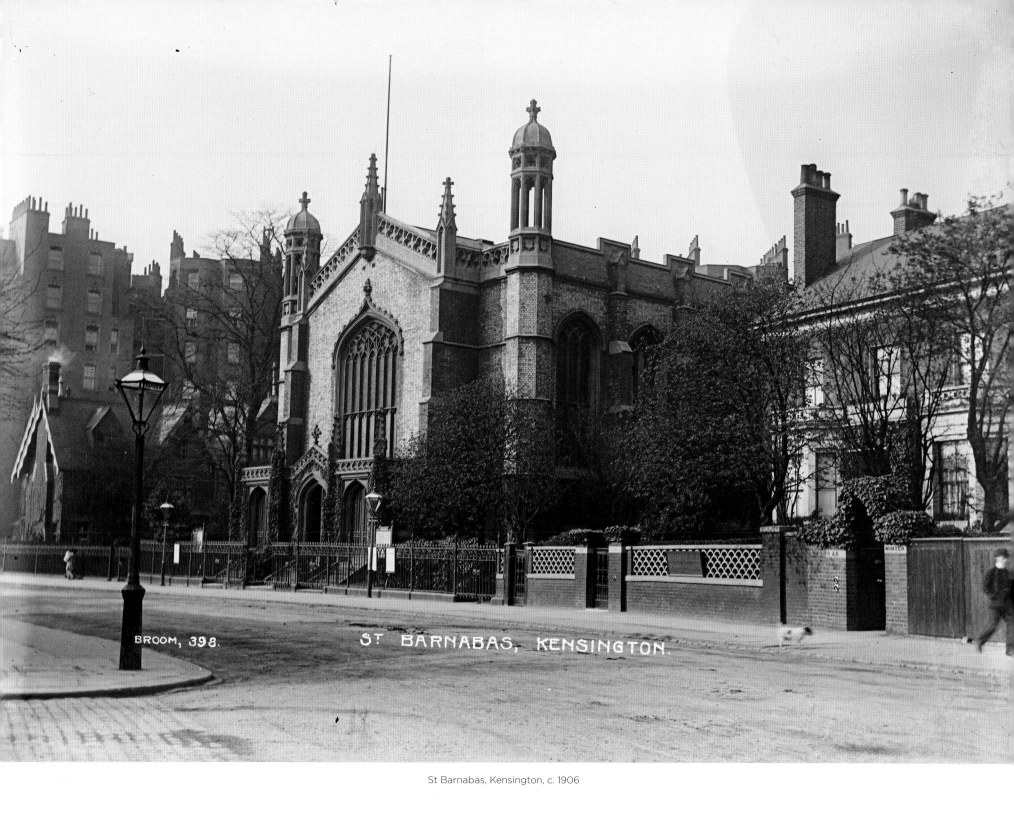

St Barnabas, Kensington, c. 1906

Horse-drawn carriages in Hyde Park, c. 1905

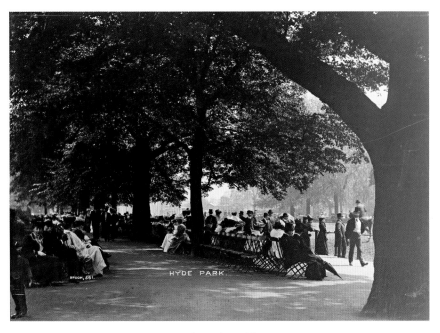

Hyde Park, c. 1905

The Lake in Battersea Park, c. 1905

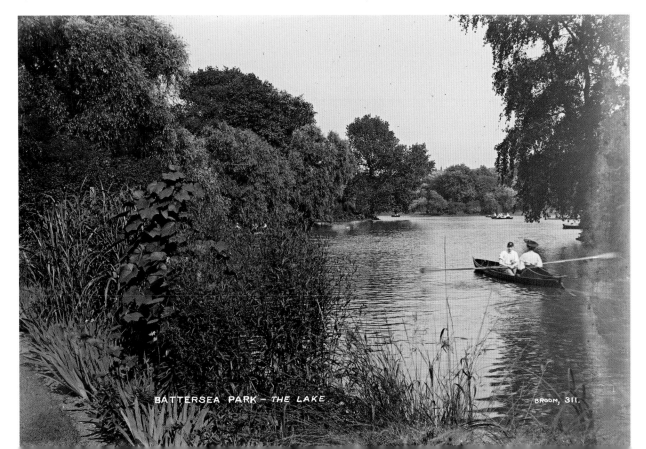

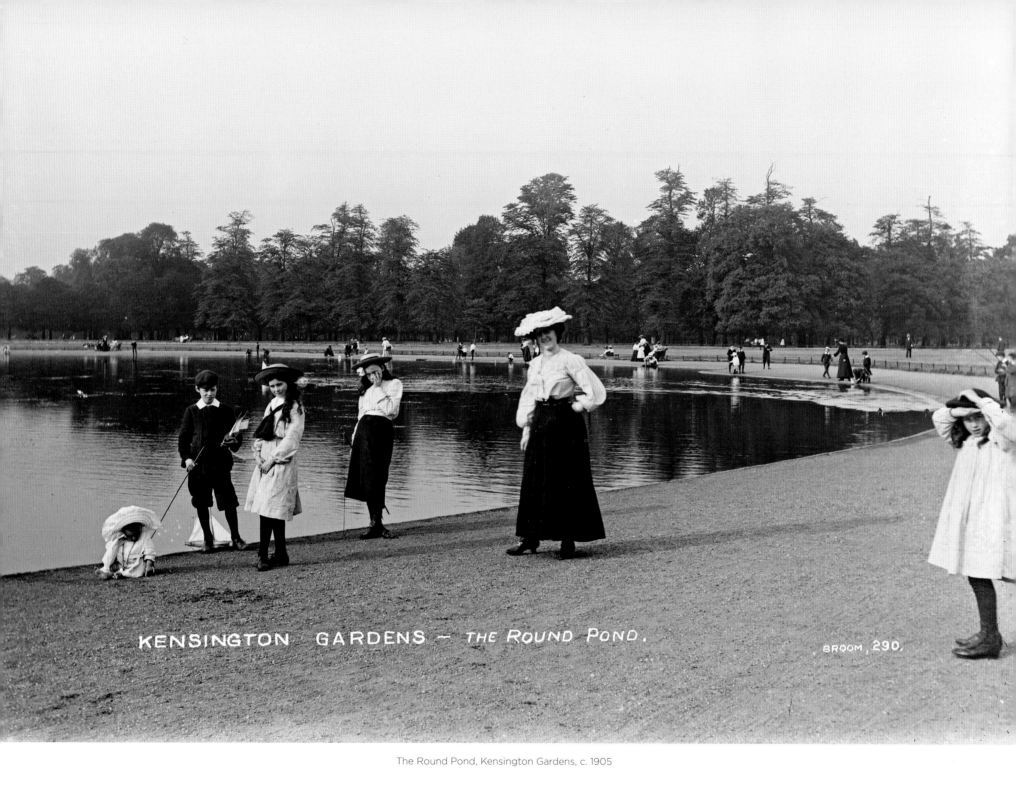

KENSINGTON GARDENS — THE ROUND POND.

BROOM, 290.

The Round Pond, Kensington Gardens, c. 1905

EARL'S COURT EXHIBITION. — THE WESTERN GARDENS.

BROOM, 1521.

Visitors to the Western Gardens at the Earls Court Exhibition, c. 1905

EARL'S COURT EXHIBITION — THE INDIAN VILLAGE.

BROOM, 1523.

Visitors to the Indian Village at the Earls Court Exhibition, c. 1905

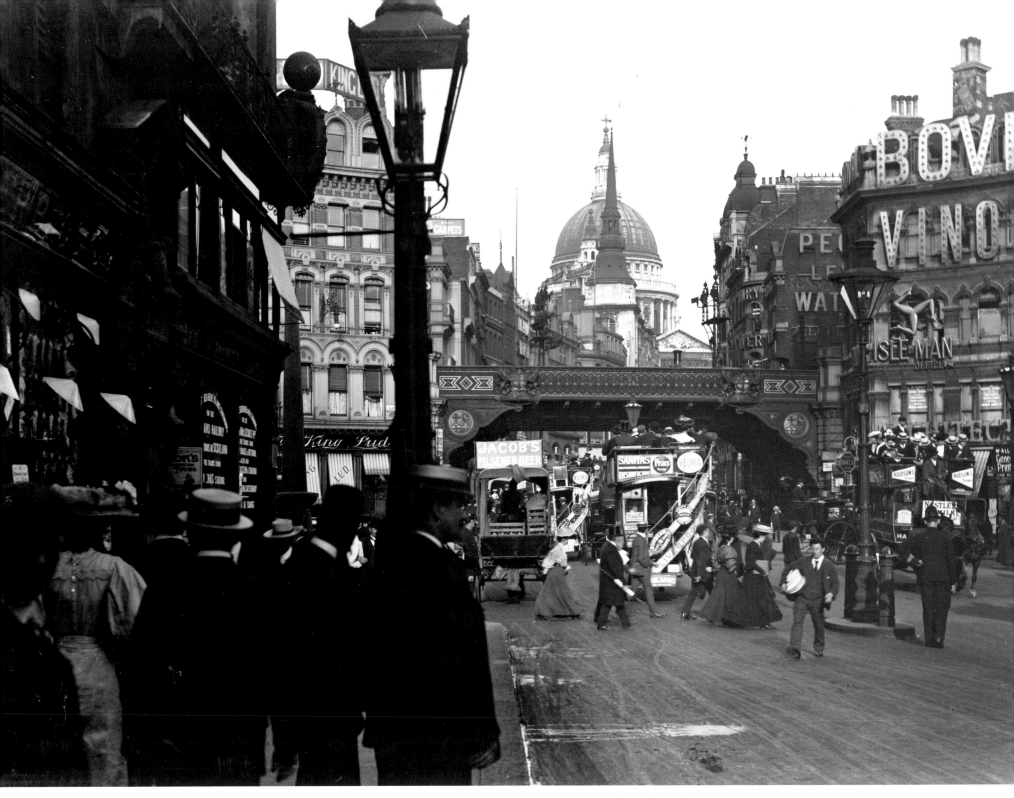

A view from Ludgate Circus towards St Paul's Cathedral, City of London, c. 1905

Developers.

Plates.

A.

70 grains (1 dram 10 grs) metabisulphite of Pott.
½ oz (or 1 in weight) Pyrogallic Acid crystals.
90 grains (1½ drms.) Bromide
½ pts. water.

use equal pts.

B.

3 oz Sodium Sulphite
3 oz Sodium Carbonate
1½ pts water

P.O.P. _ Paper. or cards.

15 grains Chloride of Gold.
(1 oz?) Acetate of Lead
¾ lb. Crushed Salt
1 lb. Hypo
1 gallon water

Hypo bath should
follow also
strong alum
bath.

Bromide. (2 developers)

½ drachm or more Metol
1½ " Hydroquinone
3 oz. Sodium Sulphite
3 oz Sodium Carbonate
1 quart or more water

if too fast
add pinch
of Bromide
Pott

2 couples Amidol
1¼ oz Sodium Sulphite
10 grains Bromide Pott.
1pt water

Diametdophenol

Potassium Ferricyanide

Broom's chemical formulas for developing plates and prints

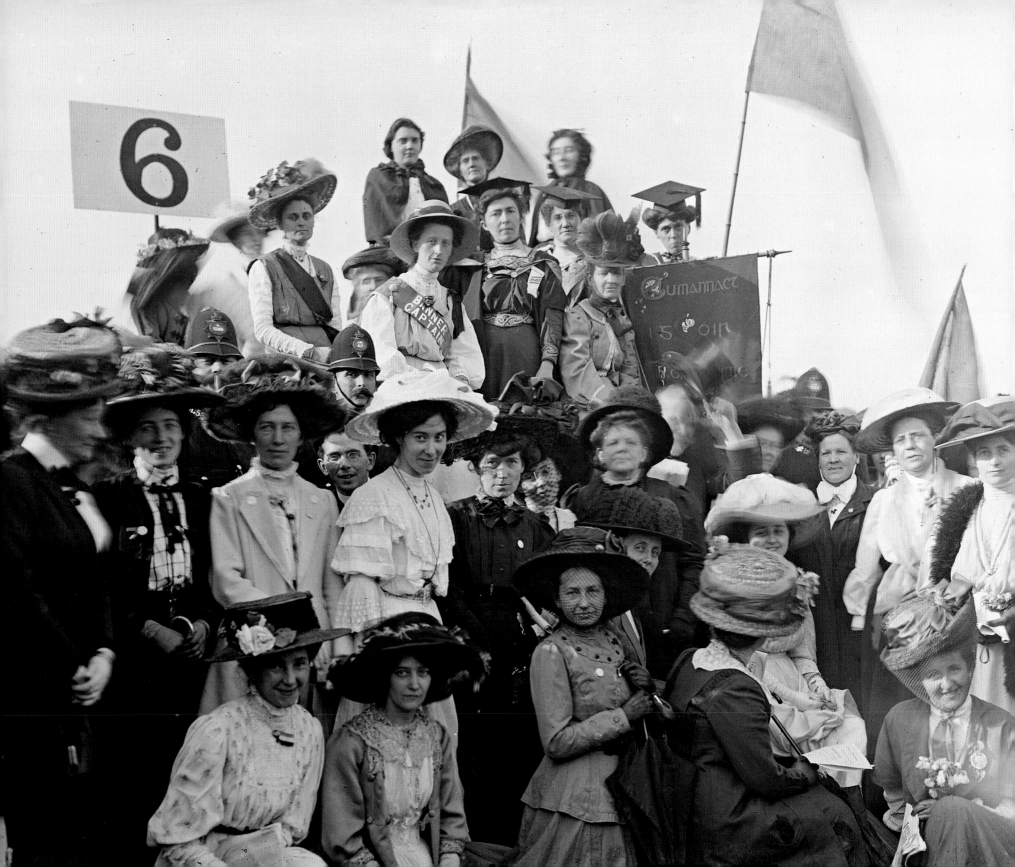

'A RIOT OF COLOUR'

MRS ALBERT BROOM'S SUFFRAGETTE PHOTOGRAPHS

Diane Atkinson

MRS ALBERT BROOM TOOK SOME OF THE BEST photographs of the brave women who campaigned for the vote in London in the years up to the outbreak of the First World War in 1914. One of the earliest of these images in the Museum of London's collection is of the Suffragettes, members of the militant Women's Social and Political Union, at their 'monster' meeting in Hyde Park on 'Women's Sunday', 21 June 1908 (Fig. 1). Her last suffrage photograph captures the arrival of the Cumberland suffragists, members of the moderate National Union of Women's Suffrage Societies, 'Women's Pilgrimage' to the capital on 26 July 1913.

When Christina Broom worked at 'Women's Sunday' she was 46 years old and living at 38 Burnfoot Avenue in Fulham with her husband Albert Edward Broom and their only child, 18-year-old Winifred Margaret, known as Winnie. Albert Broom was a keen sportsman and the captain of Battersea Cricket Club, but had to retire from working in the family ironmongery firm in 1896 after a disabling accident caused by a cricket ball. He was hit on the shin, and the bone was badly damaged and never healed, leaving him in crippling pain for the rest of his life.

Helped by Winnie, Christina Broom, who was less than five feet tall, managed to manoeuvre a tripod and a heavy half-plate box camera through the packed Hyde Park into a good position within two or three feet of platform 6 – one of 20 – and captured the earnest camaraderie of the speakers and their supporters. Mrs Broom's picture of 'Women's Sunday' shows about 30 women, hugger-mugger with each other, and two youthful-looking constables completely surrounded by a sea of smiling Suffragette faces. This was the day the Suffragette colour scheme of purple, white and green, symbolizing dignity, purity and hope, was launched. Above the pyramid of women, three tricolor flags flutter in the breeze, and a chubby policeman peeps into the edge of the shot, keen to be included. Above the face of every woman is a hat – mortar-boards as worn by the university women, or heavily decorated galleon-sized structures with ribbons, feathers and artificial flowers, some also with veils. The *Daily Mail* purred: 'I am sure a great many people never realized how young and dainty and elegant and charming most of the leaders of the movement are. And how well they spoke – with what free and graceful gesture; never at a loss for a word or an apt reply to an interruption; calm and collected; forcible, yet so far as I heard, not violent; earnest, but happily humorous as well.'[1]

When the Brooms' family business failed in 1901, Albert and Christina bought a stationery and toy shop in Streatham Hill on

Fig. 1 Suffragettes in Hyde Park on Women's Sunday, 21 June 1908

the advice of Albert's brother Alexander, himself a stationer in Hampstead, who was married to Christina's sister Amy. Albert stayed at home working as an accountant. In 1903 Mrs Broom became the family breadwinner by converting an interest in photography into a business. She borrowed a box camera and taught herself to be a commercial photographer, and came to earn a good living at this happy moment now known as 'the golden age of the postcard'. Broom would print postcards of her photographs of street scenes and, most lucratively, postcards of members of the Royal Family when they appeared in public in Chelsea and Fulham, where the Brooms lived. Mother and teenage daughter lugged the heavy camera and tripod to topical events and sporting occasions such as the Oxford and Cambridge Boat Race on the Thames. This routine was initiated when Broom went to the Epsom Derby in 1903. She struck lucky, taking a splendid photograph of the favourite, Rock Sand, and his American jockey, Danny Maher. Spotting the horse in the parade ring, she was given permission to take his photograph: Danny Maher obliged by making the horse stand for her to get a good shot. When Broom got home she developed the plate but could not remember the horse's name, asking Winnie if it was 'Sand Something'. Thirteen-year-old Winnie bought an evening newspaper, and asked her mother if the horse was called 'Rock Sand'. Winnie scanned the racing pages: '"Rock Sand Won", I shouted – the neighbours offered to buy prints to send to friends – quite a brisk little trade.'[2] This summer of 1903 was the beginning of Broom's new career, and she was able to feed the hungry demand for postcards of the top horses and jockeys of the day. Jockeys like Bertie 'Diamond' Jones, King Edward VII's jockey, were hugely popular, the celebrities of their day, whose faces appeared on cigarette cards and in print in many forms.

In 1904 Broom was already doing well and she equipped herself with a half-plate camera. Winnie left school that year, aged 14, and joined the business, helping to develop the plates, 'having already taught myself the mysteries of chemicals'[3] and using the coal cellar

as a darkroom. Albert Broom added all the neat captions by hand. One day a fortuitous encounter with the Scots Guards, who were practising sport in Burton Court, Chelsea, opened up significant new opportunities for the Brooms. After producing some plates of the event, they were invited to Chelsea Barracks the next day to take more.[4] The Brooms' long-standing professional relationship with the London military thus began and would dominate their work over the coming years. In 1908, however, hundreds of women were frequently and noisily taking to the streets of the capital, claiming public spaces everywhere to demand the vote. Often within easy travelling distance of the Brooms, the Suffragettes and the suffragists were irresistible and photogenic subjects.

When I first wrote about Mrs Broom's Suffragette photographs in 1987, the sheer number – 106 glass plates – in the Museum of London's collections and the quality, scope and drama of these Suffragette images suggested that here was a pioneering photographer who, if not a Suffragette herself, was a sympathizer, and that her gaze was in favour of the aims and methods of their cause. I have since revised my opinion of why she photographed women's suffrage activists campaigning in London. Unpicking the biographical material that Winnie lovingly curated in the 1970s has revealed helpful insights into the hard work and business acumen that informed Christina Broom's life. Winnie was not just her mother's assistant on all the women's suffrage shoots; she was a witness to the most dramatic and daring political campaigns of the twentieth century. The complexity of the images from this part of their careers, and the time frame in which it took place, suggest that for a time postcards of Suffragettes and suffragists were good for their business. There was a growing appetite among young women all over Britain for picture postcards of their heroines, both suffragists and Suffragettes, and the large and colourful events they held in London. However, there is no evidence in the family papers to suggest that mother and daughter were interested in the suffragists and Suffragettes for other than commercial reasons.

Christina Broom, nee Livingston, was born in 1863 at 8 King's Road in Chelsea, the seventh of nine children. The 1871 census shows that, though her family lived nearby, Christina, aged seven, and her elder sister, Alice Catherine, aged ten, were boarding at the 'Ladies' school' run by Miss Esther Newell at 69 Oakley Street.[5] Christina was then sent to Miss Searle's Claremont Academy in Harold Road, Cliftonville, Margate. For this school on 'high cliffs', proximity to the sea in one of the 'most salubrious places in England' was a selling point in its advertising. The curriculum was 'thorough in every branch and adapted to the requirements of the present day', and parents were assured that Miss Searle's pupils had 'obtained many honours and distinctions in the universities' local examinations ... and the Associated Board of Music and the South Kensington School of Art' (now the Royal College of Art).[6] Christina Livingston probably left the school in 1879, when she was 16.

In 1871 Christina's father, Alexander Livingston from Edinburgh, was a Chelsea boot and shoe maker, employing two men and a boy and two domestic servants (Fig. 2). When Christina married Albert in 1889 the wedding certificate said that her father, who had died in 1875, had been a 'gentleman', although boot makers were not gentlemen. This claim reveals the social-climbing ambition of Christina's mother, Margaret Fair, and Christina's own sensitivity to class. In the 1840s Alexander Livingston came to London from Scotland and was working as a goldsmith in St James when he met and married Christina's mother, a Fleet Street boot maker's daughter, in 1848. The couple were married by licence, a clue to Alexander's elevated social standing. His family had been grand: he was descended from Sir James Livingston, the second son of the First Earl of Linlithgow, who had acquired Haining Castle, also known as Almond Castle, by marriage in the middle of the seventeenth century. The Livingstons' castle and land, located between Linlithgow and Falkirk, were forfeited in 1716 and left to fall into ruins. The reality that Haining Castle was a tottering pile hardly mattered; it was the memory of grandeur passed

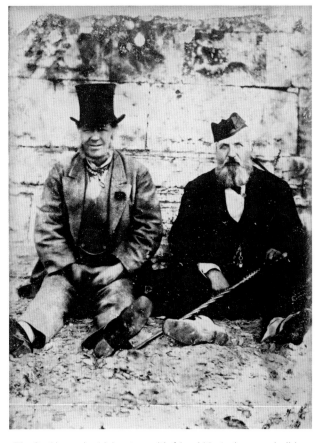

Fig. 2 Alexander Livingston with friend Mr Jackson on holiday in Margate, c. 1860

down through the generations that referred to better times. Making boots and shoes in Chelsea was a long way from being a 'gentleman jeweller', whose ancestral home had once been a castle.

Margaret Fair was running her father's other boot and shoe shop in Sloane Square when Alexander Livingston came in one day. When he later asked her to marry him she accepted his proposal, on condition that he give up his business so that she could continue in hers. Remarkably, he accepted, put his goldsmithing tools away and took up the more manual labour of shoemaking.[7] Miniature

portraits of Christina's parents painted soon after their wedding show Alexander and Margaret in a typical pose of the 1840s: solemn, starched, tightly buttoned up and thoroughly respectable models of mid-Victorian propriety.

In 1857 Alexander Livingston was elected as a vestryman for the parish of Chelsea, promoted to chairman by 1865 and active for the rest of the decade, levying and collecting local rates for street lighting and cleaning, public health inspection, and the provision of public baths and libraries. He served as a member of the Chelsea Board of Guardians for 18 years. An exemplary councillor, he was praised for his 'courteous, dignified and impartial conduct', and kind in his dealings with widows who had fallen on hard times and applied to the Guardians for poor relief. A portrait was commissioned in 1872, now owned by Chelsea Library, showing him to be a handsome, bearded fellow with clear blue eyes. When he died in 1875 his estate amounted to £12,000, which in today's money equates to over £1 million.

Christina was 12 years old when her father died: her mother inherited the family home at 146 Oakley Street (now No. 87) and the leases on other properties in Chelsea. When Christina's mother died in 1884, aged 58, she left Christina, aged 20, the family home at Oakley Street, a share of the rents and profits on a shop at 290 King's Road, and a half-share of her personal effects on Christina's coming of age. Christina expected to have a private income as well as owning her own house, but her elder brother Robert was a gambler who squandered much of his siblings' inheritance in Monte Carlo.[8]

In 1884 Christina took over the running of the boot and shoe shop at 290 King's Road, went to live above the premises and rented 146 Oakley Street to Oscar Wilde for his mother to live in for eight years. Lady Wilde called Christina her 'little landlady', and she collected the rent in person. The eccentrically dressed Lady Jane Francesca Wilde, who was an early advocate of women's rights, died in 1896. Oscar Wilde was serving two years' hard labour for sodomy and gross indecency at the time of her death.

When Christina Broom died in 1939, her daughter Winnie started to make a collection of notes and impressions titled 'Persons I Met and People I Knew'.[9] Within this Winnie remembered her mother saying that 'Oscar was not nearly so bad as folks imagine, he lived in advance of the times … and sometimes took the blame for his brother Willie's faults and doings' and that Lady Wilde 'spoilt and idolized Willie and was herself pampered'. In 1895 Christina Broom appeared as a character witness at Oscar Wilde's trial to testify that he was punctilious about paying his mother's rent. Oscar Wilde's hopeless brother Willie, whom Oscar described as 'someone who sponges off everyone but himself', also lived at 146 Oakley Street. Willie's marriage to a rich American woman was brief: she divorced him for his drinking and philandering, and in 1894 he married a Dublin widow, Sophie Lily Lees; their daughter, Dorothy 'Dolly' Irene, was born in Mrs Broom's house.[10]

Christina Livingston met Albert Broom in Battersea Park: sport was an enthusiasm the young couple shared. When Christina was a pupil at Claremont Academy she excelled in swimming, and was a good shot with a rifle and a devoted angler. Both the Livingstons and the Brooms had lived in Chelsea for at least two generations and knew each other socially, and there was an impression in their social circles that the Livingstons were well off. In August 1889 Albert Broom and Christina Livingston married at St Saviour's church in Chelsea. Years later, Winnie learned that when Christina told her new husband that she was not quite the heiress he thought she was, Albert told her not to tell his mother.[11] After the wedding the couple moved first into his parents' home at 7 Cheyne Row, and Albert worked in his family's ironmongery business. They then moved to 4 Napier Avenue (now No. 8), which was owned by Albert's father, William Rudd Broom. Their only child, Winifred, was born in 1890.

In 1871, Albert's father, who was named as a victualler on his wedding certificate in 1855, owned a small family laundry business in Cheyne Row, helped by his wife, Jane, and his sister Mary. Two

doors away from the Brooms, at 5 Cheyne Row, lived the irascible philosopher and historian Thomas Carlyle, who built himself a soundproof room at the top of the house to escape the noise of the Brooms' barking black dog. In the ten years since Thomas Carlyle's death in 1881, the Brooms had left the soap suds, the dolly and the wash tubs behind, and moved up from the lower rungs of the class ladder to join the more respectable trade of ironmongery. They were doing well and living in Carlyle Square.

Albert's sporting accident in 1896 triggered 16 years of failing health. His painful shin meant that he could not stand for long, and in the final years of the nineteenth century the family spent winters in Broadstairs, giving a clue to the onset of the tuberculosis from which he would die. During his ailing years he spent time in hospital and at seaside boarding houses, hoping that the sea air and rest would hold back the advance of the disease that was consuming him – then known as consumption. An envelope, labelled 'Daddy's and Mummies Letters and Cards' by Winnie, contains Albert's Pooterish letters to his daughter and her replies, revealing something of the dynamic of the Brooms' lives.[12] When he is recuperating Albert puts on a brave face and tries to be jolly, while back in London Christina and Winnie bustle about taking photographs, then print thousands of cards and add the captions by hand – Albert's job when fit. Albert writes to his 'Darling Girl' and her 'dear doll Mother' from Arlington House Hospital for Skin Disease in Hammersmith:

> I am afraid I haven't any news to tell you dear, as all the days here are the same. I still sit out here on the balcony as much as I can and enjoy the fresh air and rest very much indeed. My leg is going on alright, but of course slowly and I still have some pain with it at times.

Mr Broom is concerned about his wife's health, which is suffering because of his failing condition:

> I am sure my dearest Winnie, you are doing all you can to look after your dear old mother and cheer her up and get her well. Remember my darling there is *no one* – not even your dear old daddy – who can be quite the same to her as her own dear loving little daughter.

Albert asks about his daughter's exploits at fishing, a hobby they all enjoyed:

> I hope you had some sport with your fishing yesterday – those little dabs are nice, aren't they, when you catch them? Such a job to catch them though at Margate isn't it, they don't seem to like it there.

Although Albert's letters to his wife and daughter are undated, it is clear from their patters of correspondence they were written at the times when Christina and Winnie were printing and posting out dozens of bulk orders for their women's suffrage images. In the procession image (Fig. 3), Christina and Winnie Broom get in among these Suffragettes who are advertising the 'Women's Exhibition' held in May 1909, and whose extraordinary hats jostle for air rights, loaded up with feathers and flowers and frippery. Diaphanous motor veils hold hats in place, anchored with extravagant bows. Christina Broom is drawn to the costumes rather than the politics behind this gathering. The colour is lost in black and white: purple, white and green brightened up those days in May when these women took to the streets to advertise their Women's Exhibition at the Prince's Skating Rink in Knightsbridge. The two-week fund-raising exhibition which is being advertised on their banners was held between 13 and 26 May. The rink, a members-only club, was opened in 1896 for figure skaters to practise on uncrowded ice. The year before Christina Broom took this photograph, the Prince's Skating Rink hosted the 1908 Olympic figure-skating events.

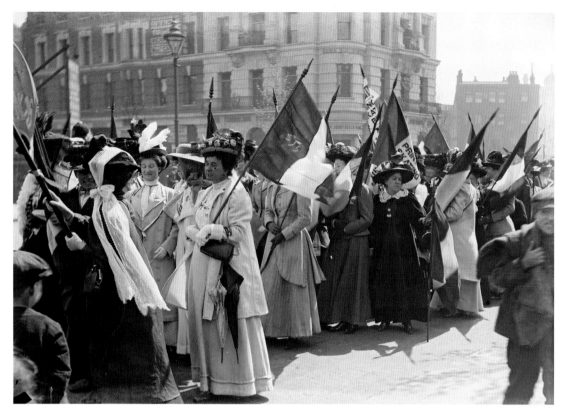

Fig. 3 Suffragettes prepare to march in a procession to promote the Women's Exhibition, May 1909

Unusually, Mrs Pankhurst is not centre stage in this shot (Fig. 4) of the Sweet Stall at the Women's Exhibition. Mrs McDonald and her daughter Flo, Mrs Thomson and Miss Leggatt are the stallholders behind the battery of sweet confectionery donated by Suffragette supporters from all over the country. The home-made sweets included 'chocolates, butterscotch and toffee and creams', and American fudge and candies were donated by American Suffragettes.[13] The exhibition raised £5,664 (now £600,000) for the 'War Chest' campaign fund, of which the sweet stall's contribution was just over £109 (now £10,000).[14]

Cropped at the top of the image, Sylvia Pankhurst's portable murals are visible. Commissioned by Emmeline Pethick-Lawrence, Mrs Pankhurst's daughter painted the canvases to cover the walls of the exhibition space, which measured 250 feet by 150 feet, at the Avenue Studios in Fulham. Helped by seven female and male student friends from her days at the Royal College of Art, Sylvia had nine weeks in which to complete the work. Young women 13 feet high were depicted sowing grain and bearing sheaves of corn, angels played stringed instruments, glorious rays of sunshine rained down, pelicans represented sacrifice, olive branches were for peace, doves for hope, and broad arrows the symbol of imprisonment. The scenes were framed with the laurels of victory. Sylvia Pankhurst found the task 'an exhilarating experience. One felt alive, indeed, as the small designs grew and covered huge surfaces. It was a tremendous rush to get finished in time. From waking to sleeping, I scarcely paused.'[15]

The Putney and Fulham WSPU shop at 905 Fulham Road was a six-minute walk from the Brooms' home in Burnfoot Avenue. Mrs Broom and her daughter would have often walked past this neighbourhood shop, which opened in February 1910. During

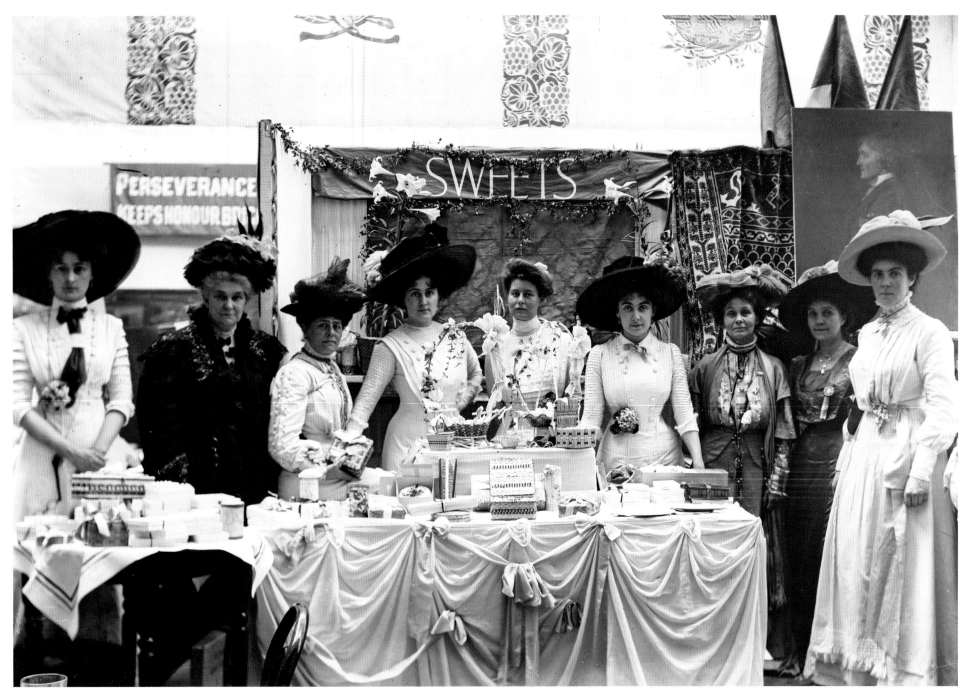

Fig. 4 The Sweets Stall at the Women's Exhibition, Prince's Skating Rink, May 1909

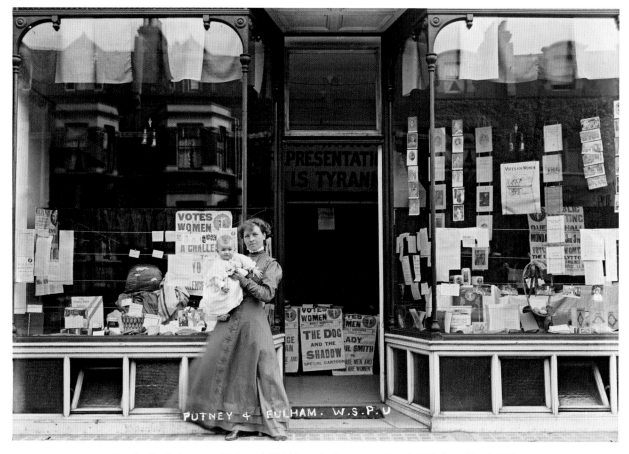

Fig. 5 The Putney and Fulham WSPU branch shop and office, 905 Fulham Road, 1910

the general election in January 1910, the local WSPU branch's campaign had been so successful that their move 'to these new and commodious premises had been rendered absolutely necessary'. The shop and office were run by Miss Lizzie Cutten, aged 40, who had been a teacher with the London School Board, and Mrs H. Roberts. At the 'shop-warming', there was much local interest and 'a policeman was on duty all day keeping watch on the very friendly crowd which gathered round the window'. The Brooms may have taken this photograph (Fig. 5) during the summer – the unknown mother and baby (possibly Mrs Roberts and her daughter) have popped out without hats and coats, and three windows at the pavement are open. The window is a visual feast and clutter of Suffragette propaganda

and merchandising: photographic portraits and postcards hang from lines strung across the bay windows; postcards of Suffragette 'stars' are displayed on vertical strings, and sheet music for 'The Purple, White and Green' song is visible. There is a muff, a 'Votes for Women' silk scarf, a basket of farm eggs, pots of jam and marmalade, and pamphlets and books.[16]

On 23 July 1910, Christina Broom and her daughter Winnie were among a huge throng of Suffragettes arriving in Hyde Park, who lobbied peacefully for the Conciliation Bill which the WSPU hoped would grant women the vote when debated in the House of Commons in the autumn. Several thousand Suffragettes, and members of a dozen other women's suffrage organizations, walked

through London to Hyde Park carrying hundreds of banners, in step to the sound of rousing brass band music, to hear speeches by 150 well-known suffrage and feminist campaigners at 40 platforms.

The Brooms set up their camera and tripod looking at three leading members of the WSPU (Fig. 6). Standing on the left is Emmeline Pethick-Lawrence, the treasurer and co-editor of the weekly newspaper *Votes for Women*, who was due to speak at platform 3. Next to her is Sylvia Pankhurst, who created the visual identity of the Suffragette movement, a speaker at platform 27 and an ardent campaigner, holding a portcullis (representing Parliament) with five arrow-shaped prongs (representing imprisonment). Beside

Sylvia is Emily Wilding Davison, heading towards platform 30 in her academic robes; she was an ex-governess and career militant Suffragette. The presence of Emily Wilding Davison is exciting: despite her dedicated engagement in every kind of militant protest, there are few pictures of her. In 1913, the notorious Miss Davison's life came to an abrupt end: her deathly dash was captured by a newsreel cameraman at the Derby and flashed onto cinema screens around the world, guaranteeing her the fame she craved as 'the Suffragette who threw herself under the King's horse', on 4 June 1913. She died of her head injuries four days later at the age of 40.

The *Standard*'s reporter at the Hyde Park rally was impressed:

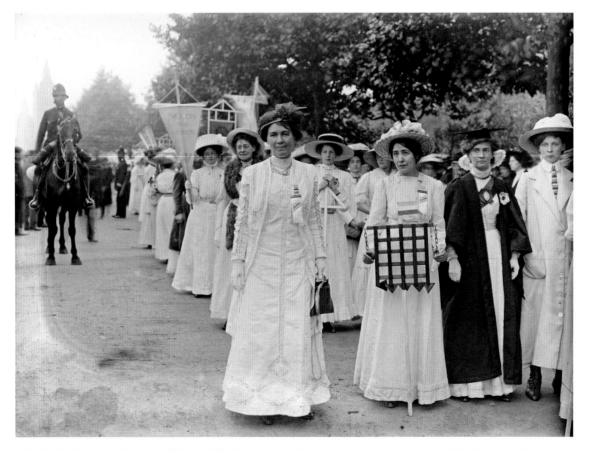

Fig. 6 The Prisoners' Pageant, 23 July 1910. At the head of the Pageant are key members of the Women's Social and Political Union, Emmeline Pethick-Lawrence, Sylvia Pankhurst and Emily Wilding Davison, themselves former prisoners

Saturday's demonstration was something more than a mere parade of women. From early morning crowds of women arrived from all parts of the kingdom, and were at once conspicuous by their dresses and their hats, which combined the colours of the suffragist movement, green, purple and white … The scene was a remarkable one. Probably no fewer than a quarter of a million people were assembled round forty platforms that had been erected.[17]

The Irish contingent of the Women's Coronation Procession on 17 June 1911 (Fig. 7) was led by women carrying green flags and a piper in national costume. Several of the women were dressed in 'colleen bawn' cloaks in emerald green, and carried gilded harps, outsize shamrocks and shillelaghs. Miss Geraldine Lennox , aged 28, from Bantry in County Cork, who worked on the *Votes for Women* newspaper at WSPU headquarters at 4 Clement's Inn, London, was

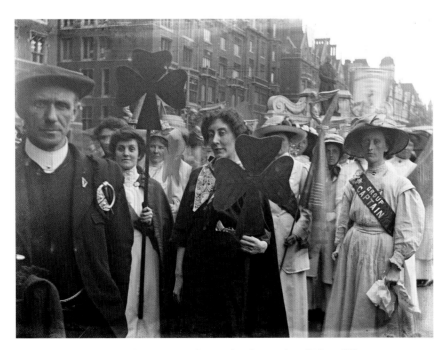

Fig. 7 The Women's Coronation Procession, 17 June 1911

the organizer of the contingent.[18] The planned procession was an ideal opportunity to present the Women's Social and Political Union's colour scheme to an international audience of dignitaries and press from all over the world, who were in London for the coronation of King George V five days later. Politics, fashion and commerce came together in the pages of *Votes of Women* in the weeks leading up to the spectacle of 60,000 women marching through the streets of London on 17 June. Annette Jay, a London milliner and corsetière, reminded readers of her stock, informing them that Spirella Corsets, 'the boning of which is unbreakable and rust-proof are highly recommended owing to their comfort' for those marching and speaking. Roberta Mills of Brixton advertised 'Emmeline Bags' and 'Christabel Shopping Bags' for sale.[19]

At the same time that Broom and her daughter were busily photographing the largest and most lavish women's suffrage procession to date, Albert Broom's health was failing. He wrote to Winnie from 'The Homestead', a boarding house on the sea front at Exmouth in Devon, boasting a 'Southerly Aspect Facing The Sea':

I miss you both very much and am always thinking of you, and wish you were down here with me … I am sure the fresh air is doing me good, and I think if you and your dear mother do not mind I will stay a few days longer and not come home tomorrow as I at first intended. I am just off now to send dear Mother and Grannie a little more cream. I hope mother got the last lot alright, it goes fine with stewed plums, you should try it old girl.

Albert died on 21 January 1912 of a lung haemorrhage. His wife and daughter left Burnfoot Avenue and went to live at 92 Munster Road, a short walk away in Fulham, where they were still living when Christina Broom died in 1939.[20]

It is not clear why Broom stopped photographing the women's

suffrage movement in the summer of 1913. Perhaps her other work became more popular and made them more money. Perhaps the escalating militancy of the WSPU was the reason for the Brooms to end this particular line of work. Between the summers of 1913 and 1914 newspapers ran stories of broken windows, arson attacks on empty houses and churches, railway stations and sporting facilities, and axe attacks on works of art and museum displays. The days of beautifully dressed photogenic women processing peacefully through the streets of London carrying artistic banners – Broom's staple – were over.

In 1971, two years before she died, Winnie spoke at length to John Fraser, the author of an article about her mother's importance as the first woman army photographer. There is a tantalizingly brief mention of the Suffragettes: it was an obvious area for Fraser to enquire about, given the publicity in 1968 surrounding the fiftieth anniversary of women being granted the vote at the age of 30 in 1918, and the fortieth anniversary of equal suffrage for women aged 21 in 1928. Winnie said her mother 'never joined them because it would have shown favour. As she was an official photographer she felt she could not join them.' The use of the word 'official' is interesting. It is possible that Winnie or Fraser are referring to Broom's work for the army as a good reason for her not to want to be openly identified with the controversial cause of women's suffrage, especially the militants. The martyrdom of Emily Wilding Davison at the Derby in 1913 when she grabbed the bridle of the King's horse Anmer, and unseated his jockey Bertie Jones, underlined the risks attached to earning a living from photographing the Suffragettes. Winnie's comment sounds like a retrospective explanation, a rewriting of history to answer a question she no doubt was asked more than once. Winnie's response and Fraser's interpretation sounded like a fudge when the Suffragettes were being rehabilitated and widely appreciated as political campaigners, not unhinged fanatics.[21]

Given Mrs Broom's personal circumstances, her focus was on earning enough to support the family and pay for her husband's

medical treatment and periods of convalescence. Her letterhead proudly boasts 'Patronised by His Majesty The King', making clear how carefully she had to tread and not offend her most important clients: first King Edward VII, then King George V, and the top brass of the Household Brigade. For Mrs Broom and her daughter to be in any way identified ideologically with the Suffragettes would have been commercial suicide. Nor is there any evidence that Winnie Broom, who was 18 when she was among hundreds of Suffragettes in Hyde Park, was politically stimulated by those feisty women. One member of the WSPU, born in 1890, the same year as Winnie, was Jessie Spinks, a chemist and druggist's daughter, living in Westminster, whose pseudonym was 'Vera Wentworth' and who had been in Parliament Square in February 1908 when more than 20 Suffragettes tried to enter the House of Commons in two pantechnicons in the Trojan Horse protest. Another of Winnie's exact contemporaries was Olive Agnes Beamish, from Cork, who had attended Clifton High School in Bristol and been active in the WSPU since 1906. Both of these young women were to have distinguished Suffragette careers.

Every one of Broom's images has an intimacy and curiosity about the well-dressed shouty women whom she has captured as they go about their political business. The Broom archive does not contain any evidence of active support for the suffragists and Suffragettes despite her being so physically close to the leaders and foot soldiers, as evidenced in the photographs – there are no autographs or signed programmes. But Christina Broom's and Winnie's physical proximity to their subjects shows empathy. The Broom women were thrusting themselves into the men's world of press photography just as the Suffragettes were trying to push their way into Parliament and the politics of men. Broom's women's suffrage photographs are suffused with glamour and a powerful stillness and drama, recording these events so that the viewer has the sense that something very significant is about to happen. Mrs Broom's style and composition make her work aesthetically powerful and historically important.

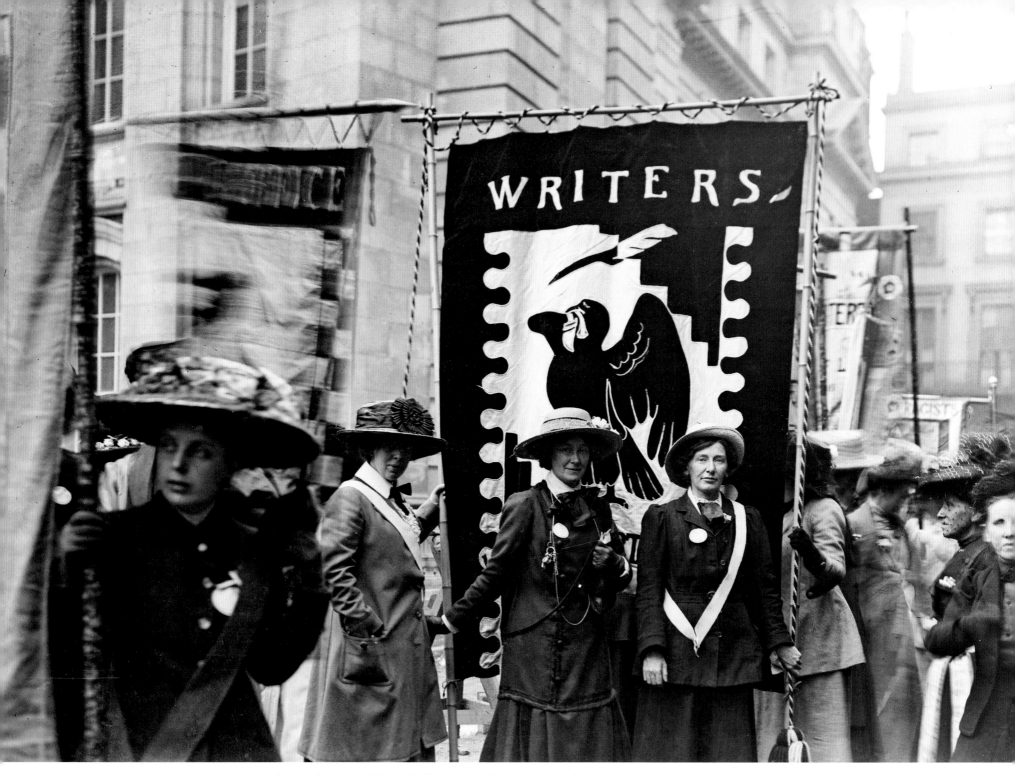

Members of the Women Writers' Suffrage League preparing to march in the NUWSS procession, 13 June 1908

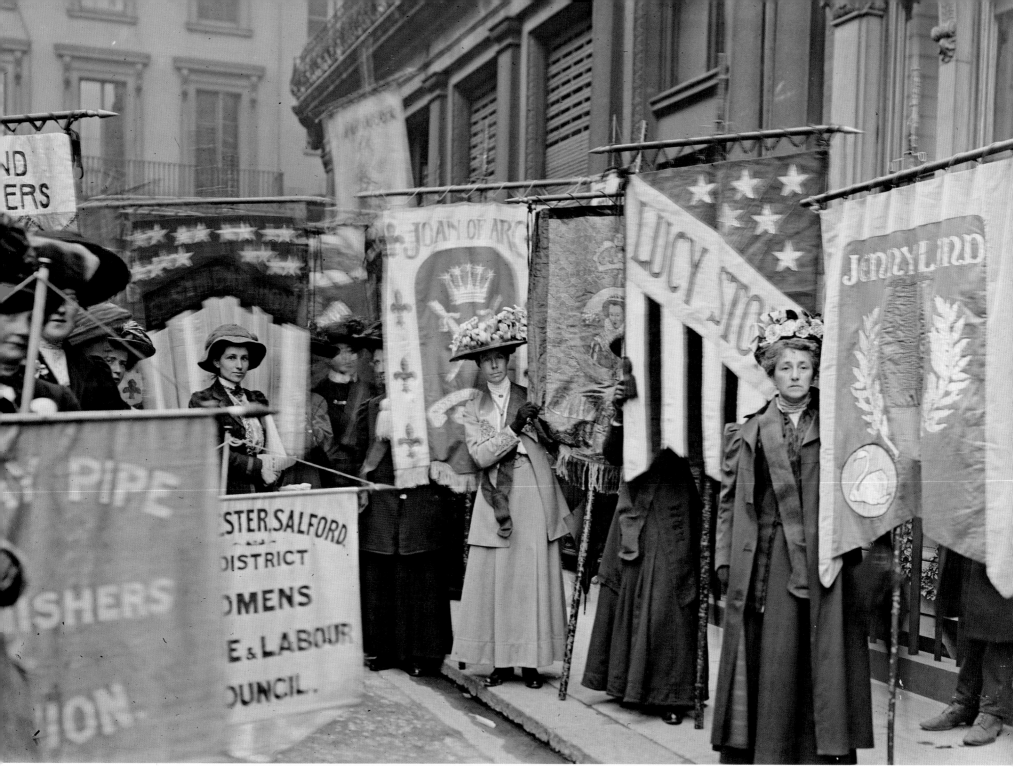

Suffragists preparing to take part in the National Union of Women's Suffrage Societies' Demonstration, 13 June 1908

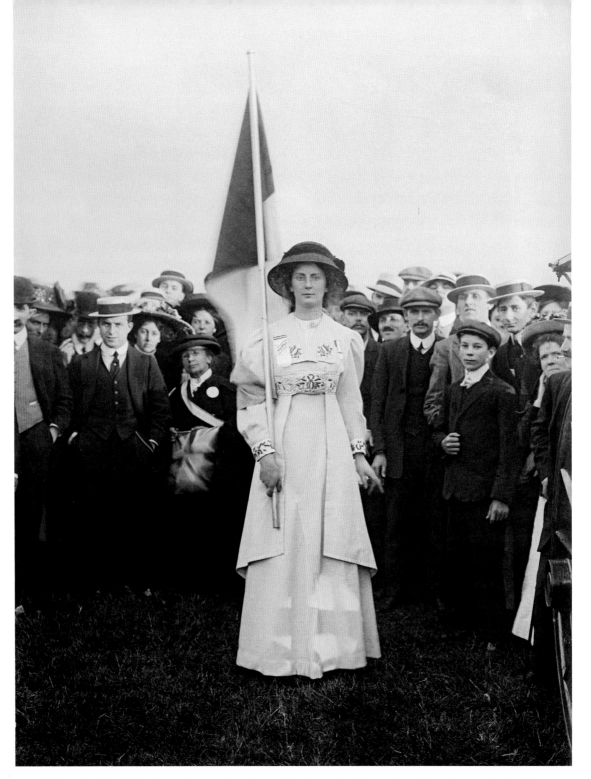

Suffragette Charlie Marsh wearing a prisoner's medal and carrying the purple, white and green tricolor flag,
Hyde Park rally, 1908

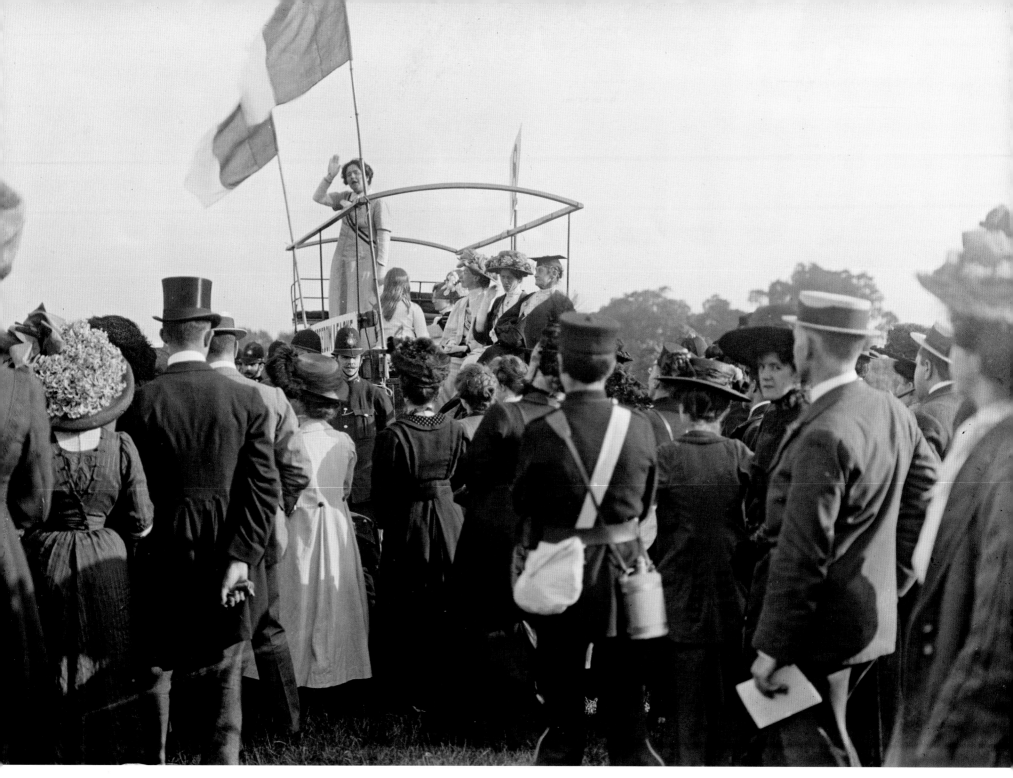

A Suffragette speaker in Hyde Park, Women's Sunday, 21 June 1908

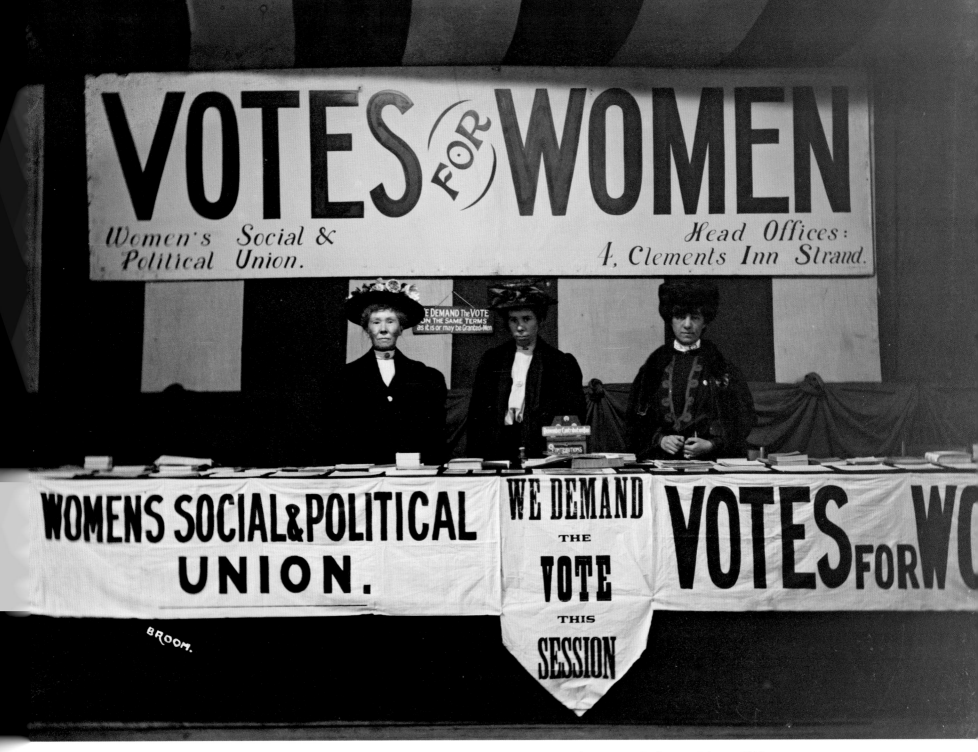

Women's Social and Political Union Exhibition stand, probably at Caxton Hall during the Women's Parliament, February 1908

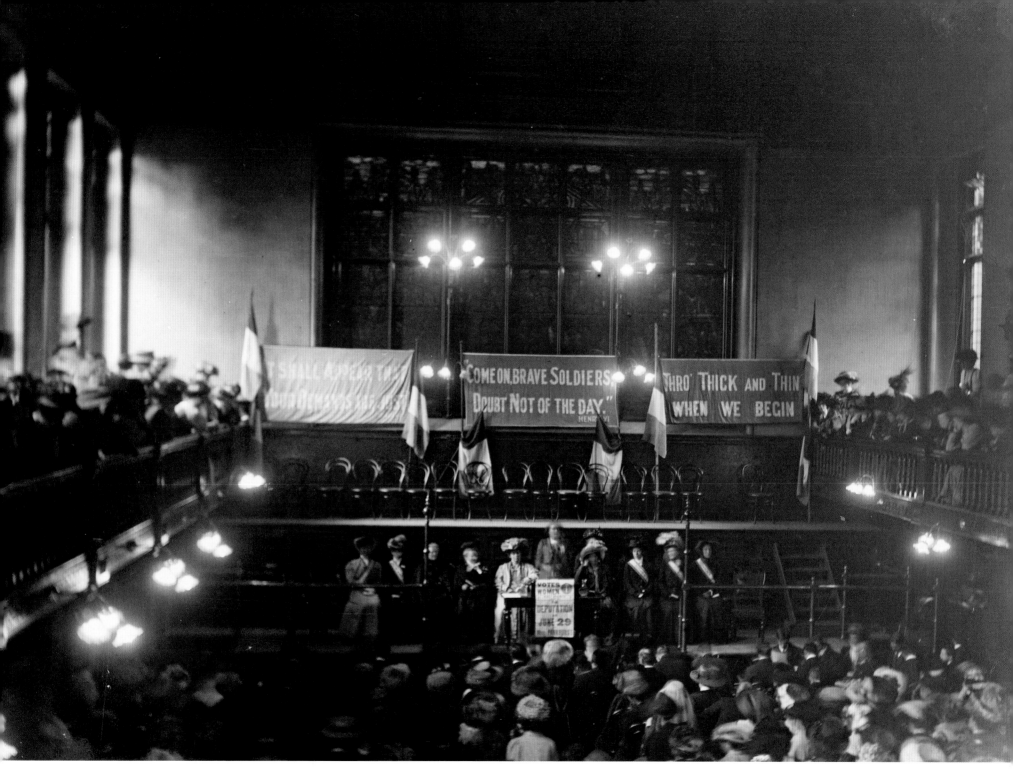

Suffragette meeting, with WSPU leaders including Emmeline Pankhurst, Caxton Hall, 29 June 1909

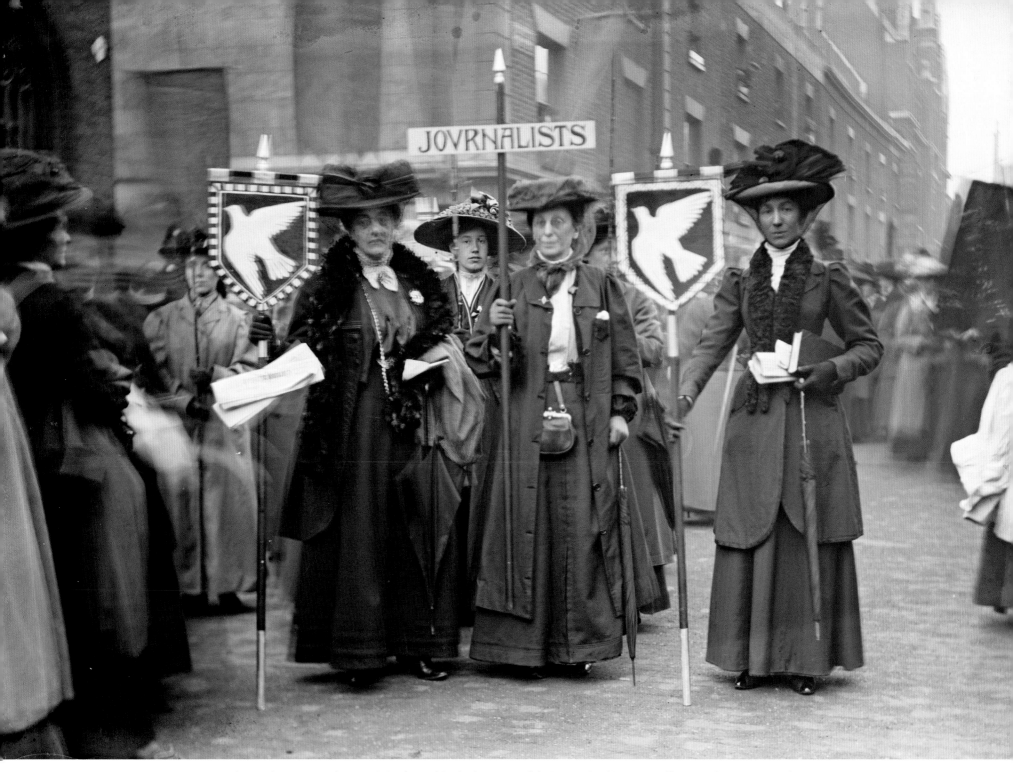

Journalists at the Pageant of Women's Trades and Professions, part of the International Woman Suffrage Conference, 27 April 1909

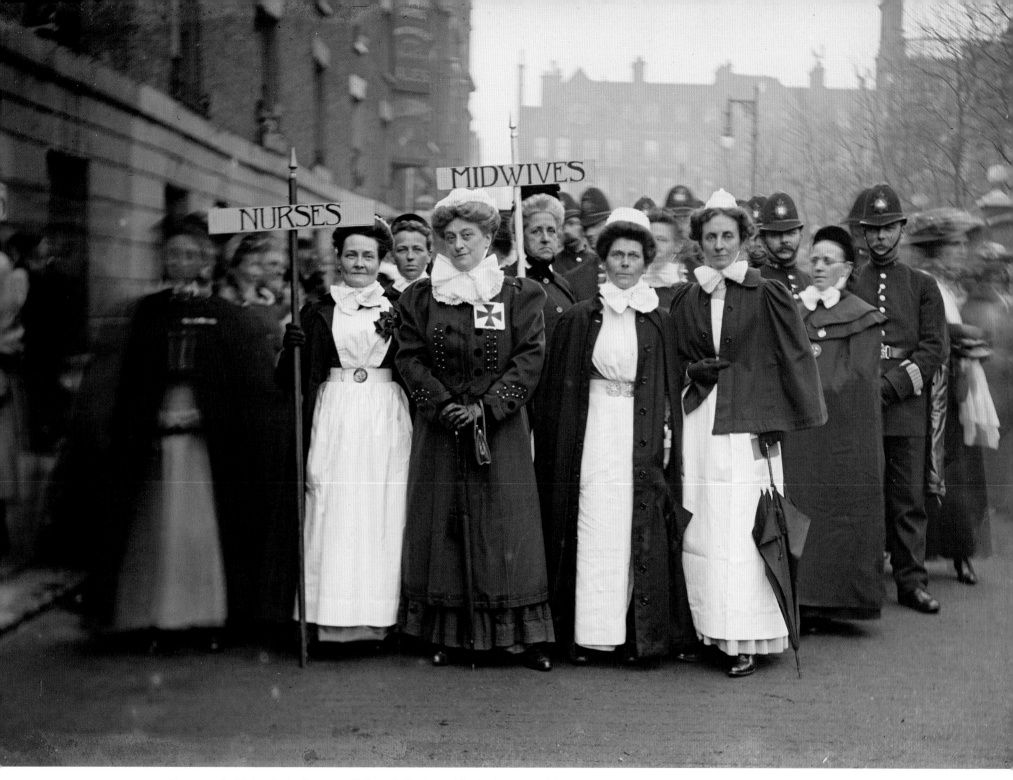

Nurses and midwives in the Pageant of Women's Trades and Professions, part of the International Woman Suffrage Conference, 27 April 1909

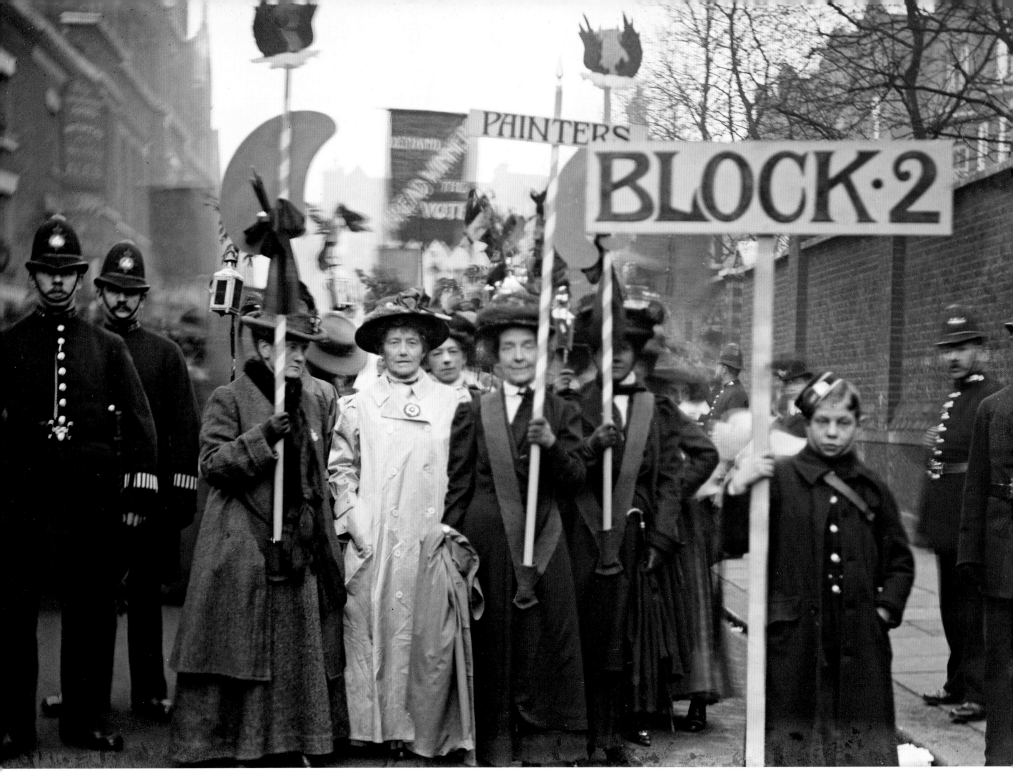

Professional artists participating in the Pageant of Women's Trades and Professions, part of the International Woman Suffrage Conference, 27 April 1909

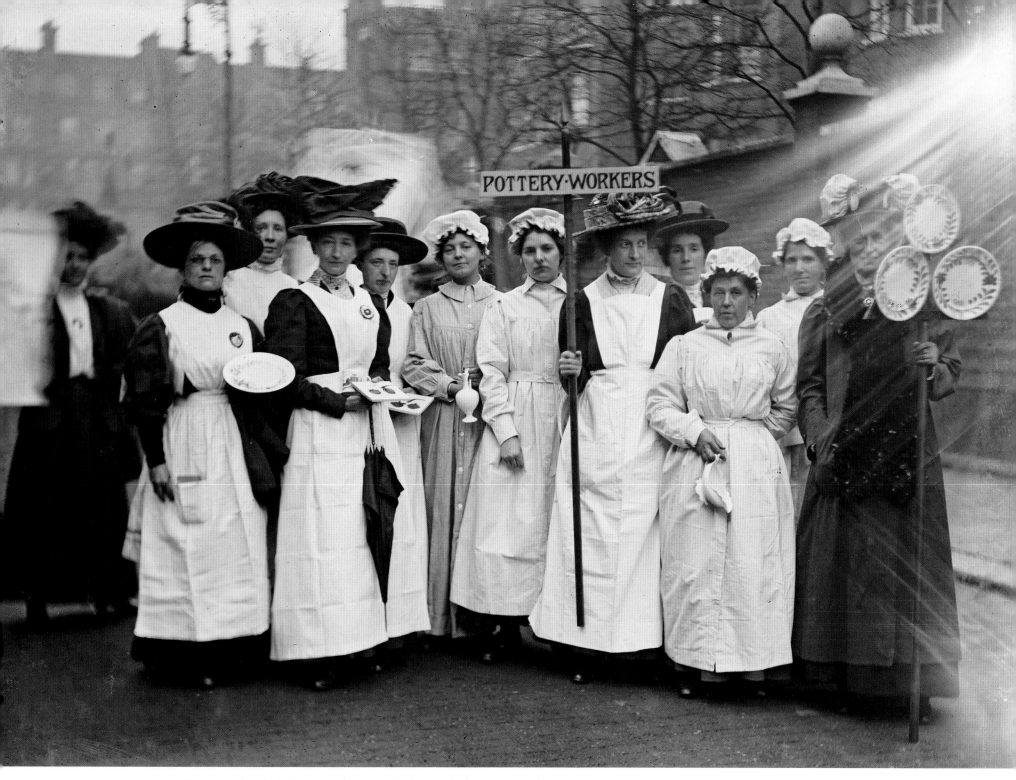

Pottery workers in the Pageant of Women's Trades and Professions, part of the International Woman Suffrage Conference, 27 April 1909

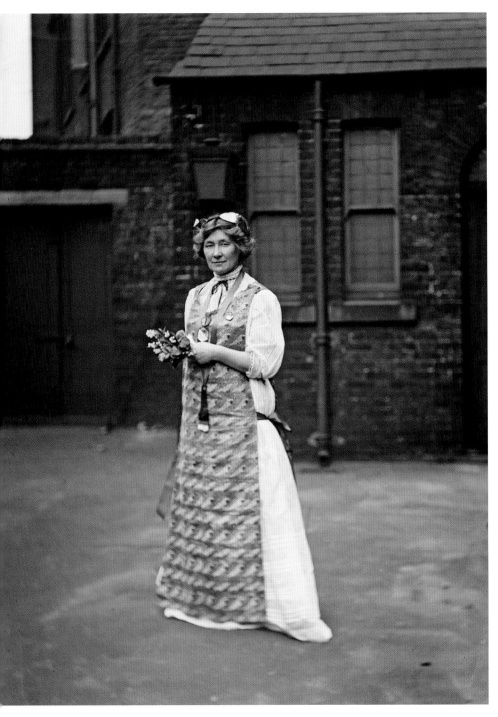

A Suffragette wearing an apron in the colours of the WFL, at the Green, White & Gold Fair organized by the Women's Freedom League, possibly at Caxton Hall, 1909

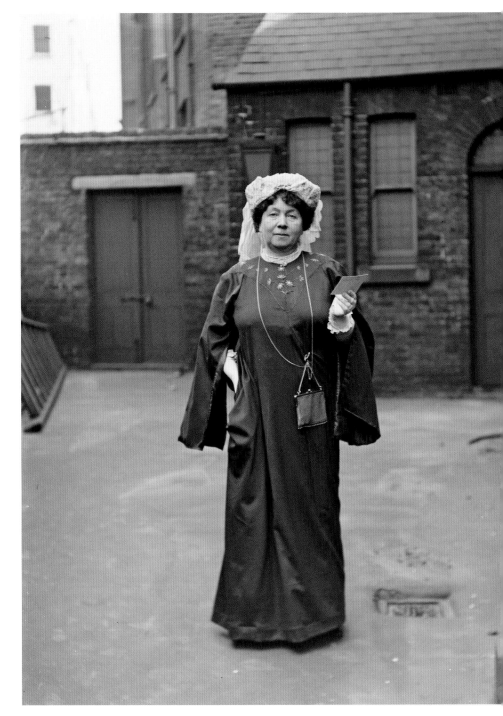

A Suffragette in costume at the Green, White & Gold Fair organized by the Women's Freedom League, possibly at Caxton Hall, 1909

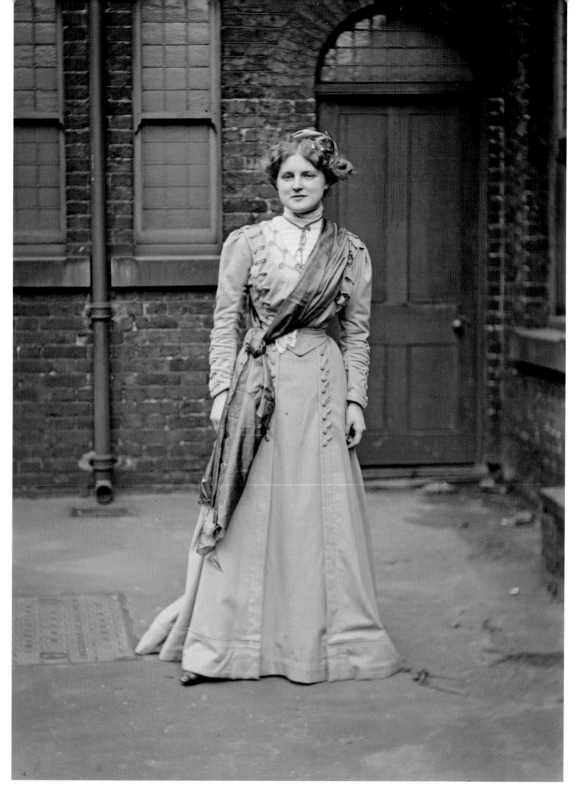

A Suffragette at the Green, White & Gold Fair organized by the Women's Freedom League, possibly at Caxton Hall, 1909

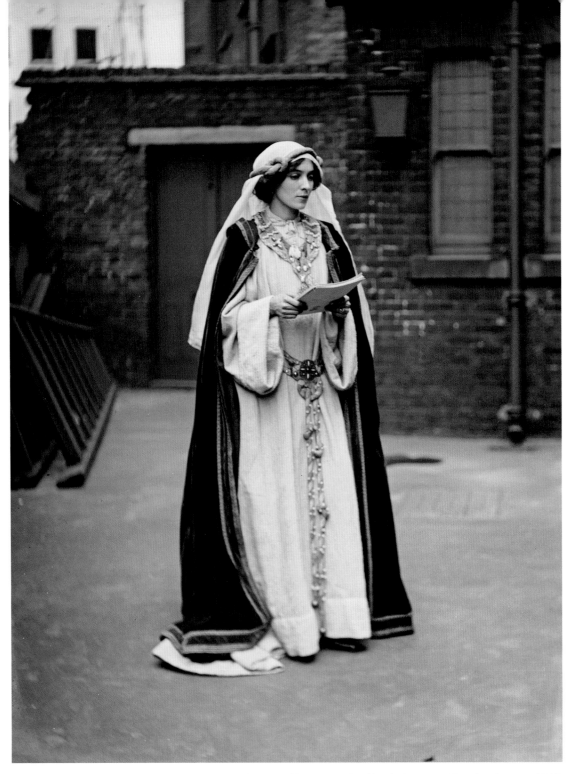

A Suffragette in historic costume at the Green, White & Gold Fair organized by the Women's Freedom League, 1909

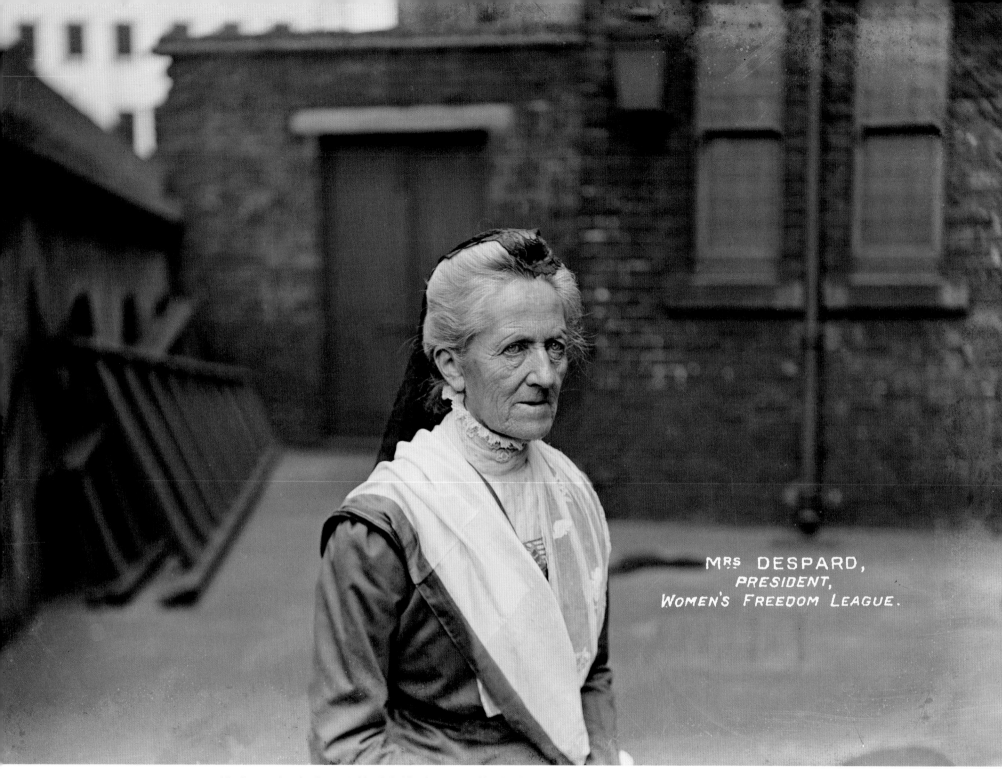

MRS DESPARD,
PRESIDENT,
WOMEN'S FREEDOM LEAGUE.

Mrs Despard at the Green, White & Gold Fair organized by the Women's Freedom League, possibly at Caxton Hall, 1909

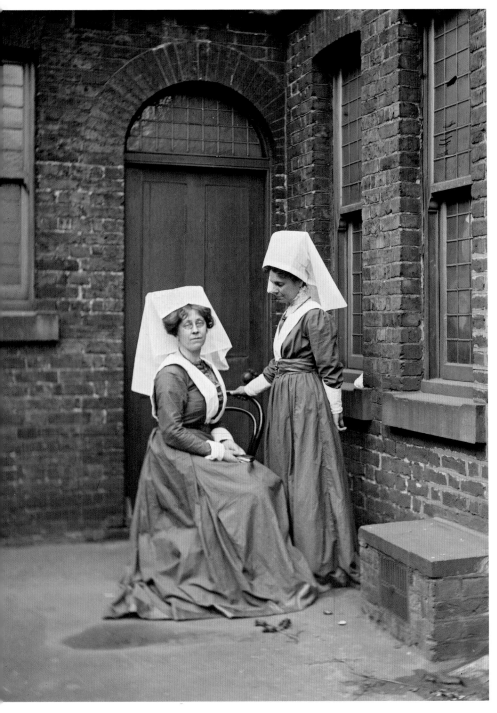

Suffragettes in costume at the Green, White & Gold Fair organized by the Women's Freedom League, possibly at Caxton Hall, 1909

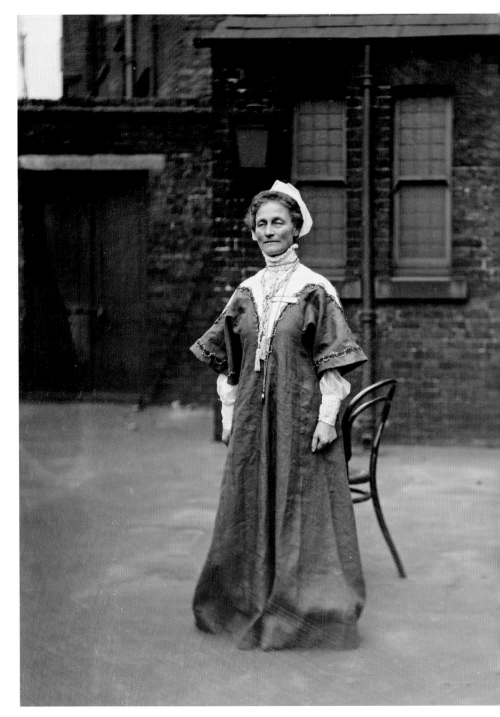

A Suffragette at the Green, White & Gold Fair organized by the Women's Freedom League, possibly at Caxton Hall, 1909. Her dress is likely to be green as they were encouraged to wear the colours of the WFL

A Suffragette wearing an apron, rosette and hairband in the colours of the WFL at the Green, White & Gold Fair organized by the Women's Freedom League, possibly at Caxton Hall, 1909

A Suffragette in medieval costume at the Green, White & Gold Fair organized by the Women's Freedom League, possibly at Caxton Hall, 1909

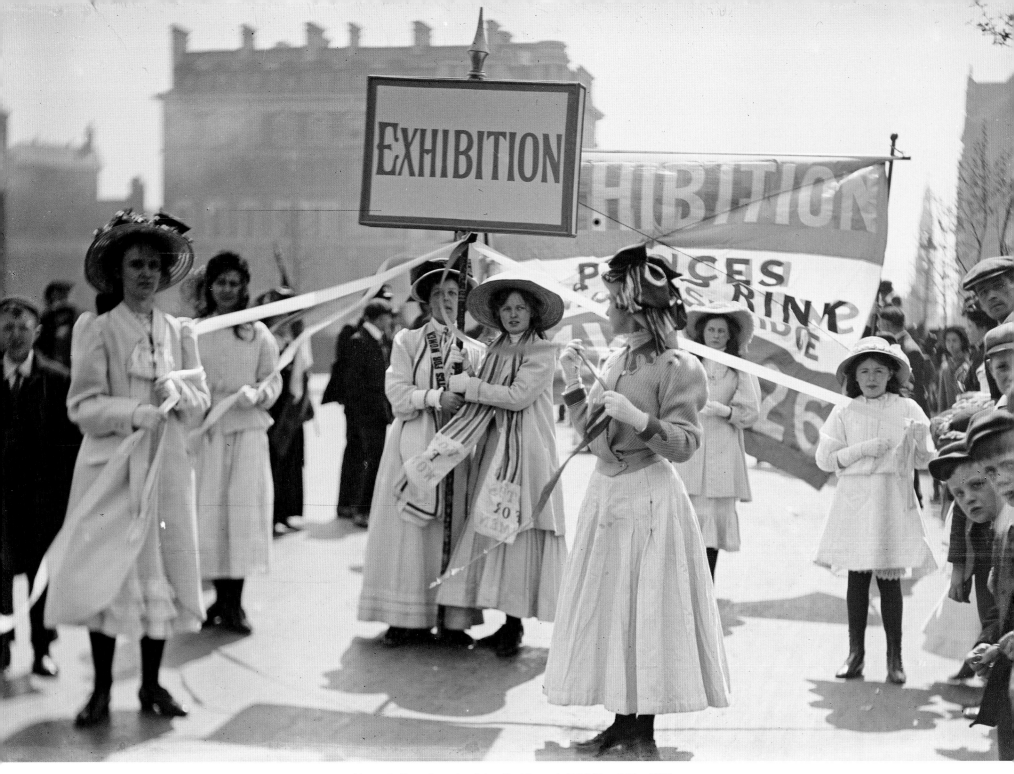

Young Suffragettes advertising the Women's Exhibition, 8 May 1909

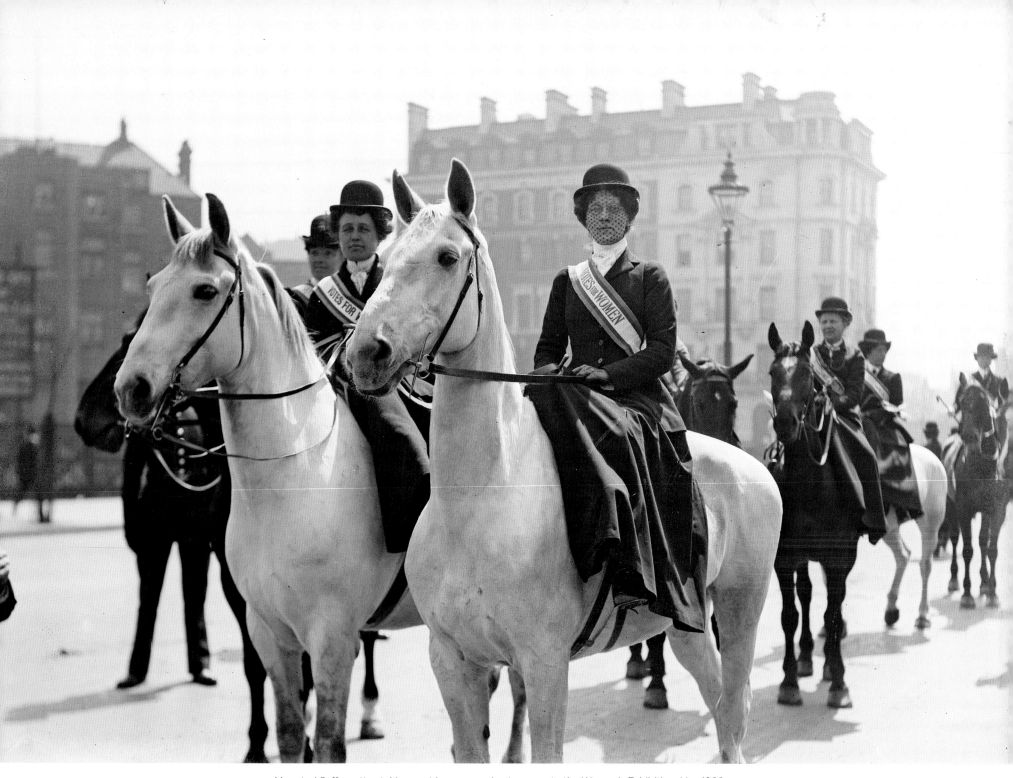

Mounted Suffragettes taking part in a procession to promote the Women's Exhibition, May 1909

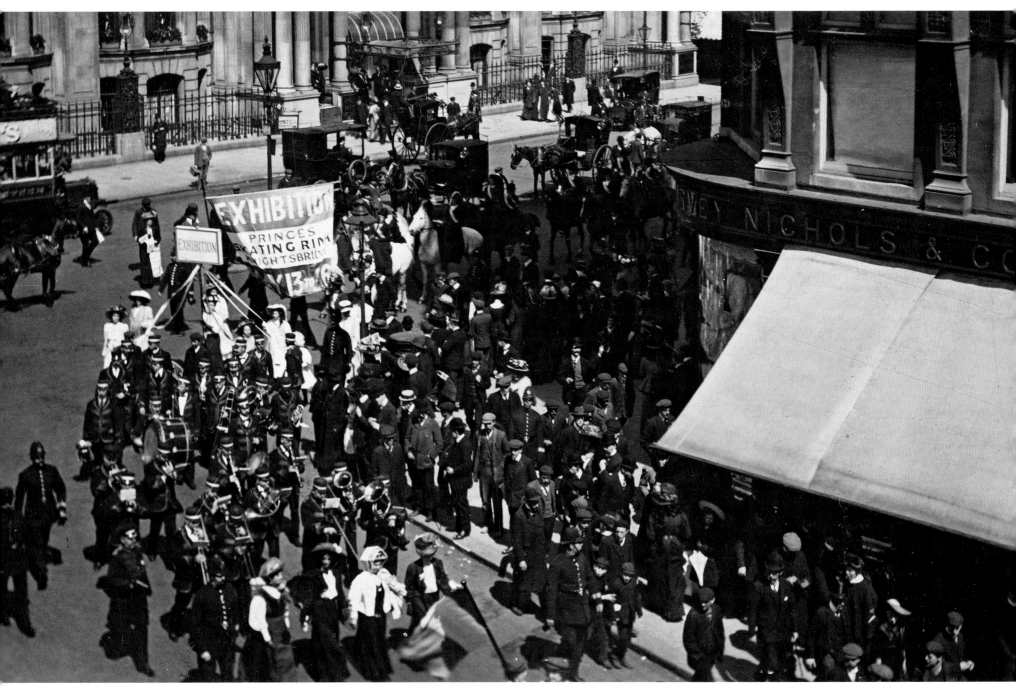

Suffragette procession promoting the Women's Exhibition held at the Prince's Skating Rink, Knightsbridge, May 1909

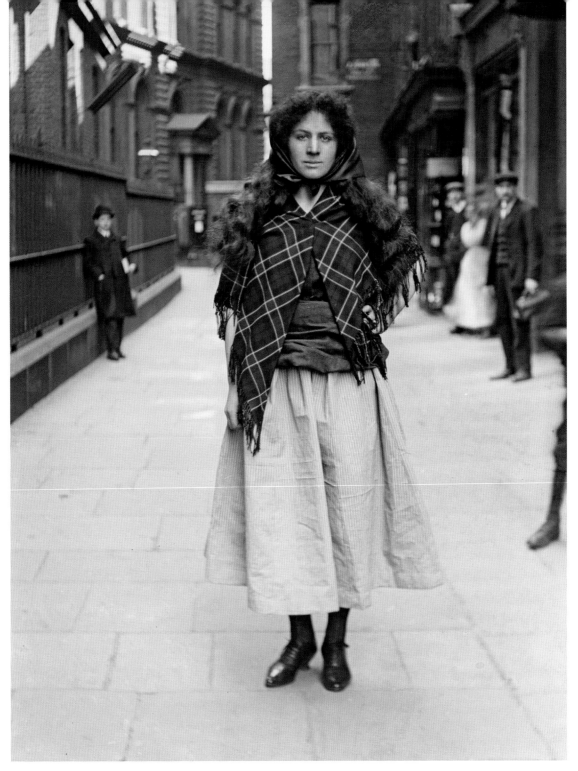

The Suffragette Barbara Ayrton dressed as a fisher-girl representing Grace Darling, promoting the Women's Exhibition, May 1909

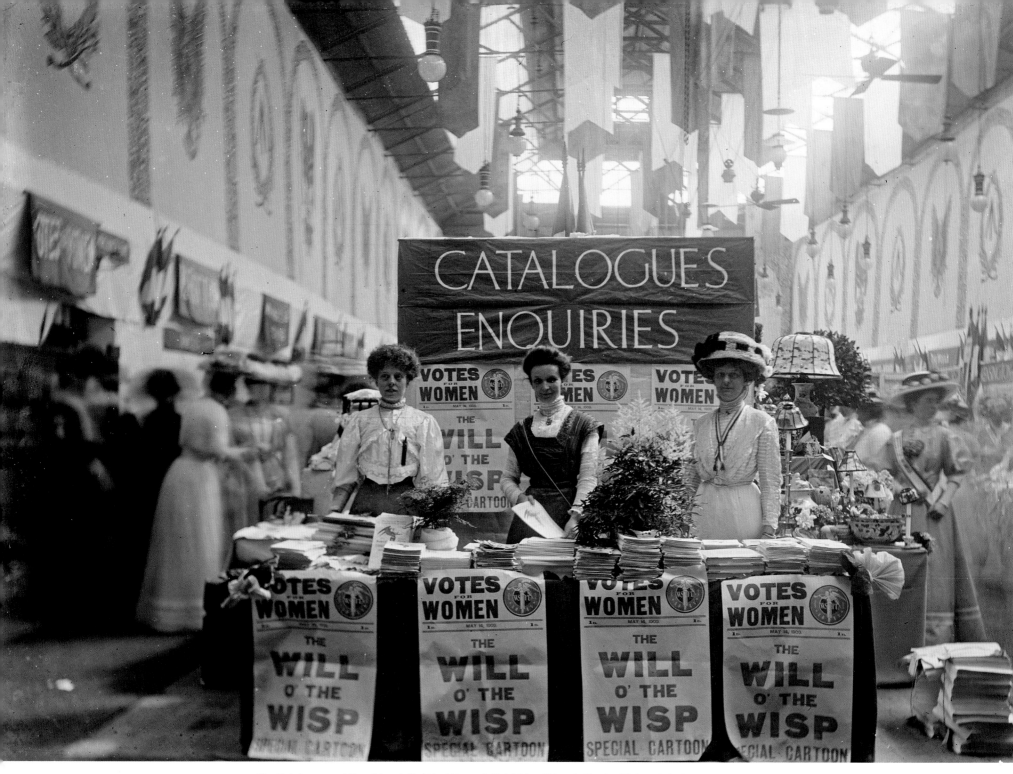

The Catalogue and Enquiries stall at the Women's Exhibition, Prince's Skating Rink, Knightsbridge, May 1909

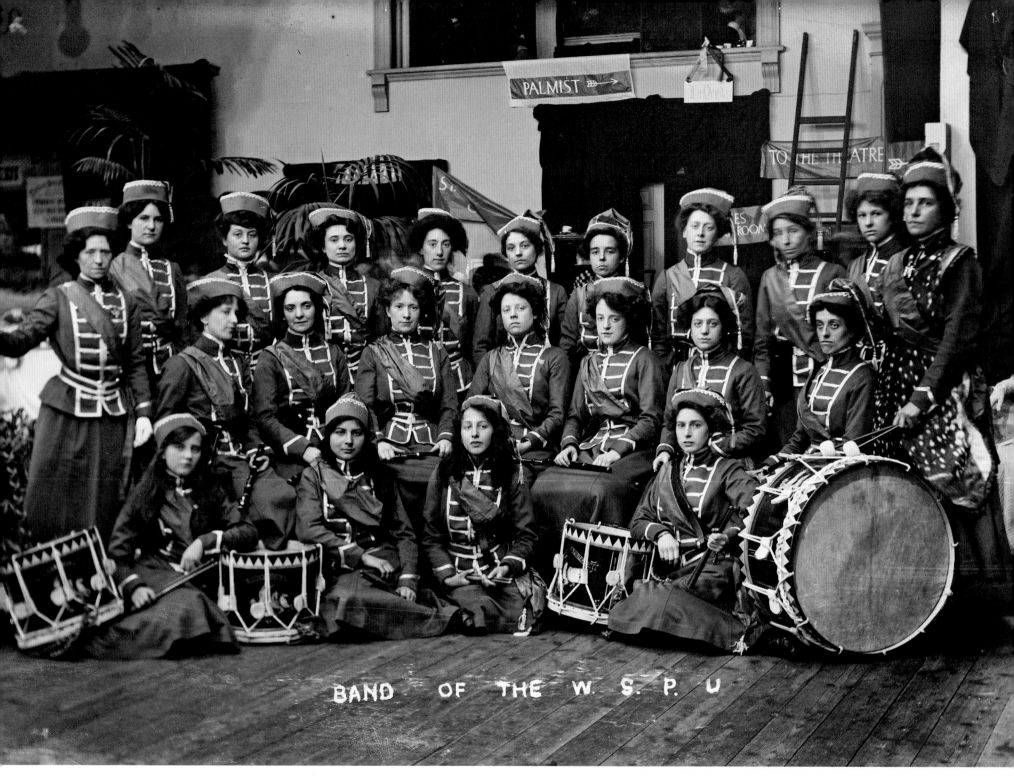

BAND OF THE W. S. P. U

The Drum & Fife Band of the Women's Social and Political Union at the Women's Exhibition, Knightsbridge, May 1909

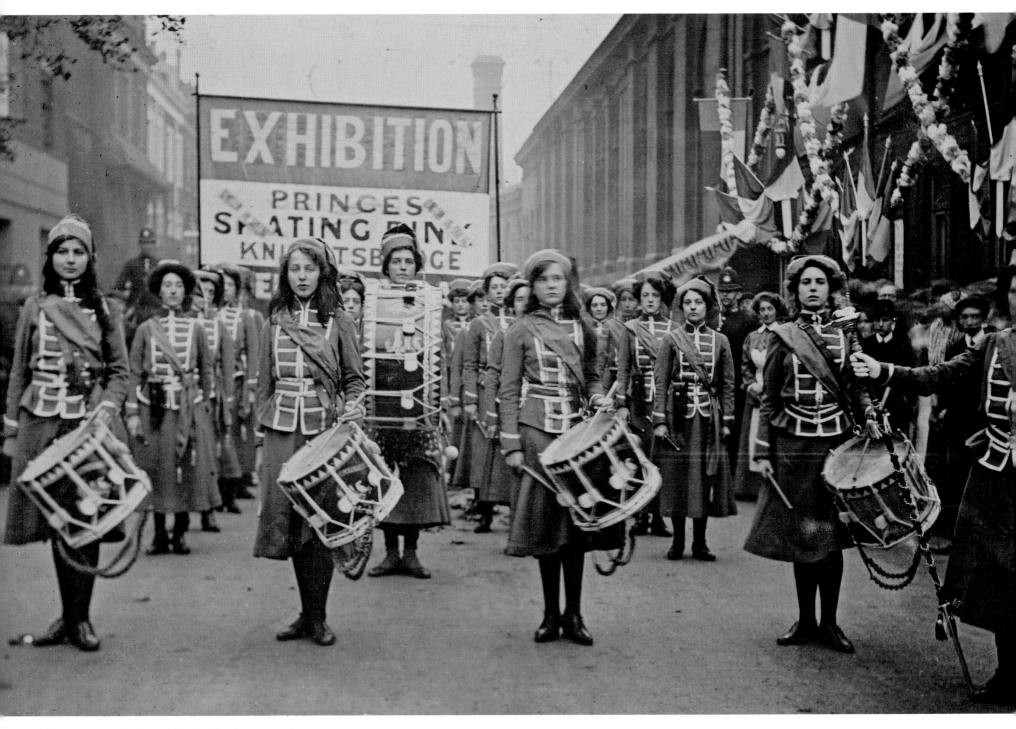

The Drum & Fife Band performing in a procession
to promote the Women's Exhibition, 15 May 1909

The Suffragette leader Christabel Pankhurst at the Women's Exhibition,
Prince's Skating Rink, Knightsbridge, May 1909

EVERY MONDAY
AFTERNOON

COMING JUNE

MISS PANKHURST.

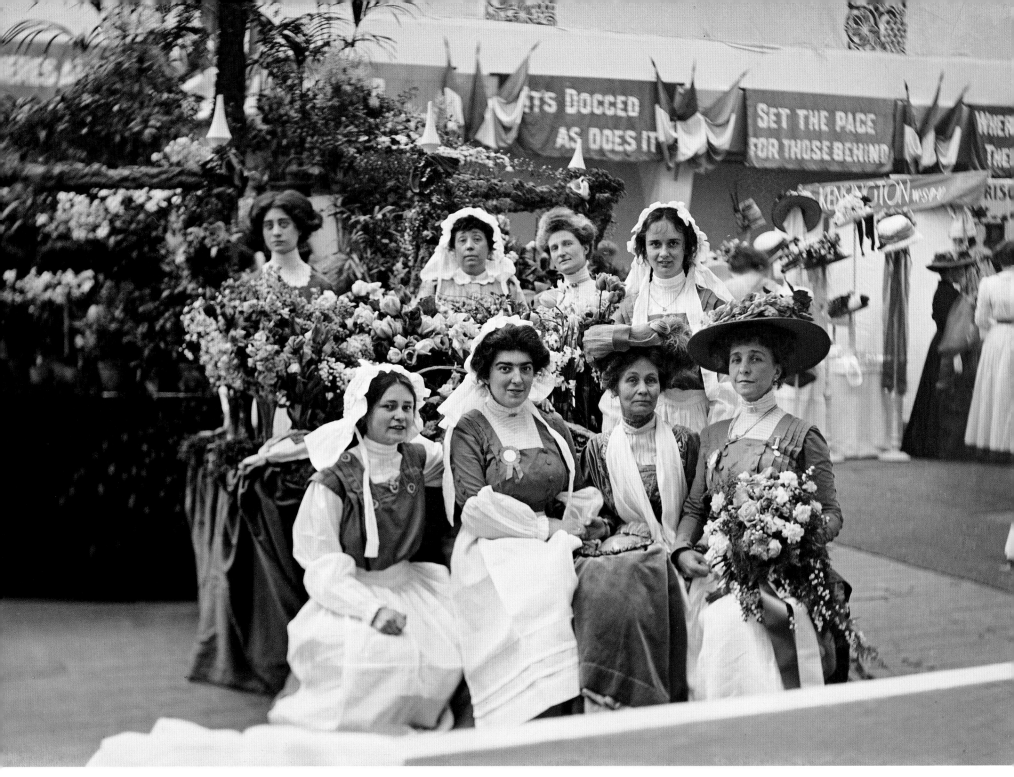

The Suffragette leader Emmeline Pankhurst, (front row, third from left), at the flower stall of the Women's Exhibition, Knightsbridge, May 1909

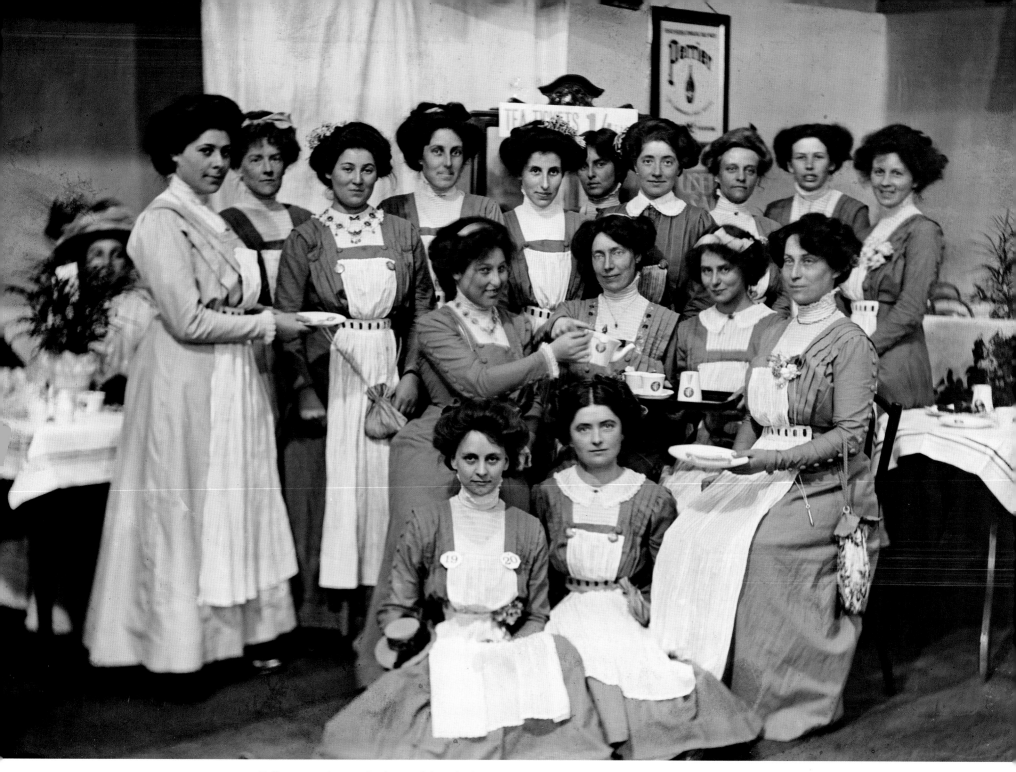

Suffragette volunteers in charge of the refreshments at the Women's Exhibition, Knightsbridge, May 1909

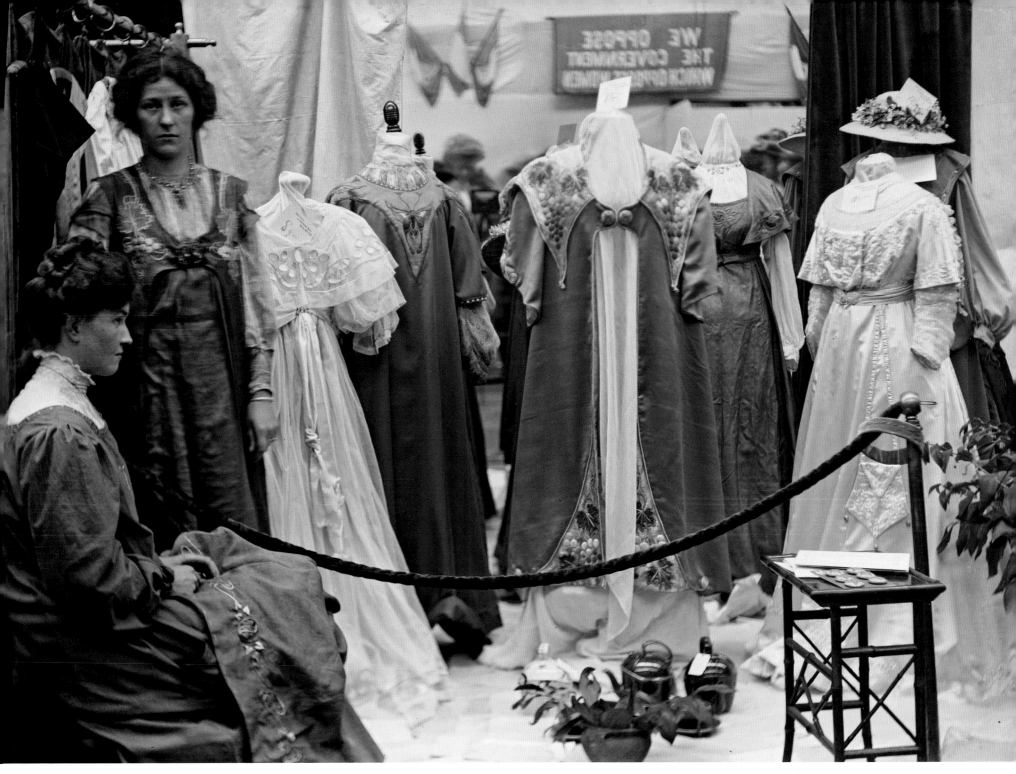

A Suffragette stall with dresses displayed on mannequins. A banner hanging at the back of the stand reads 'We oppose the government which opposes women'

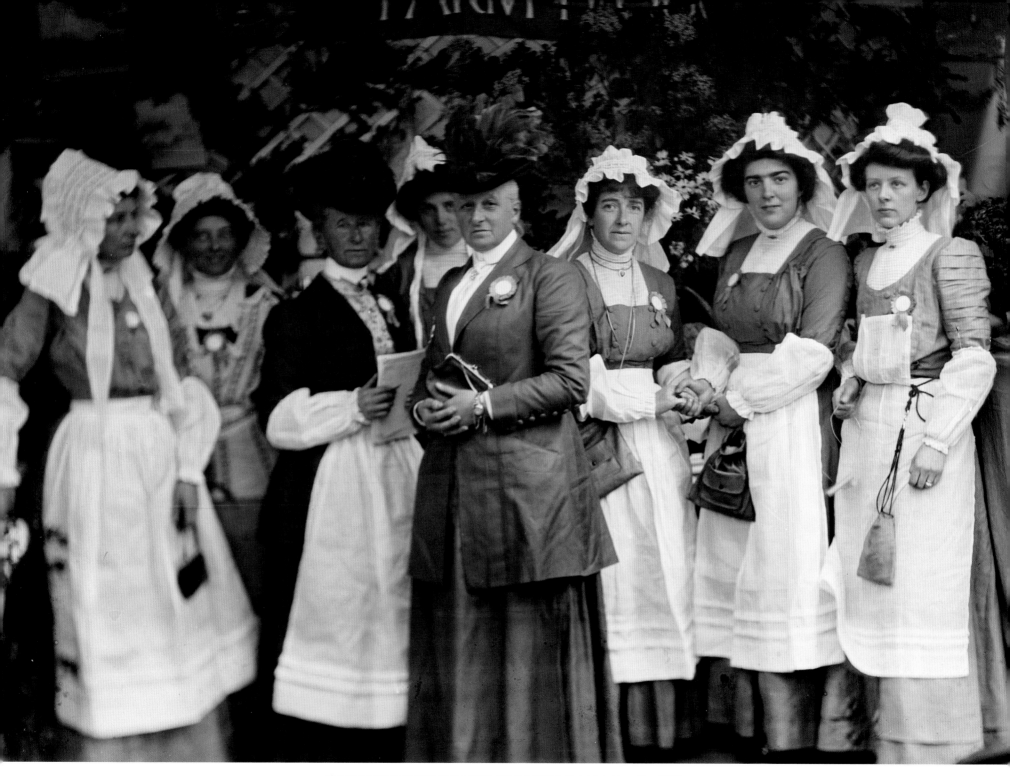

The Farm Produce Stall at the Women's Exhibition, Knightsbridge, May 1909

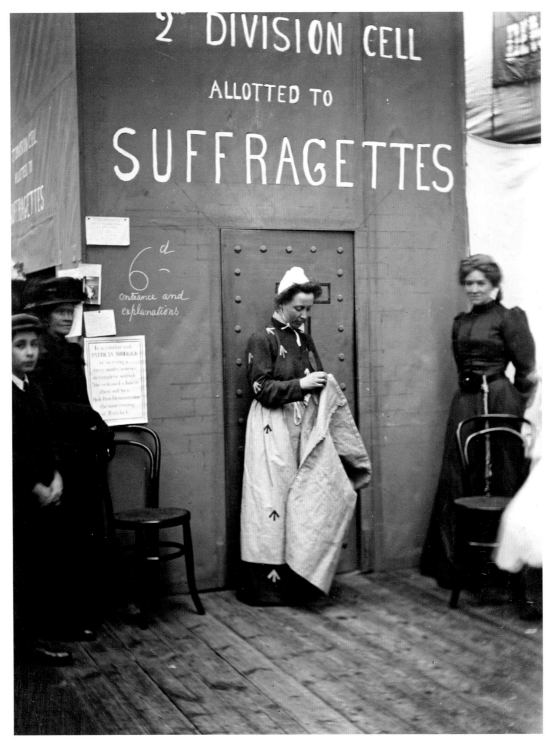

The reconstructed prison cell exhibit at the Women's Exhibition, Prince's Skating Rink, Knightsbridge, May 1909

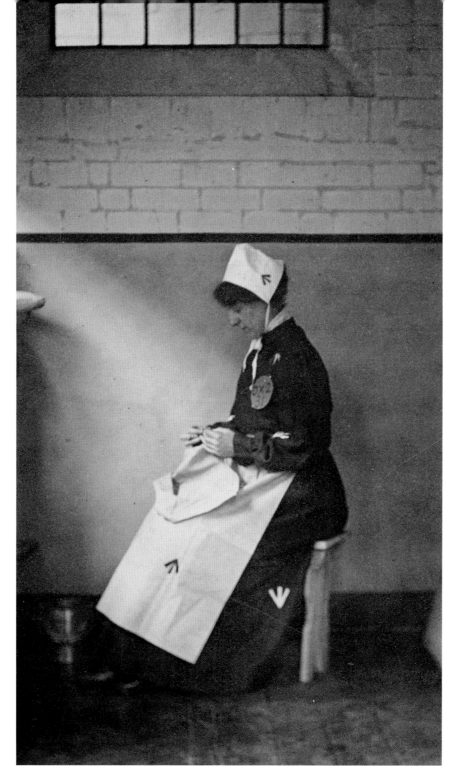

Suffragette Marie Brackenbury dressed in replica prison clothing at the Women's Exhibition, Prince's Skating Rink, Knightsbridge, May 1909

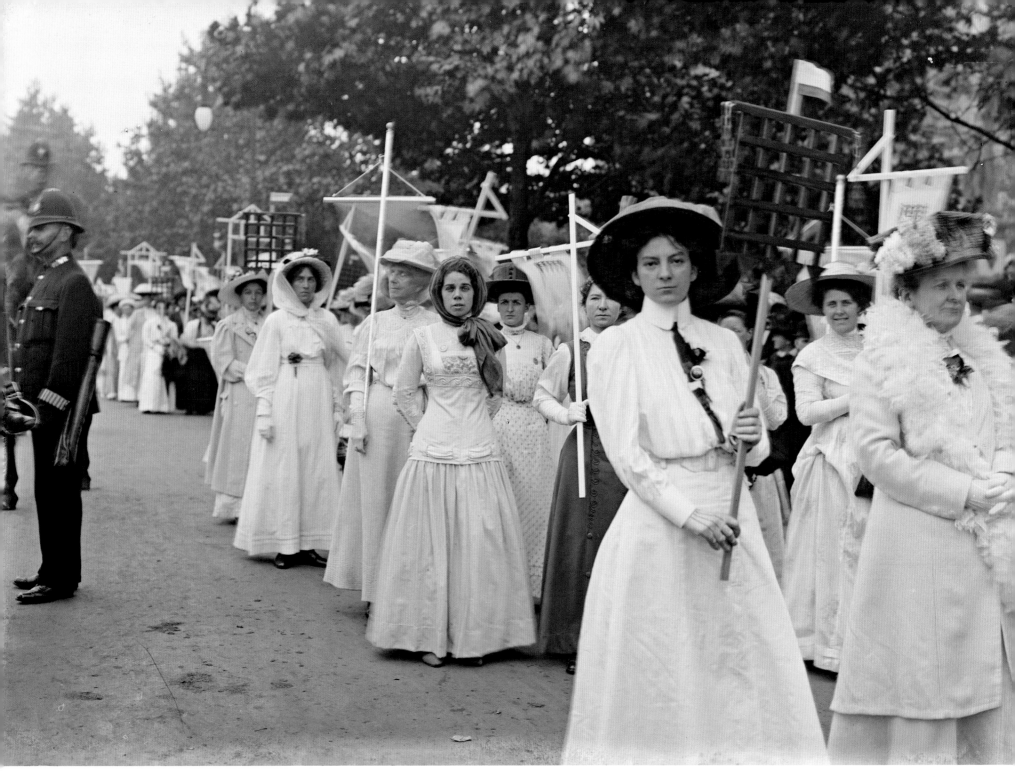

The Prisoners' Pageant section of the Suffragette Procession, 23 July 1910. The Pageant formed the most dramatic section of the procession and included over 600 women who had served terms of imprisonment walking alongside key members of the Women's Social and Political Union

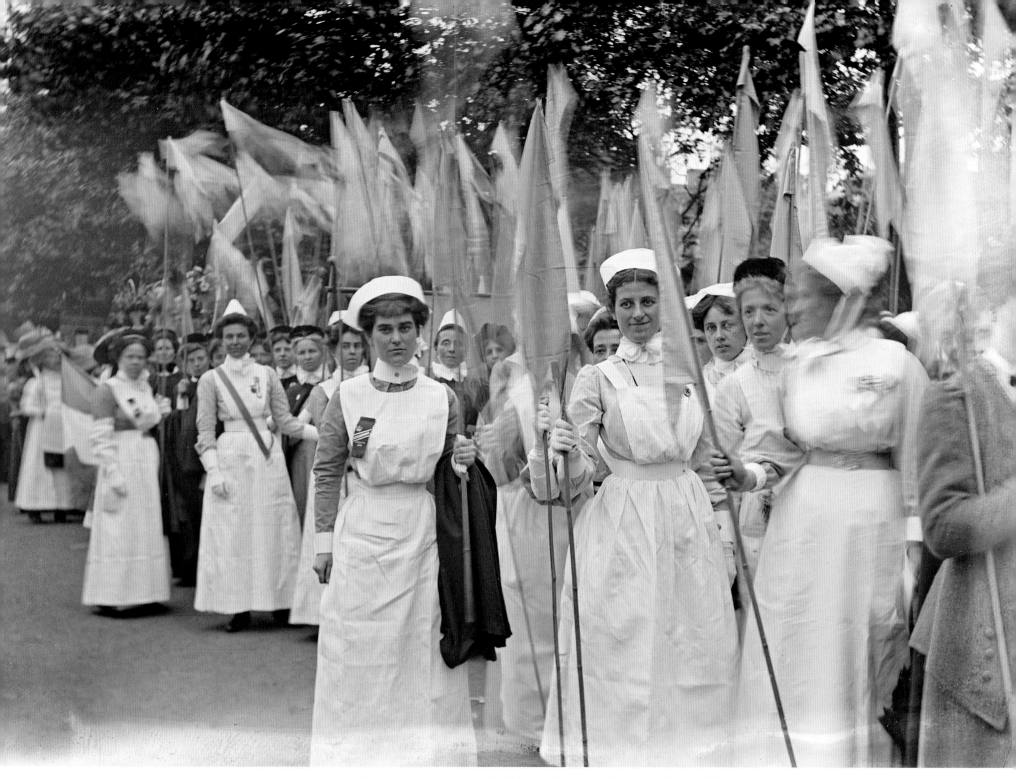

Nurses and midwives prepare to march in the Women's Coronation Procession, 17 June 1911

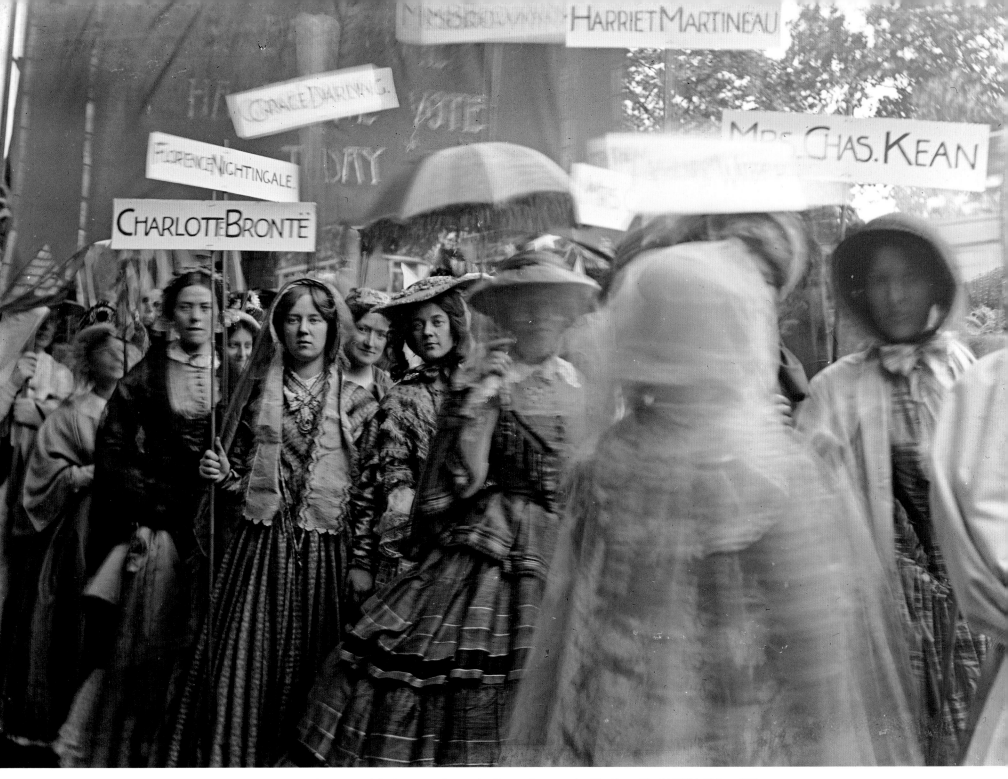

The Historical Pageant of the Women's Coronation Procession organized by the militant WSPU, 17 June 1911

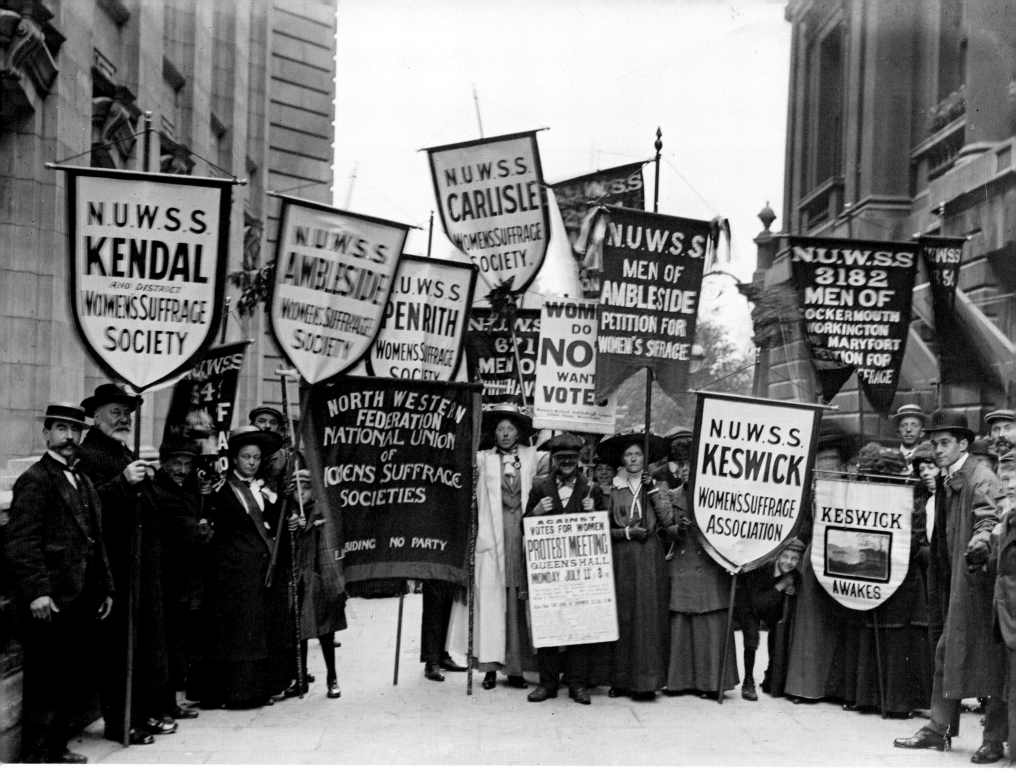

Suffragist pilgrims arrive in London for the Great Pilgrimage of Suffragists organized by the National Union of Women's Suffrage Societies, 26 July 1913

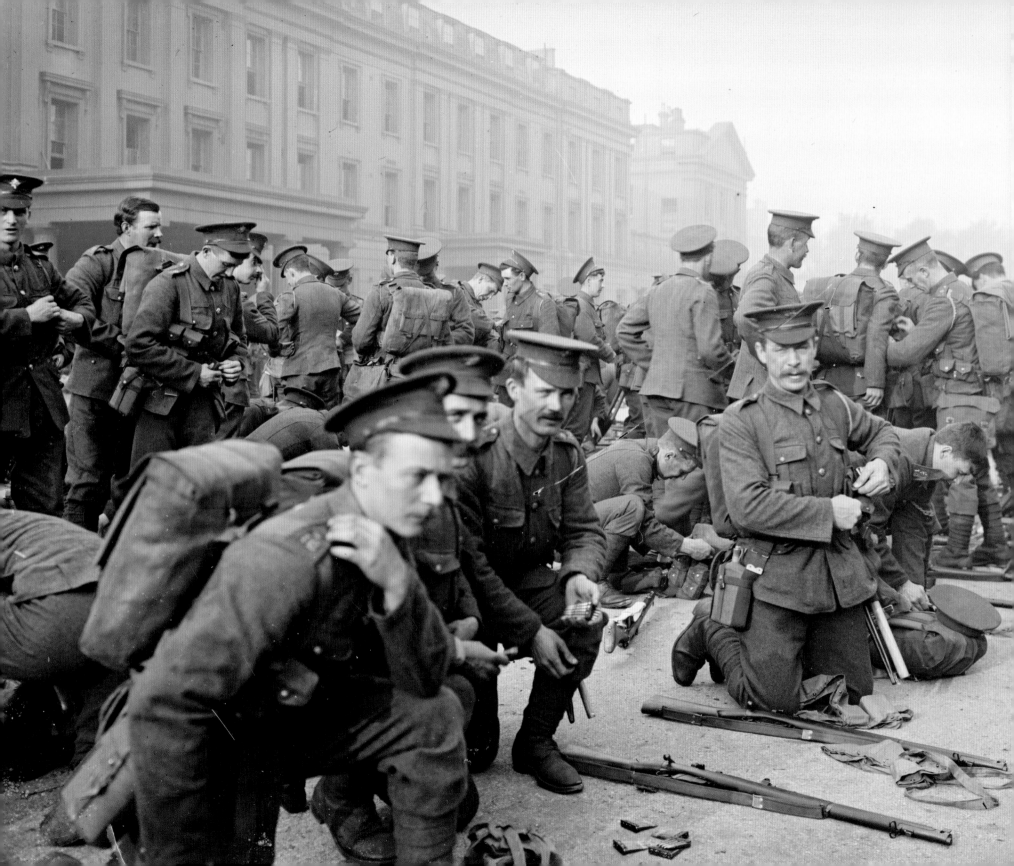

CEREMONY AND SOLDIERING

MRS ALBERT BROOM'S PHOTOGRAPHY OF THE ARMED FORCES IN BRITAIN 1904–1939

Hilary Roberts

PHOTOGRAPHY HAS PLAYED AN IMPORTANT PART in shaping public understanding of the world's armed forces since the mid-nineteenth century. John McCosh (1805–85), a Scottish surgeon and amateur photographer serving with the East India Company's Bengal Army, created what are currently believed to be the earliest photographs of British soldiers between 1843 and 1856, a period which included the Second Anglo-Sikh War (1848–9). Elsewhere, an unknown daguerreotypist photographed American troops during the American–Mexican war of 1846–8. Despite the obvious constraints of early technology, both photographers captured the combination of ceremony and soldiering that forms the essence of military life. Other nineteenth-century practitioners soon followed in their footsteps. Roger Fenton, James Robertson, Felice Beato, Matthew Brady, Timothy Sullivan and Captain Linneaus Tripe photographed soldiers and sailors of various nationalities on and off duty in times of war and peace. However, it was not until the early twentieth century that a female photographer, Mrs Albert Broom, displayed more than a passing interest in photographing the military.

Christina Broom (Fig. 2) worked primarily in the London area as a freelance photographer from 1903 until her death in 1939. Now recognized as the first woman to style herself a press photographer,

Broom submitted news photographs to picture agencies for publication in magazines and national newspapers. However, the core of her business, and the key formative influence on her photography, was the British picture postcard industry, which peaked in popularity between 1902 and 1914. Trading under her married name of Mrs Albert Broom and equipped with a medium-format glass plate camera, Broom developed a low-cost but lucrative style of postcard photography. Street scenes were supplemented by photographs of groups and individuals, shot primarily on location in the open air. Broom's adept stage management, combined with a restrained yet natural empathy for her subjects, resulted in thousands of carefully composed photographs. Despite their prevailing formality, Broom's photographs are consistently revealing and often possess a surprising intimacy.

Christina Broom's technique lent itself to military and ceremonial subjects. In 1904, a chance assignment with the Scots Guards triggered a chain of events which culminated in Broom's appointment as official photographer to the prestigious Household Division, comprising the Brigade of Guards and the Household Cavalry. In her memoir of 1971, Winifred Broom (Christina's daughter and assistant) described the circumstances in which this came about:

Fig. 1 Soldiers of 1st Battalion Irish Guards prepare to depart for France following the outbreak of the First World War, Wellington Barracks, Westminster, London, 6 August 1914

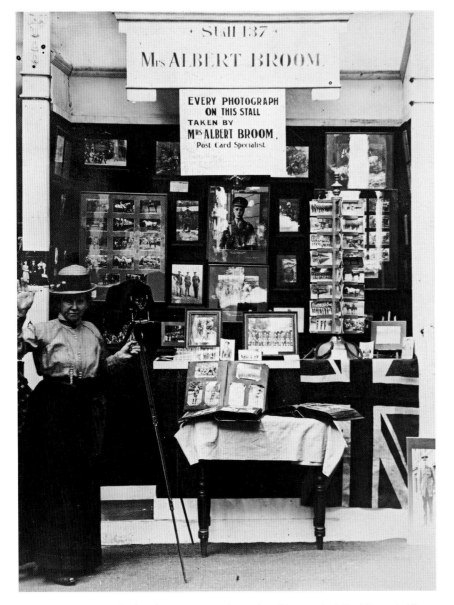

Fig. 2 Mrs Broom displays her camera and samples of her work at the Women's War
Work Exhibition, Knightsbridge, London, May 1916 (Winifred Broom)

My father was permanently injured in an accident, and Mother thought she, being unused to earning a living earlier, would invest in a ½-plate camera, and, learning that stationery shops wanted post-card local views, decided to venture in that line. We went to several districts with good results but – while at Chelsea – we noticed some sports taking place in Burton Court, and a soldier outside invited us to go in and 'watch the fun', giving us a programme. We thought it a chance to test the new camera's shutter for speed, so took some snaps of tug of war, mop fighting. Having already taught myself the mysteries of chemicals etc. (and discharged myself from school as I was 14) I had prints ready next morning. Father said 'They are good' – 'No good at all,' said Mother – 'Shops won't buy these.' 'Why not send them to the head officer – after all, we had no permission – with our apologies?' I said. So Mother did just that – sending them to the Commanding Officer of Scots Guards, Chelsea Barracks. Same day, we had [a] reply: 'Would Mrs. Broom please come and photograph Guard Mounting tomorrow morning!!!'[1]

As Winifred's entertaining memoir makes clear, this first assignment was derailed by her mother's complete lack of familiarity with military procedures and protocol:

Upon arriving at Chelsea Barracks at appointed time, Mother asked the Sergt. On Guard to tell her the procedure of Guard Mounting. He told her 'men would form up, Officers would Inspect', – and pointed to [a] place on [the] parade ground. So she fixed the camera on [the] tripod, and waited on the ground indicated. The bugle sounded, the men 'fell in', and Officers came, inspected, then walked up and down – Mother waited. Suddenly the Officers took their places – and all marched off! – Mother still waiting. Sergt. On Guard sent a

man to enquire if she had 'finished' – Mother said 'No, because the Officers had not stood still, but I suppose they will all be back in a minute!!!'[2]

Despite this inauspicious beginning, Christina Broom was allowed to return and quickly established a working commercial relationship with the officers and men of the Household Division which endured until her death in 1939. The value of this relationship with the Division was recognised and sanctioned at the highest level:

Several months later, The Irish had a General's Inspection. I told Mother I was sure it was Lord Roberts VC[3] so Mother did not get too close with the camera – we did not wish to be in the way. After parade was dismissed, Lord Roberts, with two Officers, walked over to Mother – 'Mrs Broom?' 'Yes, My Lord. I hope my camera was not in your way?' 'Mrs Broom, you are taking good photographs which you sell amongst the men at 2d. each, with an envelope so they can enclose a letter when they write home, and their relatives see men well fed, well shod, and happy. I have prayed and begged for recruits, and now the 3rd Scots and the Irish Guards, are suddenly flooded with recruits from their homes.' Turning to the Officers, he added: 'Gentlemen, where our prayers failed, these two women have shown us the way – I shall tell the King!'

Roberts's endorsement to King Edward VII enabled Christina Broom to obtain unique and preferential access not only to the Household Division but also to the Royal Mews and members of the Royal Family. By the standards of the day, this was truly exceptional and, more than a century later, still seems surprising given the prevailing attitudes of the time.

Prior to the First World War, the general attitude of the British Army and Royal Navy towards civilian photographers ranged from a wary suspicion in peacetime to a deep hostility at times of open conflict. Photographers were a nuisance at best. At worst, they were a security hazard which threatened the armed forces' ability to carry out their duties. As I have written elsewhere, when it came to photographers in the war zone:

The adverse experience of the Crimean War (1853–1856), which was the first war to be publicly reported in detail as events unfolded, had reinforced a general military aversion to wartime publicity and a reluctance to publish campaign information unless absolutely necessary. Graphic images showing American Civil War casualties after the Battle of Antietam in 1862, which were publicly exhibited in New York by Matthew Brady (1822–1896), strengthened a particular bias against photographers. Consequently, the practice of photography for propaganda and public information purposes was not included in the remit of military photographers and professional civilian photographers were barely tolerated either on the battlefield or on board ship.[4]

Christina Broom was not a combat photographer, nor one who aspired to work in war zones. Nevertheless, as Winifred's memoir repeatedly confirms, she and her daughter were always careful to respect military priorities, particularly when working in barracks or other military establishments. This respect formed the basis of the rapport which Broom developed with the Household Division in the years leading up to the First World War.

A key requirement of any photographer who works with the British armed forces is the ability to work equally well with all ranks, regardless of seniority, status or role. Christina Broom bridged these divisions extremely well. Her strong personality and ability to communicate at every level enabled her to negotiate entrenched social and military protocols and transcend early twentieth-century

barriers of gender and class. It is noteworthy that Broom was photographing the pre-war women's suffrage movement (including Suffragette protests and the increasingly controversial Pankhurst family) at the same time that she was photographing what was very much the British establishment, albeit in a military setting.

It is clear that Christina Broom succeeded in ensuring that she was regarded first and foremost as a professional photographer, rather than a woman operating in an exclusive and male (or female) environment. In an endorsement of Broom's work, written shortly after her death in 1939, Brigadier-General G. C. Nugent wrote:

> When I was Brigade-Major, Brigade of Guards, I had many dealings with her and I always found her an admirable worker, and a charming personality to deal with.[5]

Broom's gender is barely acknowledged in Nugent's endorsement, which is in itself a testament to her professionalism.

Then, as now, the elite Household Division was regarded as the public face of the British Army and a bastion of tradition. Its unique role as the Sovereign's official body guard dates back to the reign of King Charles II, and many of its ceremonial duties do too. The British Army's explanation of the continuing importance of the Division's ceremonial role in 2014 was equally valid in 1904:

> A key defence output, and one of the Army's Standing Tasks, Public Duties and State Ceremonial form part of the 'fabric of the nation'. For a country with global interests, these roles offer a powerful symbol of our operational military heritage, whilst enhancing the standing of the Sovereign and the Nation before national and international audiences.[6]

Broom's photography of the Household Division's ceremonial duties conformed to these requirements. She highlighted the spectacle

of the occasion as well as the Division's military excellence, dignity and discipline. Her photographs reflect the fact that she was often required to work at a distance, using a tripod and without the benefit of long-range lenses, while her cumbersome equipment, which was not optimized for press work, struggled to portray subjects in motion. Nevertheless, her most successful photographs do full justice to pre-war military ceremonial while also humanizing the men involved. A beautifully composed group of Life Guards in full dress uniform at Regent's Park Barracks (Fig. 3) is made all the more striking by the fact that one man has removed his plumed helmet, allowing us to see his face.

Although the importance of the Household Division's ceremonial role was clearly acknowledged at the start of the twentieth century, its effectiveness as an operational unit was under review in the aftermath of the Second Boer War in South Africa (1899–1902). Despite the undoubted courage of officers and men, the Division's general performance in the Boer War, like that of the British Army as a whole, had highlighted serious shortcomings which needed to be addressed. Morale was also a problem. The war had undermined the faith of soldiers in their generals. In his history of the Household Cavalry, Barney White-Spunner writes:

> By 1902 the only generals held in any respect in both the Household Cavalry and The Royals were French and Haig. This air of cynicism was to pervade the 'Old Contemptibles' as they struggled to cope with the German advances into Belgium and France twelve years later.[7]

The start of Christina Broom's association with the Household Division therefore coincided with the start of a period of significant change for the Household Division. Between 1904 and 1914, as White-Spunner points out, measures were introduced which were intended to modernize and strengthen the Division's operational role while

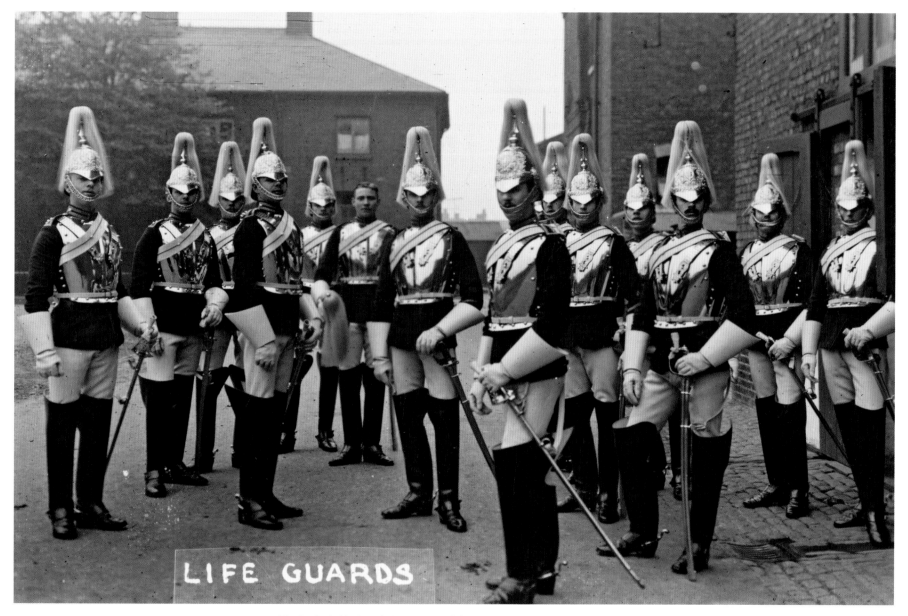

Fig. 3 2nd Life Guards in ceremonial dress at Regent's Park Barracks, 1909

preserving the essential elements of its ceremonial role:

The Boers' use of artillery and the effect of their rapid, if inaccurate, rifle fire, however, augured a new way of fighting, which others recognised; the new Cavalry Drill Book, produced in 1904, confirmed that 'instead of the fire-arm being an adjunct to the sword, the sword must become an adjunct to the rifle'. More horrifying to many, khaki permanently replaced scarlet, except for ceremonial parade use.[8]

It is arguable that this climate of change and modernization facilitated Christina Broom's pre-war access to the Household Division, which was rendered more amenable to the consideration of new ideas at this time. While her pre-war photography of the Division's non-ceremonial activities offers little sense of these

changes, they are very apparent in her photograph of a dismounted draft of The Blues and Royals, recorded shortly before they left London for the Western Front to fight as an infantry unit in the trenches c. 1915 (Fig. 4). Dressed in khaki and deprived of their horses and spurs, the troopers appear ill at ease on foot. Their cavalry swords offer an incongruous and somewhat defiant visual reference to their true identity as a cavalry unit and a poignant reminder of past glories.

Broom came to know the officers and men of the Household Division extremely well. They were a complex social mix, united by their pride in their regiment. While the majority of the Division's officers were drawn from the extended Royal Family and upper echelons of British society, the men they commanded came from very different backgrounds. In the Household Cavalry, for example:

Although there were still a few relatively wealthy 'gentlemen rankers', commercial opportunities in Edwardian England were such that most troopers tended to come from relatively poor backgrounds, like Cusack, the so-called conscription of hunger. The average officer had a private income and had possibly been raised on an estate where his chief interests were horses and hunting. Well intentioned as Cardwell's reforms had been, forty years later cavalry officers were from much the same background as they had been in 1870 and in relatively the same financial situation. A lieutenant in 1910 was, for example, only paid £230 a year, and the average mess bill … came to nearly £300. However, many troopers were from agricultural backgrounds too, and once they and the officers had been through the rigours of riding school together, social barriers broke down, at least to a degree.[9]

By 1914, the Household Division, like the rest of the British Army, was a highly efficient professional force formed of volunteers. Its primary function was to defend Britain and its vast Empire in minor

Fig. 4 A Cavalry draft. Blues and Royals dismounted, 1915

colonial wars. In comparison to European armies (most notably that of Germany), the British Army was a small force. The Royal Navy, and sea power, formed the mainstay of British military power. In 1909, Christina Broom photographed HMS *Dreadnought* off Southend during a royal review of the Fleet staged for King Edward VII and his guest, Tsar Nicholas II of Russia (Fig. 5). For Broom, this was a rare but important departure from her usual pre-war fare of ceremonial and soldiering. HMS *Dreadnought*, a revolutionary warship launched in 1906, had triggered an international arms race, thereby fuelling the tensions which would culminate in the outbreak of the First World War in 1914. In stark contrast to her usual focus on people, Broom's camera concentrates on the ship itself in an effort to convey its power and importance. The few people who appear in her shots are dwarfed into insignificance.

In the context of her work with the armed forces, Christina Broom's pioneering achievements as a photographer and woman are undoubtedly exceptional. But what is the enduring value of these photographs? It could be argued that her pre-war photography of the British armed forces was often static and formulaic. However, this criticism is less applicable to her wartime photography, which documents a world in upheaval. Her coverage of the Division as it mobilized for war in August 1914, amid the patriotic fervour then sweeping the country, is strikingly restrained (Fig. 6). Her photographs of the Division preparing to leave for France capture a grim urgency as men gather their equipment and assemble for departure (Fig. 1, p. 86). By this time, Broom had worked with these soldiers for ten years. For her, this was not only a professional assignment, but a personal farewell to men she knew well and, in many instances, would not see again. White-Spunner notes:

The Old Contemptibles, as the British Expeditionary Force that embarked for France in the baking sunshine of August 1914 were called, were probably the most efficient force Great

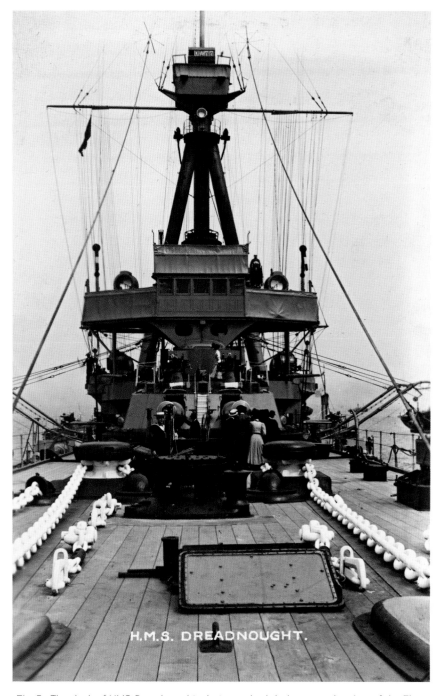

Fig. 5 The deck of HMS *Dreadnought*, photographed during a royal review of the Fleet off Southend, 1909

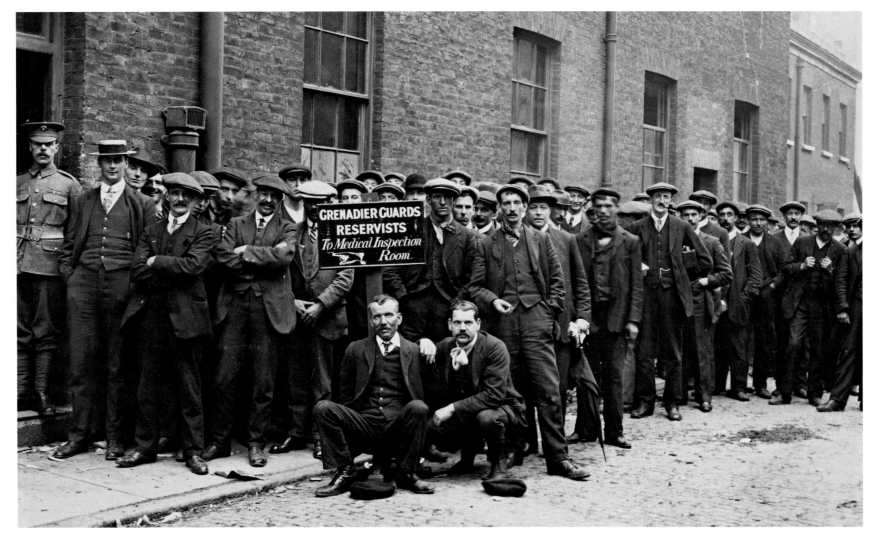

Fig. 6 Reservists of the Grenadier Guards queue for a medical inspection while re-enlisting following the outbreak of war, Wellington Barracks, Westminster, London, 5 August 1914

Britain has ever assembled and they were self-confident. They consisted, wrote John Buchan, of 'perhaps the most wonderful fighting men that the world has seen. Officers and men were curiously alike. Behind all the differences of birth and education there was a common temperament; a kind of humorous realism about life, a dislike of talk, a belief in inherited tradition and historical ritual.' None of them that summer could believe that the war to which they were deploying would last five long and

bloody years, and would change for ever their 'ordered past' as Julian Grenfell succinctly described the first decade of the twentieth century.[10]

Six months later, virtually all the soldiers photographed by Broom in August 1914 were dead, maimed or imprisoned. In many instances, a poignant record of their fate, carefully documented by Winifred Broom, can be found on the reverse of prints now held by the

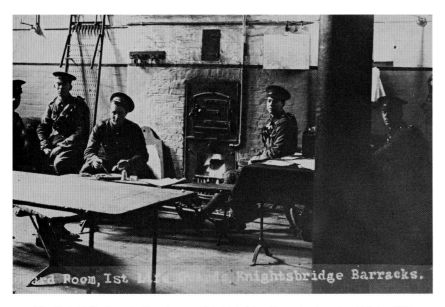

Fig. 7 1st Life Guards Guardroom, Knightsbridge Barracks, London, Winter 1915

Museum of London and the Imperial War Museum.

The exigencies of war all but eliminated Christina Broom's ceremonial photography and took their toll on both her health and her income. Broom, no longer a young woman,[11] was confined to a wheelchair for some time in 1915, a likely consequence of constantly lifting heavy photographic equipment. However, she continued to work undaunted. Her coverage of wartime events in London and the impact of war on the Household Division now constitutes an important historical record. Her camera captured the expansion of the Household Division and the influx of new recruits, many of them conscripts, camped in and around the London area (Fig. 7 and Fig. 8). A photograph of a Guardsman's equipment in barracks (Fig. 9) was, in all probability, the outcome of a Divisional request to provide a visual reference for new recruits.

A rare wartime letter, written to her daughter after a visit to

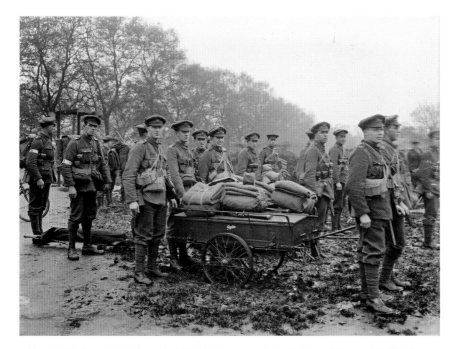

Fig. 8 Soldiers of the Household Battalion, a special infantry unit formed in 1916 from Household Cavalry reserves, assemble for draft in Richmond Park, Surrey, shortly before deploying to the Western Front, November 1916. The Battalion was virtually decimated during the Battle of Passchendaele in 1917 and was disbanded soon afterwards

Fig. 9 An Irish Guardsman's kit laid out for inspection, Wellington Barracks, First World War

one of the Household Division's camps near Brighton in June 1917, provides evidence of the continuing bond between Christina Broom and the soldiers as well as the demands on Broom herself:

My Dear

Am so hot, the Camp very much like Aldershot, blazing sun. The bhoys [*sic*], Grenadiers. Irish, Scots, Welch, Coldstream, a few Life Guards, Horse Guards and many other regs all mixed up in different Companys all over the place, cab from Station, walk back.

Glad I have been, all so very pleased to see the old woman and would I bring the camera. Am now going back to B and hope to get something to eat.[12]

Broom's photography of other key wartime events in the London area is both expressive and informative. In 1916, she documented the mobilization of women to the war effort. A group of women police officers (p. 212), photographed at an exhibition of Women's War Work in 1916, present an undeniably formidable appearance. This photograph makes a clear point about these former Suffragettes who had abandoned their violent political protest of the pre-war years to become dignified, disciplined upholders of the law in wartime Britain. In contrast, a photograph showing a group of Women's Volunteer Reserve signallers (p. 213) conveys a sense of amateurish enthusiasm. Broom avoids any suggestion of freakishness in a poignant image of two convalescent Anzac servicemen, with one leg between them, photographed in London on a rainy day in 1917 (Fig. 10). Welcome and

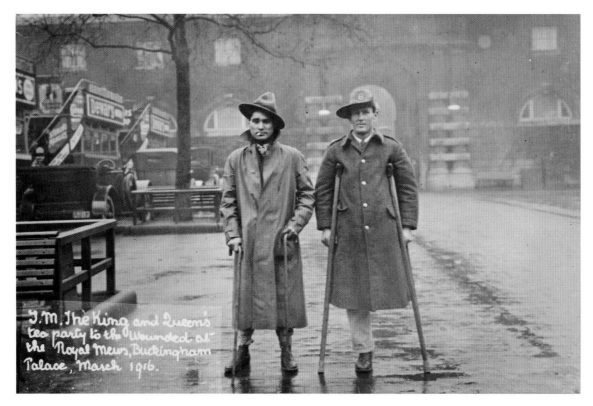

Fig. 10 Two Anzac soldiers, both amputees, with one leg between them, London, c. 1917

Fig. 11 Sombre crowds gather outside Buckingham Palace on Armistice Day, London, 11 November 1918

relief are inherent in Broom's depiction of the massed ranks of fresh-faced American troops at lunch soon after their long-awaited arrival in Britain (p. 160). Her final photograph of the war, showing sombre crowds assembled outside Buckingham Palace on Armistice Day in November 1918, is strikingly funereal (Fig. 11). Rather than celebration, the photograph is suggestive of public war fatigue and personal loss. Broom's photographs go on to capture the Division's transition from war to peace and the resumption of ceremonial duties.[13] The dedication of memorials to the Division's dead, many of whom were known personally to Christina Broom, form a moving footnote to her coverage of the First World War.

Christina Broom continued to photograph the Household Division after the war, although there is a clear sense that the relationship was winding down as a consequence of her advancing age and the

changing times. In 1930, her relationship with the Royal Mews came to an abrupt end following a complaint from a visiting member of the public,[14] but she continued to photograph the Guards and Household Cavalry in other locations until her death on the eve of the Second World War. Winifred Broom (who was left without an alternative source of income) applied to continue her mother's work but was thwarted by the newly established Ministry of Information:

> After Mother died, in 1939, I sought permission from the Colonel of the Senior Regiment, 1st Life Guards, Col. E. Brassey, to carry on with the work, which was granted, but the newly-formed Ministry of Information, under Sir Stewart G. Menzies, formerly in 2nd Life Guards and knew me, told me I would have to delete all backgrounds on negatives, send them prints, and wait at least three months before I could print copies for the troops – which would have been useless for my customers, who were used to overnight prints to send to families before they left for the front line. Moreover, the camera needed repairs, and my dealer told me that the Ministry of Information had acquired services of all repairers and bought up best cameras, all plates and chemicals![15]

The Brooms' 35-year association with the Household Division was therefore at an end. It has never been replaced and remains a unique period in the Division's history. The British Army's own professional photographers assumed responsibility for photographing the Division's personnel and activities in 1940.

A sense of how Christina Broom's role has evolved over the past 70 years is conveyed in Leigh Hamilton's 2012 interview with Staff Sergeant Steve Hughes, Royal Logistic Corps:

> MOD employs civilian and military photographers from all three Services who capture stills and video of the full range of activities undertaken by Defence personnel; from operations overseas and training exercises to homecoming parades and ceremonial events.

One of the 39 professionally trained Army photographers is Sergeant Steve Hughes, who is currently posted to Headquarters London District.

Having taken stills in Kosovo, Iraq, Northern Ireland and Afghanistan, he is now responsible for capturing images in London of visiting dignitaries and ceremonial events involving the Royal Family, which, as he explained, is a completely different take on the job than he had experienced previously:

'Within a month of being here, I've photographed most of the Royal Family, a lot of MPs and celebrities, and I hadn't done any of that in the previous six years of being a photographer.

'But with the glamour of being based in London also comes a lot of hard graft.

'A lot of people say "oh, you're a photographer, that's a cushy job isn't it?" but you really do work hard,' he said.

'For instance during the Remembrance weekend, I worked long hours and would be in the office until midnight sometimes in order to sort through all the images. Having said that, I really enjoy being a photographer. It has got to be the best job in the Army, without a doubt.'[16]

Christina Broom's pioneering legacy of military photography is now preserved by the Museum of London and the Imperial War Museum, where it is consistently accessed by researchers and lovers of photography. Examples of her work appear in new publications every year, and her memory is cherished by the Household Division. For the current generation of male and female military photographers, Christina Broom provides an enduring role model.

BEWARE! ENGLAND IS NOT ASLEEP.

ROOM. 1433.

The copyright in this photograph of a lion in a zoo enclosure was purchased by Broom in the early days of her business. She published it then with the addition of the caption. Broom reissued it at the onset of the Great War

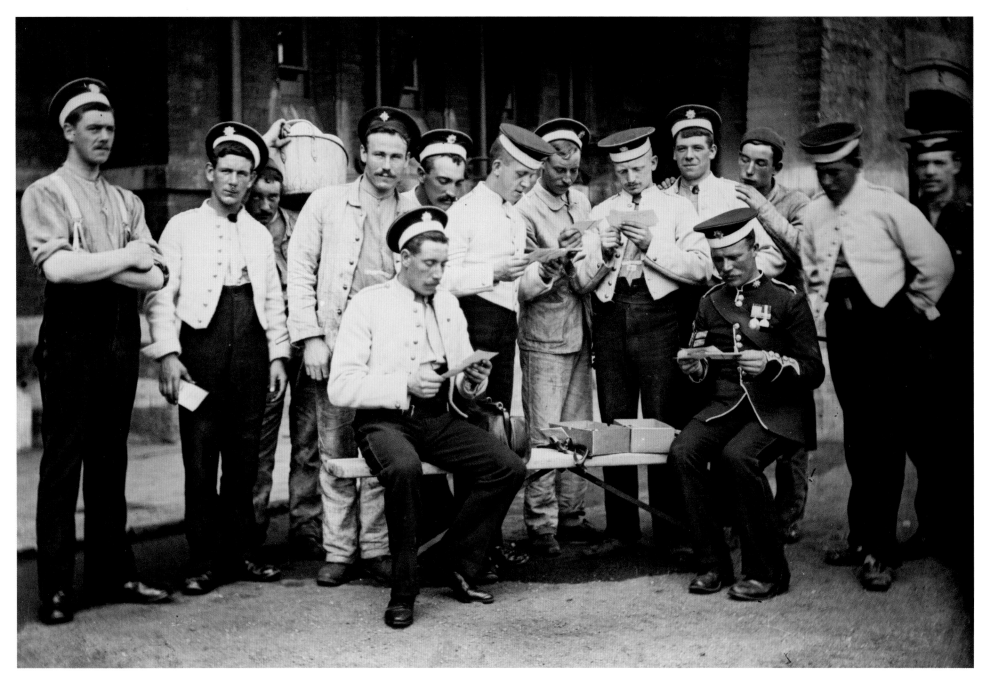

Coldstream Guards looking through Mrs Broom's postcards, Chelsea Barracks, 1906

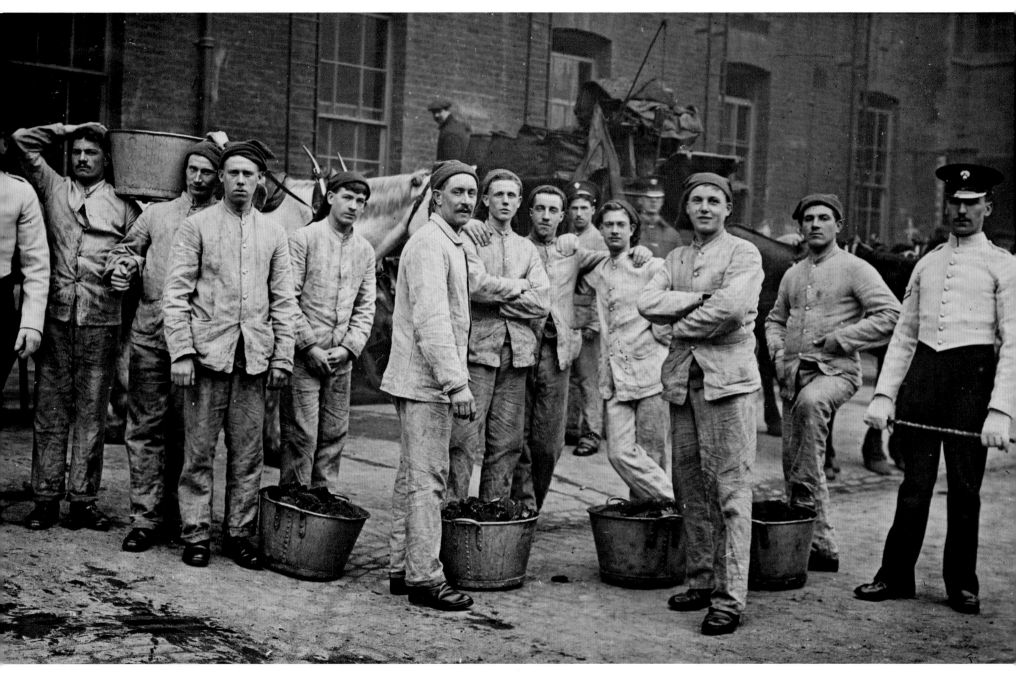

Grenadier Guards pause for the camera while moving coal, Wellington Barracks, c. 1904

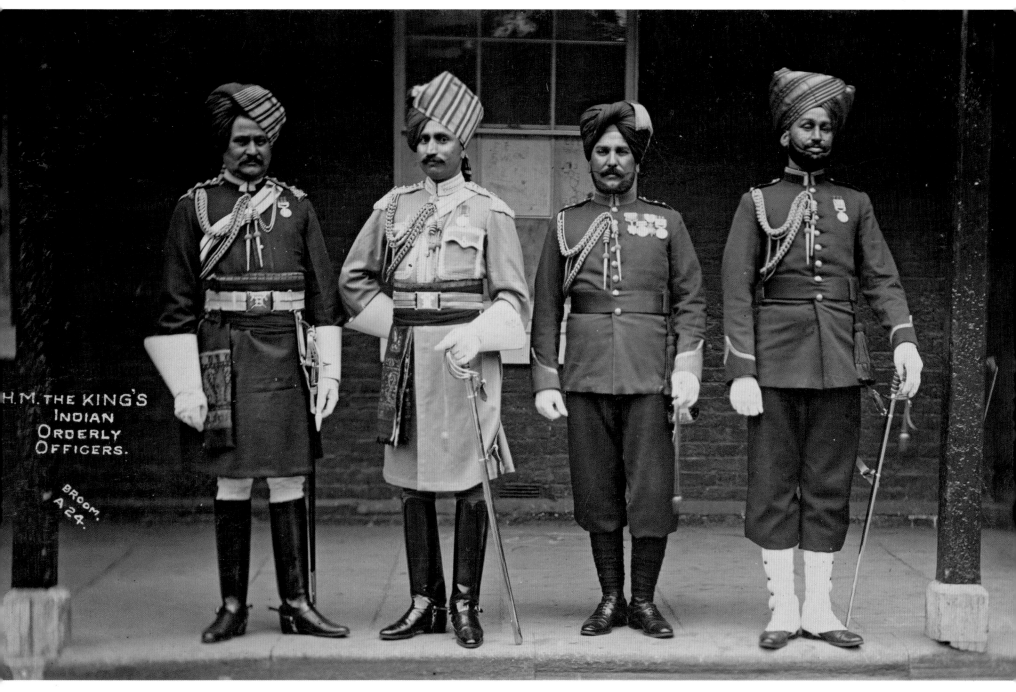

H.M. THE KING'S INDIAN ORDERLY OFFICERS.

BROOM. A 24.

Four King Edward VII Indian Orderly Officers, Royal Mews, c. 1905

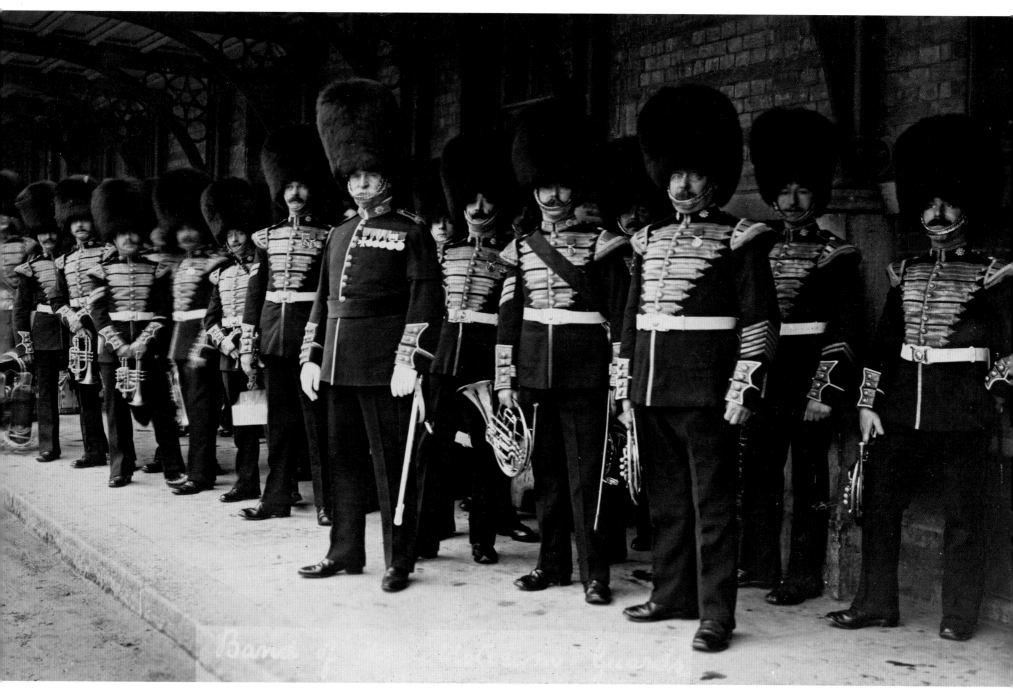

Lt. Mackenzie Rogan, Director of Music, with the Coldstream Guards band, Chelsea Barracks, c. 1905

14TH BATTN. COUNTY OF LONDON (LONDON SCOTTISH.)

14th Battalion London Scottish at Herne Hill in Brockwell Park surrounded by children, 1907

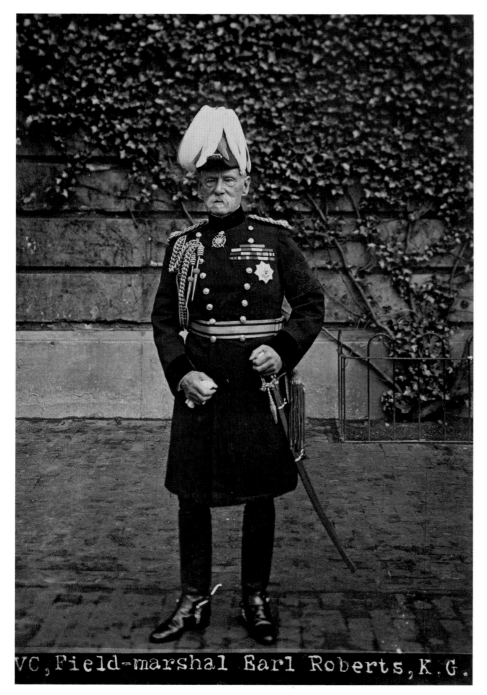

VC, Field-Marshal Earl Roberts, KG, c. 1908

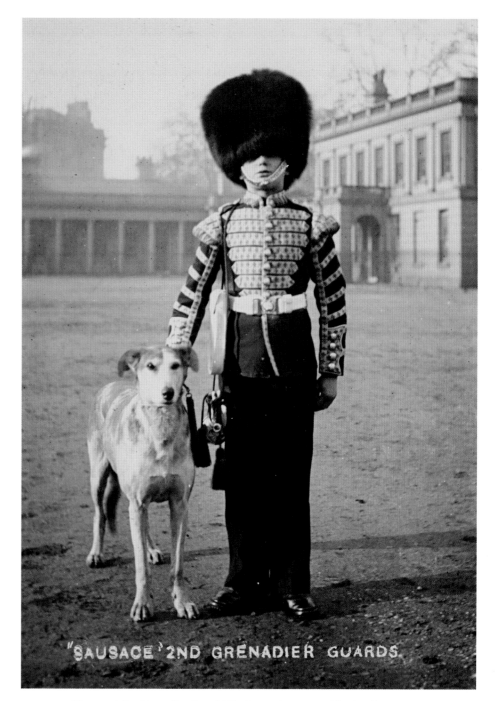

'Sausage', the Grenadier Guards' Regimental mascot with a bugler,
Wellington Barracks, 1908

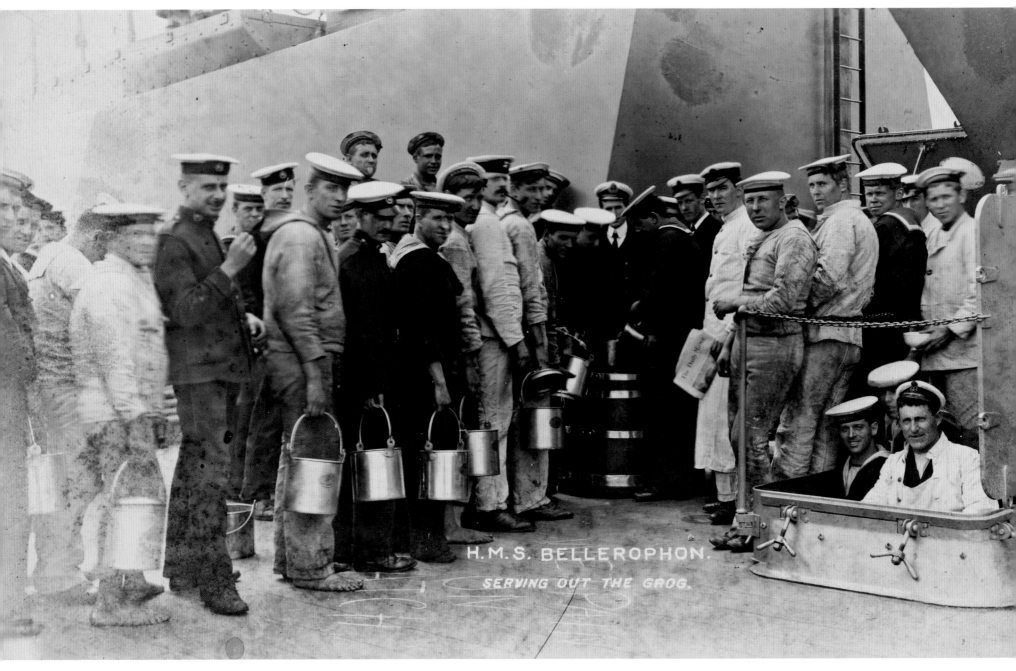

H.M.S. BELLEROPHON.

SERVING OUT THE GROG.

Sailors on board HMS *Bellerophon* after inspection by King Edward VII, Southend, 19 July 1909

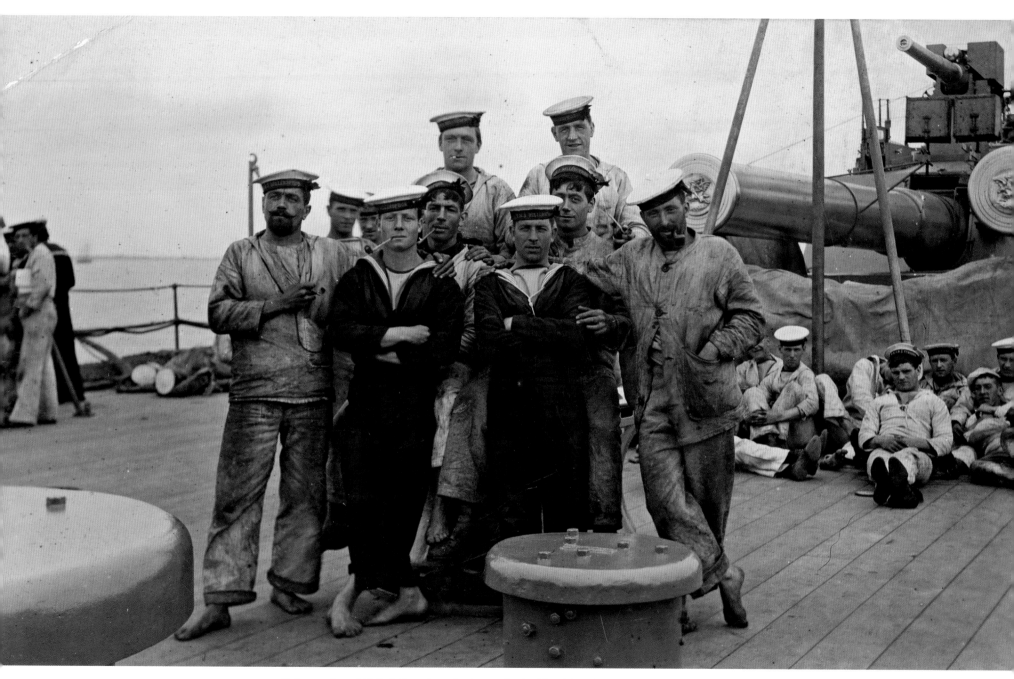

Sailors on board HMS *Bellerophon* after inspection by King Edward VII, Southend, 19 July 1909

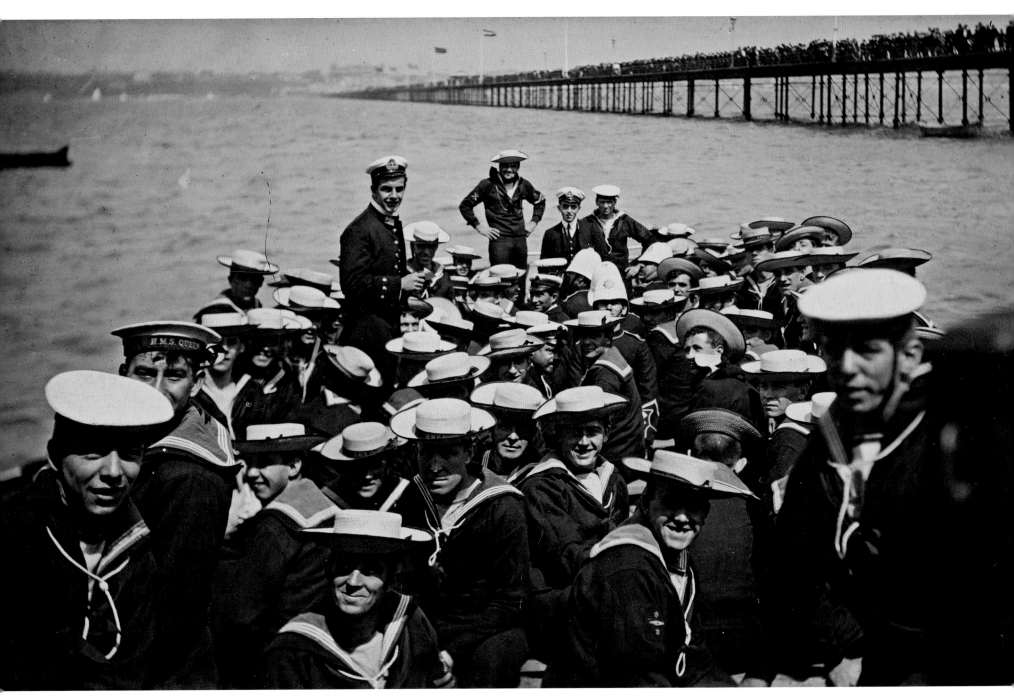

Sailors from HMS *Queen* on board a boat to shore, July 1909

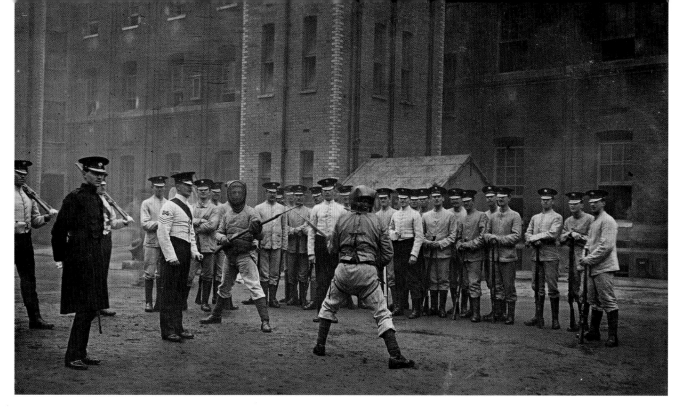

Bayonet practice, 1st Irish Guards, 1911–12

Barrack Room, Wellington Barracks, c. 1912

Irish Guards and wolfhound, St Patrick's Day, Wellington Barracks, 1908

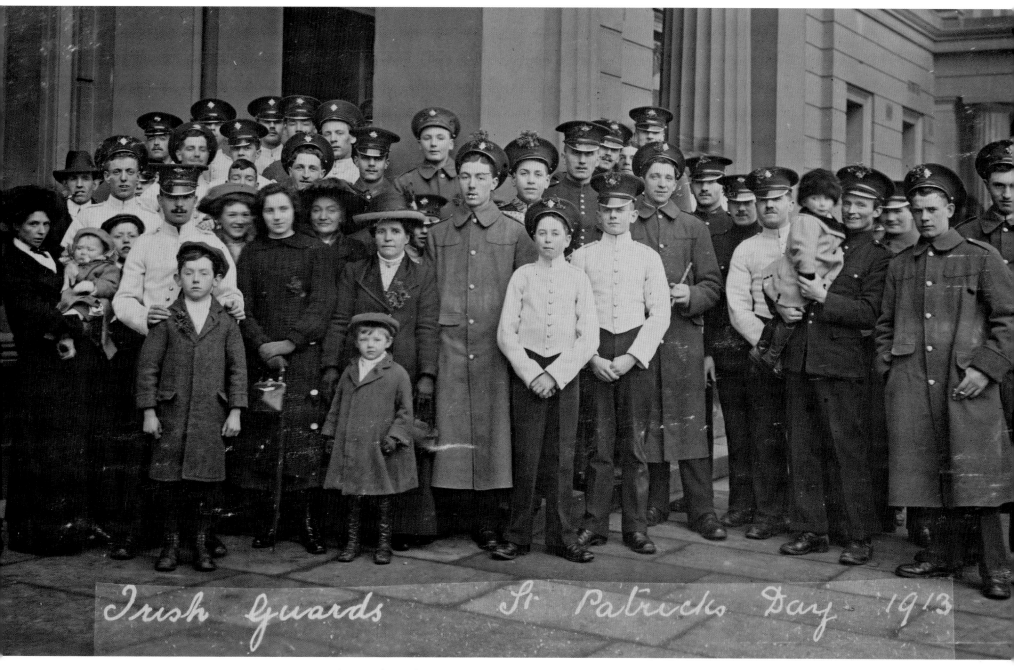

Irish Guards St Patricks Day 1913

A group shot with wives and children, celebrating St Patrick's Day, 1913

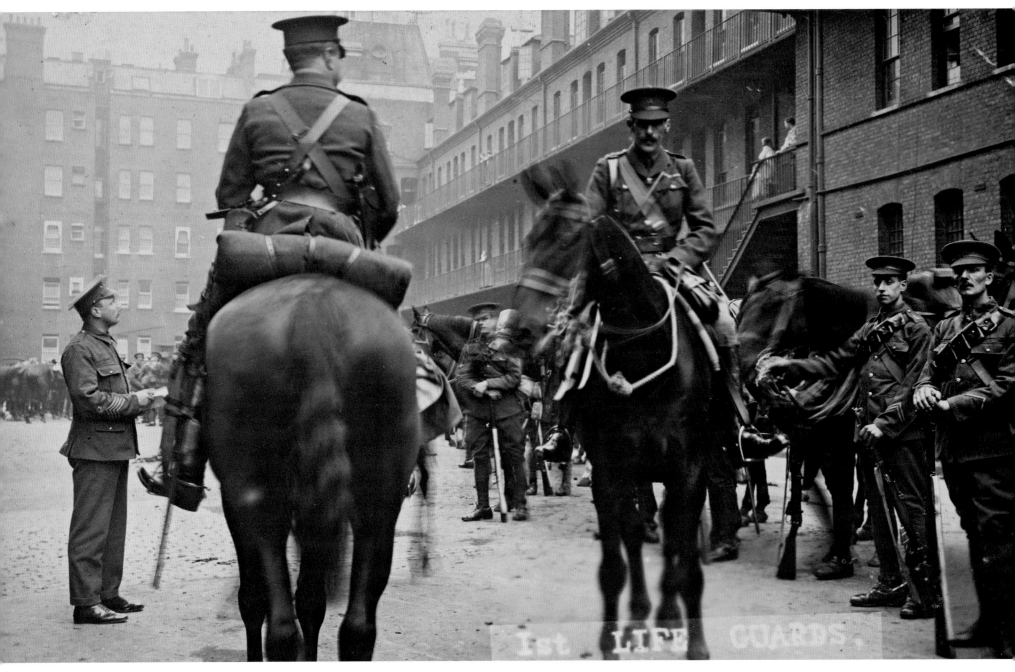

First contingent of the 1st Life Guards, leaving for war, 15 August 1914. Many shown were fatally wounded

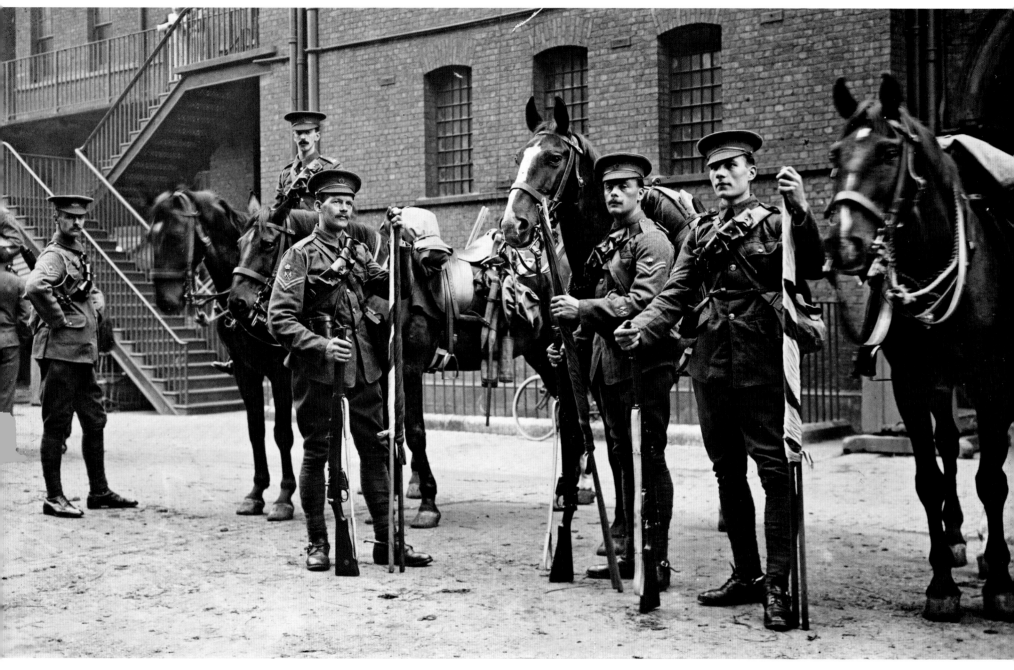

1st Life Guards mobilizing at Knightsbridge Barracks to leave for France, August 1914. They were destined for Mons

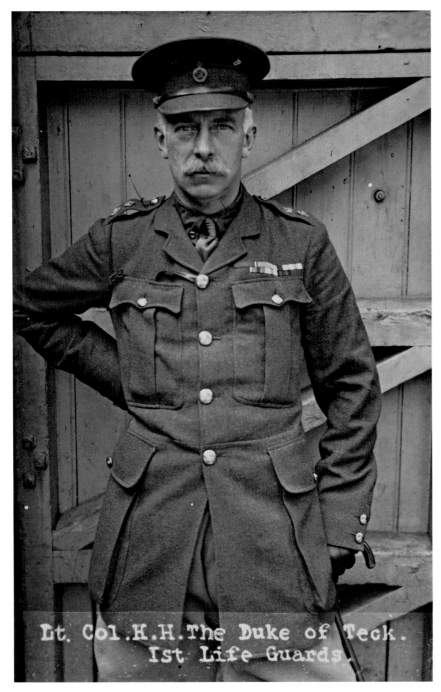

Lt. Col. H.H. The Duke of Teck, 1st Life Guards and Queen Mary's brother,
Knightsbridge Barracks, 1914

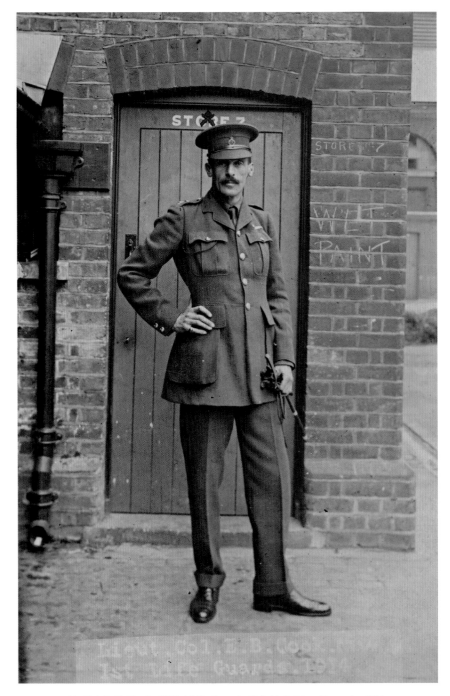

Lt. Col. E. B. Cook, OC 1st Life Guards, Knightsbridge Barracks, 1914.
Affectionately referred to by the men as 'Bertie'. Died from wounds, 1914

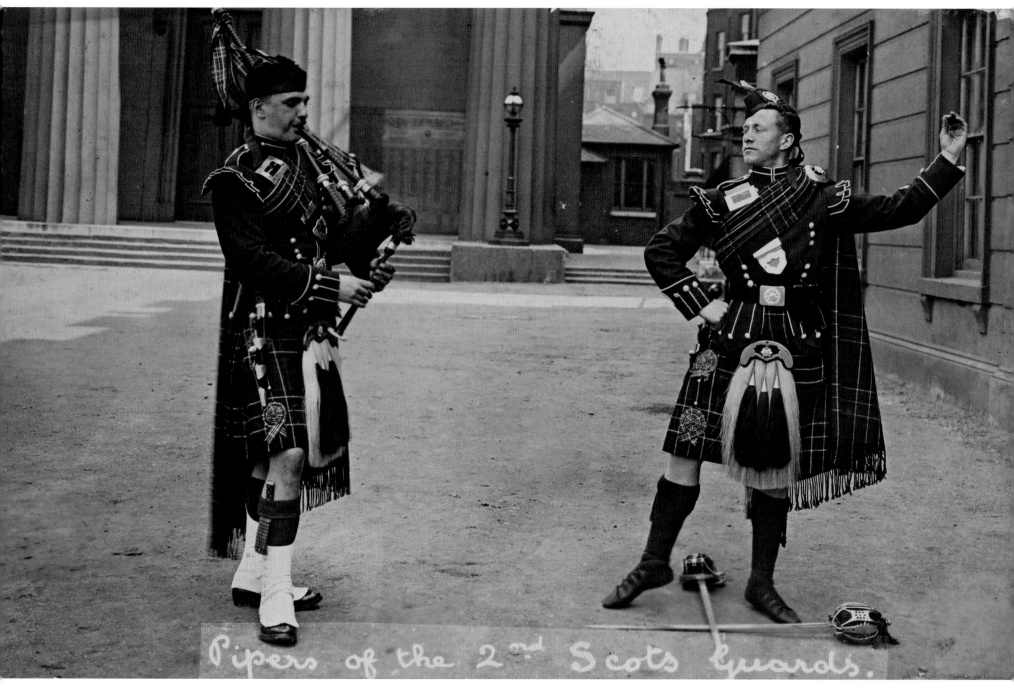

Pipers of the 2nd Scots Guards, during the First World War

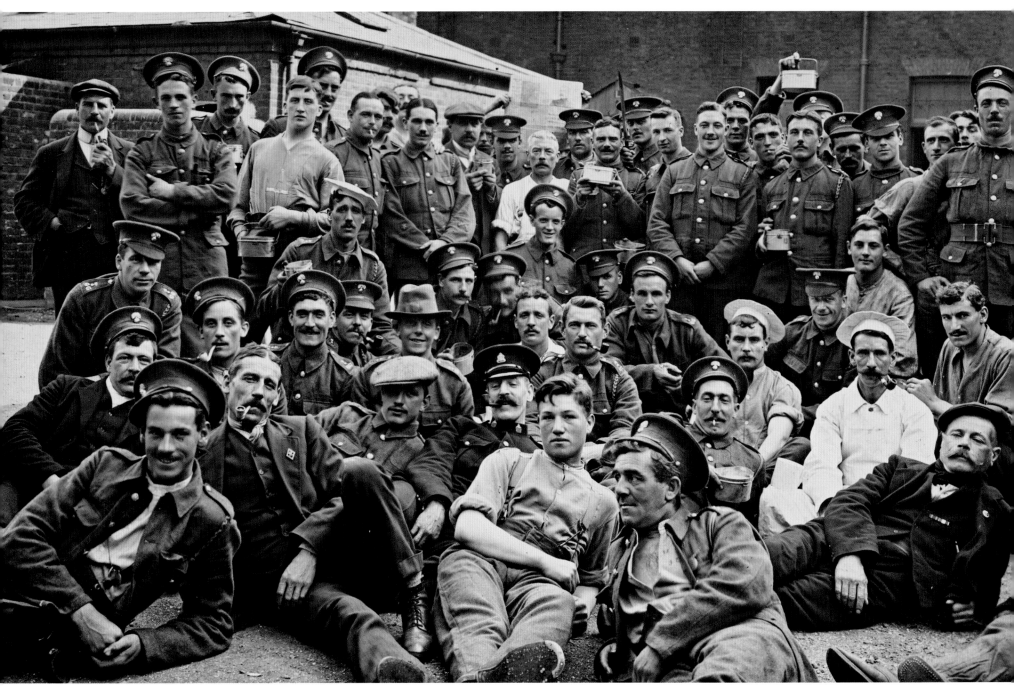

2nd Battalion Grenadier Guards Reservists, Chelsea Barracks, 1914

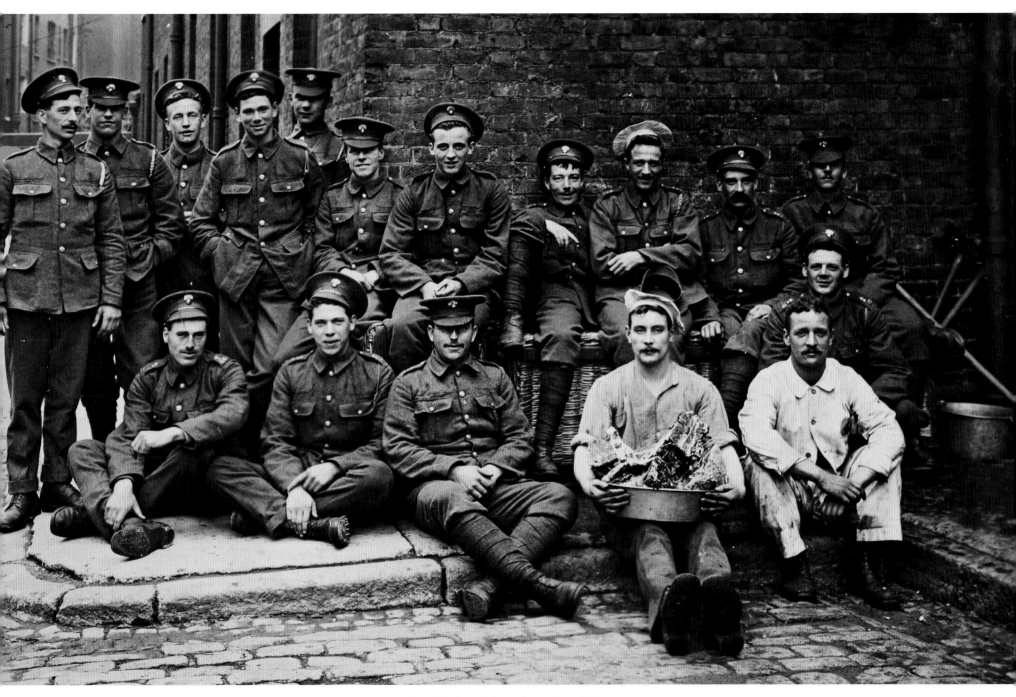

Grenadier Guards, including cooks, c. 1914

3rd BTTN GRENADIER GUARDS, WIMBLEDON COMMON, 1914.

3rd Battalion Grenadier Guards at Camp, Wimbledon Common, 1914

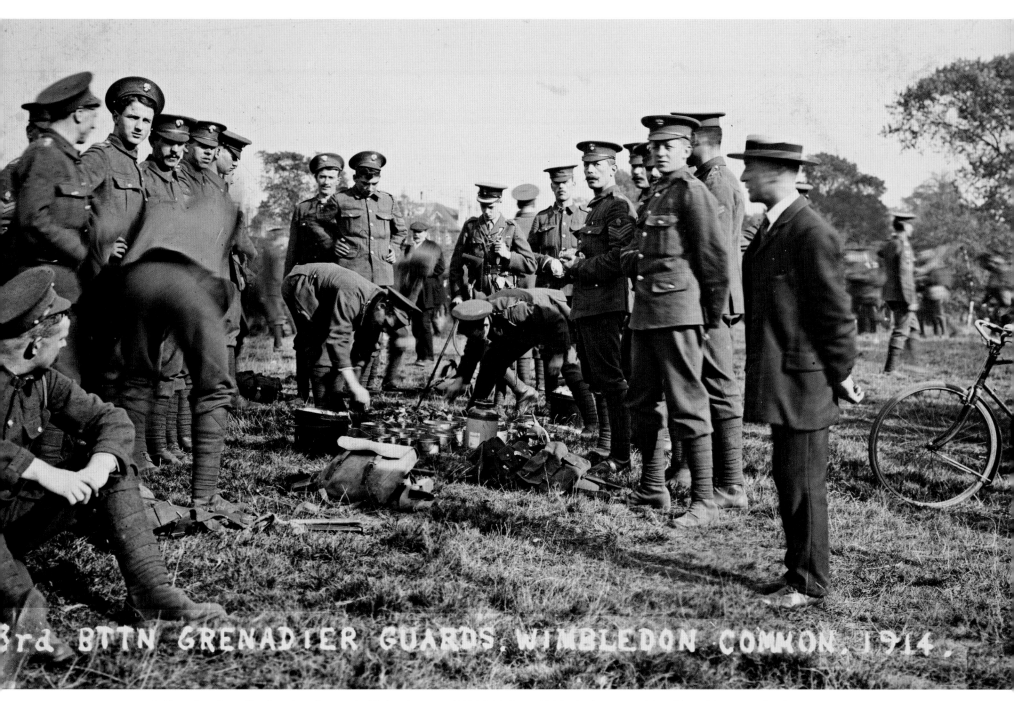

3rd Battalion Grenadier Guards at Camp, Wimbledon Common, 1914. HRH Prince of Wales in the centre with walking stick, eventually given to Broom

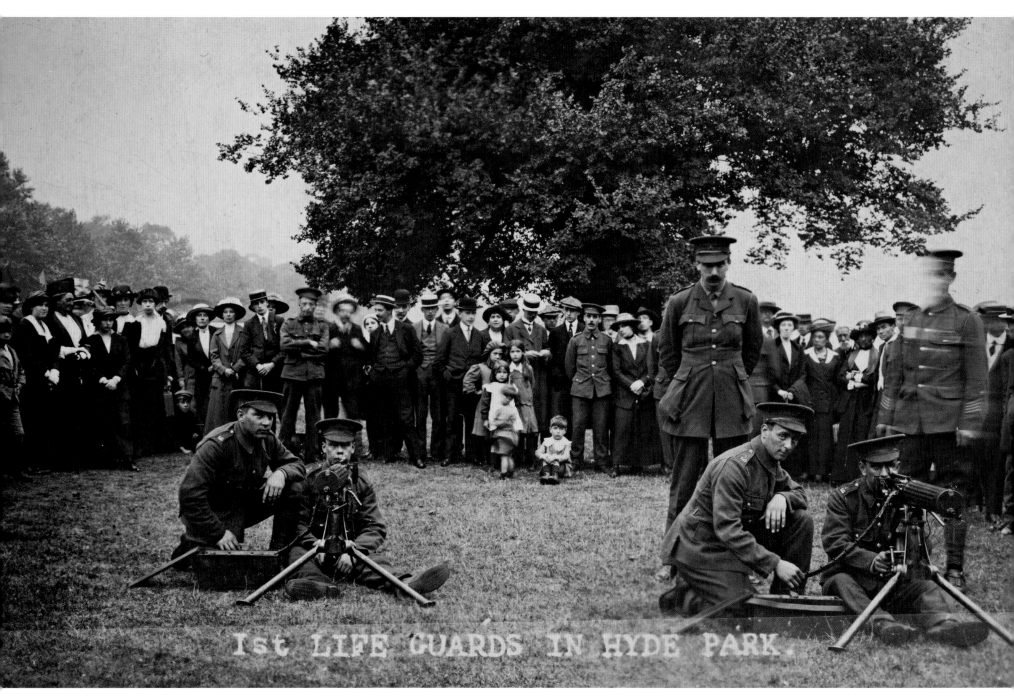

1st LIFE GUARDS IN HYDE PARK.

1st Life Guards with the 11th Marquess of Tweeddale, Hyde Park, 1914

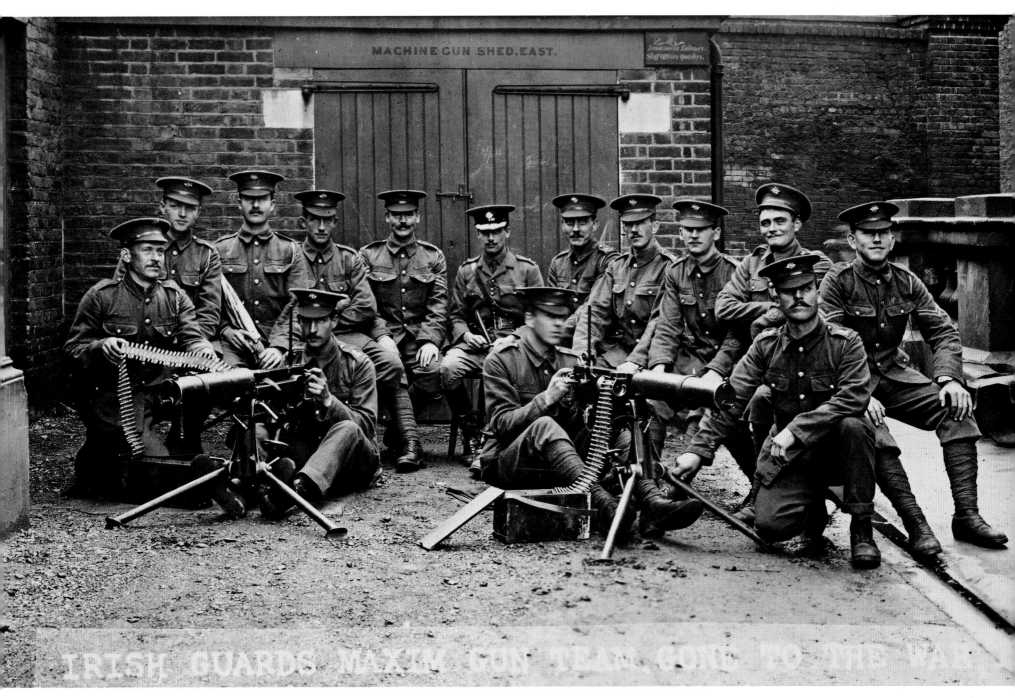

Captain Greer of the 1st Irish Guards and his machine gun team just prior to leaving for the war. They were all killed in battle soon afterwards, 1914

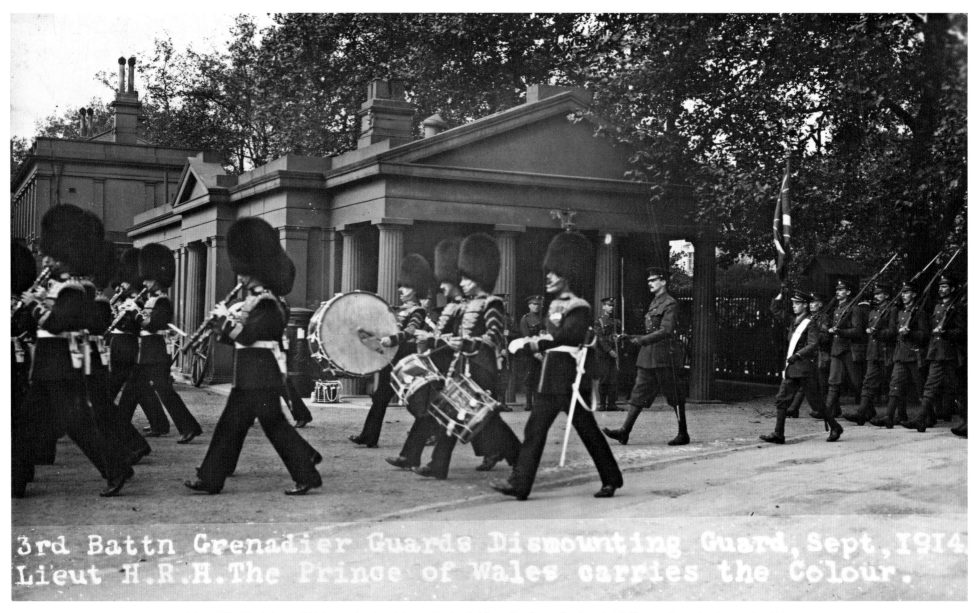

3rd Battn Grenadier Guards Dismounting Guard, Sept, 1914.
Lieut H.R.H. The Prince of Wales carries the Colour.

Lieut. HRH The Prince of Wales carries the Colour with the 3rd Battalion Grenadier Guards, Wellington Barracks, September 1914

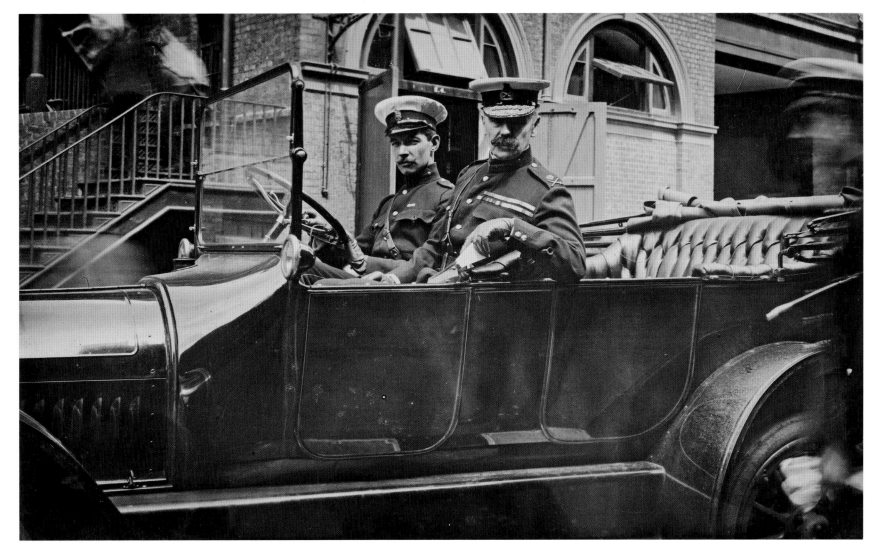

Major General Sir Francis Lloyd with Captain Diggle, Army Ordnance Corps, First World War

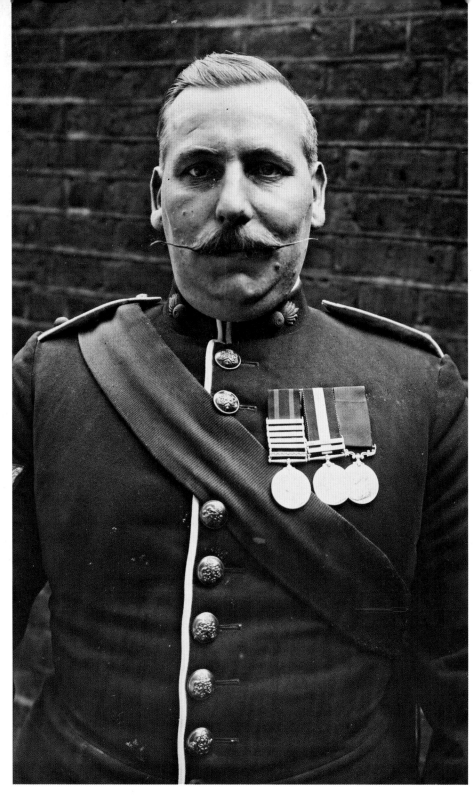

An unknown Grenadier Guard, Chelsea Barracks, 1911–14

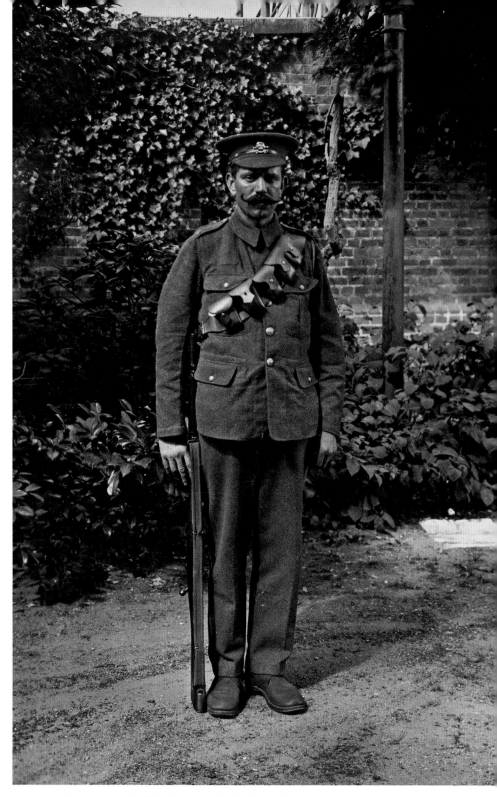

An unknown 2nd Life Guard, drafted in from the 17th Lancers, at Windsor,
September 1914

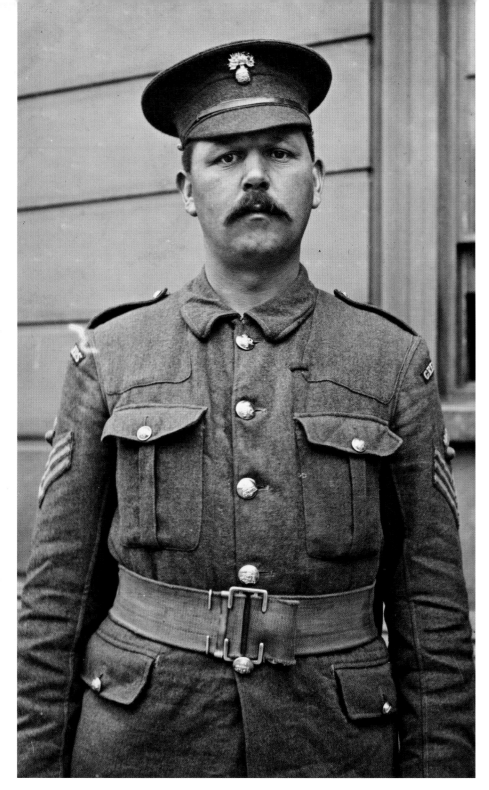

An unknown Grenadier Guard, during the First World War

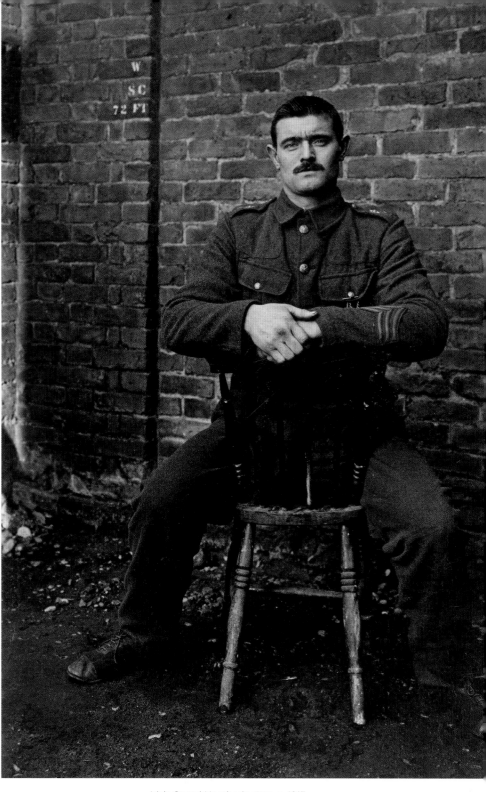

Irish Guard Heatherington, c. 1915

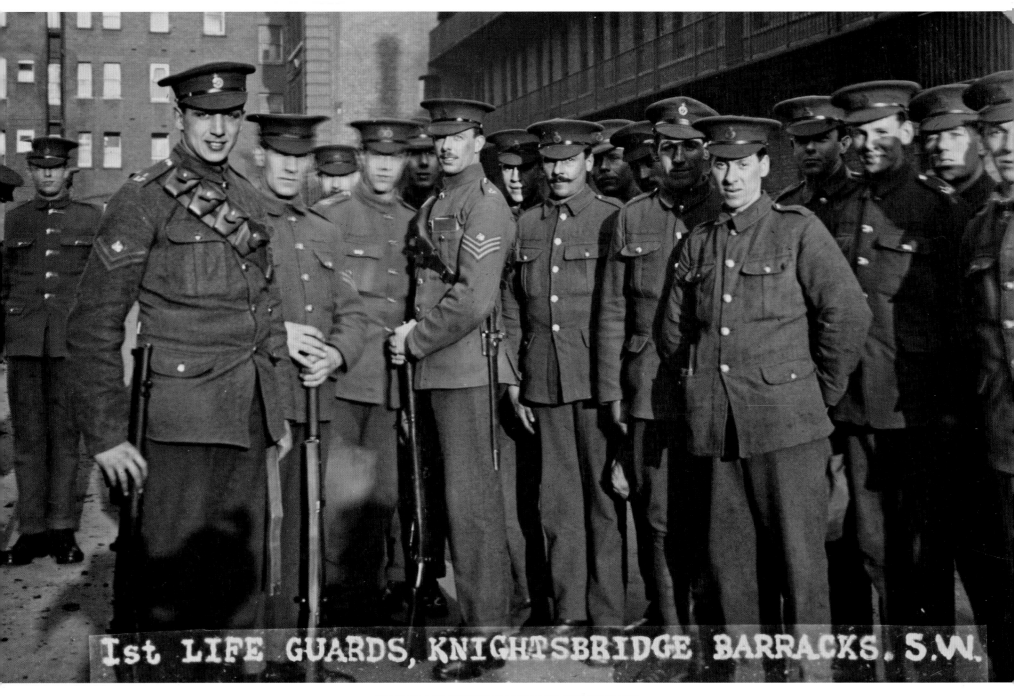

1st LIFE GUARDS, KNIGHTSBRIDGE BARRACKS. S.W.

1st Life Guards, Knightsbridge Barracks, First World War

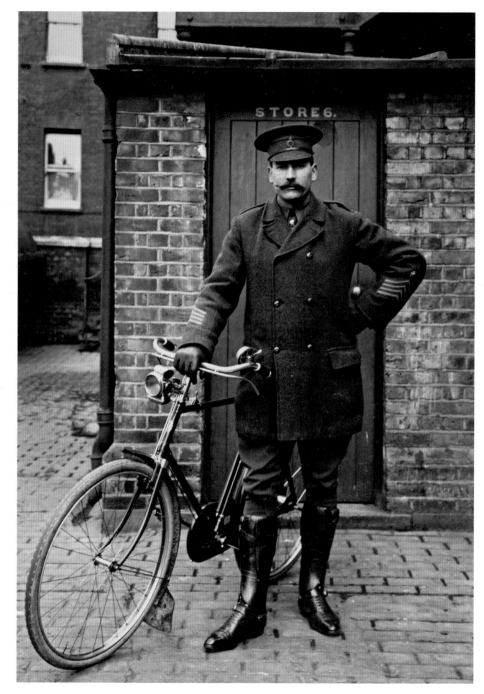

Corporal Major Paul of the 1st Life Guards at Knightsbridge Barracks, 1914

Corporal A. S. Monck, 1st Life Guards, at Knightsbridge Barracks, 1915

Life Guards S. Raper, Sidney Crockett and William H. Beckham, 13 September 1915

1st LIFE GUARDS.

1st Life Guards watching a football match, 1914–15

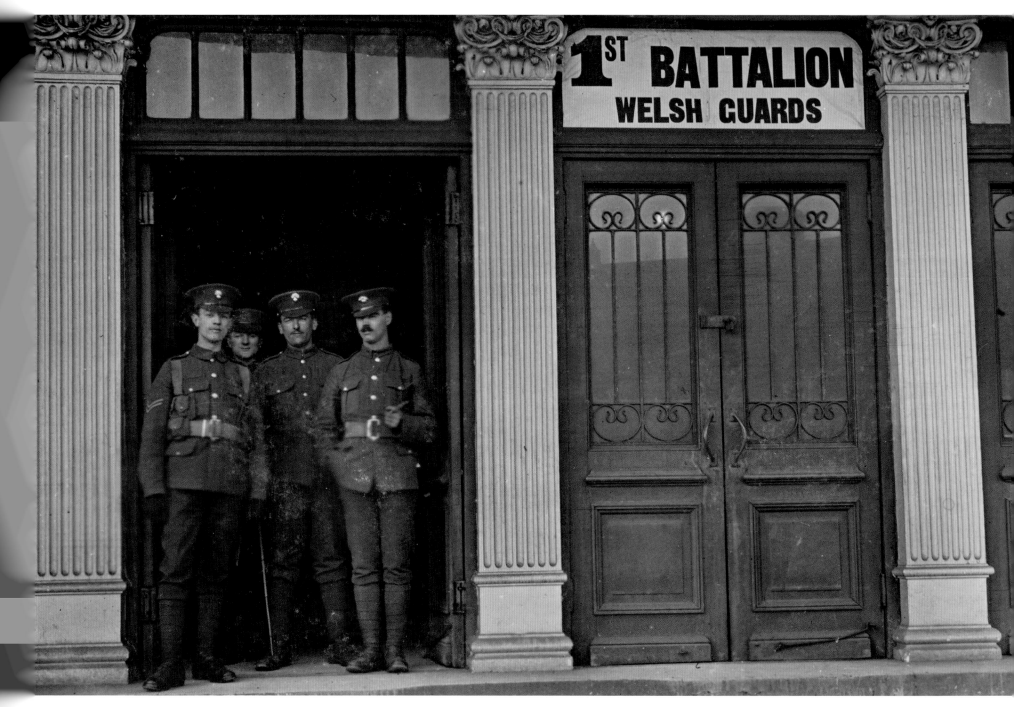

Formation of the 1st Battalion Welsh Guards, recruiting at White City, 1915–16

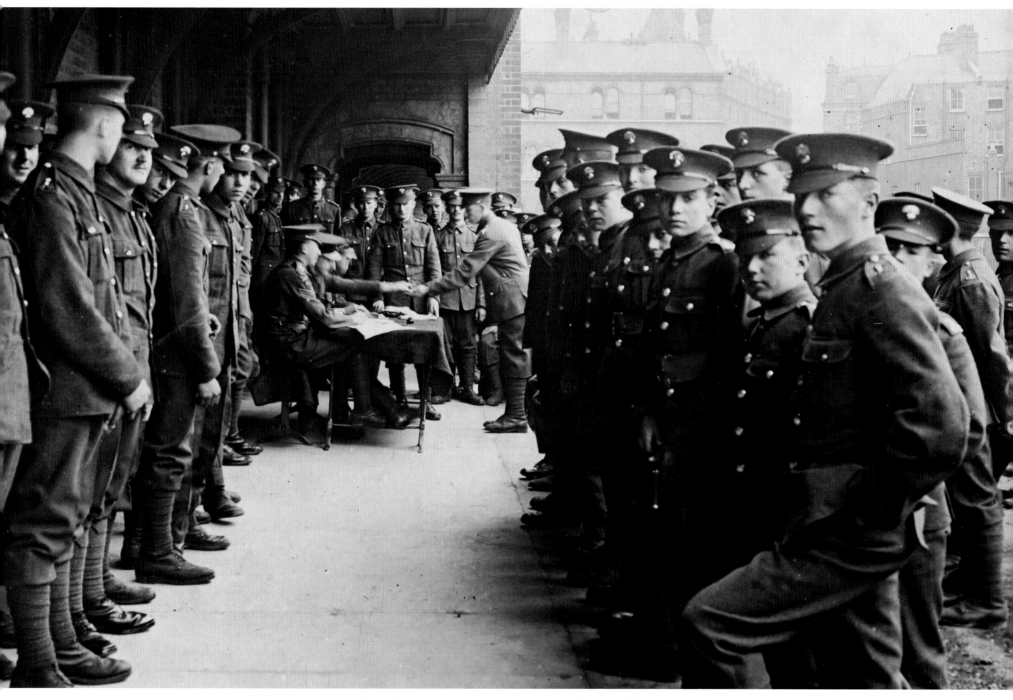

Grenadier Guards on Paying Out Day, Chelsea Barracks, 1917

"Gee-up, Daddy!"

Captain Spencer, Officers Mess Sergeant of 1st Life Guards, and baby, 1914

Grenadier Guard and his wife, August 1914

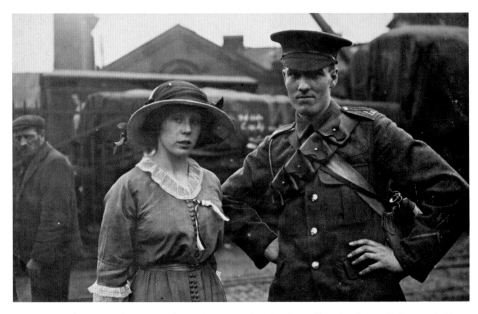

A soldier from 1st Life Guards departing Nine Elms Station, off to the Front, 15 August 1914

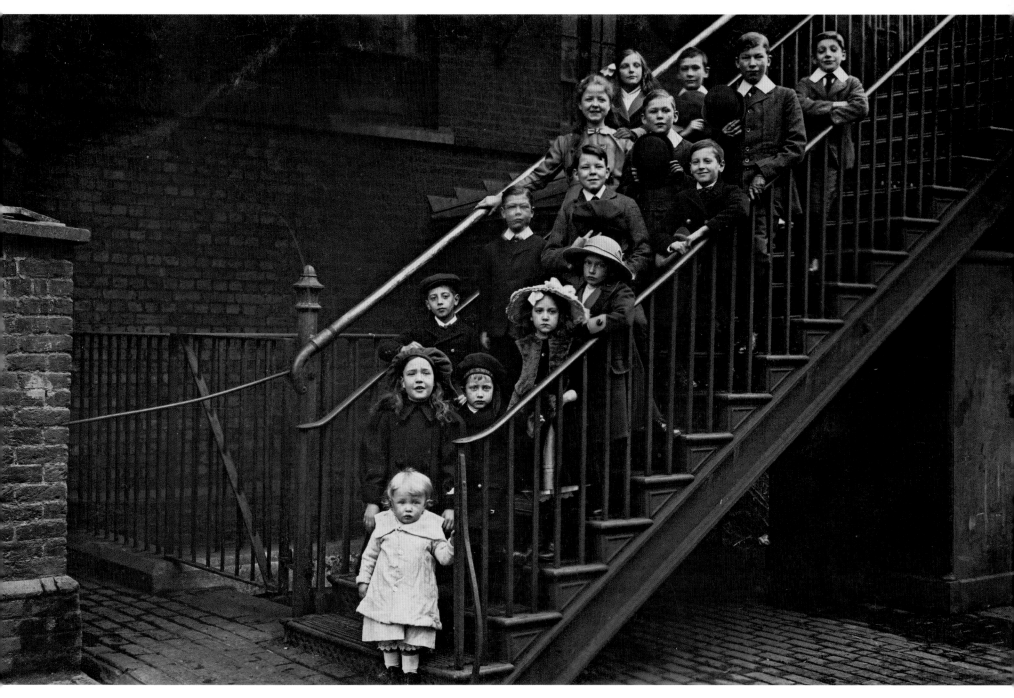

Children of the 1st Life Guards Knightsbridge Barracks, 1914, leaving for their new war home. The young boy in the cap, named Lappage, was run over and killed

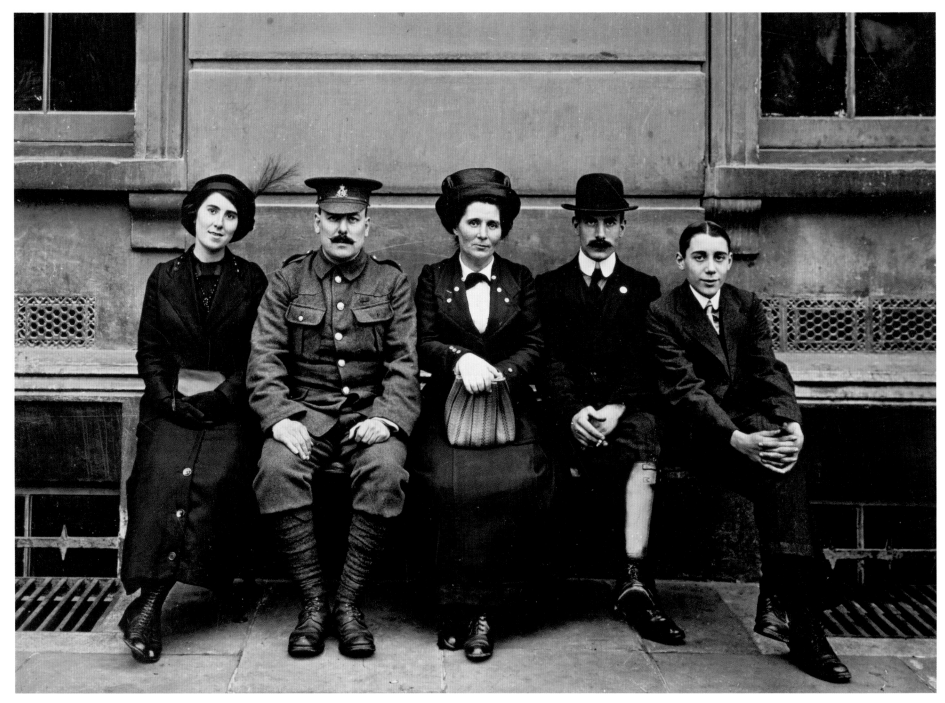

A Sergeant from the Grenadier Guards and family, photographed in the Barracks, 1915

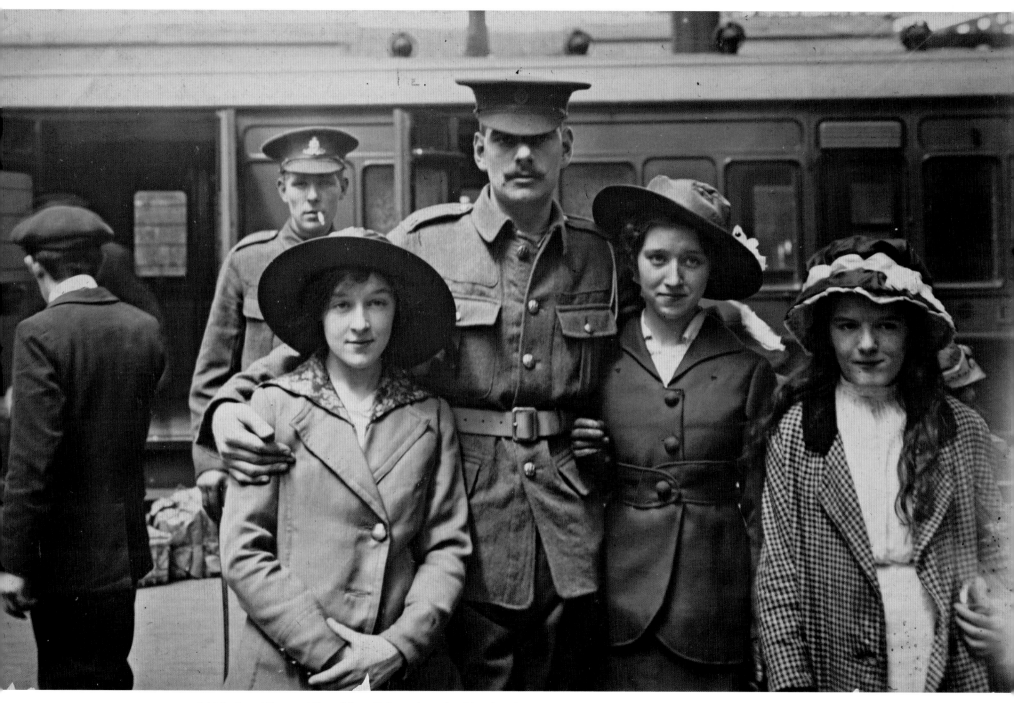

1st Life Guard, Trooper Wannell from Fulham, departing Waterloo, 1915. He returned and was later a caretaker at Fulham Town Hall

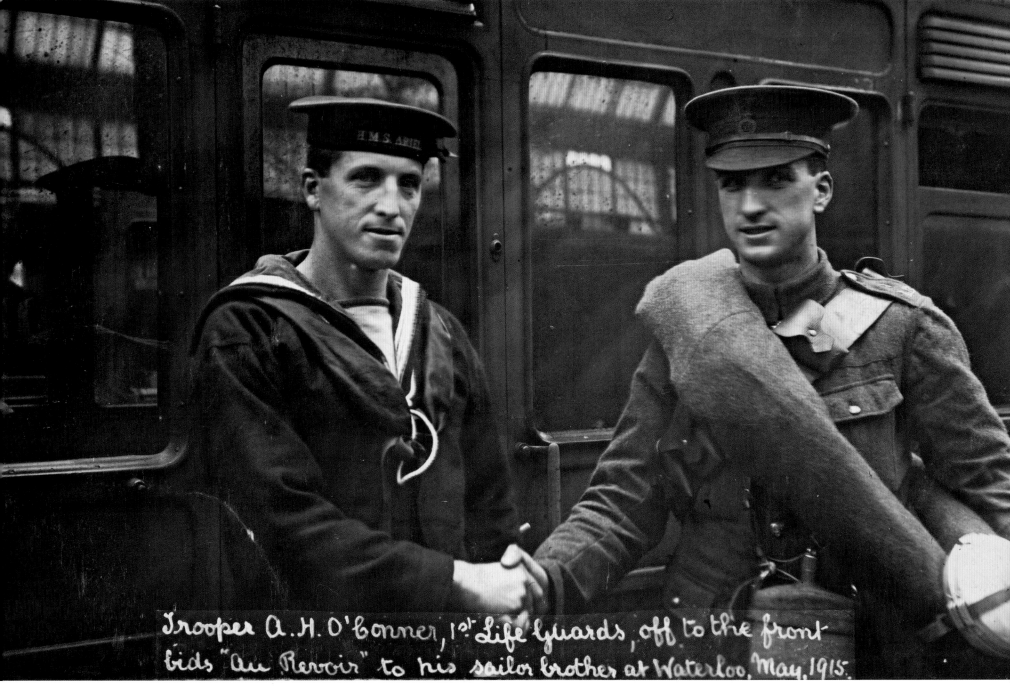

Trooper A. H. O'Conner, 1st Life Guards, off to the front bids "Au Revoir" to his sailor brother at Waterloo, May, 1915.

American men, Trooper A. H. O'Conner, 1st Life Guards and his sailor brother, Waterloo Station, May 1915. A third brother had drowned reportedly on the *Lusitania*

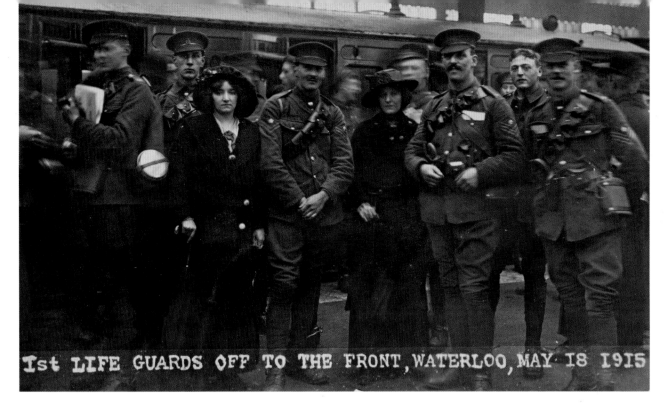

1st Life Guards say goodbye to their wives as they depart for the Front, Waterloo Station, 18 May 1915

Families and friends say goodbye to the ill-fated Guards from the Household Battalion, Waterloo Station, November 1916

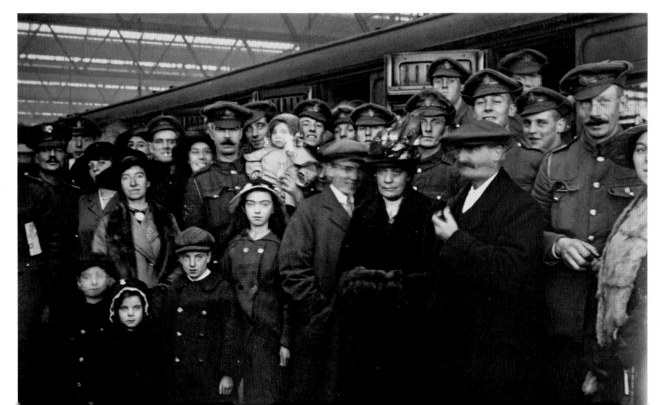

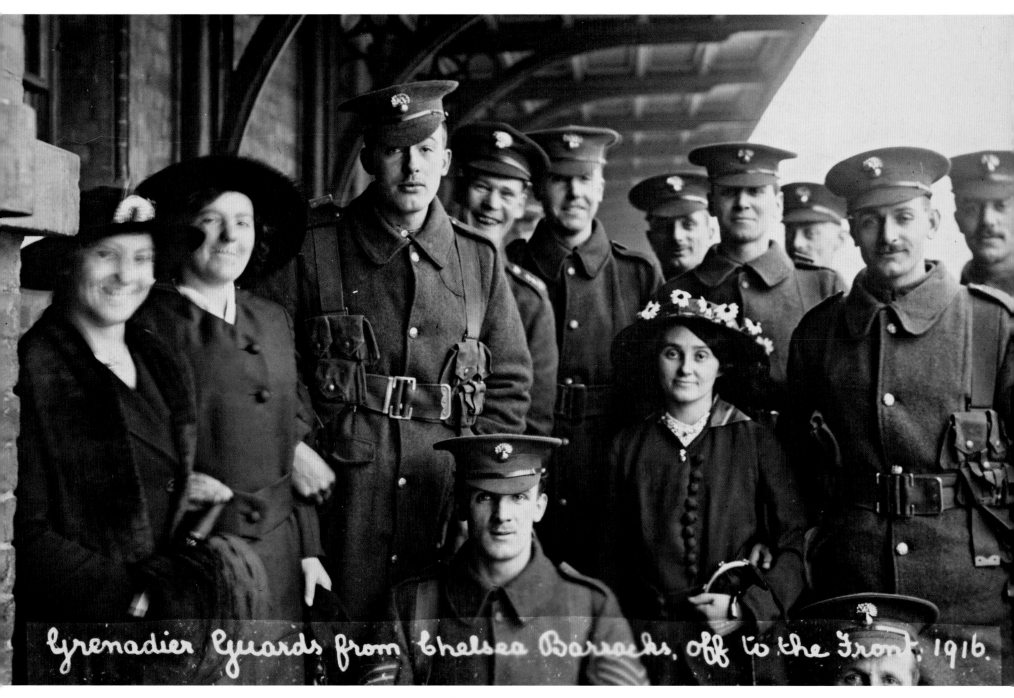

Grenadier Guards from Chelsea Barracks, off to the Front, 1916

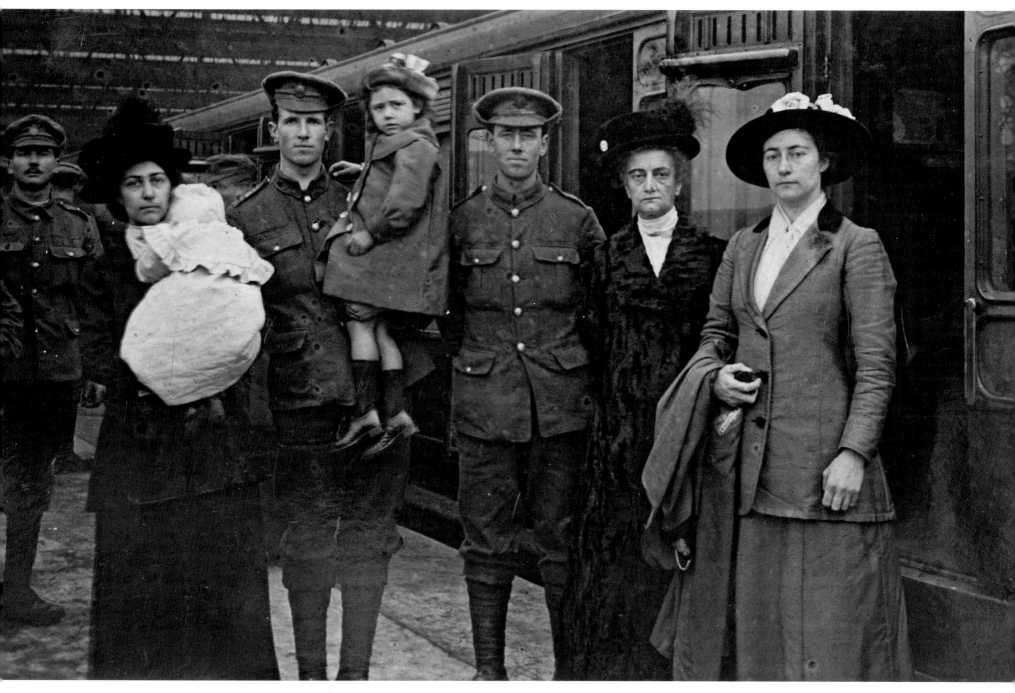

Two guards from the Household Battalion say goodbye to their families, Waterloo Station, 1916

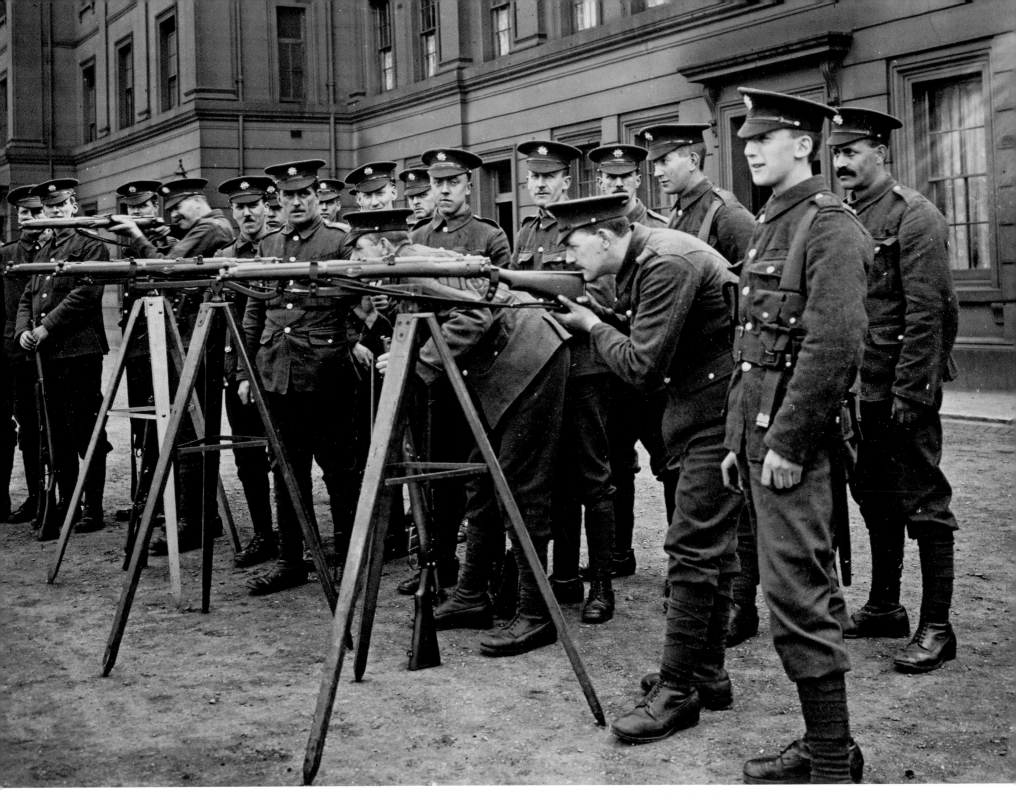

Musketry instruction for a wartime draft, 3rd Scots Guards, Wellington Barracks, 1914–18

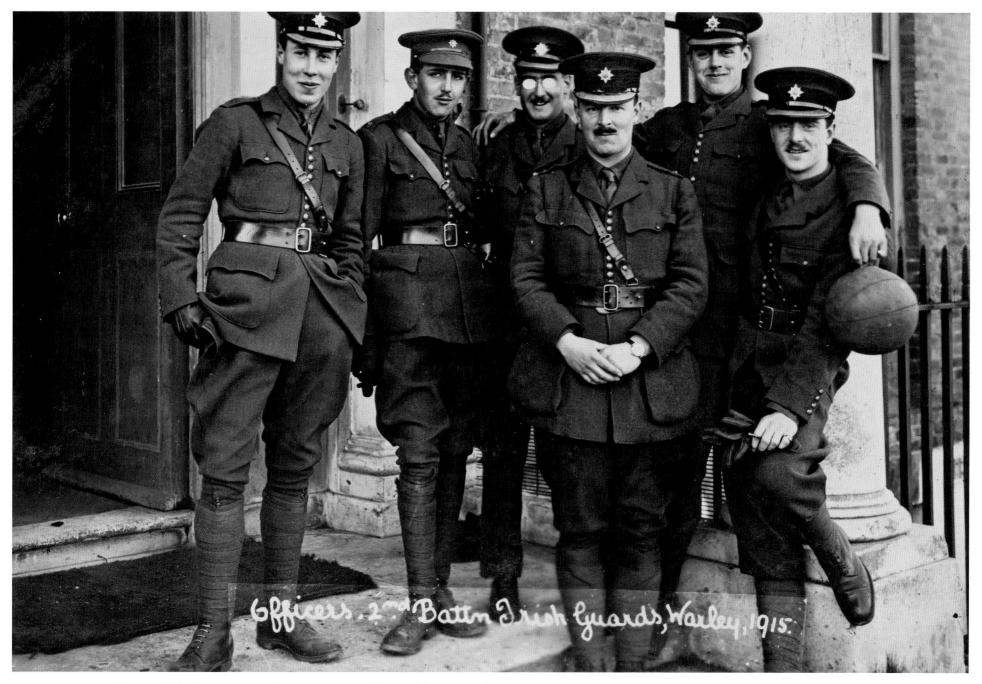

Officers. 2nd Battn Irish Guards, Warley, 1915.

Rudyard Kipling's son John, wearing glasses, among Officers of the 2nd Battalion Irish Guards, Warley, 1915. John Kipling died in France in September that year

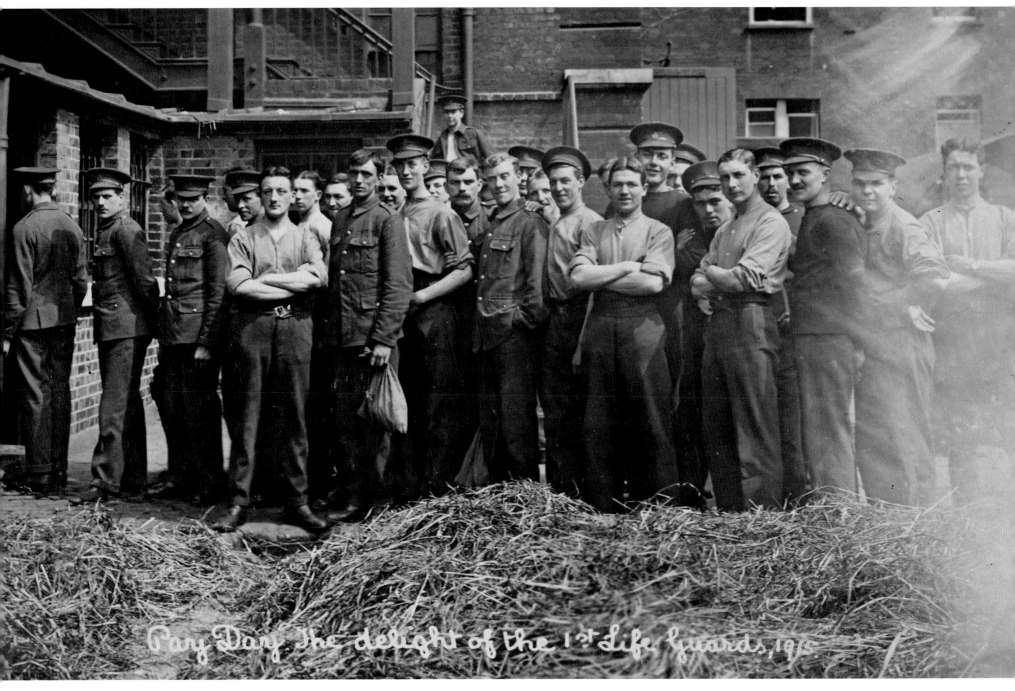

1st Life Guards queue up to receive their pay, 1915

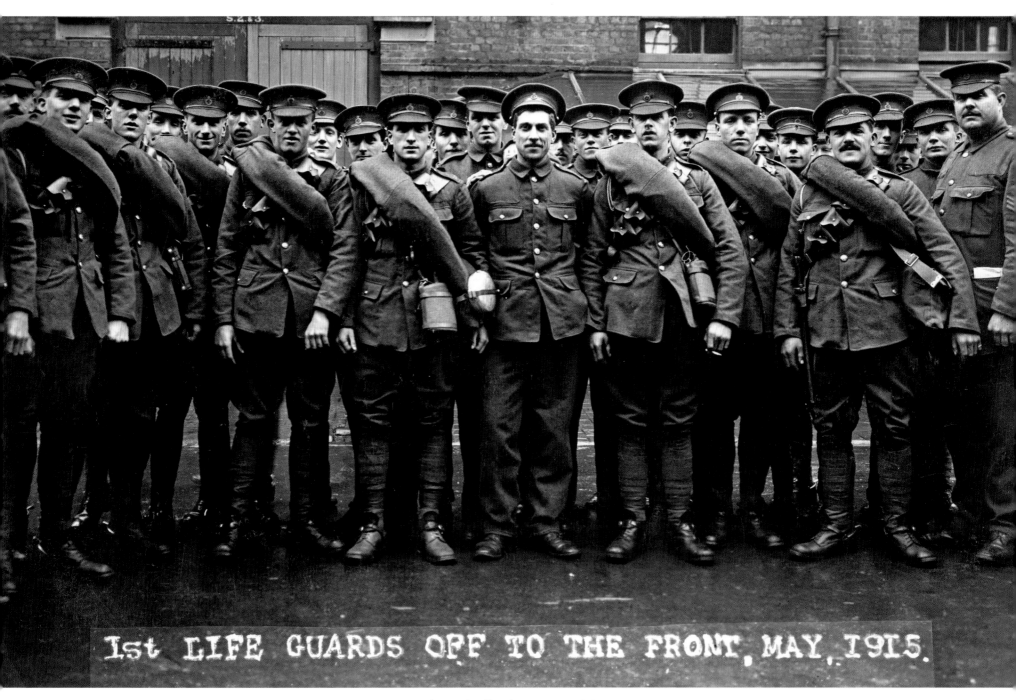

1st Life Guards off to the Front, May, 1915

Lt. Col. William Delaney DCM, Irish Guards, date unknown. The annotated description on the reverse of the photograph states 'Conspicuous gallantry devotion to duty and untiring efforts to rescue wounded'

Col. E. S. Wyndham DSO of the 1st Life Guards in 1915, Hyde Park Barracks. He became Lord Leconfield and died in Oct 1967

Major Edgar Sheppard DSO, Grenadier Guards, Chelsea Barracks, 1914–16

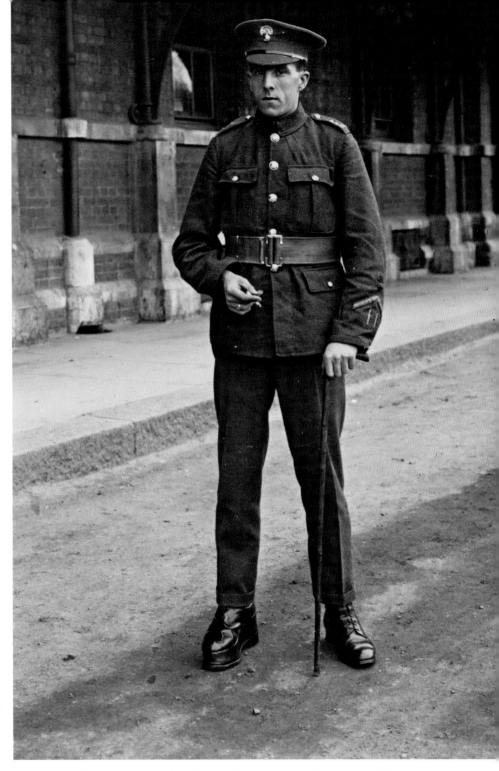

Grenadier Guard on exercise 'duty' awaiting discharge after wounds, 1916

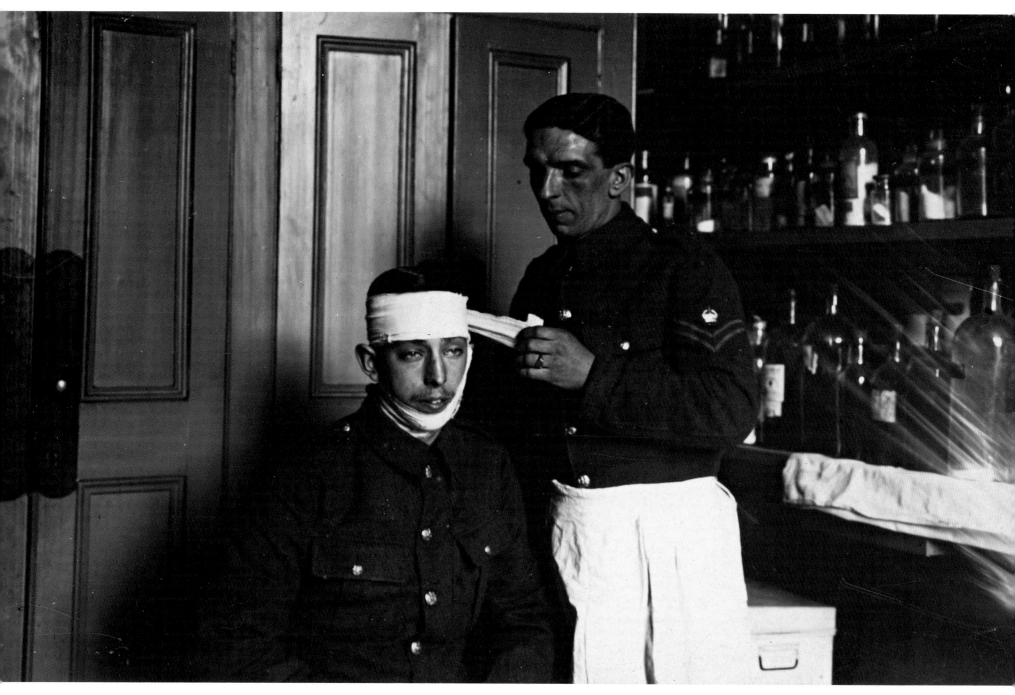

Dispensary at Knightsbridge Barracks, during the First World War

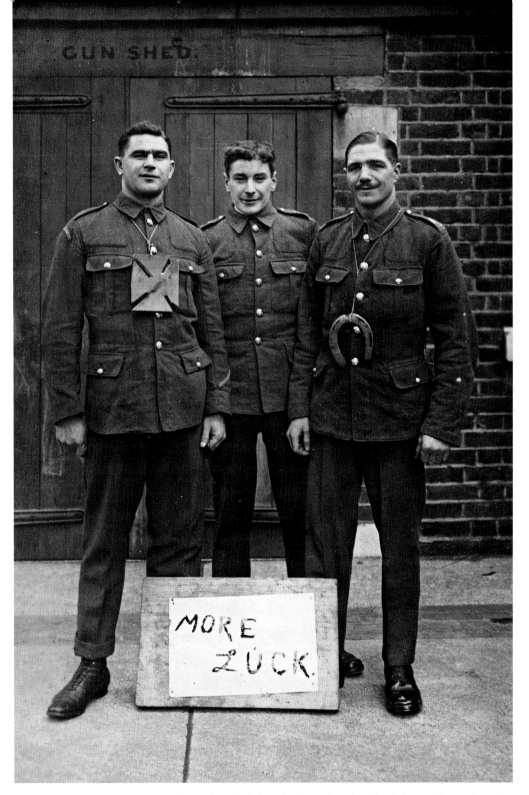

A trio of soldiers, including an Irish Guard on the left and a Scots Guard on the right, stand together with their hopeful message, during the First World War

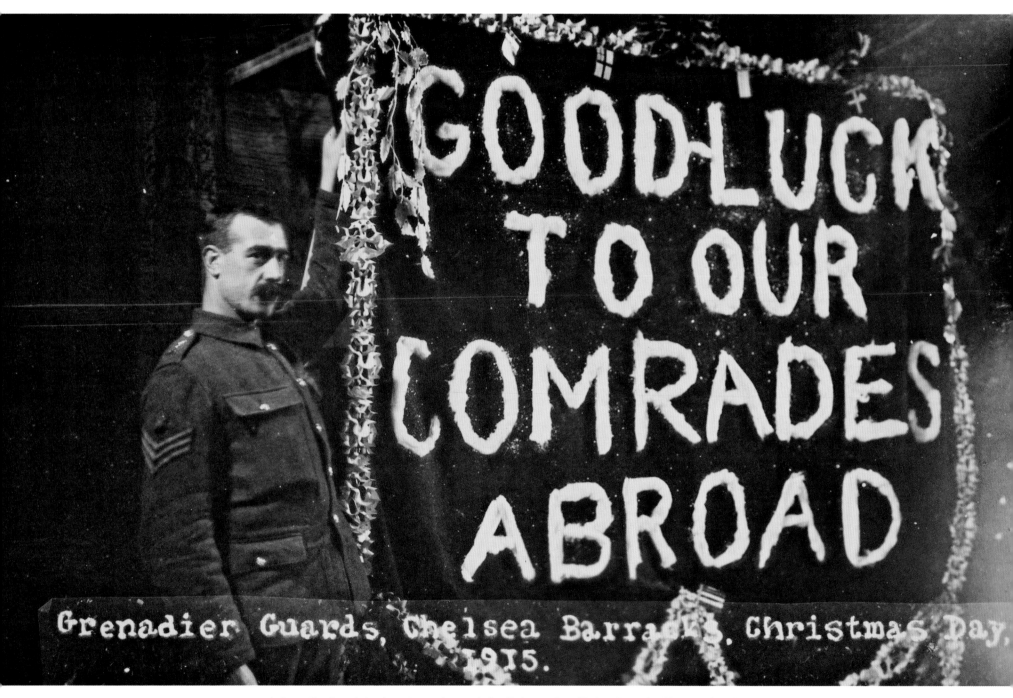

GOODLUCK TO OUR COMRADES ABROAD

Grenadier Guards, Chelsea Barracks, Christmas Day, 1915.

A Grenadier Guard stands next to a sign made for Christmas Day, Chelsea Barracks, 25 December 1915

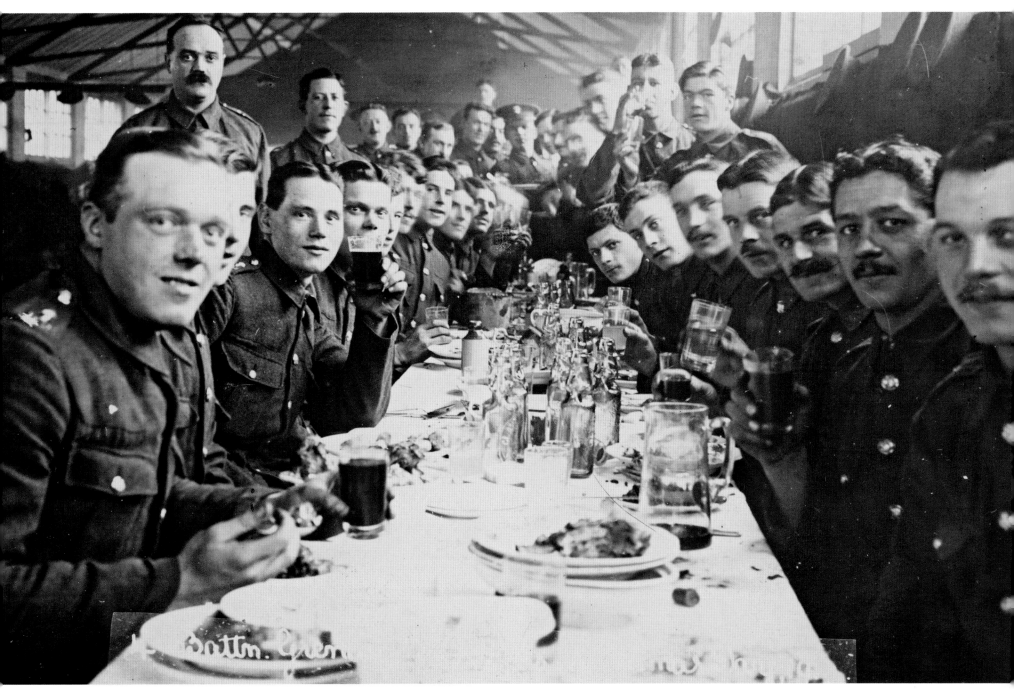

4th Battalion Grenadier Guards enjoy Christmas Lunch, 25 December 1914

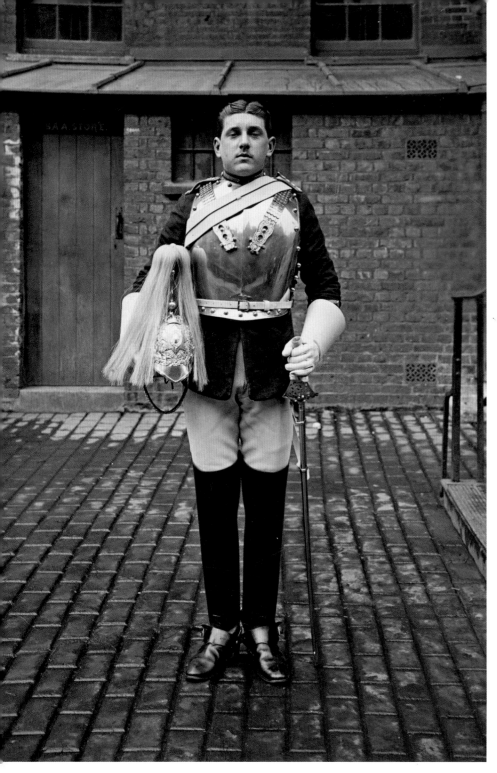

An unknown 1st Life Guard, Knightsbridge Barracks, during the First World War, 1915

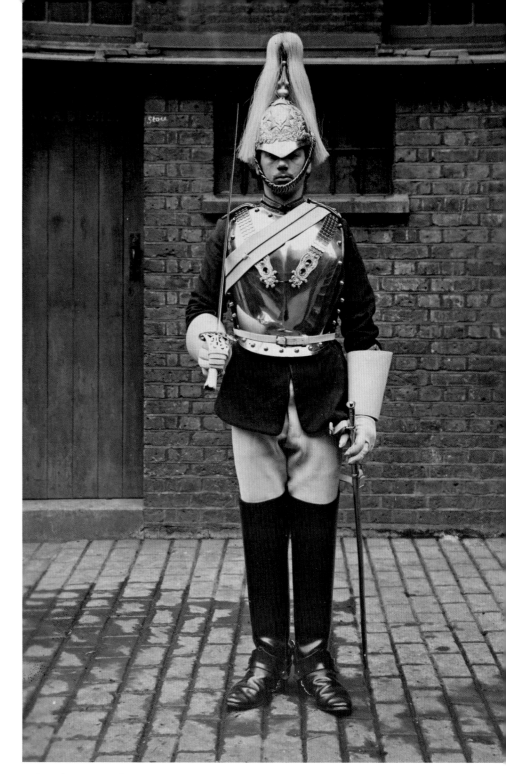

An unknown 1st Life Guard, Knightsbridge Barracks, during the First World War, 1915

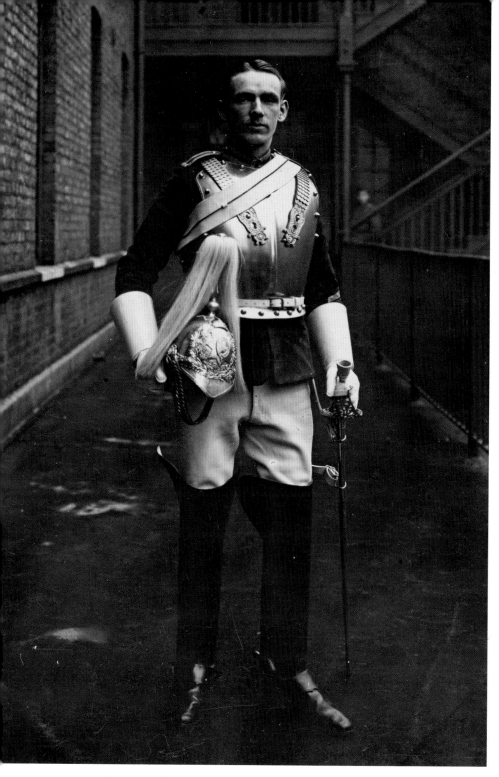

An unknown 1st Life Guard, Knightsbridge Barracks, during the First World War, 1915

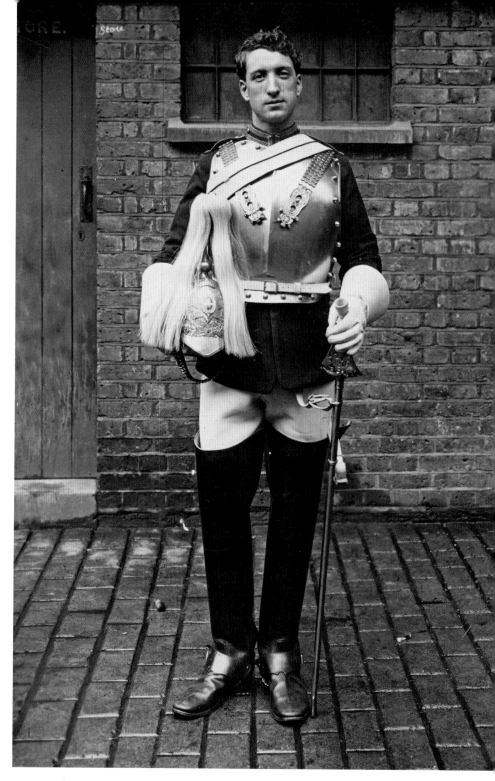

1st Life Guard Alfred H. O'Connor, B Squad 3321, Knightsbridge Barracks, 1915

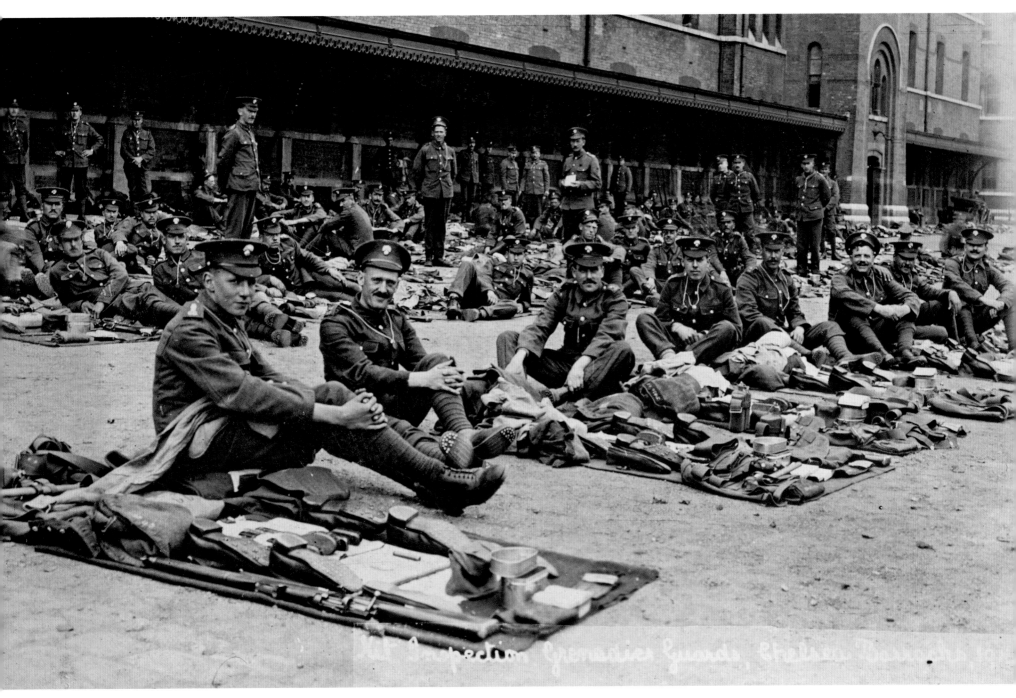

Grenadier Guards awaiting kit inspection, Chelsea Barracks, 1916

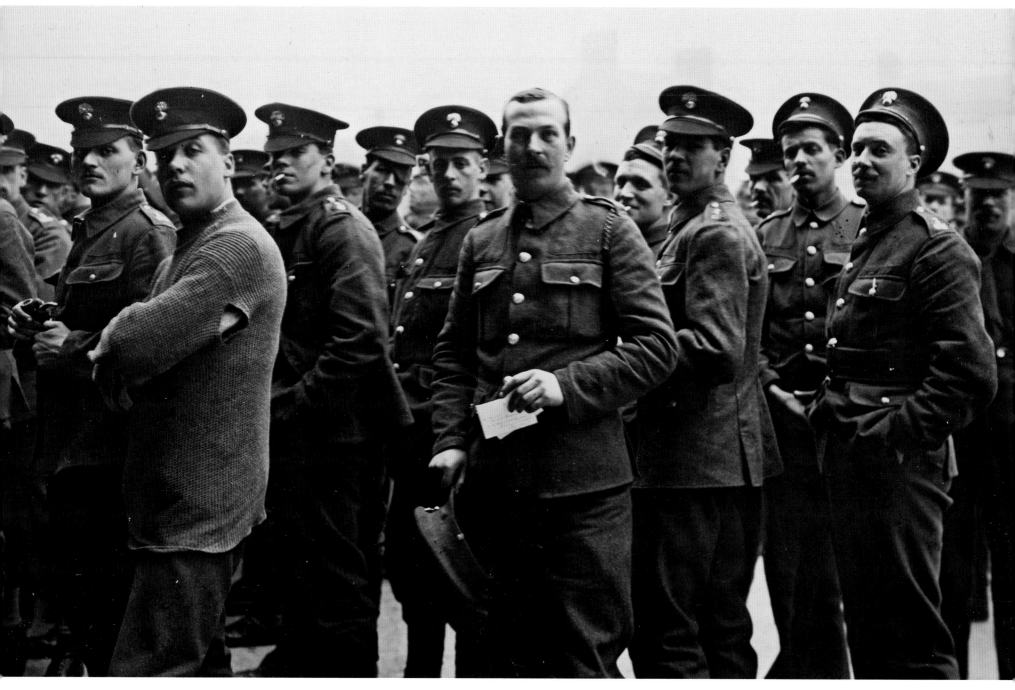

Group of Grenadier Guards, date and location unknown

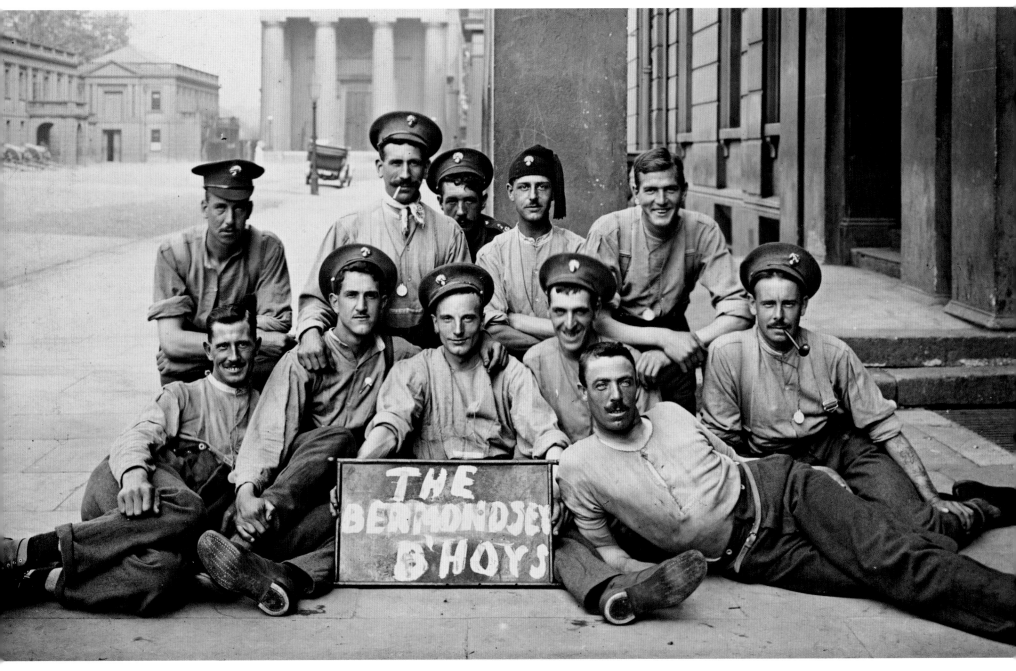

Grenadier Guards with a makeshift sign reading 'The Bermondsey B'hoys', Wellington Barracks, c. 1915

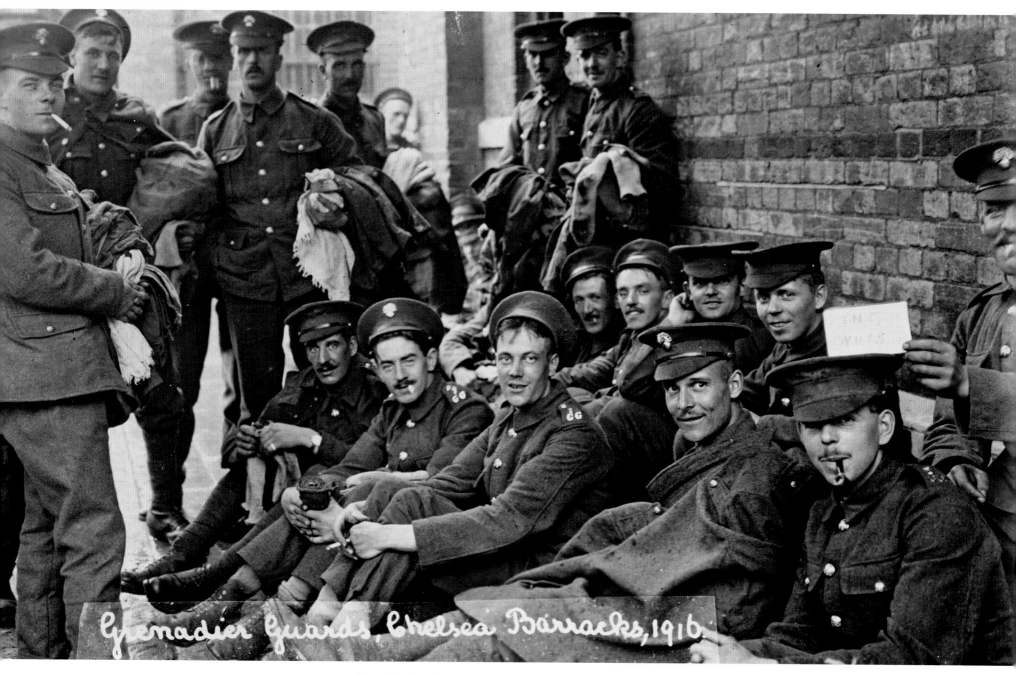

Grenadier Guards, Chelsea Barracks, 1916.

Grenadier Guards awaiting the postman, Chelsea Barracks, 1916

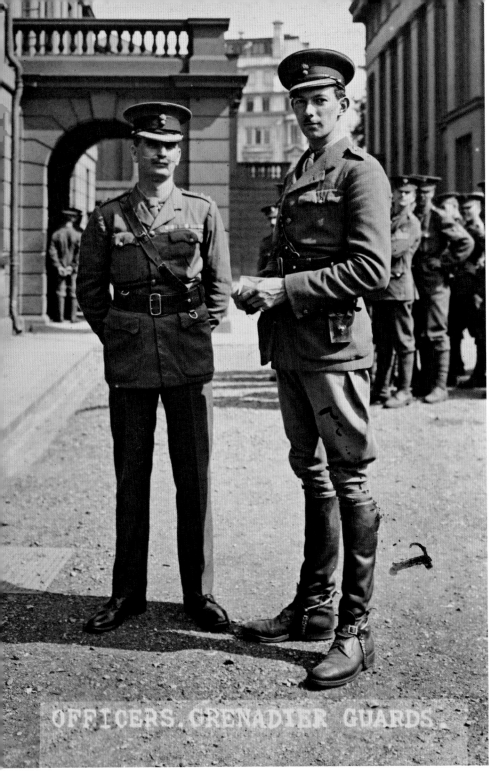

OFFICERS, GRENADIER GUARDS.

Officers, Grenadier Guards, Wellington Barracks, 1916

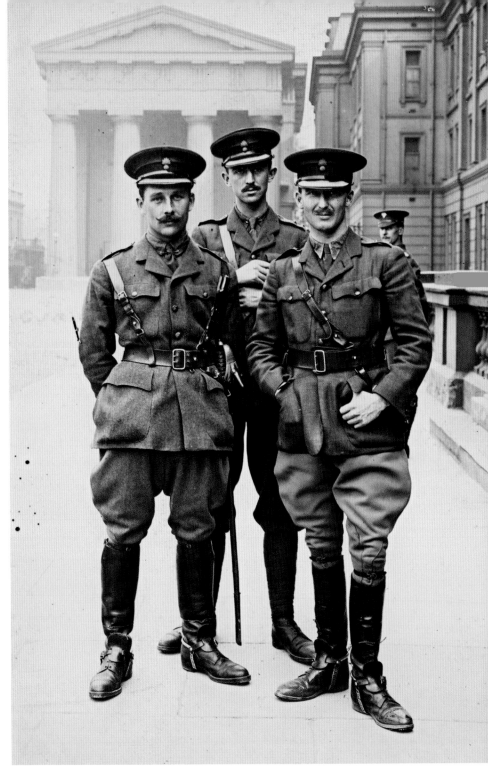

Officers, Grenadier Guards, Wellington Barracks, 1916

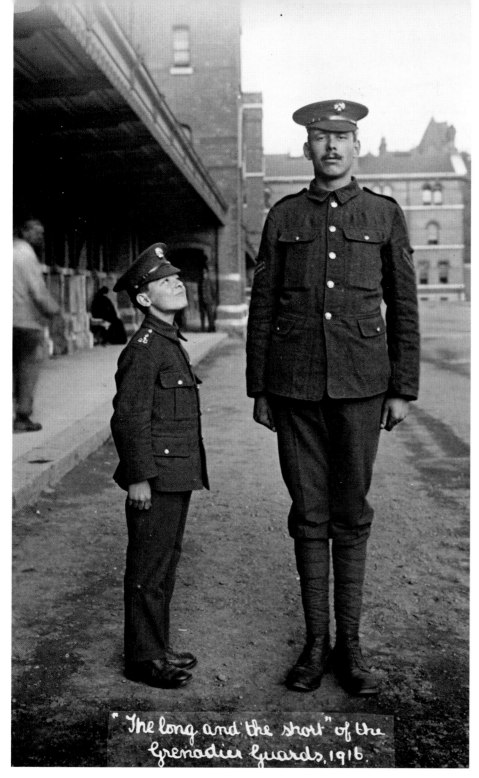

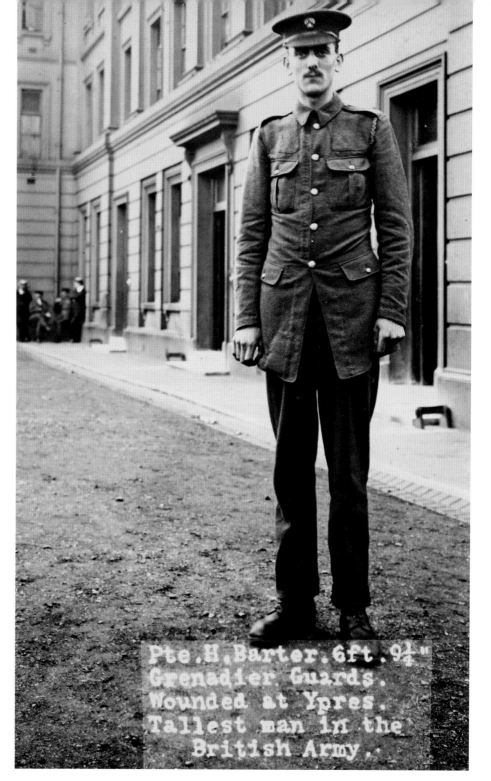

Pte. H. Barter. 6ft. 9¼"
Grenadier Guards.
Wounded at Ypres.
Tallest man in the
British Army.

"The long and the short" of the
Grenadier Guards, 1916.

The Long and the Short of the Grenadier Guards, Chelsea Barracks, 1916

Private H. Barter, Grenadier Guards, date unknown. Shot in the ankle at Ypres

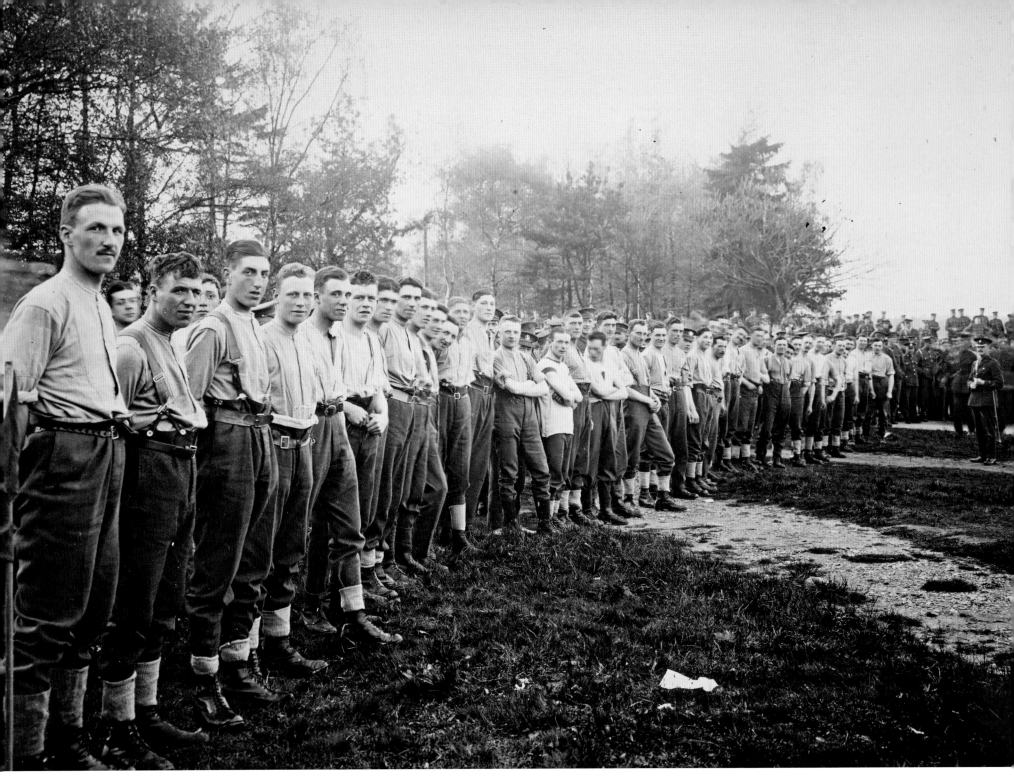

Jam for Tea Race, Machine Gun Guards before leaving Pirbright for Paris, 1918. Two days later they were bombed

A. C. Liney and P. Malin 1st Life Guards of the Guards Machine Gun Regiment, possibly at Caterham, c. 1918

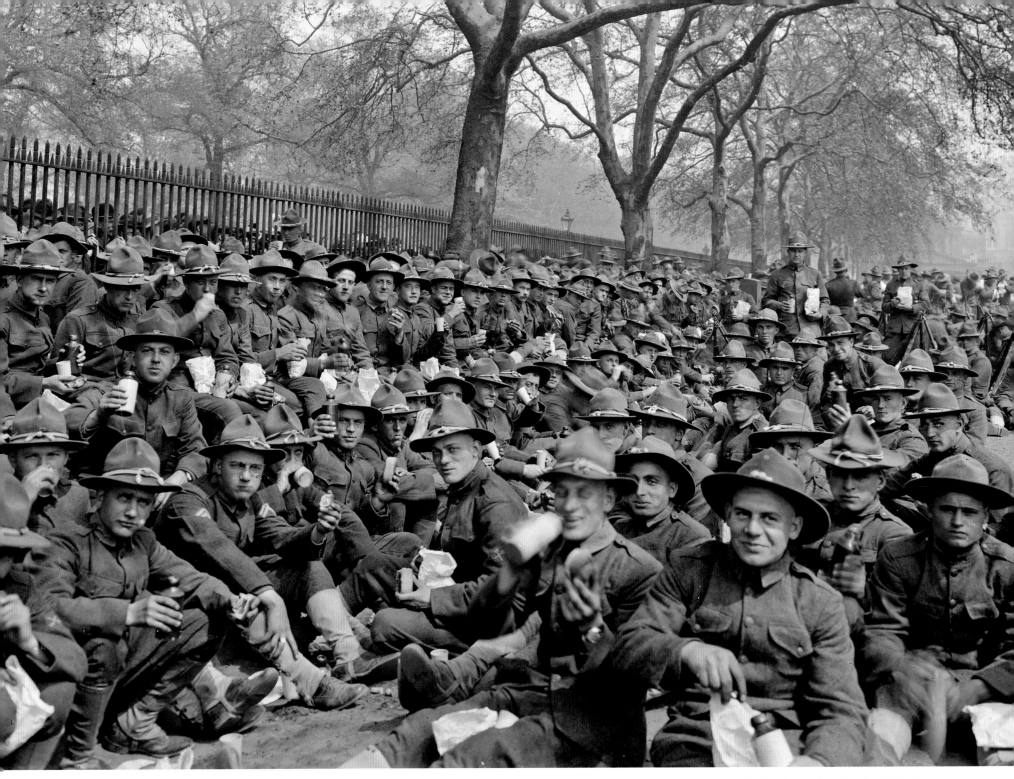

Soldiers of the American Expeditionary Forces, recently arrived in London, at lunch in a park before parading in front of King George V at Buckingham Palace, London, 13 May 1918

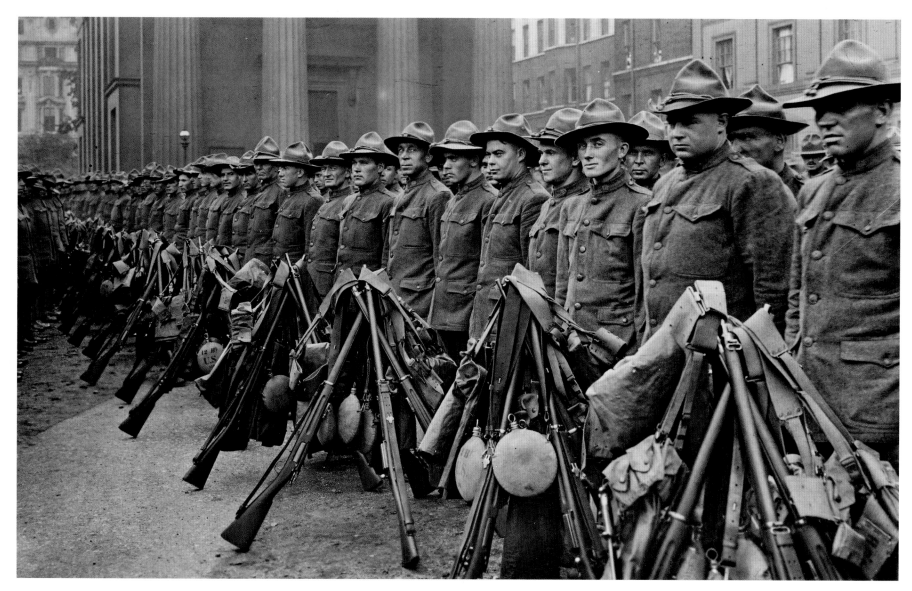

First American Contingent of the War, Wellington Barracks, 1917

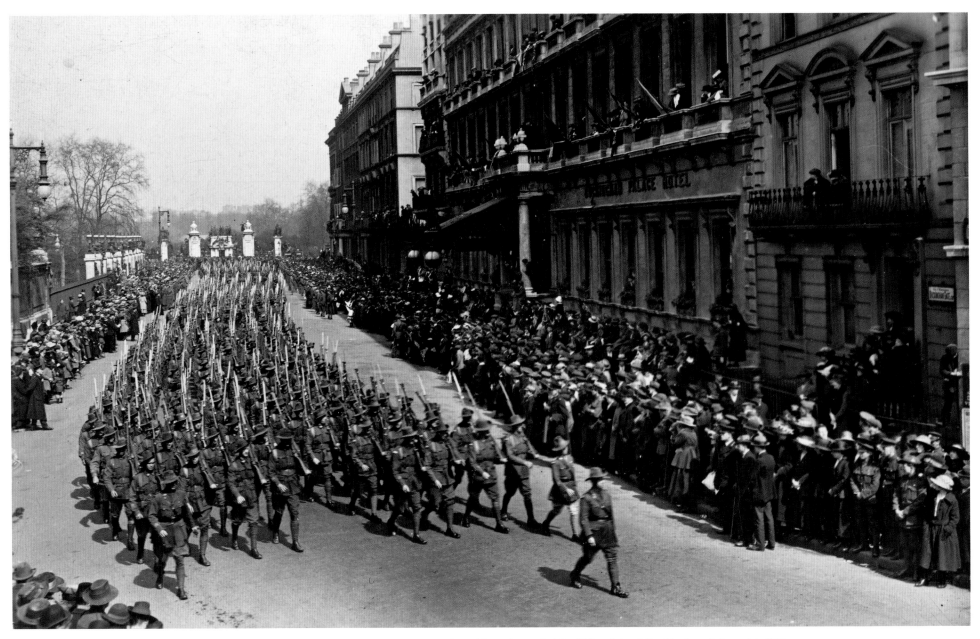

Australian troops marching in the Peace Procession, viewed from the roof of the Riding School, Buckingham Palace, July 1919

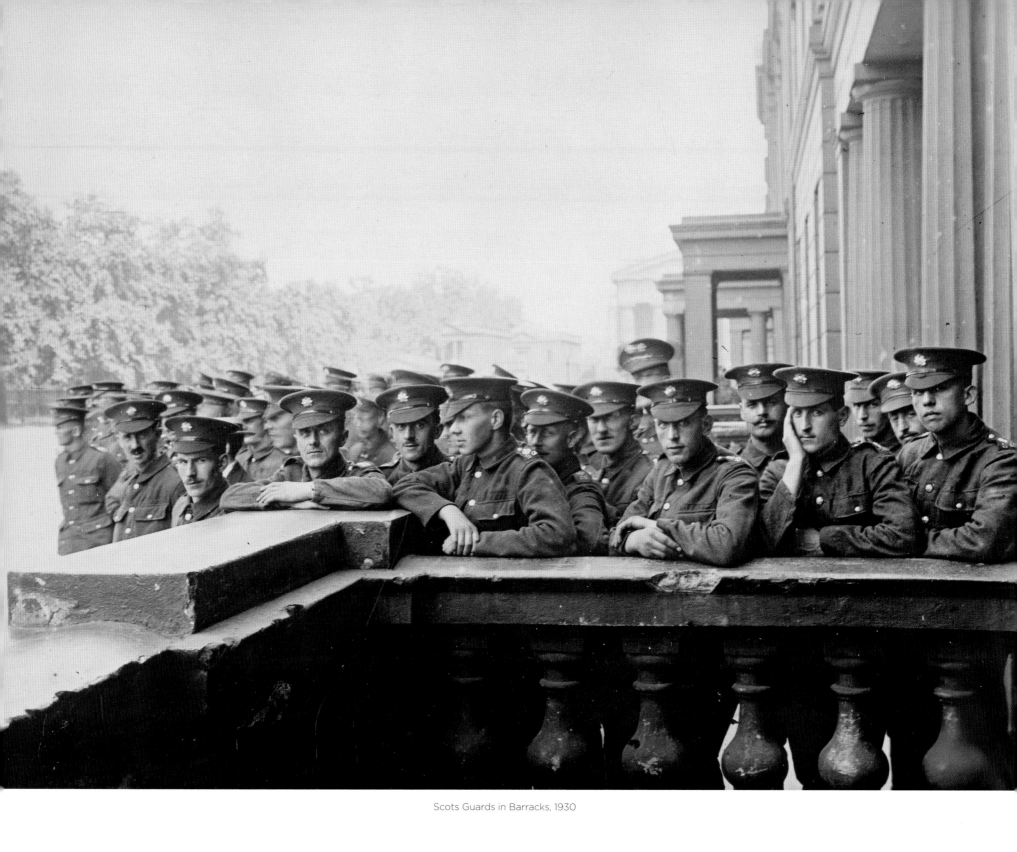

Scots Guards in Barracks, 1930

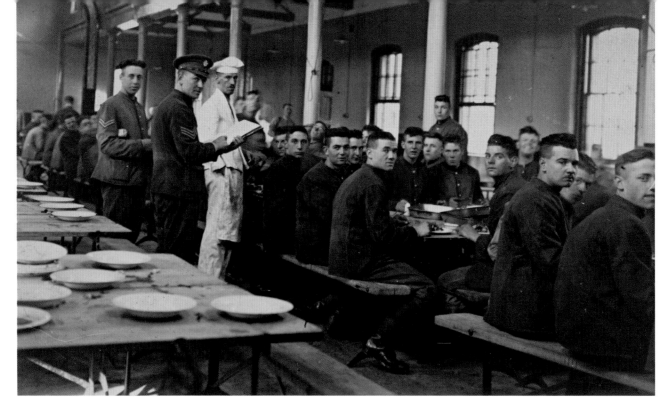

1st Scots Guards, Chelsea Barracks, Armistice Day, 1930

Former chaplains to the Guards, before the unveiling ceremony of the Guards Memorial, photographed at Wellington Barracks, 16 October 1926

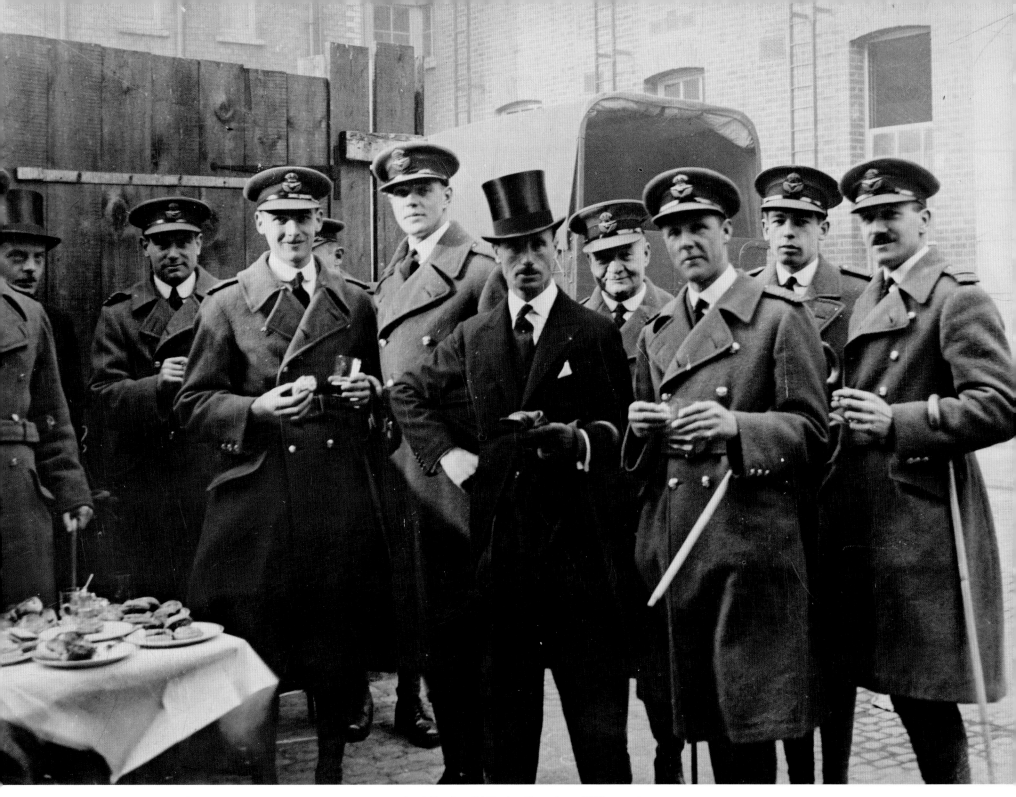

Armistice Day, Wellington Barracks, c. 1920

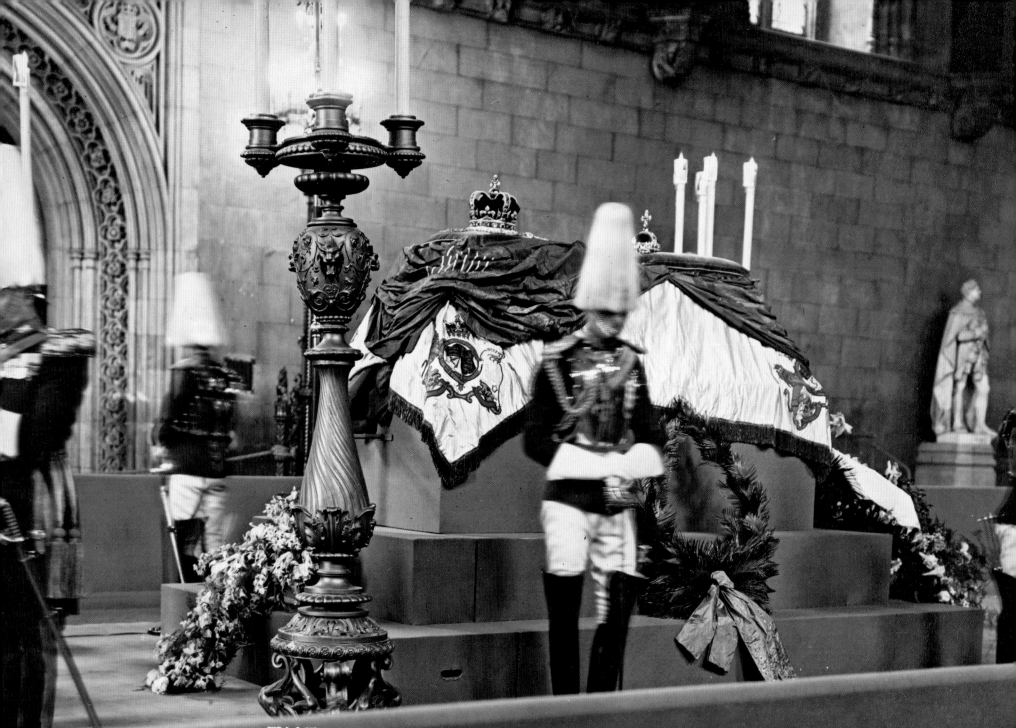

THE LYING-IN-STATE OF KING EDWARD VII.
WESTMINSTER HALL, MAY, 1910.

FROM ROYALTY TO RACING

MRS ALBERT BROOM PHOTOGRAPHS THE
SPECTACLES OF LONDON

Anna Sparham

THE LONDON THAT CHRISTINA BROOM KNEW and embraced as she embarked on her ventures with photography in 1903 would profoundly shape her ambitions, subject matter and way of working. Tradition, pageantry and ceremony, in keeping with the era, interweave Broom's work. This might be deemed fairly conventional. Yet her compositions, approach and the access she determinedly obtained, indicative of this photographer's strength of character, define and distinguish her images from the work of her contemporaries. Collectively, they demand the viewer to linger a little longer, and to consider in context the woman behind the camera.

As a mother and wife, Broom took up the reins of her family's prospects when her husband's capacity to work was unexpectedly curtailed. The cricket accident Albert suffered in 1896 had left him struggling with necrosis of the tibia and fibulae bones. The Brooms needed to generate an income and to provide for their daughter Winifred, although fortunately her age would prove enormously beneficial to the imminent family trade. Hopeful of a financial solution, they opened a stationers shop at 87 Streatham Hill in middle-class suburban south-west London. Selling general postcards with relative success, they identified further potential opportunities with this humble form of cheap visual communication. The picture postcard

business was emerging as a thriving ubiquitous industry.

The testing circumstances in which Broom found herself, with the decline in her husband's health and an entire change of circumstance now as a working woman, stimulated her independent and resourceful qualities. At first indirectly, and soon personally, she inventively turned to the camera as a commercial avenue. Broom instigated this pursuit by acquiring copyright in other photographers' existing pictures in order to publish them as block-printed, and later real photographic, postcards. The Brooms would sell these from their shop and to bulk order.

Royalty featured in this work right from the beginning. Broom could not have foreseen then the professional relationship that would later develop between the royal household and herself as a photographer in her own right, which she would go on to nurture and respect throughout the years. Among these purchased images is a group portrait including King Edward VII, Queen Alexandra and the King and Queen of Italy by established photographers Robert Hills and John Henry Saunders (Fig. 2). William Slade Stuart made formal photographs of the Royal wedding in 1904 of Prince Alexander of Teck and Princess Alice. Broom appears to have purchased two of these to publish as well. She also included a photograph of Princess

Fig. 1 King Edward VII lying-in-state at Westminster Hall, 18 May 1910

Fig. 2　Royal group portrait including King Edward VII and Queen Alexandra, photographed by Hills and Saunders and published as a postcard by Broom, c. 1904

Victoria of Schleswig-Holstein by Ernest Brooks, an appointed royal photographer and later official war photographer in the trenches at the Front.

Several images of society's leading personalities as well as notable events were added to the stock, for example a portrait by the renowned Bassano Studio of comic actor J. L. Toole. Broom must have become acquainted with some of these (active) photographers to drive business. The Brooms lived within reasonable distance of numerous studios and photographic establishments, particularly in Chelsea and South Kensington, the areas that Christina and Albert had both known intimately all their lives. Stuart, for example, had a studio at 162 Sloane Street, just at the end of the King's Road where Christina was born.[1] The political illustrator David Wilson, later chief cartoonist for *The Graphic*, was also commissioned by the Brooms to produce four illustrations published as postcards (Fig. 3). He was a neighbour and a customer in their shop.[2]

In an undated letter addressing Mrs Broom, Ernest Brooks writes with regard to a photograph of his own: 'if you care to have it for 5/- you may. I never as I said before let anyone else have anything under 10/6 the usual fee.'[3] This sheds some light on the important business relationships Christina was building in those formative days. It is also indicative of the respect that had grown for her.

The initial two years of the business were pivotal for the Broom family as Christina's work intensified. Her name wasn't built solely on the publishing of the work of others, of course. She made the immense personal transition to becoming a photographer herself

Fig. 3　Peace – the Russian–Japanese War, drawn by David Wilson, commissioned and published as a postcard by Broom, c. 1904

from 15 May 1903, when she documented the opening of the electric tramway at Westminster by the Prince and Princess of Wales (p. 6). Christina recorded the scene at a distance, the royal figures just recognizable; however, they are centrally framed within a clear and effective composition. Printed as a postcard, the image was typically enhanced by hand, but it does still reveal a promising talent for the complete novice she then was. Broom registered the copyright in her own creation 12 days later on 27 May.[4]

Christina's own work was inevitably influenced by that of other photographers also recording newsworthy events. Her awareness would derive partially from the grand state occasions of recent years – Queen Victoria's Diamond Jubilee (1897) and funeral (1901), and the Coronation of King Edward VII (1902). Photographs by the London Stereoscopic and Photographic Company, for example, would include the rituals of ceremony, mounted cavalry, carriages and crowds, recorded both from ground level and at height from nearby buildings. Such imagery would be familiar to Broom from the popular periodicals at least, even if not always reproduced as photographs. It is difficult to accurately determine the authorship in a few of her postcards; such is her gravitational interest in photographing subjects similar to the work of those she published. A scene depicting the royal carriage on its way to open Parliament in 1904 (Fig. 4), reproduced in *The Graphic*,[5] could very feasibly have been made by Broom as it resembles photographs she later creates around the Royal Mews. It is close to the action, showing good access to proceedings, with the carriage and figures playing their central role in the frame. This published image is uncredited, and an existing original postcard, while bearing the Broom name on the front, is not stamped with 'published and photographed by Mrs Albert Broom' on the reverse. If it were indeed Broom's image, it would be an unlikely, very early successful submission to the press by her. Her topical photographs would be distributed as news postcards, rather than in the printed press, for a while to come.

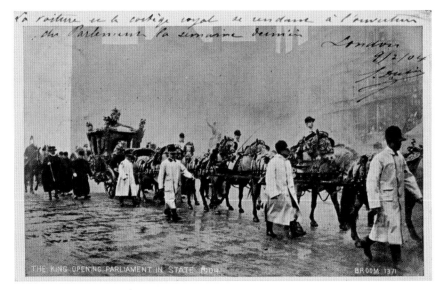

Fig. 4 The State Opening of Parliament, published as a postcard by Broom, c. 1904

Winifred was also fascinated by photography, teaching herself how to use a camera and the chemistry of printing. It is not surprising that either mother or daughter should wish to experiment with the medium, given the increased popularity among women of the camera as a recreational pastime. This was spawned by the marketing drive towards women by leading global camera companies in the late Victorian and Edwardian period alongside the production of less unwieldy equipment. Even Queen Alexandra would have her work published in a supplement to *The Graphic* as a most keen enthusiast, exemplifying the acceptance of photography as an activity for women. However, at the age of 40, entirely self-taught but for the recent exposure to other photographers, that Christina should turn to photography as a business enterprise, and not merely a hobby, is remarkable. It is even more exceptional considering she did so outside of a studio, which would have been a more plausible and proven route to take for a woman interested in the field.

Broom had sat before studio portraitists earlier in life, photographers to the crown W. & D. Downey included. Yet it was the street, out of necessity, drive and chance, that became her studio, followed by the less accessible military barracks, Royal Mews and Windsor. This was a financial and practical reality for Broom involving no major overheads compared to the expense of leasing studio premises. She even used a second-hand camera until she eventually bought her own in 1911. The home darkroom could be set up reasonably affordably, adverts for the necessary equipment being found in numerous printed magazines and theirs would be located in the coal cellar, from where Winifred would in fact undertake the majority of printing.

Despite Broom's parents' comfortable lives, her father's position as chairman of Chelsea Vestry, and her earlier associations with the likes of Oscar Wilde, Albert and Christina were not particularly well connected socially. Kate Pragnell, an established woman photographer operating a studio in Sloane Street until her death in 1905, commented with regard to aspiring women studio photographers:

I suppose a girl fortunate in the possession of a large circle of friends and acquaintances, starts with a considerable advantage over the beginner, who can hope for no ready-made connection.[6]

In a London increasingly saturated with studios, where many failing photographers would be superseded by others and several would end in bankruptcy, such a network would be deemed a necessary survival tool. However, Broom's principal breaks in fortune were achieved through her sheer boldness, perseverance and skill rather than by connection.

Accessing content to record in and around the locality she knew so well must have felt, to a degree, controllable. Born of both necessity and character, her entrepreneurial attributes were also likely to have been buoyed up by the surrounding geographical and sociological environment. In a new era, under the reign of King Edward VII, London was rapidly transforming. Furthermore, Broom was living in an increasingly progressive, albeit challenging, period of change for women, with regard to social status and aspiration. She took up her camera just as support (and condemnation) for the women's suffrage cause began to present itself more publicly. The capital inevitably took centre stage, and Broom would seize the opportunity to beautifully document this prior to the campaign's more turbulent twists.

Broom focused upon the immediate vicinity of her home and what was reasonably accessible by public transport. Her gamble with the business of photography was initially more achievable for her if working with the nearby and familiar. Living in Burnfoot Avenue and eventually Munster Road in Fulham, roads described by Charles Booth at the turn of the century as 'fairly comfortable',[7] the Brooms were not too physically distant from the more affluent districts of central London. This would contribute to the content she perceived as her objective in making commercially appealing, aesthetically pleasing imagery for an eager market.

There were plenty of obstacles to overcome even there, however. Establishing the techniques and conquering the apparatus was one; having the nerve and ability to take these skills into the street, publicly projecting herself as a 'professional photographer', and most significantly as a woman, was another.

Historic and new attractions lay close by. Broom recorded traditional leisure pursuits, from relaxing in the Royal Parks, through to visitors attending the novel Earls Court exhibition. Cultural hubs, including those in Chelsea, were being expanded to include new theatres, hotels, restaurants and department stores from Knightsbridge through to the Strand. New construction and landmarks also attracted Broom, from extensive new housing

schemes to the Queen Victoria Memorial outside Buckingham Palace, unveiled before an invited crowd on 16 May 1911 (p. 196). And of course, Chelsea and Wellington Barracks were conveniently nearby.

The Royal Family was central to London, the main residence for the monarch, and visual perceptions of the capital were synonymous with royalty due to the many royal aspects, traditions and events it offers, both historically and as today. King Edward VII and subsequently George V were firmly and symbolically visible at London's heart and a royal presence in the city was profoundly well received by Londoners of all classes. Thousands watched Edward VII officially open the new Kew Bridge on 20 May 1903 (p. 19), Broom, using her borrowed camera, among them. Many more crowded the streets in 1911 for the Coronation of King George V, as indeed did she. The Royal Family, as it continues to be, was overwhelmingly topical, and the fervour surrounding it was unrivalled. Mrs Belloc-Lowndes wrote in 'Royalty in London', published 1903:

> It may be whispered that one of the most irksome duties connected with Royal life in London is that of being more or less constantly photographed. The portrait of a Royal personage is a valuable commercial asset, and this is more so than ever now that it is has become the fashion in illustrated papers to reproduce portraits of distinguished people.[8]

There was scope for the enthusiastic photographer, amateur or professional, to engage with such popular London occasions. The professionals, of course, had to find ways to disseminate their photographs and most importantly achieve work that stood out from the crowd. They needed to generate images that would be favoured for their style as well as their content.

Although it is not known precisely when, Ernest Brooks aided Broom by teaching her a few photographic techniques. Brooks wrote to her:

> I am extremely sorry for you having so much worry. I thought it must of [sic] been something like that for you to make a mistake. Hope you will soon be alright. It warrants a good nerve I know.[9]

Broom will undoubtedly have benefited from his expertise – not solely in receiving guidance and empathy in grappling with the broader sphere of the commercial photographic industry, but also because she had found herself within such similar circles as Brooks relatively quickly. While the mistake Brooks refers to isn't known, it is likely there were many that would challenge Broom along the way. One such occasion came when photographing the Tourney at Earls Court in 1912, when she accidentally overheated the negative plates while developing, ruining them in the process.[10] A good reputation would award her necessary access to events, and this it seems was sustained long term regardless of occasional mishaps.

Winifred, long after her mother died, related an account of how fortune and repute played their part in securing Broom her enviable royal ties in the first place. In 1904, having already achieved incredible access to the Household Division, Broom attempted to photograph the King's new horse, Kildare, who was present at Chelsea Barracks. Conscious of the commercial popularity of such a print, she was, however, immediately stopped by the King's Groom, Mr Green. Instead, Broom could only leave him her business card. Winifred describes how, the next day, the Groom spoke to the King about the encounter:

> 'Mrs Albert Broom' – that's the woman Roberts told me about. Thinks she could photograph my horse, does she? Well, let her try to, in the Mews. I wonder what mess she will make of it![11]

As one of several retrospective versions, the words may be an inaccurate interpretation of events, yet the citing of Earl Roberts,

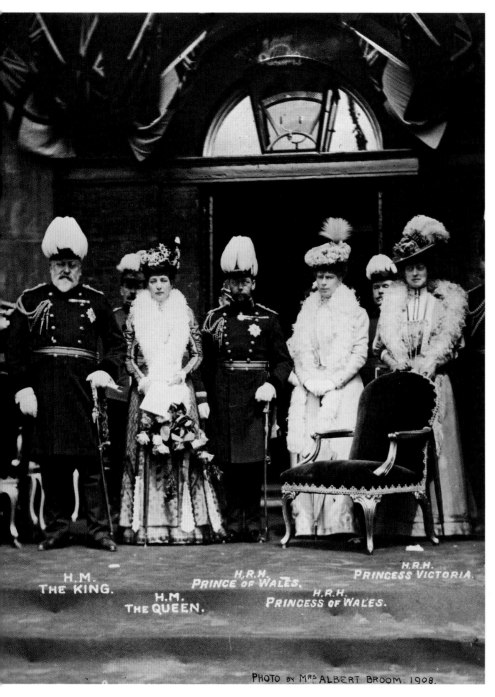

H.M. THE KING.

H.R.H. PRINCE OF WALES.

H.R.H. PRINCESS VICTORIA.

H.M. THE QUEEN.

H.R.H. PRINCESS OF WALES.

PHOTO BY MRS ALBERT BROOM. 1908.

Fig. 5 A royal group portrait during a state visit to the Duke of York's School, 1908.
An exclusive Broom photograph

a hugely influential figure in the development of Broom's career as an army photographer, was appropriate and the outcome the same: Edward VII granted Broom permission. The results sufficiently impressed, and she was subsequently granted frequent privileged access to the Mews. The enormity of this opening for Broom is evident. To her extraordinary advantage she now had the freedom to photograph the comings and goings of people, horses and carriages within the grounds of Buckingham Palace: 'Everybody poses for Mrs Broom, from the Prince of Wales to the stable boys.'[12] During the season she twice weekly erected a small stall at the entrance to the riding school beside the main gate, selling her prints to the public. As Winifred comments, 'In short – Mother was "in".'

Indeed, Broom received royal endorsement, and trust in her work led to numerous photographic opportunities. Approval from the Crown extended to the acceptance of her prints into even Queen Alexandra's, Queen Mary's and later the Duke of Windsor's collections. This was most often by gift, both during and after Broom's lifetime, but they also evidently were occasional consumers,[13] despite Broom's defiant unease with what she saw as one reporter's disrespectful positioning of the Royals: 'Customers indeed! That is a nice way to speak of one's King and Queen!'[14] Queen Mary's personal photograph albums, annotated by her own hand, include, for example, Broom's enchanting records of the tea parties held for the war wounded at Buckingham Palace (p. 211) and the striking portrait of the Duke of Teck, Queen Mary's brother (p. 114).

Broom attended royal engagements where possible, often with visiting foreign monarchs and other dignitaries present, from Kaiser Wilhelm II to Winston Churchill. The earliest opportunities only permitted photography from a less than ideal distance, but as her status grew, she closed the gap. In 1908 she obtained her first exclusive royal group when asked to photograph a state visit to the Duke of York's Military School in Chelsea, now in Dover (Fig. 5). While not the immaculate composition, considering foreground and

background, that other experienced photographers of royal groups might have achieved, Broom has evidently directed the attention of the party towards her, most notably that of the King and Queen. The foremost figures arranged at the front are balanced to create a robust image, weighted centrally by the future King George V, particularly in her cropped rendering of the original landscape frame. The fineries of the uniforms, dresses and hats, although partially through overexposure, leap out to catch the eye and meet the deftly annotated names.

Another important exclusive came in 1914 with a portrait of the Prince of Wales, then aged 20 (Fig. 6). The intimate portrait suggests an ease with the photographer, even if the occasion remains formal. Broom captures a youthful face, complete with an inescapably earnest expression, as the Prince directly engages the camera within a close, tight frame. Such a young man bearing the gravity of a full war kit makes for a striking visual contrast. On the outbreak of war, he was made Second Lieutenant of the Grenadier Guards and attended Knightsbridge Barracks for training. However, the Prince was never permitted to fight at the Front. Broom respectfully documents him, including on a route march to the Wimbledon Common camp and exclusively on the only occasion when he acts as paymaster to the Guards. While obviously vital to these images, with the exception of the solo portrait Broom photographs him without interfering, simply recording his activity in context. This exemplifies her ability to work as a spontaneous recorder, as she did out in the street. In another picture she makes of him at the Royal Mews in 1919 the Prince exudes confidence (p. 218). There is a strong suggestion of mutual respect as he appears comfortable with the familiar woman behind the lens. Although so often in front of a camera, it is worth considering that most women photographers the Prince would encounter by then would be in the formal studio, being photographed by portrait artists rather than press photographers. Or, of course, it might be the

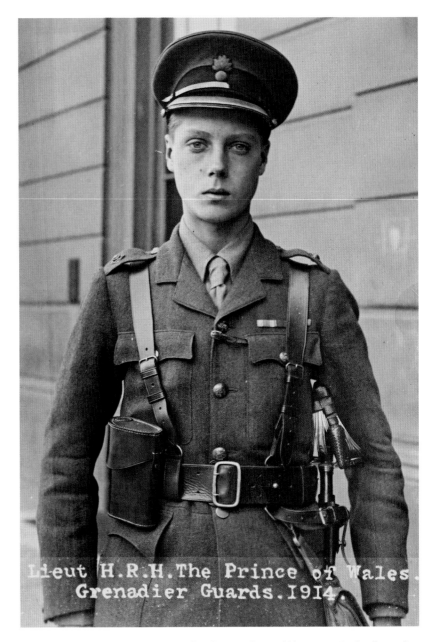

Fig. 6 Portrait of HRH The Prince of Wales as a Second Lieutenant in the Grenadier Guards, Wellington Barracks, 1914

informal lens of his mother. Either circumstance would influence the way he would act in front of a camera. The Prince 'was always very nice to me … always liked my pictures', Broom claimed. A walking stick he had used when marching to Wimbledon Common was later presented to her. She treasured it.

The majority of Broom's photography clearly shows that her primary interest lay in recording people rather than place. Even her topographical depictions are enhanced by her inclusion of people, even if incidental. In her direct portraits she avoids discriminating between hierarchy and class, instead treating each individual in a similar way. Given her ardent loyalty to the Royal Family, perhaps more accurately she chose to project each of her subjects as equally eminent. Portraying people attractively and prominently, in as positive a light as possible, held commercial value. Business intentions and esteem for royalty aside, Broom's approach suggests an egalitarian perspective when it came to photography. The back of one print supports this notion, reading: 'postcards, 2/- for king and soldier alike'.[15] Broom was a hard-working, determined and aspirational woman – qualities she also acknowledged and presented in many she photographed.

Broom excelled at the photography of groups of people or individuals in situ. She decelerated the moment, carefully composed, and attracted everybody's attention decisively but serenely towards the camera. The many faces reflect a relaxed relationship between subject and photographer, despite the formality of occasion in most. Broom had an untrained eye, compared to the men and women who studied the field. Awareness of this could have hindered her in the earliest days, triggering a conscious fear of expectation and failure. However, her naivety arguably contributed to her success. The pictures are unpretentious, their straightforward nature adding to their strengths. As confidence increased, this apparent openness towards her grew further.

Broom's photographs of individual soldiers, postilions and coachmen at the Royal Mews do not include any additional feminized details, which one might expect to see in the work of some female studio photographers; there are no affixed softening props such as flowers, textiles or artificial lighting. They are straight, orderly records placing the subject centrally as the main focus. Through her crafting of eye-to-eye contact, as opposed to a staring pose looking away from the camera, Broom captures something of her sitters' personality in conjunction with the role that each is playing

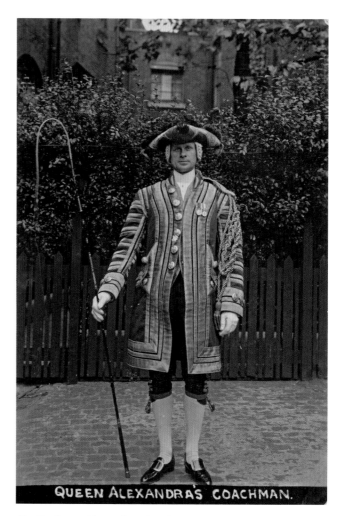

Fig. 7 Queen Alexandra's Coachman, at the Royal Mews, c. 1908

officially (Fig. 7). Strip away the pomp and ceremony represented on the surface – the rich fabrics and brocade, the buttons, hats and meticulous layers of tradition – and you witness a skilfully and gracefully presented idea of the person behind that façade, subtly captured through their facial expression. The photographs are also important as historical documents, depicting specifics of uniform, custom and decorum, on which Broom became something of an expert. The expectation from such a subject might be to see a more prescribed, disconnected response to the camera. However, this is diminished. The mutually fond and longstanding relationships between this intriguing and rare woman photographer and her often male subjects shine through.

As a commercial London photographer with privileged access to royalty, state funerals and coronations unsurprisingly feature among her work. At these huge events, Broom had to be able to compose herself in the commotion, act swiftly and expertly, and produce results. Her small stature and the debilitating back pain she suffered with advancing years most definitely would have added to the challenge. In 1926, when asked, 'How do you get through the London crowds with your camera, say for example in the big crowd like that at the unveiling of the Guards Memorial last Saturday?', Broom confidently replies, 'Walk through.'[16] Her self-assured, nonchalant response is indicative of her character, and the role she saw herself fulfilling, rather than taking account of the reality of shifting about cumbersome camera equipment and glass plates, in ankle-length female attire.

One of the most important moments, in terms of her career as a serious topical photographer, came at Edward VII's death. As she had worked so closely with the King, the enormity of his passing must have had a great personal and professional impact upon her and Winifred. She sought authorisation from the Ministry of Works to record the King lying in state at Westminster Hall (Fig. 1, p. 166). On 18 May 1910 members of the press were permitted entry for one hour at 6 a.m., before the doors opened to the public queuing in their thousands. Broom, however, was among the very first there and instead allowed entry at around 5 a.m., accompanied by the respected amateur photographer Sir Benjamin Stone.[17] That Broom was permitted the same access as Stone, who as a Member of Parliament was often awarded the unique privilege of recording key people and events, says much about the regard in which she was held at that time. Like Stone with his large plate camera, Broom stood up to the pressure, managing the limited and contrasting light inside the Hall sufficiently to make several good negatives. She proceeded to print and sell many hundreds, as listed in Winifred's order book that year.[18] On the day of the funeral itself her permit to photograph states that she could stand at the Royal Artillery Boer War memorial, on the corner of Horse Guards Parade and The Mall.[19] Additionally, it was requested that Broom photograph the cortège passing through Horse Guards. A window was removed and a platform even built for the best vantage point. Both Christina and Winifred, who in fact ultimately made the stronger photograph (p. 192), lay awaiting the moment. Whether these photographs were reproduced in the printed press is uncertain. The heavily illustrated periodicals and newspapers from the *Daily Sketch* to the *Illustrated London News* carried a multitude of images marking the King's life and death.

Broom did, however, succeed in having royal-related photographs printed in the press at later times. For the Silver Jubilee, she saw an extensive ten photographs printed in a special supplement of the *Daily Sketch*, on 1 May 1935. Her photograph of the Prince of Wales standing framed within the architecture of Wellington Barracks graced the *Tatler* in July 1934 (p. 225). Broom had found her way into the newspapers more frequently through her imagery of the Guards, particularly during the Great War.

Aside from royalty and the military, her press printed images also came from the less momentous yet newsworthy annual Oxford and Cambridge University Boat Race. Once again, Broom's proximity

Fig. 8 The Cambridge University crew with Mrs Albert Broom, their
photographer for 34 years, 1936

to popular goings-on benefited her. Her boatbuilding friends in
Putney – William Sims, known to Winifred as 'Uncle Bill',[20] and
Bossy Phelps – were both heavily involved in the Boat Race; Broom
became a cherished photographer to the race for over 30 years
(Fig. 8). Winifred noted of Bossy that the 'kettle always boiled at his
boathouse, where all and sundry – oarsmen, press and friends were
always sure of welcome'.[21] Broom was very much at the heart of the
action. In just a few seconds of film footage made at the race prior
to the war, she appears. This enticing glimpse, although without her
camera, shows her conversing with others, walking stick in hand. The
exposure briefly discloses her demeanour and prominence among the
other (male) photographers, race organizers and oarsmen. She seems
very much a part of the scene.[22]

These photographs are often made from the water's edge (Fig. 9).
Broom positions herself close to the participants, not usually
incorporating the broader activity. The oarsmens' faces are clearly
identifiable, complete with the glow of ambitious anticipation. Still,
flat water depicted in some of these photographs adds tension to
the scene. An empathy is created, arising through the focus on the
oarsmen alone and the surrounding water, and the removal from
the immediate thronging crowd of spectators. Broom's approach
informs through achieving the necessary access and familiarization
with the teams. Ever commercially minded, she intends to reproduce
a particular print and postcard; she aims for a better angle than the
amateur snapper positioned further back in the crowd, or some of
the professional press photographers targeting the race underway
or at the finishing line. However, the future film producer and
director Alexander Korda,[23] a press photographer in 1912, appears,
like Broom, beside the water, and framed within two of her images
(p. 204). Winifred writes on the back of one race postcard in 1912:
'dear father had died and we were penniless'.[24] Whatever the reality
of their financial situation, these two women were pursuing their
photographic efforts with even more determination.

Only months after the 1914 race, 17 of the 18 oarsmen that Broom
photographed had crossed other waters to fight in the trenches of
the Great War. Oxford's Reginald William Fletcher died at Ypres in
1914, aged 22. From Cambridge's team, four perished. Dennis Ivor Day,
tragically shot through the eye at Vermelles in September 1915, was
brought back to St Ives by his parents, but died from his injuries in
October, aged 23. John Andrew Ritson followed him in 1916, aged 24.
Kenneth Gordon Garnett, 25, and the cox, L. E. Ridley, 23, were both
killed in 1917.[25]

Broom's solo oarsmen prints demonstrate, as do many of her
soldiers, suffrage supporters and royal staff photographs, her strong
capabilities as a portraitist. She seizes the young men's distinct
characters, loaded with personality, in crisply sharp, intimate poses.

These include, in 1923, her cousin, P. G. Livingston, standing with Ritson and Andrew Irvine; the latter died only the following year during a Mount Everest expedition alongside George Mallory (Fig. 10). Looking at these pictures it is difficult to separate the sitters' eventual fates, adding to them as we do through nostalgic hindsight a sense of foreboding. The sheer contrast between the jubilation of a competitive race and the brutality of the First World War is then particularly apparent, undoubtedly making them all the more poignantly powerful.

Aside from their war relevance, these photographs are important as informal views of high society. Press photographer Horace Nichols,

a contemporary of Broom, often candidly documented such echelons of society. His clever and revered images present an informative and relatively objective reflection of people, caught unaware of the camera. Broom's approach, while contrasting with that of Nichols, created an equally authentic impression, whereby the individual was consciously able to react to both her and her camera. We are offered of each person an alternative image to that which would have been captured if they were off guard.

The Boat Race ceased during the war years, as did many other London entertainments. When it resumed Broom continued her alliance with it until 1938, only once employing another local

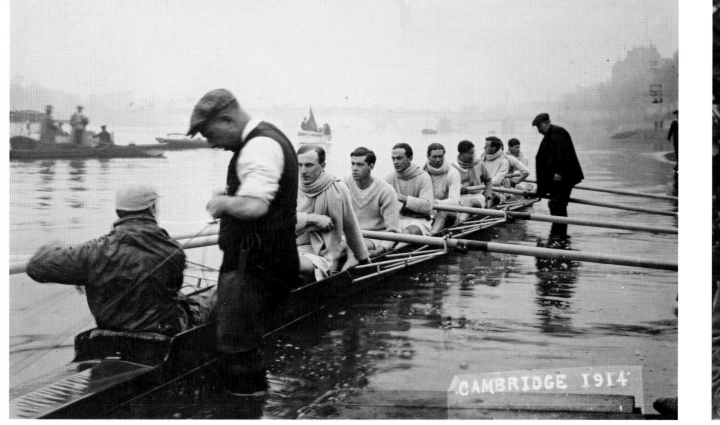

Fig. 9 The Cambridge crew shortly before the start of the Boat Race at Putney, 1914

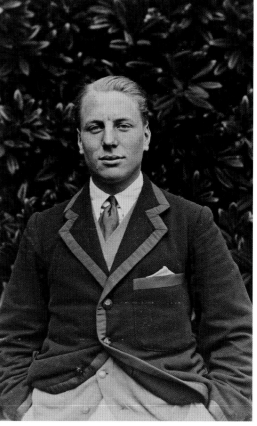

Fig. 10 Andrew Irvine, Oxford University Boat Race, c. 1923. Irvine died on Mount Everest the following year

photographer on her behalf when she was too unwell to attend.

Prominent personalities of the day were undoubtedly important for postcard sales. For Broom this included leading men, from explorer Ernest Shackleton to actor and theatre manager Sir Francis Robert 'Frank' Benson, and women from Suffragette leader Christabel Pankhurst (p. 75) to notable actress Cicely Courtneidge (p. 190). Commercial demand was of course there, and Broom was at ease photographing both the known and the unknown faces within this sphere. She was not a socially concerned photographer. She did not, for example, explore the backstreets to record London's poorer sections of society. This would fall to the emerging social documentary photographers such as Norah Smith, who would photograph scenes evidencing the work of the East London Federation of Suffragettes in 1914–15. Broom's photography also did not chime with those photographers armed with a social purpose such as Edith Tudor Hart and Cyril Arapoff, where political commitment shaped their portrayals of the East End; or, around 1902, the Reverend John Galt, who in order to raise money for the London City Mission recorded the poverty-stricken backyard industries of Whitechapel. Instead, Broom carved out her niche among an altogether different division of society, nonetheless representative of London's history. And she did so with real flair, to produce a 'dignified, static photography which dealt with grandeur and status, with organised pageantry and celebration'.[26] The range of her work traverses the idea of pageantry very neatly. Photographs of suffrage processions, ceremonial parades of the establishment and even the spectacle of the Boat Race come together with what Broom made of the Chelsea Pageant, the English Church Pageant, both 1909 and the Army Pageant of 1910, all staged locally at Fulham Palace.

The Chelsea Pageant was arranged to convey to a paying audience the history of Chelsea through re-enactment. Broom made some wonderful portraits there, most notably one of 'Queen Elizabeth I'; however, prints are scarce. At the Army Pageant,

Broom presents photographs in which history and time appear intriguingly and intentionally hazy. This Pageant served to illustrate 'the development of the Art of War among the people of the British Empire',[27] presenting re-enacted histories of battle. In the official accompanying publication, Field Marshal Earl Roberts described it as an 'historic and beautiful spectacle'.[28] Broom excels in her adeptness at choreographing clusters of people, gathering them from the action and directing them to face the camera. In the mesmerizing photograph of war maidens in AD 811 (Fig. 11), the participants gaze intently. The combination of expression, composition, representative costumes through the ages (as they are here, unlike soldiers' uniforms) and the subjects' empathy with the viewer make this atmospheric scene an important historical document in its own right.

Sir Benjamin Stone founded the National Photographic Record Association in 1897, inaugurated to ensure that photographs of landmarks and culture, among them historical folk customs, would be preserved for posterity. Stone contributed outstanding work himself, covering similar ground at times to that which Broom was negotiating commercially, including local pageantry. As an amateur photographer, Stone expressed the view:

> Anybody can be a good photographer, I doubt there is much skill in it. At all events, the difficulties are exaggerated. The worst of it is that people give it up because something has to be learned before any progress can be made.[29]

Simultaneously, however, as a man who placed much pride in the quality of his and others' work, he commented on the democratic existence of the postcard:

> Picture postcards have benefitted the mass of the people but the cheap representation of things has prevented fine collections from being made.[30]

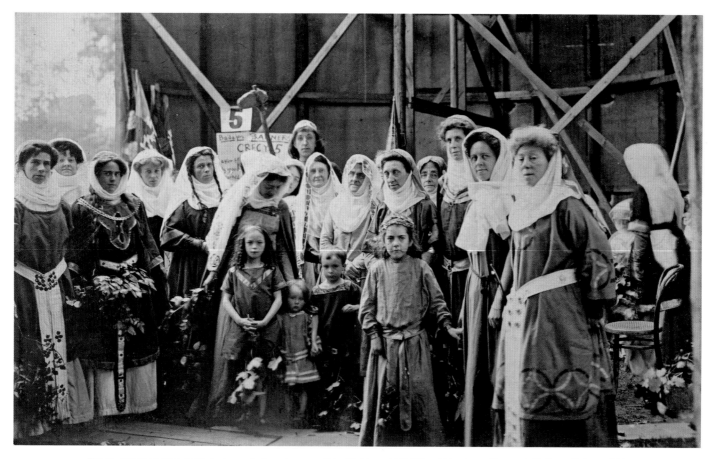

Fig. 11 Women and children in period costume as War Maidens (AD 811), at the Army Pageant, Fulham Palace, 1910

Perhaps Stone would have welcomed Broom's work and her unmitigated commitment, despite her predominant role as a creator of postcards. They share an eye for aesthetic composition and the spectacle, within the pageant pictures at least. Stone allows for more contextual content within the frame, but there are common features. Broom's approach and production methods, immersed in the creation of hand-printed photographs, suggest an appreciation of the relevance of photography beyond that of simple monetary gain, and one akin to Stone's.

With regard to Broom's photography of royalty, tradition and spectacle, although the subjects themselves indicate images worthy of note, she achieves something beyond the commemorative. Her people-focused, refreshing eye made consistently attractive yet intriguingly understated imagery. Her impressive photographs can appear remarkably contemporary at times, despite their historic bearing.

It is inspiring to observe that one of the royal subjects Broom photographed on several occasions, of whom she would circulate postcards throughout the years, should play a pivotal part in ensuring Broom herself was fittingly acknowledged and her work retained in perpetuity. According to Winifred, Queen Mary suggested that she put her mother's negatives into museums for safekeeping rather than they be stored hidden away.[31] Winifred willingly obliged, and Broom's historic oeuvre survives to be compared, contrasted and valued into the future.

THE LORD MAYOR'S COACHMAN

The Lord Mayor's Coachman driving the coach through the streets of London, c. 1905

The Lord Mayor's Coachman, 1905–6

Reverend G. H. Andrews and boys of the Duke of York's Royal Military School, 1906

City of London policemen in front of the Guildhall, 1906

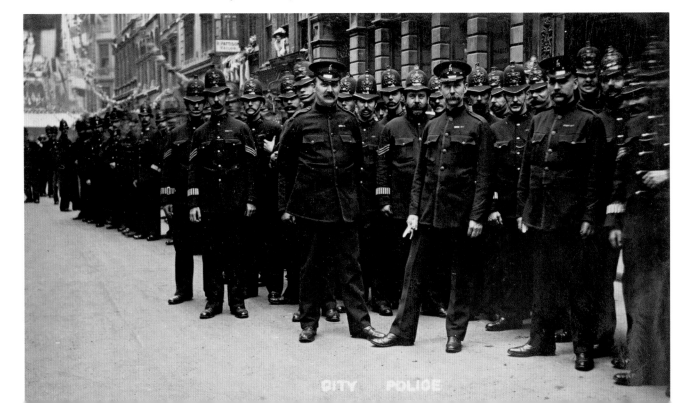

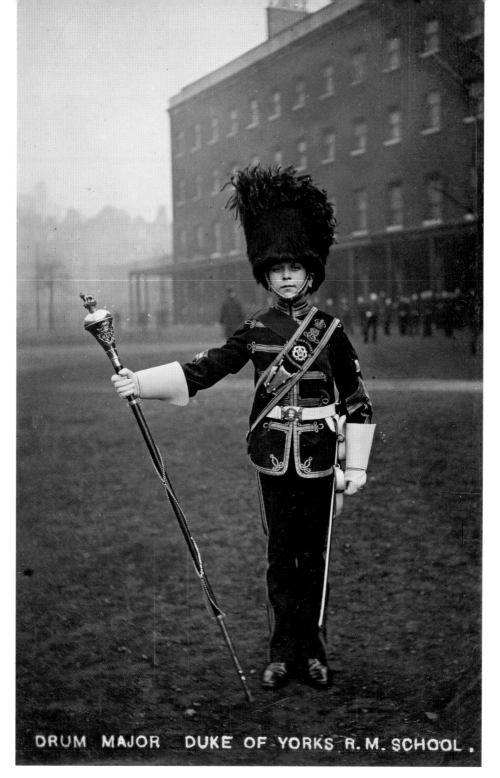

DRUM MAJOR DUKE OF YORKS R. M. SCHOOL.

Portrait of young Drum Major at Duke of York's Royal Military School in Chelsea, 1907

Men, women and children dressed in medieval costume at the Army Pageant, Fulham Palace, 1910

St George and a young knight at the Army Pageant, Fulham Palace, 1910. Mr Charles Ffoulkes plays St George

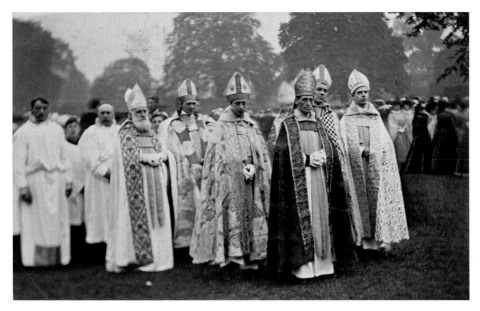

Procession of Archbishops in the English Church Pageant, Fulham Palace, 1909

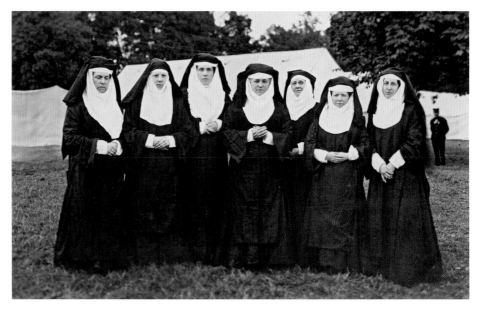

Seven women dressed as nuns at the Army Pageant, Fulham Palace, 1910

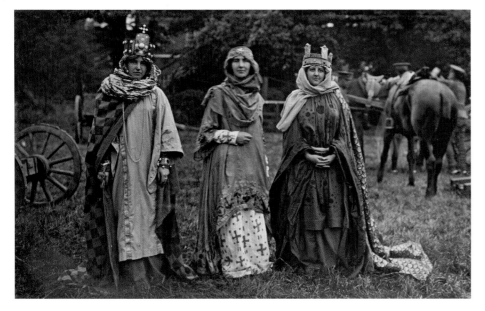

Women dressed as Ethelburga of Kent, possibly at the English Church Pageant,
Fulham Palace, 1909

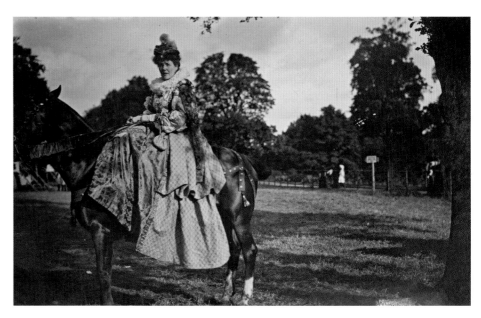

A woman in period costume on horseback at either the Chelsea Pageant or the
Army Pageant, Fulham Palace, 1909–10

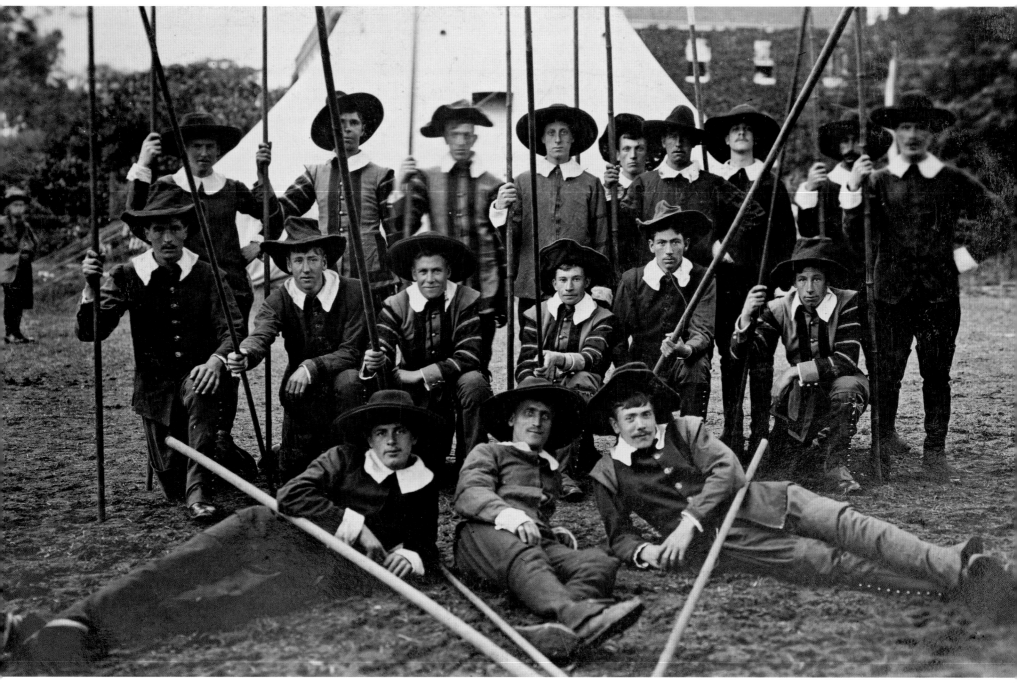

Men dressed as Civil War Pikemen at the Army Pageant, Fulham Palace, 1910

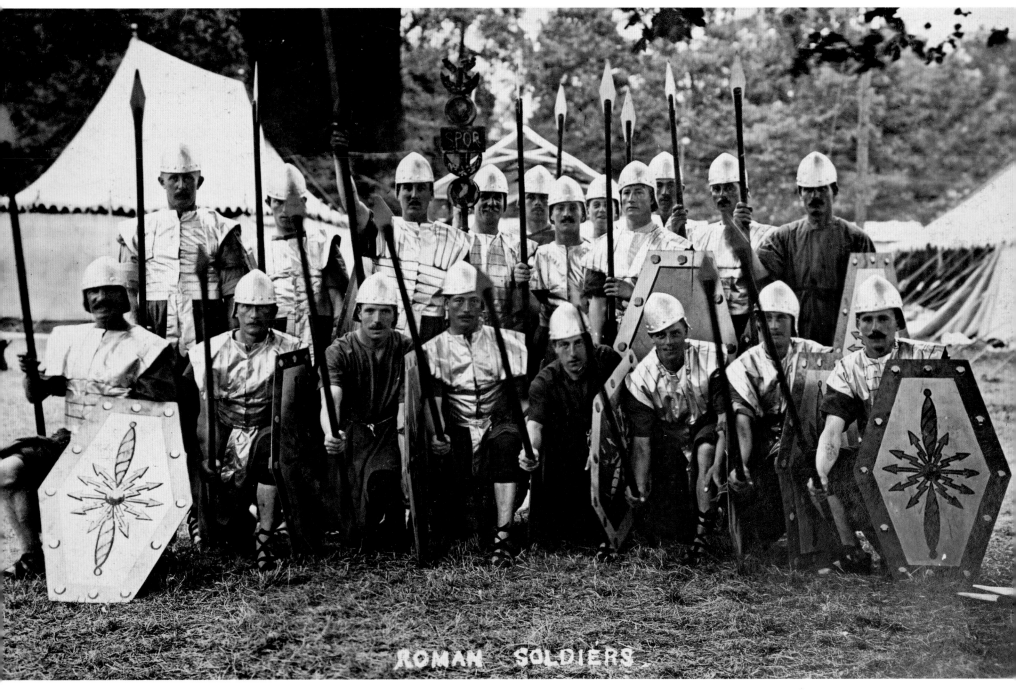

ROMAN SOLDIERS.

Men dressed as Roman Soldiers (AD 114) at the Army Pageant, Fulham Palace, 1910

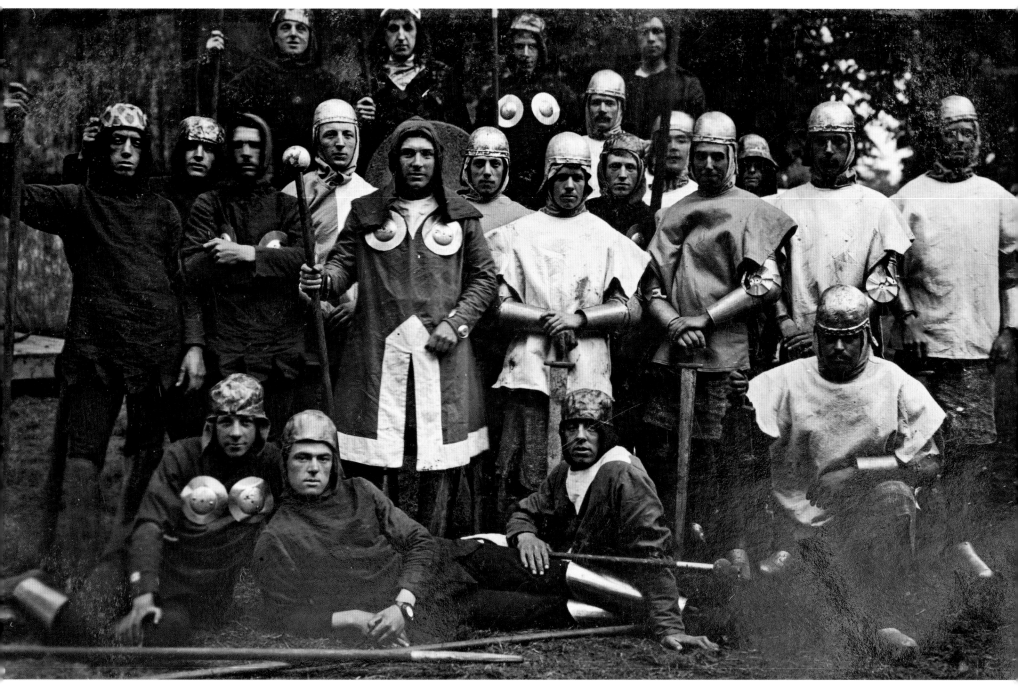

Men dressed as Spearmen (AD 1346) at the Army Pageant, Fulham Palace, 1910

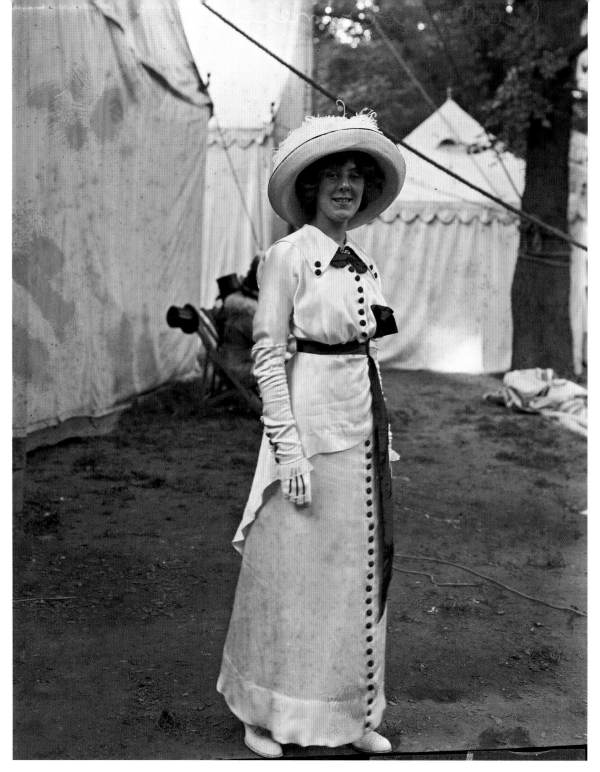

Esmerelda Cicely Courtneidge, possibly at a theatrical garden party, c. 1910

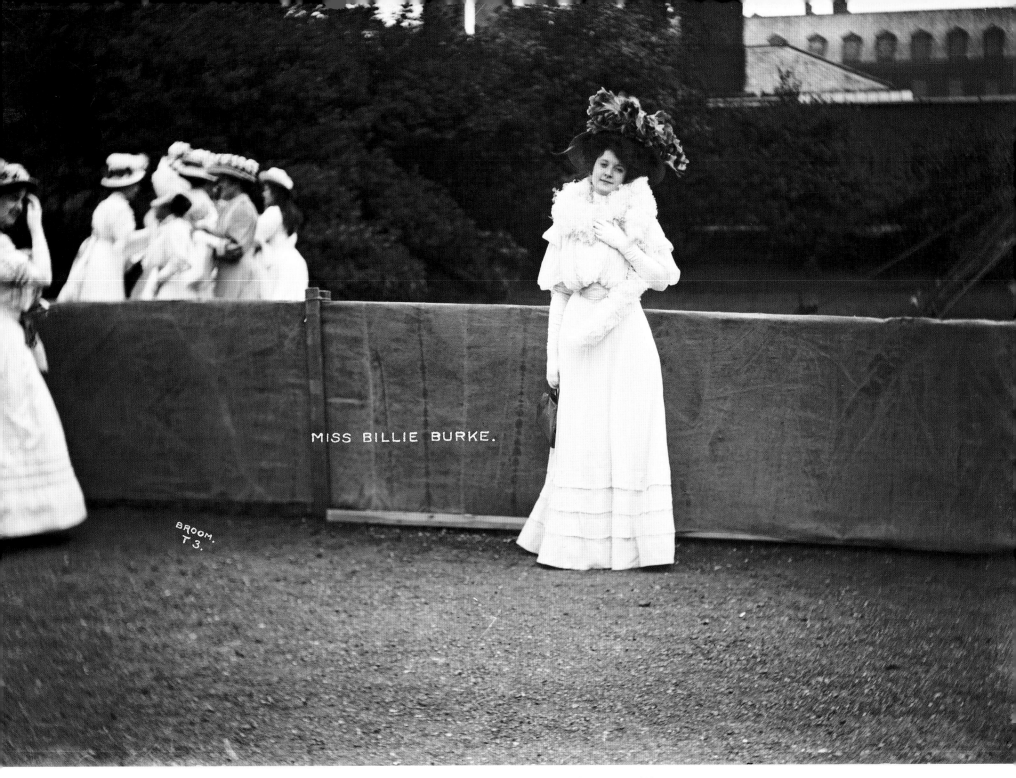

MISS BILLIE BURKE.

BROOM.
T 3.

Actress Billie Burke, possibly at a theatrical garden party, c. 1910

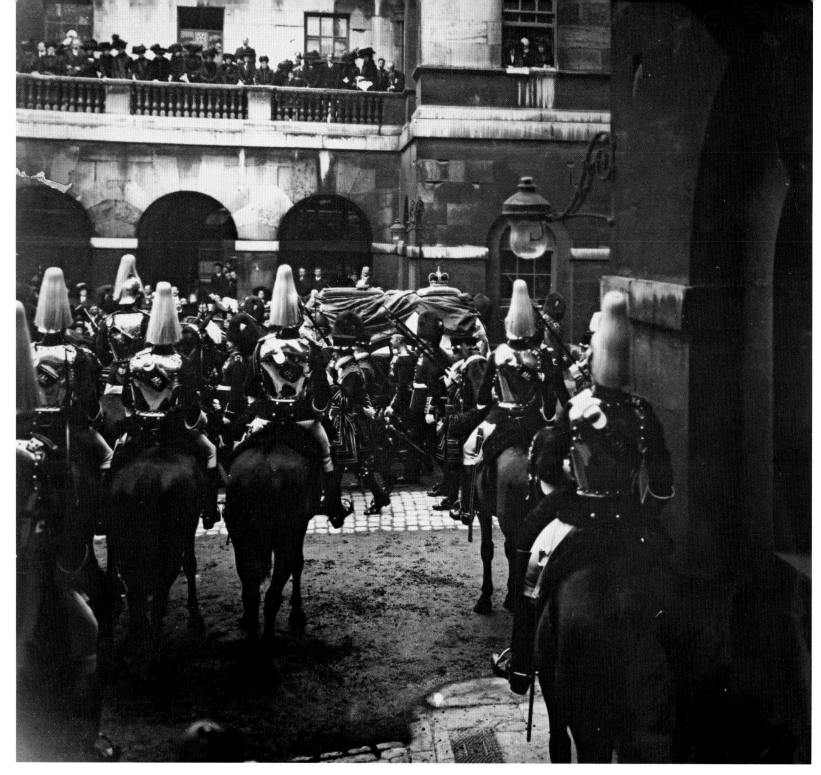

Funeral cortège of King Edward VII passing through Horse Guards, Whitehall, 20 May 1910

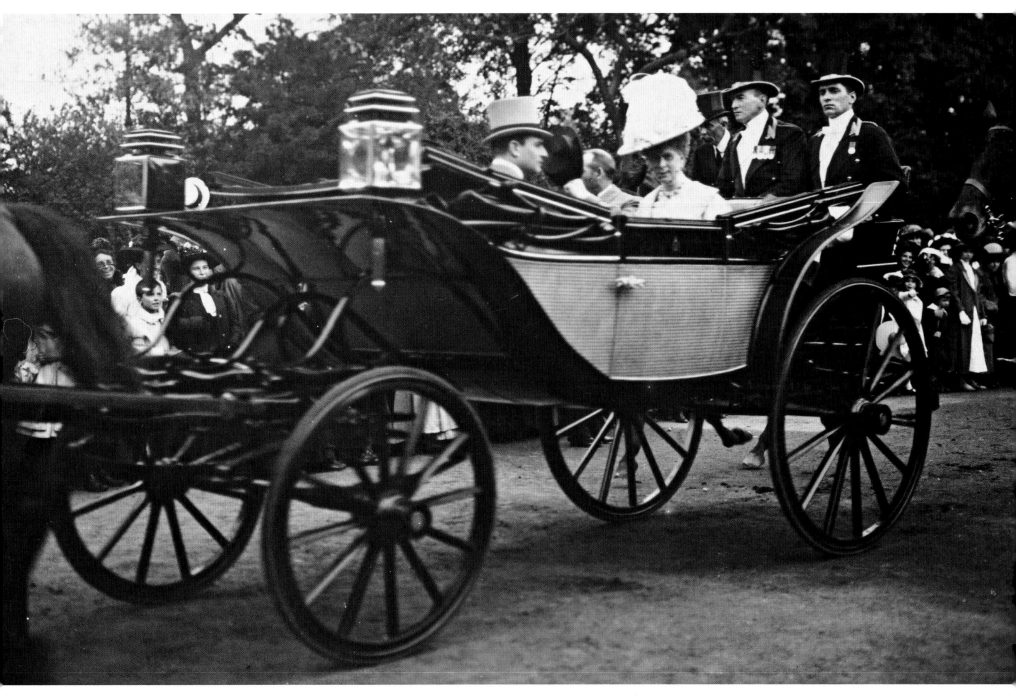

Adolphus Frederick, Grand Duke of Mecklenburg-Strelitz, Queen Mary and King George V ride together, 1913

Postilion at the Royal Mews, c. 1908

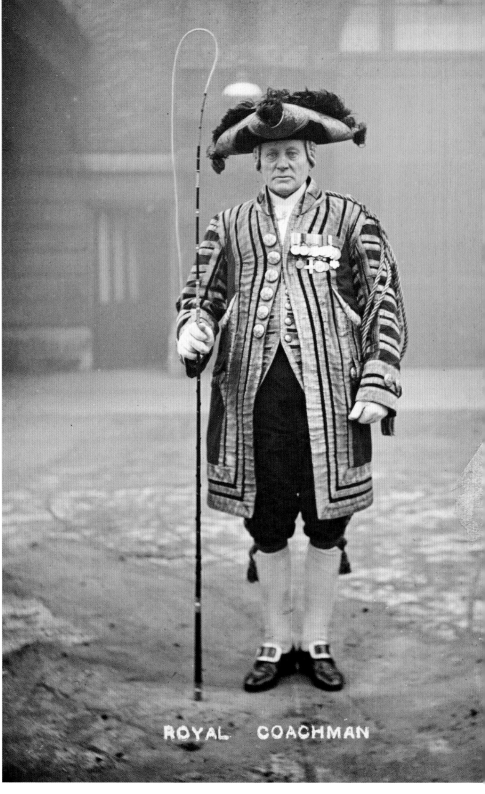

Royal Coachman at the Royal Mews, c. 1908

The largest stable in the Royal Mews, date unknown

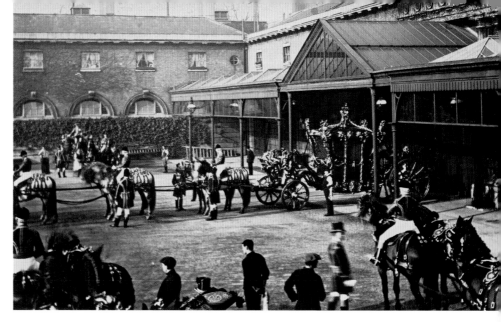

The King's State Coach at the Royal Mews, c. 1912

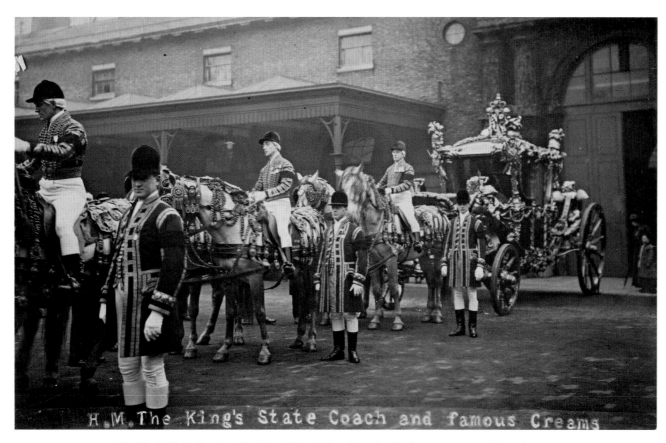

H.M. The King's State Coach and famous Creams

The King's State Coach at the Royal Mews being drawn by the famous creams, date unknown.
The Royal Hanoverian Creams, now an extinct breed, were reserved for royal duties

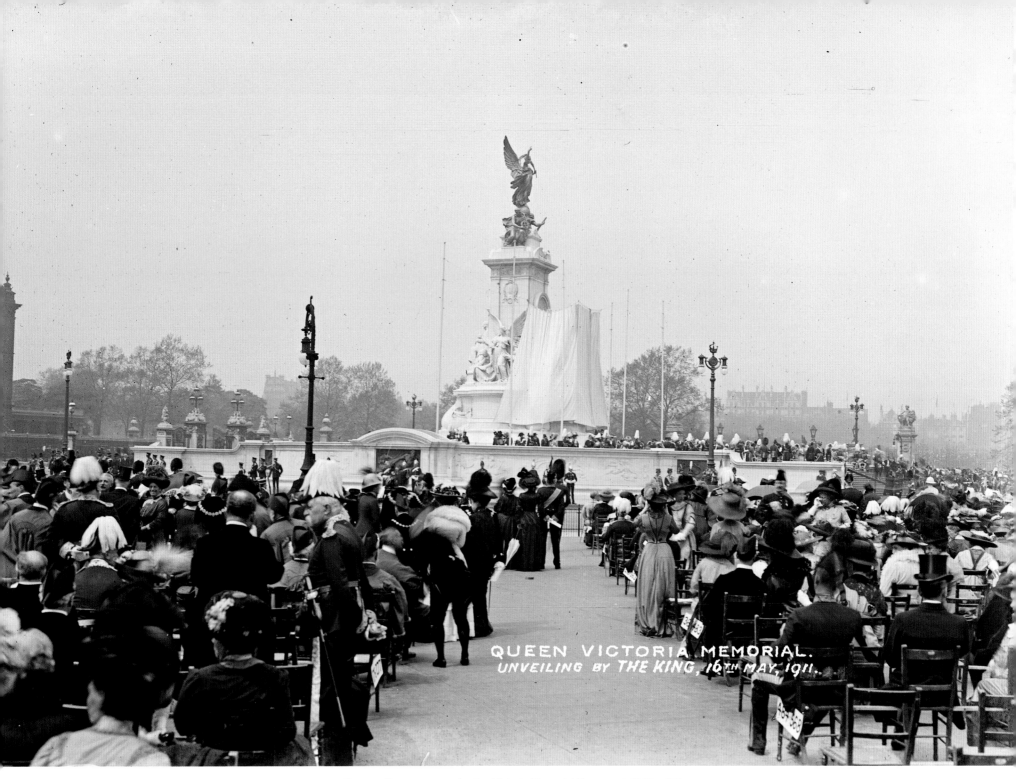

QUEEN VICTORIA MEMORIAL.
UNVEILING BY THE KING, 16TH MAY, 1911.

The unveiling ceremony for the Victoria Memorial Monument, 16 May 1911

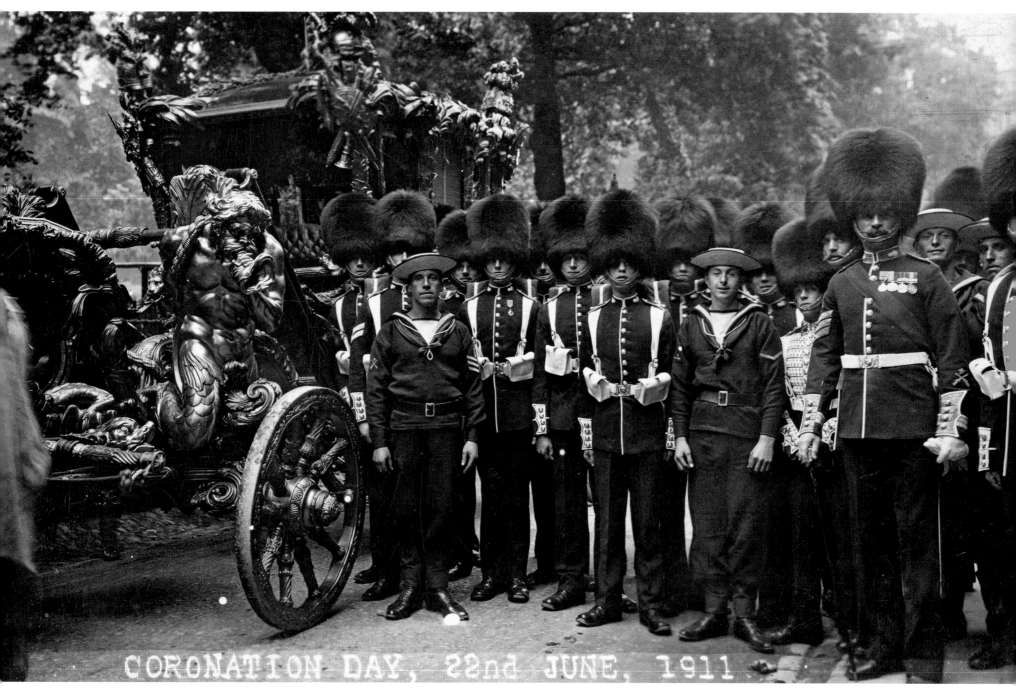

CORONATION DAY, 22nd JUNE, 1911

The King's State Coach on King George V's Coronation Day. Guards and sailors in the foreground, 22 June 1911

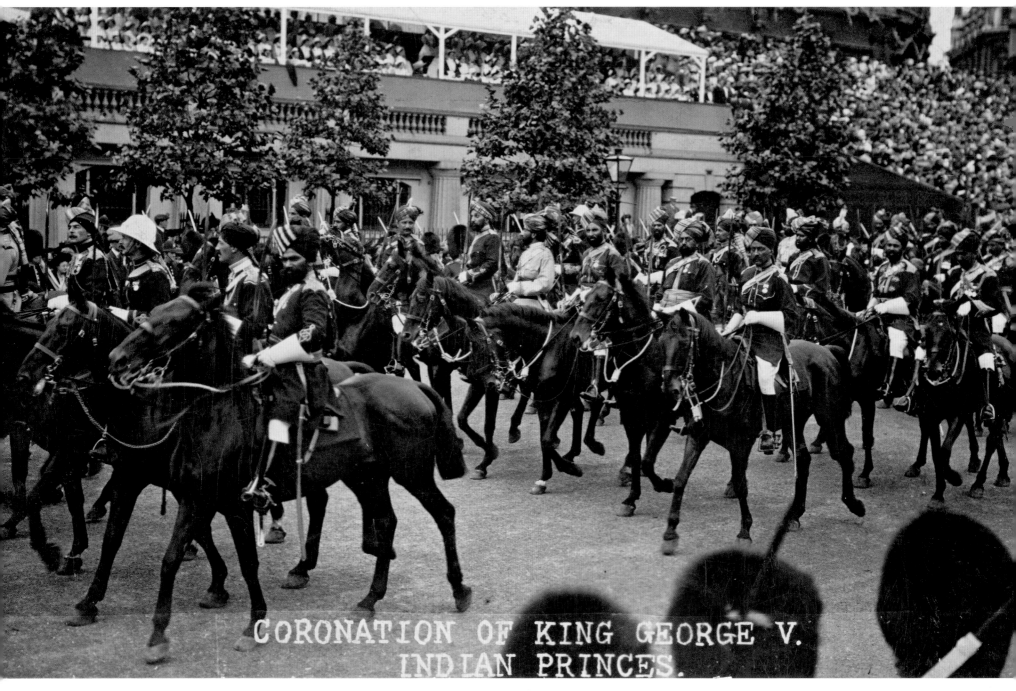

Indian princes on horseback at the Coronation of King George V, 22 June 1911

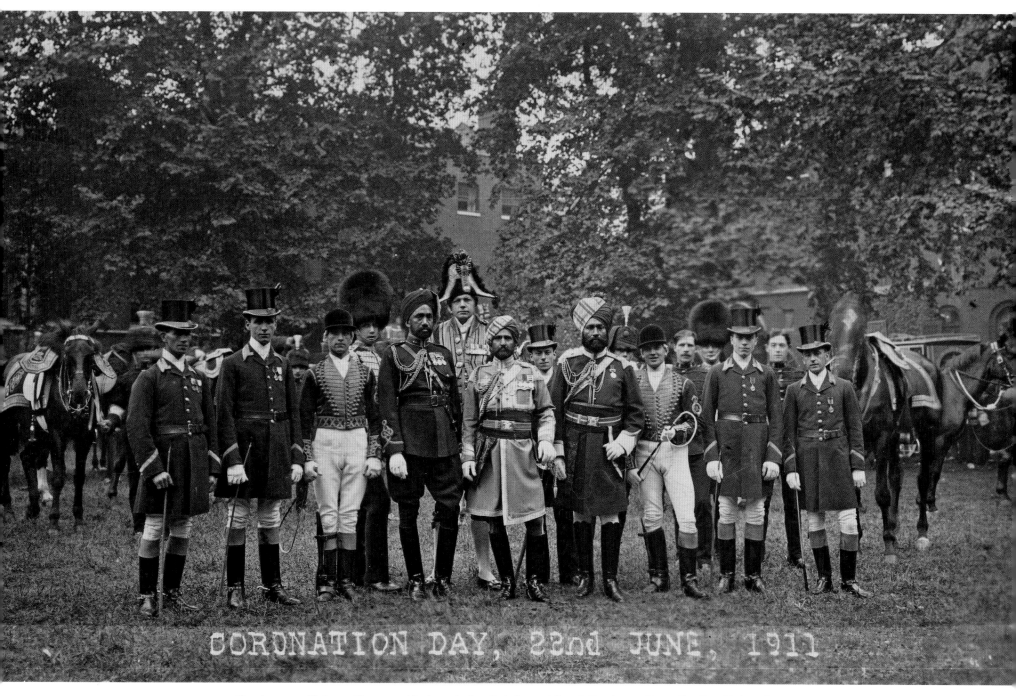

CORONATION DAY, 22nd JUNE, 1911

Royal grooms, State postilions, royal footmen, Indian Orderlies and Guards Bandsmen, Coronation Day, 22 June 1911

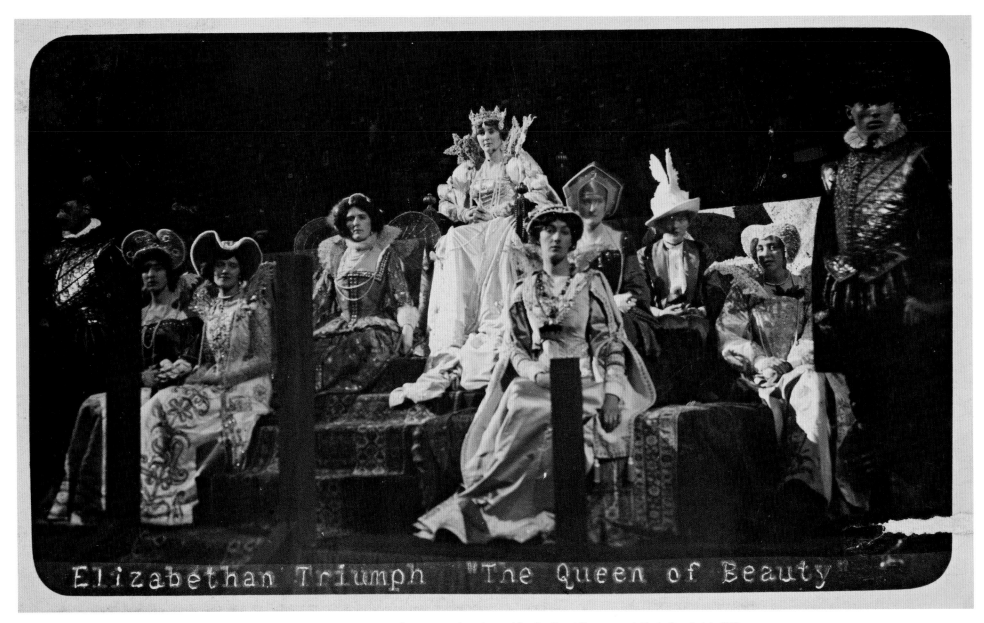

Elizabethan Triumph "The Queen of Beauty"

Viscountess Curzon as Queen of Beauty at the rehearsal for the Royal Tournament, Earls Court, July 1912

Portrait of Russian Princess Mary Eristoff, date unknown

Band of the 2nd Life Guards
King St. Lord Mayor's Day. 1912.

Band of the 2nd Life Guards join the procession on Lord Mayor's Day, King Street, City of London, 1912

THE RICHMOND ROYAL HORSE SHOW, 1914.
WINNER OF THE COACHING COMPETITION.

The winner of the coaching competition at the Richmond Royal Horse Show, 1914

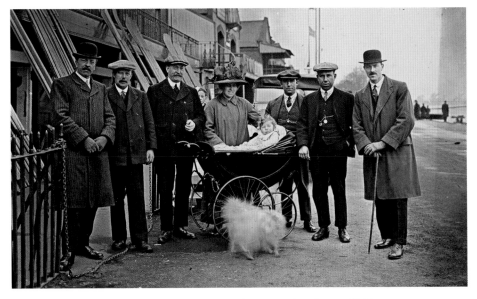

Bossy Phelps and family on the tow path at Putney, 1906

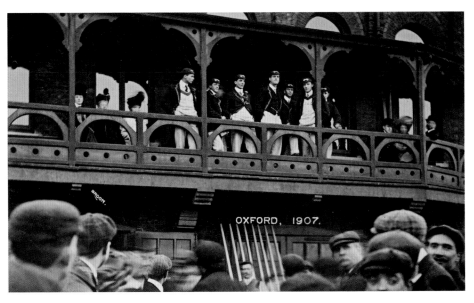

The Oxford Team, University Boat Race, Putney, 1907

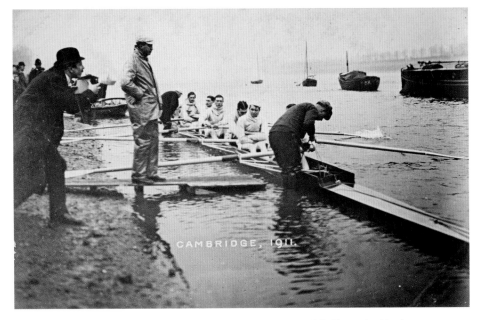

The Cambridge Team, University Boat Race, Putney, 1911. Alexander Korda as
Press Photographer on the left

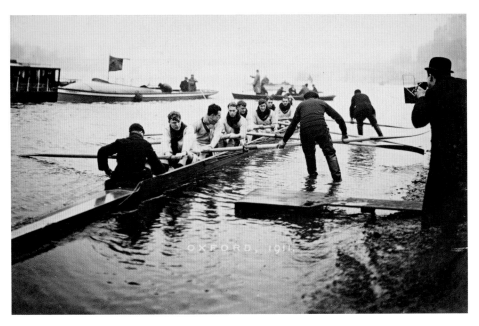

The Oxford Team, University Boat Race, Putney, 1911. Alexander Korda as
Press Photographer on the right

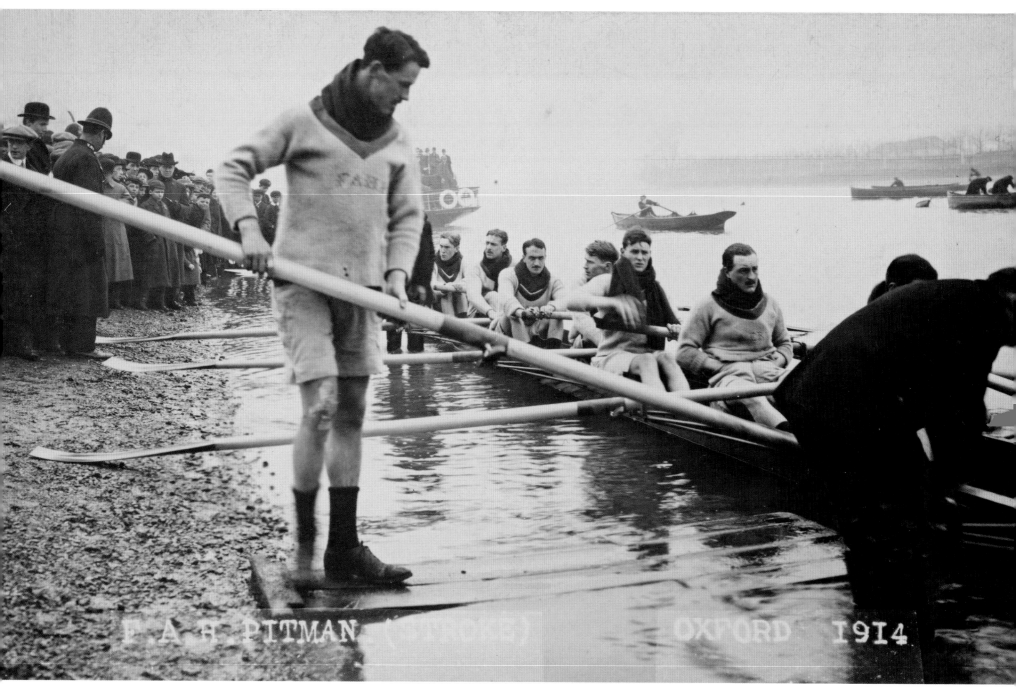

F. A. H. Pitman, stroke for Oxford in 1914, entering the boat as the last of the crew. Crowd stands on the river bank watching, Putney, 1914

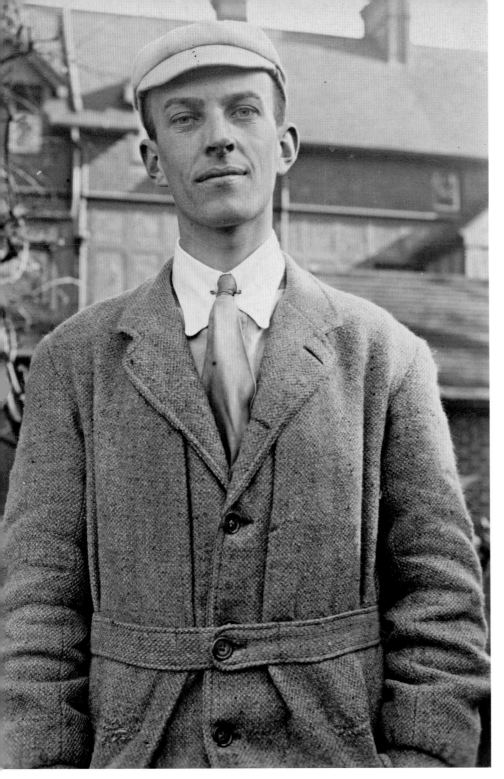

Portrait of University Boat Race oarsman, Sydney Ernest Swann, Cambridge Team, 1914

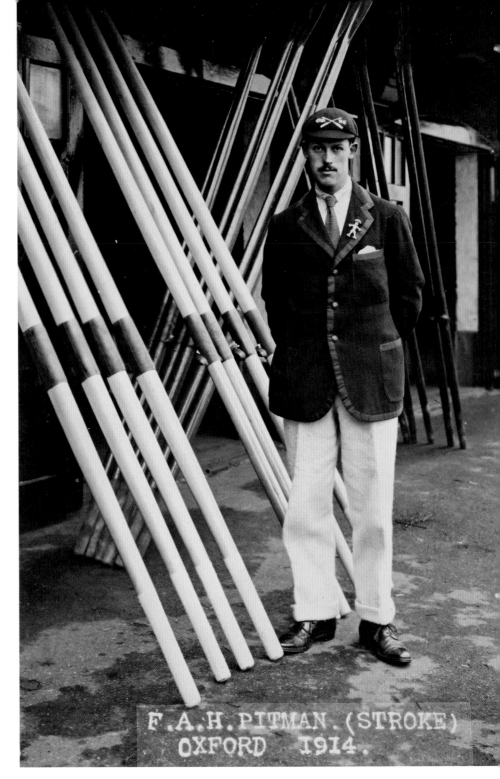

F.A.H. PITMAN. (STROKE)
OXFORD 1914.

Portrait of University Boat Race oarsman, Frederick Archibald Hugo Pitman of Oxford, 1914

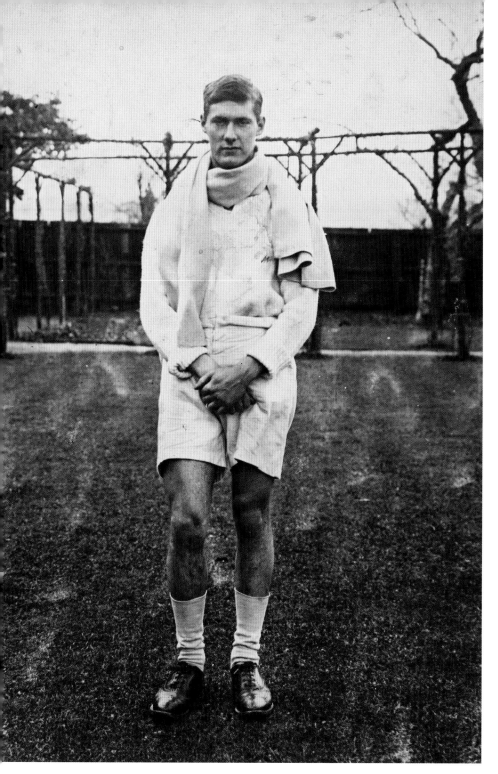

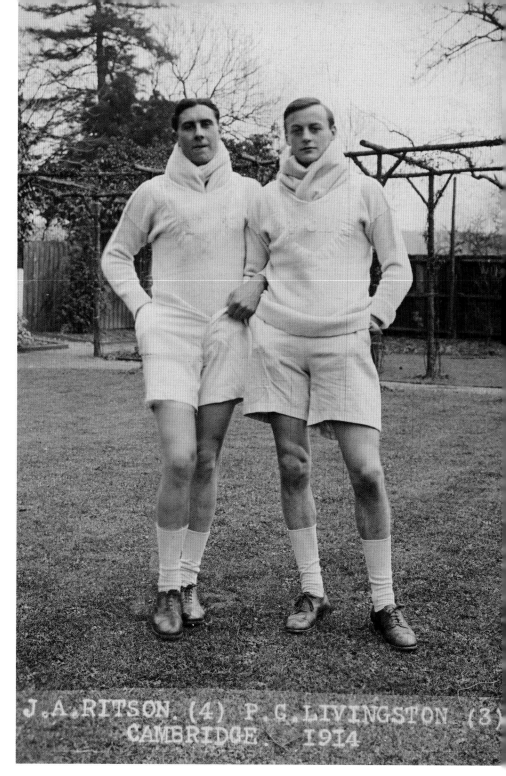

J.A.RITSON. (4) P.G.LIVINGSTON (3)
CAMBRIDGE. 1914

Mr Dennis Ivor Day, Cambridge oarsman, University Boat Race, 1914.
Died from his wounds fighting in the war, 1915

John Andrew Ritson and Phillip Clermont Livingston, Cambridge Team oarsmen, 1914.
Ritson was killed during the war in 1916. Livingston, a relative of Mrs Broom, became
Air Marshall Sir Philip Livingston KBE AFC

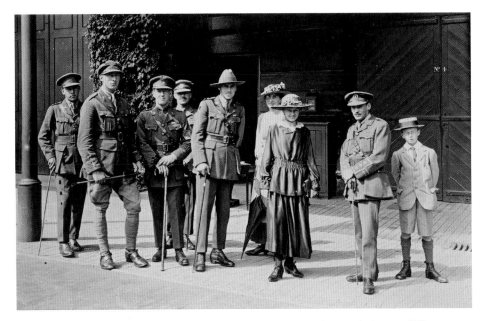

Guests from King Edward VII's Hospital for Officers at the Royal Mews, c. 1915

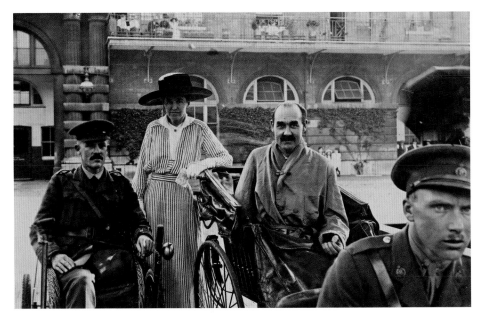

Wounded patients from King Edward VII's Hospital for Officers visit the Royal Mews, 1915

Guests from King Edward VII's Hospital for Officers at the Royal Mews, c. 1915

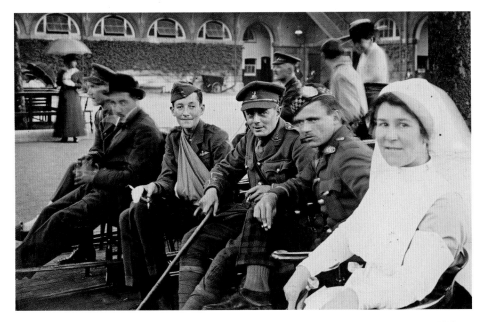

Patients and nurses from King Edward VII's Hospital for Officers at the Royal Mews, c. 1915

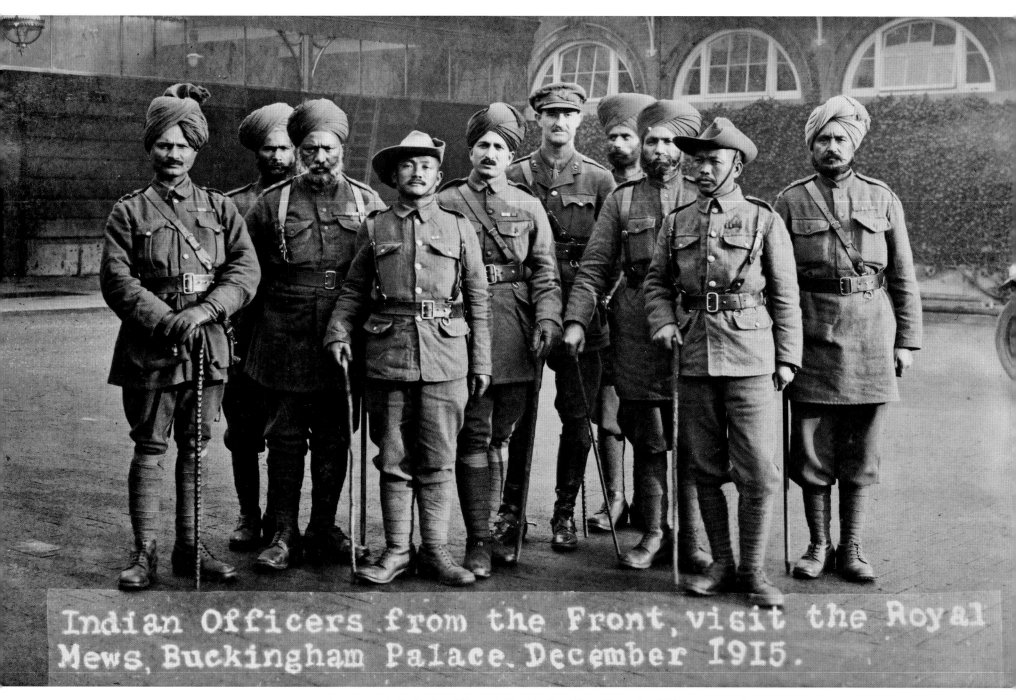

Indian Officers from the Front, visit the Royal Mews, Buckingham Palace, December 1915.

A group portrait of Indian Officers visiting the Royal Mews, December 1915

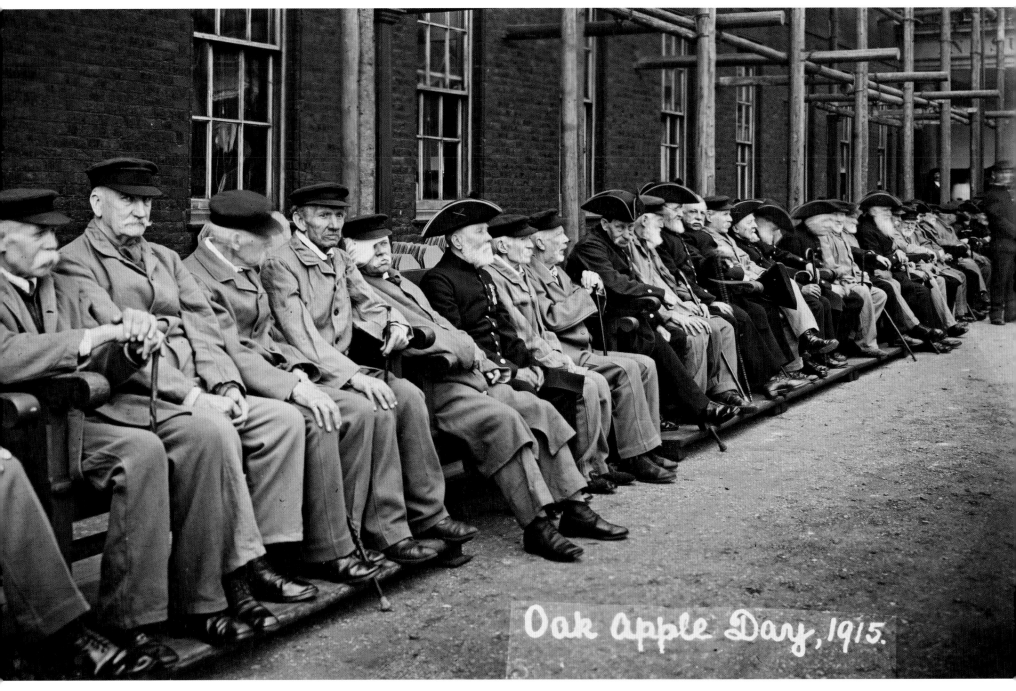

Oak Apple Day, 1915.

Chelsea Pensioners on Oak Apple Day, or Founders Day, Royal Hospital Chelsea, 1915

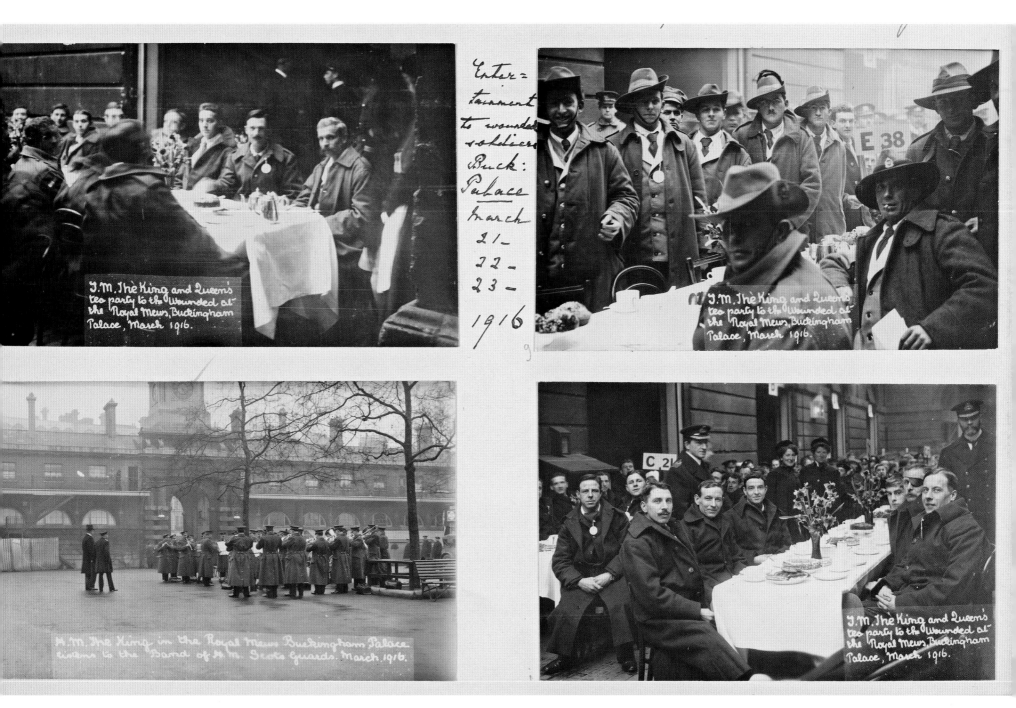

Enter=
tainment
to wounded
soldiers
Buck:
Palace
March
21 —
22 —
23 —
1916

I.M. The King and Queen's tea party to the Wounded at the Royal Mews, Buckingham Palace, March 1916.

I.M. The King and Queen's tea party to the Wounded at the Royal Mews, Buckingham Palace, March 1916.

H.M. The King in the Royal Mews Buckingham Palace listens to the Band of H.M. Scots Guards, March 1916.

I.M. The King and Queen's tea party to the Wounded at the Royal Mews, Buckingham Palace, March 1916.

A page from one of Queen Mary's personal albums, showing Broom photographs of the tea party for wounded soldiers held at Buckingham Palace, March 1916

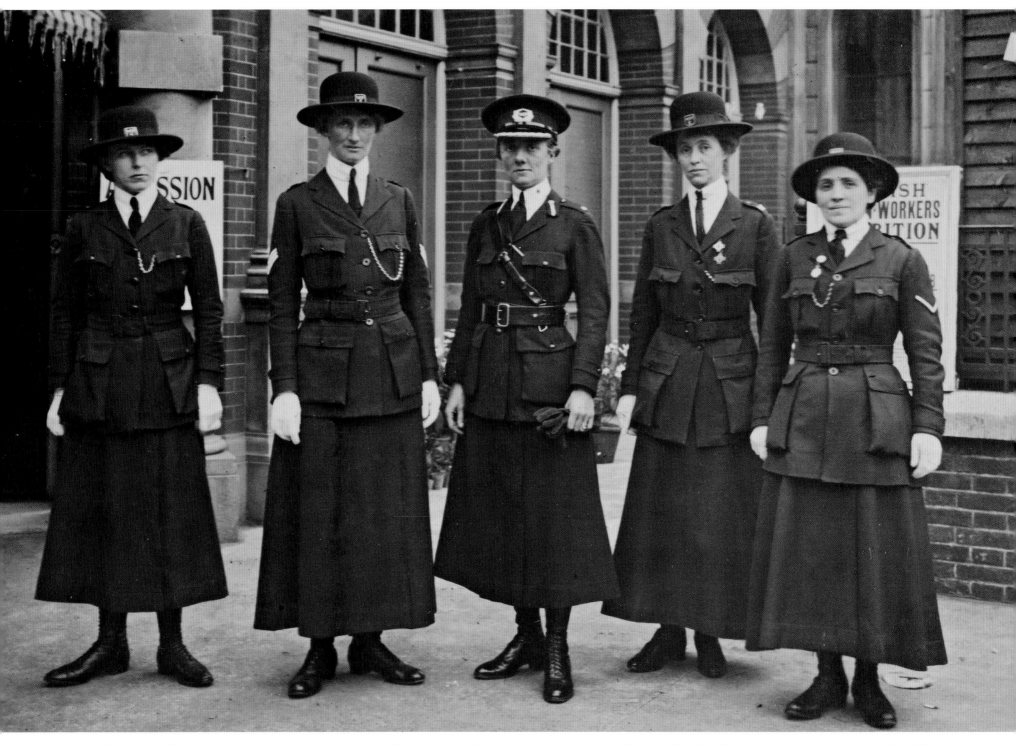

Officers of the Women's Police Service, led by Inspector Mary Allen (a former Suffragette), maintain order at the Women's War Work Exhibition, Knightsbridge, London, May 1916

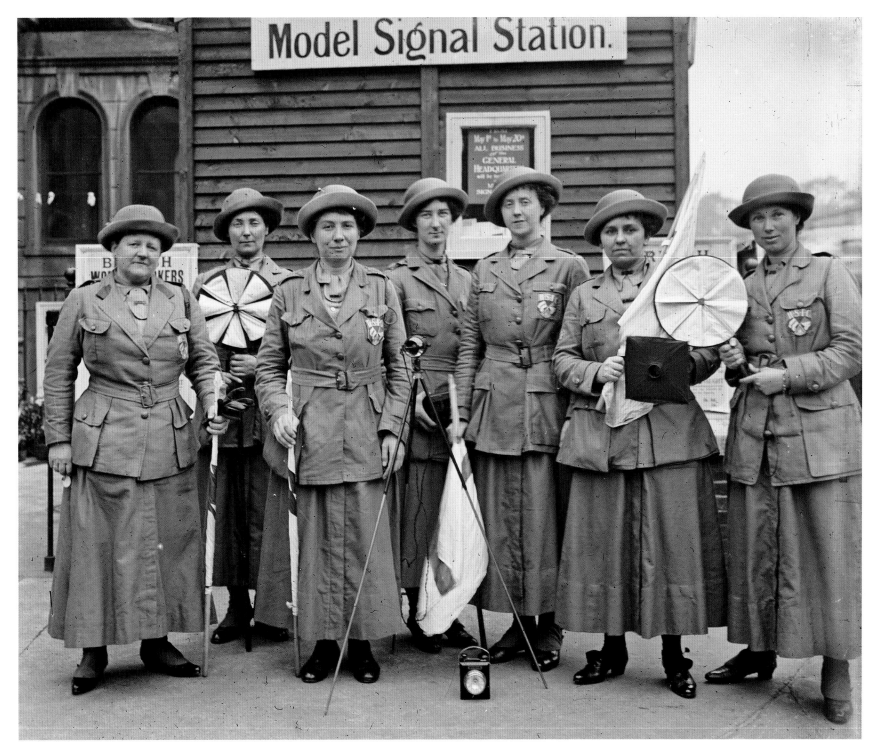

A group of Women's Volunteer Reserve Signallers at the Women's War Work Exhibition, Knightsbridge, London, May 1916

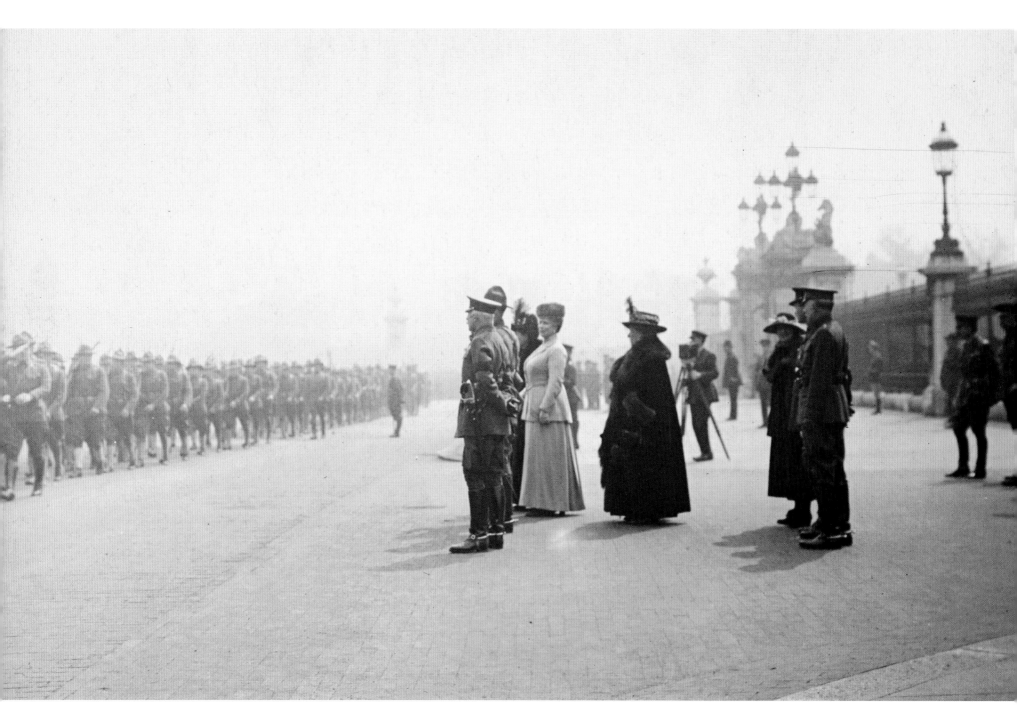

The first Americans in London before leaving for the War marching past King George V and Queen Mary, 1917

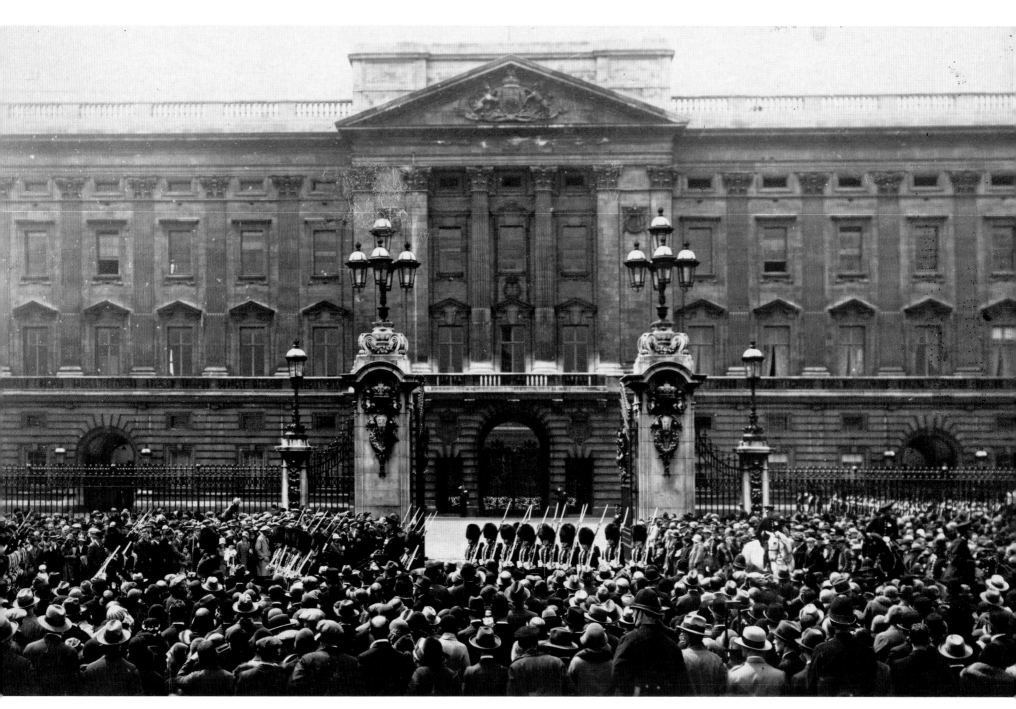

Guards parading outside Buckingham Palace, date unknown

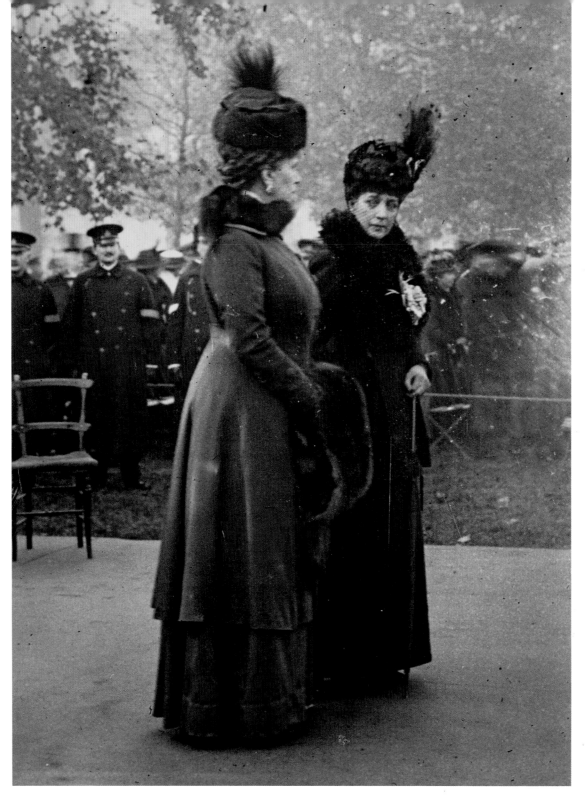

Queen Mary and Queen Alexandra, 1916

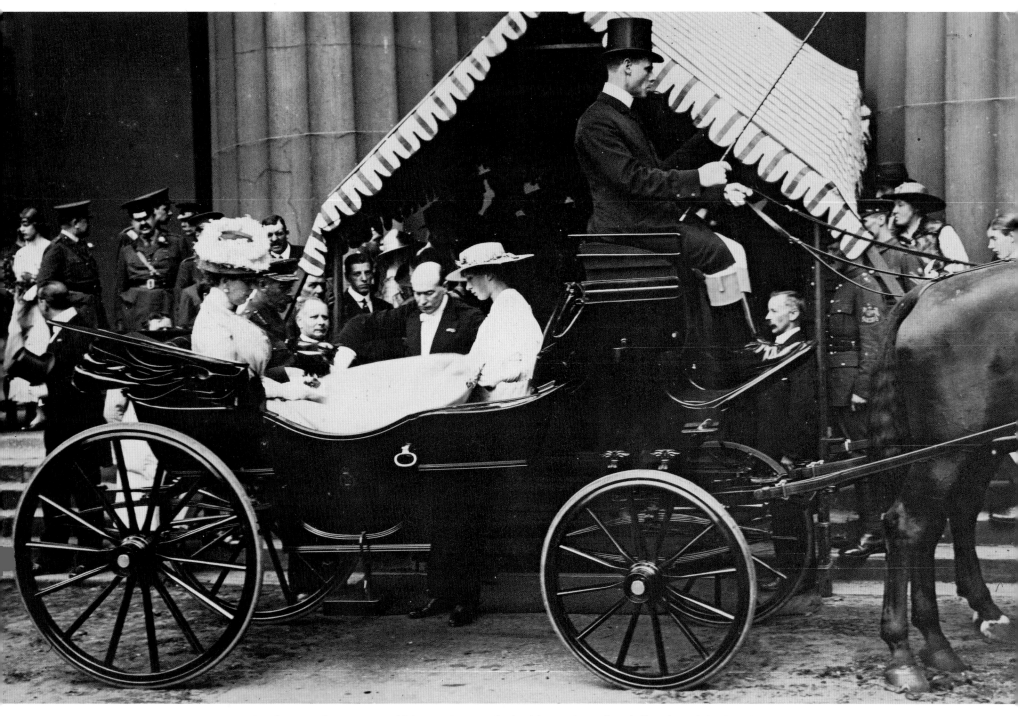

King George V, Queen Mary and Princess Mary, at a thanksgiving service at Guards Chapel, Armistice Day, 1918

HRH Prince of Wales in the centre, his Equerry Piers Leigh, left, and Sir Charles Fitzwilliams, Crown Equerry at
the Royal Mews, on return from Guards Victory March, 1919

6th Stockport Baden-Powell Sea Scouts visiting the Royal Mews, May 1919

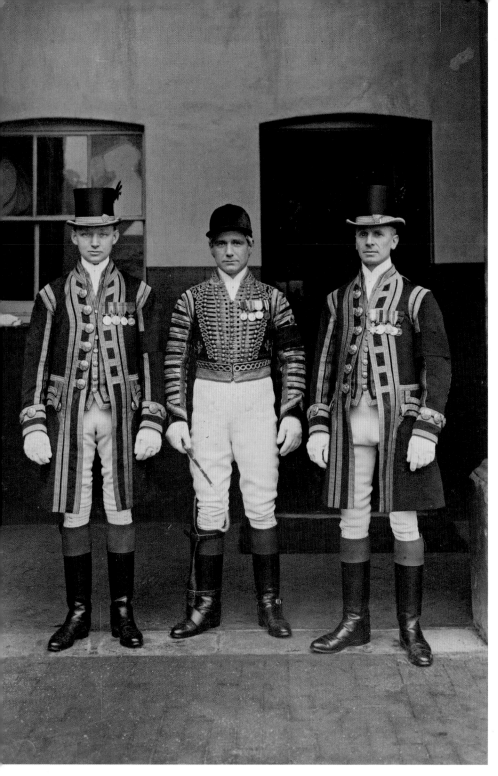

Footmen and Postilion at the Royal Mews, date unknown

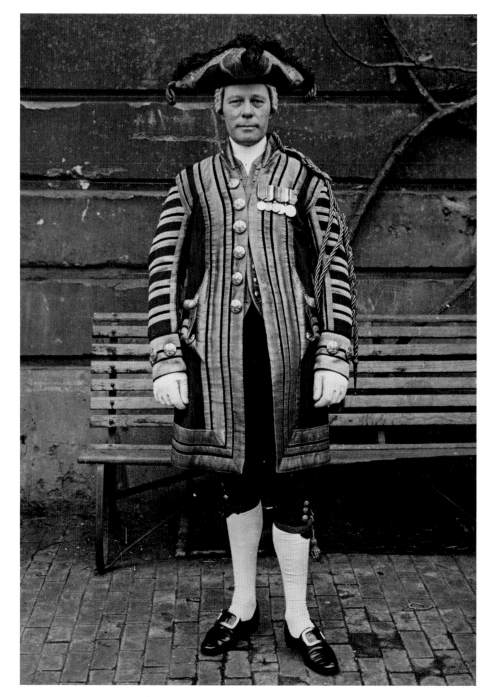

Mr Collins, State Coachman, at the Royal Mews, 1920

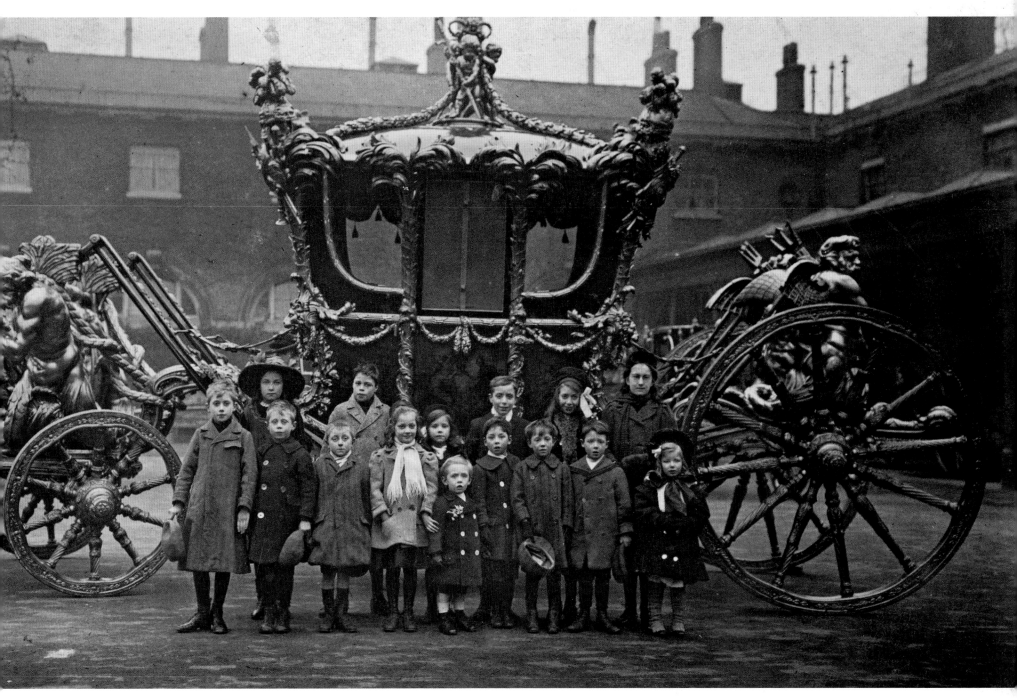

Children alongside the King's State Coach at the Royal Mews, c. 1925

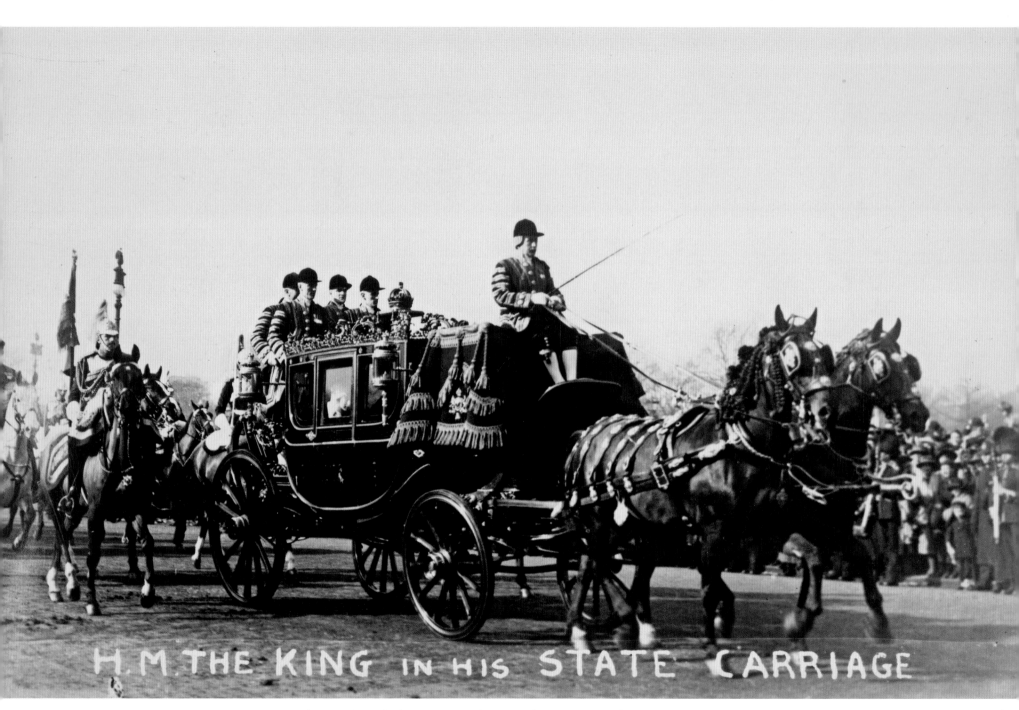

H.M. THE KING IN HIS STATE CARRIAGE

The King's State Carriage transports the King and Princess Mary on her wedding day, 1922

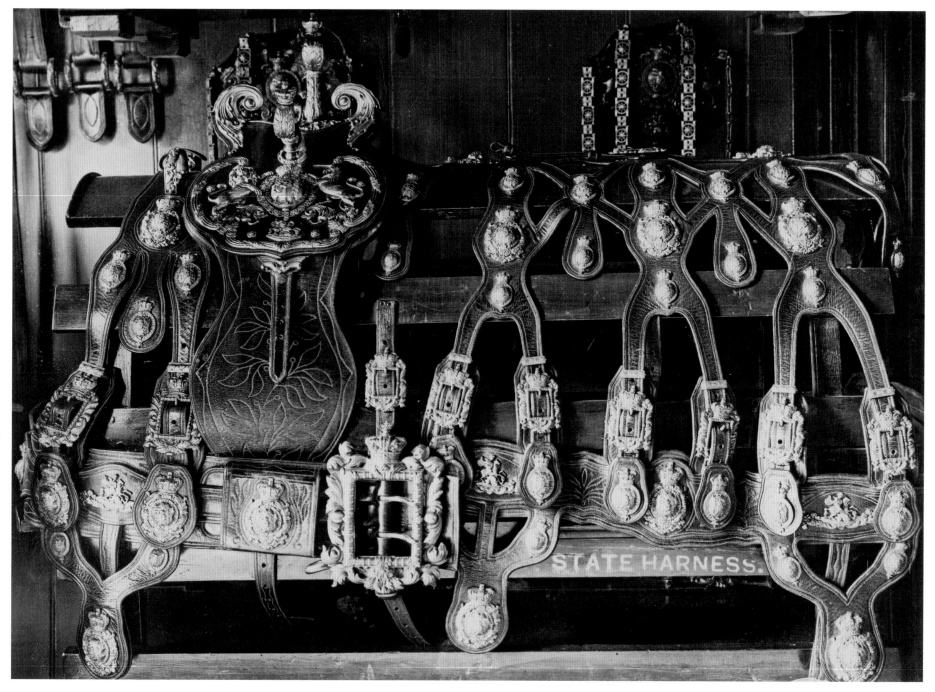

The King's State Harness, to be used at the Silver Jubilee, c. 1935

Group portrait of daughters of serving men on the steps of Wellington Barracks, c. 1927

An Inspection of the Welsh Guards by their Colonel HRH The Prince of Wales in 1934. Widely circulated in postcard form as 'Pillars of Our Empire'

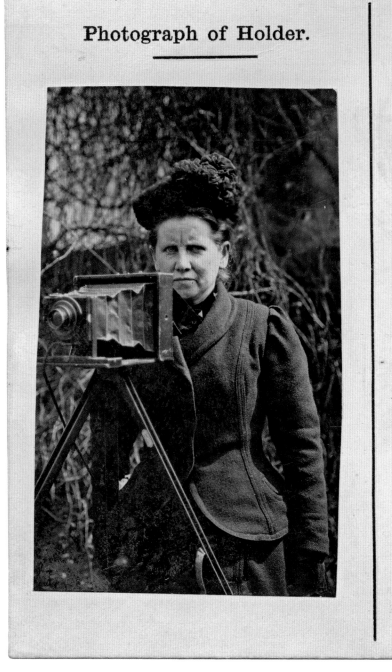

Photograph of Holder.

PERMIT TO PHOTOGRAPH.

TO THE POLICE.

PASS the representative of _____

Mrs Broom

(whose portrait is shewn hereon), to

whom permission has been given to use

a *Stand Camera at the Site of Artillery*

Memorial, The Mall

on Friday, May 20th, 1910

E. R. Henry

The Commissioner of Police of the Metropolis.

Press pass permitting photography on the day of King Edward VII's funeral, 20 May 1910. The portrait was made by Winifred Broom

Admission Pass for the Opening of Parliament, 14 February 1912

Admission Pass for the Opening of Parliament, 12 February 1918

Admission Pass for the Opening of Parliament, 7 February 1922

Admission Pass for the Opening of Parliament, 9 December 1924

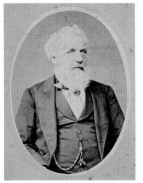

Alexander Livingston, by Collier, St George's Place, Knightsbridge, c. 1872

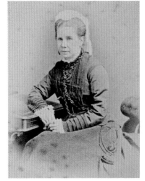

Margaret Livingston, nee Fair, widowed, photographed by Henry Goodman, Margate, c. 1875

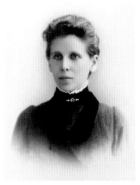

Portrait of Christina Livingston made 3 days before her marriage, from an opal-type made by Goodman, 1889

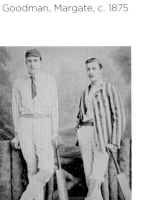

Albert Edward Broom, Captain of Battersea Cricket Club, and Louis Glaister, by South Kensington Studio, Fulham Road, c. 1892

A tintype showing Albert, Christina and baby Winifred, Margate, c. 1892

Christina Broom posed with her camera, by daughter Winifred Broom, May 1910

FAMILY AND BUSINESS EVENTS	YEAR	BRITISH AND WORLD EVENTS
Alexander Livingston born	1812	
	1820	King George III dies – 29 January; succeeded by George IV
	1830	King George IV dies – 26 June; succeeded by William IV
	1837	Queen Victoria ascends the British throne – 20 June
Alexander marries Margaret Fair – 15 June	1848	
	1851	Great Exhibition, Hyde Park, London – opens 1 May
Christina Livingston born – 28 December	1863	
Albert Edward Broom born	1865	
Alexander Livingston dies	1875	
	1880	First Boer War breaks out – 16 December
Margaret Livingston dies	1884	
Christina and Albert marry – 15 August	1889	
Winifred Margaret born – 7 August	1890	
Family living at 4 Napier Avenue, Fulham (later renumbered No. 8)	1893	New Zealand's adult women are first in world to be granted right to vote – 19 September
Albert receives injury to shin during cricket match	1896	
	1899	Second Boer War begins – 11 October
	1901	Queen Victoria dies – 22 January
Christina and Albert open their shop at 87 Streatham Hill	1902	Second Boer War ends – 31 May
		Coronation of Edward VII – 9 August
Christina uses a borrowed ¼ plate camera for the first time	1903	Women's Social & Political Union formed in Great Britain by Emmeline Pankhurst
Christina gains permission to photograph within the barracks of the Household Division and the Royal Mews	1904	
Christina first photographs suffrage supporters	1908	
	1910	King Edward VII dies – 6 May; succeeded by George V
Albert Broom dies	1912	
Christina and Winifred move to 92 Munster Road, Fulham	1913	Suffragette demonstrations in London

FAMILY AND BUSINESS EVENTS	YEAR	BRITISH AND WORLD EVENTS
	1913	Emmeline Pankhurst sentenced to three years' imprisonment – 2 April
		Suffragette Emily Wilding Davison dies from injuries sustained by stepping in front of King George V's horse at Epsom Derby – 4 June
Christina photographs soldiers mobilizing at the very beginning of the Great War – 4 August	1914	Britain declares war on Germany – 4 August
Winifred begins voluntary work as a VAD		
	1918	Armistice signed – 11 November
		Representation of the People Act (includes women over 30 meeting minimum property qualifications to receive the vote) – 6 February
	1919	Funeral of Edith Cavell, Norwich Cathedral – 15 May
Winifred awarded title of Best Printer in London	1920	
	1926	Opening of the Guards Division War Memorial – 16 October
	1928	Representation of the People (Equal Franchise) Act; women over 21 get vote – 2 July
Christina ceases to sell her pictures from outside the Royal Mews	1930	
Daily Sketch reproduces ten Broom photographs within its Silver Jubilee supplement – 1 May	1935	
	1936	King George V dies – 20 January; succeeded by Edward VIII
		King Edward VIII abdicates – 10 December; succeeded by his brother, George VI
Christina dies – 5 June	1939	Britain declares war on Germany – 3 September
Winifred goes into private nursing and cares for her elderly aunt, Christina's sister Margaret	1940	
Winifred suffers long illness, convalescing in Margate	1945	VE Day celebrated 8 May; VJ Day celebrated 15 August and 2 September
Winifred begins process of rehousing negatives into public institutions		
Winifred dies – 22 June	1973	
	2015	*Soldiers & Suffragettes: The Photography of Christina Broom* exhibition at Museum of London

Winifred Broom with her toy lion just after moving to Munster Road, 1913

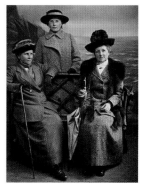

Christina, Winnie and Aunt Margaret Dunkley at Folkestone, October 1913

Robert William Livingston, photographed by Broom in 1916

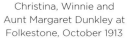

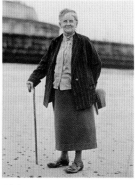

Christina Broom in Margate, 1930

Last photograph of Christina Broom, fishing in Margate, just before she died, 1939

NOTES

Introduction

1 Helmut Gernsheim and Alison Gernsheim, *The History of Photography*, Oxford: Oxford University Press, 1955, p. 345.

2 Val Williams, *The Other Observers: Women Photographers in Britain 1900 to the Present*, London: Virago, 1986, p. 27.

3 Frank Staff, 'Mrs Albert Broom', *Picture Postcard Collector's Gazette*, September 1975.

'Mrs Albert Broom's Interesting "Snap Shot" Post Cards'

1 Mrs Broom's permission pass for 23 June 1911 granted her admittance to photograph at the Admiralty Arch Stand, South Side, Staircase between Blocks 5 and 6. Located in the Christina Livingston Broom Collection, Harry Ransom Center, University of Texas at Austin.

2 Tonie Holt and Valmai Holt, *Picture Postcards of the Golden Age: A Collector's Guide*, London: MacGibbon & Kee, 1971, p. 17.

3 The 1891 England Census lists the Brooms residing at 4 Napier Avenue, Fulham. Class: G12; Piece: 54; Folio: 100; Page 16, GSU Roll 6095164.

4 The 1901 England Census records the couple at 7 Osborne Road, Isle of Thanet in the County of Kent. Albert is listed as a 'retired iron monger'. Class: RG13; Piece: 828; Folio: 179; Page 3.

5 John Fraser, 'Postcard pioneer', *British Journal of Photography* 136 (2 February 1989): 8–9. Christina's father died when she was 12 and her mother when she was 20. Upon her mother's passing, she and her brother Robert inherited the family business, several properties and promise of an income; but he squandered the family fortune gambling, leaving her virtually no assets.

6 *Kelly's Directory*, Southern Districts, London, 1902.

7 In 1902, 488,900,000 postcards were mailed in Great Britain. *The Photogram*, 10, 118 (October 1903): 311, 318.

8 The 1911 England Census recorded Albert's occupation as 'accountant', suggesting that, although disabled, he had devised a way to contribute to the family economy. Class: RG 14; Piece: 341.

9 Hughes's decorative background settings simulate both interior and exterior spaces: 'about eight different backgrounds …' Alice Hughes, *My Father and I*, London: Thornton Butterworth Ltd, 1923, p. 125.

10 Between April 1898 and November 1909, Hughes's photographs appeared on 143 *Country Life* covers (21% of the total). The photographer Richard Speaight followed with 113 covers or 17%.

11 When she closed her London studio, Hughes sold her negatives, which numbered 50,000, representing the number of exposures made over nearly 20 years. Alice Hughes, 'Photographic portraiture as a profession', *Some Arts and Crafts*, London: Chapman & Hall Ltd., 1903, pp. 295–320.

12 Ignota, 'A lady photographer: an interview with Miss Kate Pragnell', *Woman at Home* 7 (1899): 667–76.

13 Ibid., pp. 668–9.

14 M. Griffith, *The Photographic News* (25 October 1895): 677.

15 *Bystander* (15 February 1905): 12.

16 *Bystander* (9 March 1904).

17 Although Pragnell passed away on 19 November 1905, her studio continued to produce and publish work under the name Kate Pragnell throughout the decade.

18 1901 England Census, Class: RG13; Piece: 117; Folio: 134; Page 18.

19 *Sketch* 24, 305 (30 November 1898); *Country Life* 5 (3 June 1899); 'Madame Lallie Charles's portraits', *Lady's Realm* 8 (1900): 45.

20 Frank Staff, *The Picture Postcard and Its Origins*, New York: Frederick A. Praeger, 1966.

21 For an expanded list of picture postcard publishers in Great Britain, see Holt, pp. 173–86.

22 Staff, p. 74.

23 Holt, p. 174.

24 Martin Willoughby, *A History of Postcards from the Turn of the Century to the Present Day*, London, Bracken Books, 1994, p. 117.

25 Willoughby, p. 79.

26 Holt, p. 184.

27 Ibid.

28 Ibid., pp. 87–89; 175–6.

29 Ibid., p. 87.

30 Although Mrs Albert Broom was a known entity as a postcard publisher for at least 30 years, and early postcard historians Tonie and Valmai Holt and Frank Staff used her illustrations in their books, they failed to mention Broom by name and/or include a discussion of her postcard production. See Staff, Plate 97, and Holt, Plate 9. In order to correct his error, a decade later Staff published a letter written by Winifred Broom pointing out his omission. Frank Staff, 'Mrs. Albert Broom', *Picture Postcards and Collectors Gazette*, September 1975.

31 Rosamond B. Vaule, *As We Were: American Photographic Postcards 1905–1930*, Boston: David R. Godine, 2004, p. 212. Vaule's extensive research has discovered several American women postcard photographers, including Mrs K. A. Raftice, Carson City, Nevada, and Mary E. Stimson, Montpelier, VT.

32 Richard Carline, *Pictures in the Post*, Bedford, England: Gordon Fraser, 1959, p. 5.

33 Unpublished manuscript, 'Mrs. Albert Broom: an appreciation' by Guardsman E. J. Collings, 1974, located in the London Borough of Hammersmith and Fulham Archives and Local History Centre.

34 *Evening Standard*, 19 October 1926. Quote also appears in Fraser, p. 8.

35 Christina Livingston Broom Collection, Harry Ransom Center, the University of Texas at Austin.

36 Nancy Stieber, 'Postcards and the invention of Old Amsterdam around 1900', in *Postcards: Ephemeral Histories of Modernity*, ed. David Prochaska and Jordana Mendelson, University Park, Pennsylvania: Pennsylvania State University Press, 2010, pp. 24–41.

37 Charlotte Gere, *Artistic Circles: Design & Decoration in the Aesthetic Movement*, London: V & A Publishing, 2010, pp. 141–2. Originally built by architect Frederick Cockerell, the Wattses' home was added on to by George Aitchison, who built the picture gallery and added a terracotta porch.

38 J. M. Richards, *English Architecture*, London: Weidenfeld and Nicolson, 1981, pp. 224–5.

39 John Leonard, *London's Parish Churches*, Reading: Spire Books Ltd., 2011, pp. 223–5.

40 Ibid., pp. 219–20.

41 Richards, pp. 221.

42 Eugène Atget kept a hand-lettered sign outside his studio: 'Documents for Artists'.

43 Chronicle, 19 October 1926. Presumably, Broom was referring to Field Marshall Lord Roberts, or 'Bobs', Colonel of the Irish Guards, who expedited her connection to King Edward VII.

44 Albert Edward Broom passed away on 21 January 1912. The probate of 16 December indicates that the effects left to his widow amounted to: £370 6s 6d. At the time, the couple resided at 38 Burnfoot Avenue in Fulham. Following the death of her husband, Christina moved with her daughter to 92 Munster Road, Fulham, where she lived and worked for 27 years.

'A Riot of Colour': Mrs Albert Broom's Suffragette Photographs

1 *Daily Mail*, 25 June 1908.

2 Winifred M. Broom, unpublished memoir, 1971, Christina Broom Collection, Museum of London, p. 1.

3 Ibid.

4 Ibid.

5 Census Returns: Chelsea, 1871, 1881, 1891.

6 www.shelwin.com, website of private schools in Thanet.

7 Unpublished manuscript, 'Mrs. Albert Broom: An Appreciation', by Guardsman E. J. Collings, 1974, Christina Broom Collection, Museum of London.

8 John Fraser, 'Postcard pioneer', *British Journal of Photography* 136 (2 February 1989): 8

9 Christina Broom Collection, Museum of London.

10 Fifth Report of the Vestry of the Parish of Chelsea; Stephen Inwood, *City of Cities: The Birth of Modern London*, pp. 14–16.

11 John Fraser, 'Mrs Albert Broom: first woman army photographer', unpublished article, 1989, pp. 3–6.

12 Christina Broom Collection, Museum of London.

13 The Women's Exhibition programme, Suffragette Collection, Museum of London

14 *Votes For Women*, 4 June 1909, p. 757.

15 Sylvia Pankhurst, *The Suffragette Movement*, 1931, p. 305.

16 *Votes for Women*, 18 February 1910, pp. 311–312; Census Returns: Chichester, 1881; Fulham, 1901.

17 *Votes for Women*, 29 July 1910, p. 726.

18 *Votes for Women*, 16 June 1911, pp. 615–16

19 Diane Atkinson, *The Purple, White and Green: Suffragettes in London, 1906–1914*, p. 26.

20 Christina Broom Collection, Museum of London.

21 Fraser, p. 16.

Ceremony and Soldiering: Mrs Albert Broom's Photography of the Armed Forces in Britain 1904–1939

1 Winifred M. Broom, unpublished memoir, 1971, Christina Broom Collection, Museum of London, p. 1.

2 Winifred M. Broom, p. 1.

3 Field Marshal Lord Roberts VC (1832–1914) was one of the most successful and popular military leaders of his generation. As Commander-in-Chief of the Armed Forces, 1901–4, he worked to overcome the legacy of mismanagement which had afflicted the British Army during the Boer War.

4 Hilary Roberts, *Photography before the First World War*, in *1914-1918 online International Encyclopedia of the First World War*, Freie Universität Berlin (Pub), Berlin, 2014 http://encyclopedia.1914-1918-online.net/article/photography (accessed 20 December 2014).

5 Unpublished letter, Brigadier-General G. C. Nugent to Winifred Broom, 4 July 1939, Christina Broom Collection, Museum of London.

6 http://www.army.mod.uk/armoured/regiments/28071.aspx (accessed 19 December 2014).

7 Barney White-Spunner, *Horseguards*, London: Macmillan, 2006, p. 435.

8 Ibid.

9 Ibid., p. 437.

10 Ibid., p. 449.

11 Christina Broom was 52 when the war commenced in 1914.

12 Unpublished letter, Christina Broom to Winifred Broom, 15 June 1917, Christina Broom Collection, Museum of London.

13 See example photograph: *A portrait of two guardsmen of the Blues and Royals, wearing full dress and service dress uniforms at Horse Guards, London, 1919*, IWM Photograph Ref: Q 66185, Imperial War Museum, http://www.iwm.org.uk/collections/search?query=Q+71674&submit=&items_per_page=10 (accessed January 2015).

14 See Shirley Neale, *Broom, Christina (1862–1939)*, Oxford Dictionary of National Biography, Oxford: Oxford University Press, 2004, online edn May 2006. http://www.oxforddnb.com.ezproxy.londonlibrary.co.uk/view/article/54345 (accessed 31 December 2014).

15 Winifred M. Broom, p. 2.

16 Leigh Hamilton,'*Soldiers first: the role of army photographers*', Ministry of Defence, London, 2012. https://www.gov.uk/government/news/soldiers-first-the-role-of-army-photographers (accessed 31 December 2014).

From Royalty to Racing: Mrs Albert Broom Photographs the Spectacles of London

1 PhotoLondon, 'The database of 19th century photographers and allied trades in London: 1841–1901: Stuart, William Slade', *PhotoLondon.org.uk* http://www.photolondon.org.uk/pages/details.asp?pid=7466 (accessed December 2014).

2 John Fraser, 'Postcard pioneer', *British Journal of Photography* 136 (2 February 1989): 8–9.

3 Unpublished letter, Ernest Brooks to Mrs Broom, undated, Christina Broom Collection, Museum of London.

4 National Archives, 'Copyright Registration: Photograph. Opening of Kew Bridge showing carriage with King's Indian attendants, soldiers in fore ground', *nationalarchives.gov.uk* http://discovery.nationalarchives.gov.uk/details/r/C13305083?descriptiontype=Full&ref=COPY+1/461/440 (accessed December 2014).

5 *The Graphic*, 6 February 1904: 175.

6 'A lady photographer: an interview with Miss Kate Pragnell', *Women at Home* 7: 673.

7 Charles Booth, 'Charles Booth Online Archive', *booth.lse.ac.uk* http://booth.lse.ac.uk/notebooks/b361/jpg/211.html B 367 p. 210 (accessed December 2014).

8 George Sims, *Living London,* London: Cassell and Company Limited, 1902–3, vol. 1, p. 104.

9 Unpublished letter, Ernest Brooks to Mrs Broom, undated, Christina Broom Collection, Museum of London.

10 Fraser, pp. 16–18.

11 Winifred M. Broom, unpublished memoir 1971, Christina Broom Collection, Museum of London, p. 2

12 *Star*, 20 August 1929.

13 The letter details a postal order for two shillings as payment for 12 postcards by Queen Mary. Unpublished letter, E. W. Wallington, Buckingham Palace to Mrs Albert Broom, 1 October 1914, Christina Broom Collection, Museum of London.

14 *Evening Standard*, 19 October 1926.

15 Christina Broom Collection, Museum of London

16 *Evening Standard*, 19 October 1926.

17 Christina Broom Collection, Museum of London

18 An Order Book March 1910–Jan 1911 belonging to Winifred Broom, located in the Gernsheim Manuscript Collection, Harry Ransom Center, the University of Texas at Austin.

19 Mrs Broom's photographer's permit for the funeral of King Edward VII, 20 May 1910, located in the Christina Livingston Broom Collection, Harry Ransom Center, University of Texas at Austin.

20 Unpublished letter, William Sims to Winifred M. Broom, 9 June 1939, Christina Broom Collection, Museum of London.

21 Unpublished notes, Winifred M. Broom, 'People I once met and knew', Christina Broom Collection, Museum of London.

22 British Pathe, Boat Race 1910–1920, *British Pathe.com* http://www.britishpathe.com/video/boat-race-2/query/Boat+race (accessed November 2014).

23 Korda links alongside Broom again in 1934, when she is present to observe Coldstream Guards dressed in Napoleonic uniform for scenes in his film *The Scarlett Pimpernel*. A photograph from the set, made by Broom, is located in the Christina Broom Collection, Museum of London.

24 Christina Broom Collection, Museum of London.

25 Commonwealth War Graves Commission, *Find War Dead,* http://www.cwgc.org/find-war-dead.aspx?cpage=1 (accessed April 2014).

26 Val Williams, *The Other Observers: Women Photographers in Britain 1900 to the Present*, London: Virago, 1986, p. 26.

27 A. T. Craig and F. R. Benson, *The Book of the Army Pageant Held at Fulham Palace*, London: Sir Joseph Causton and Sons Limited, 1910, p. 15.

28 Ibid., p. 14

29 Frederick Annesley, Cuttings Vol. 5, p. 18, The Benjamin Stone Photographic Collection, Library of Birmingham.

30 *Evening Standard*, 28 May 1910, Cuttings Vol. 11, The Benjamin Stone Photographic Collection, Library of Birmingham.

31 Winifred M. Broom, unpublished memoir 1971, Christina Broom Collection, Museum of London, p. 3.